Word and image

This book was awarded the
Prix de la Confédération Internationale des Négociants
en Oeuvres d'Art 1980

WORD AND IMAGE

French painting of the
Ancien Régime

NORMAN BRYSON
Fellow of King's College, Cambridge

CAMBRIDGE UNIVERSITY PRESS

Cambridge
New York New Rochelle Melbourne Sydney

Published by the Press Syndicate of the University of Cambridge
The Pitt Building, Trumpington Street, Cambridge CB2 IRP
32 East 57th Street, New York, NY 10022, USA
10 Stamford Road, Oakleigh, Melbourne 3166, Australia

© Cambridge University Press 1981

First published 1981
First paperback edition 1983
Reprinted 1985 1986 1987

Printed in Great Britain at the
University Press, Cambridge

Library of Congress catalogue card number: 81–10124

British Library Cataloguing in Publication Data
Bryson, Norman
Word and image.
1. Painting, French 2. Painting, Modern
– 17th–18th century – France
I. Title
759.4 ND546
ISBN 0 521 23776 9 hard covers
ISBN 0 521 27654 3 paperback

For Alan and Linda Rubin

Finally the journey leads to the city of Tamara. You penetrate it along streets thick with signboards jutting from the walls. The eye does not see things but images of things that mean other things: pincers point out the toothdrawer's house; a tankard, the tavern; halberds, the barracks; scales, the grocer's. Statues and shields depict lions, dolphins, towers, stars: a sign that something – who knows what? – has as its sign a lion or a dolphin or a tower or a star ... The wares, too, which the vendors display on their stalls are valuable not in themselves but as signs of other things: the embroidered head-band stands for elegance; the gilded palanquin, power; the volumes of Averroes, learning; the ankle bracelet, voluptuousness. Your gaze scans the streets as if they were written pages: the city says every-thing you must think, makes you repeat her discourse, and while you believe you are visiting Tamara you are only recording the names with which she defines herself and all her parts. However the city may really be, beneath this thick coating of signs, whatever it may contain or conceal, you leave Tamara without having discovered it. Outside, the land stretches, empty, to the horizon; the sky opens, with speeding clouds. In the shape that chance and wind give the clouds, you are already intent on recognising figures: a sailing ship, a hand, an elephant.

Italo Calvino

Contents

Illustrations

Preface

ACCORDING TO LEGEND, the birds paid homage to the great realist painter of antiquity, Zeuxis, by flying down to eat from his painted vine. The grapes of Zeuxis form the limit-case of an aesthetic which has rarely been far from the centre of art in the West: the utopian dream of art as a perfect reduplication of the objects of the world. Yet the legend of the grapes of Zeuxis points also in another direction which art in the West has always followed, and with as much enthusiasm: the idea of art as a place where certain dimensions of the real world are to be renounced. For the birds, pursuing the utopian objective of painting as the site where objects reappear in all their original presence and plenitude, everything which stands in the way of perfect reproduction is impediment, obstacle. But for ourselves, for humanity, art begins where an artificial barrier between the eye and the world is erected: the world we know is reduced, robbed of various parameters of its being, and in the interval between world and reproduction, art resides. An image by Hilliard may well stand for the universal type of the work of art, for very deep in human thought, as the anthropologists tell us, lies the idea of art as miniaturisation. All miniatures seem to have an aesthetic quality about them, and conversely the vast majority of works of art are small scale. One might think such a characteristic to be primarily an affair of economy of means and materials; and one might appeal to support from works which are undoubtedly artistic but are also on a grand scale. Indeed, a very cogent aesthetic was propounded by Burke in defence of almost the opposite case: the Sublime appears when we contemplate objects on a scale which exceeds the familiar – and here 'scale' may include not only physical size, but emotional intensity; Sublimity appears in the faces of men in the throes of death as well as in the spectre of Brocken. But one must be clear about the idea of reduction. In contemplating a painting of the Alps, or such a work as the *Raft of the Medusa*, we are still within reduction: that which was colossal is now miniature. In the case of the spectre, as in all those instances where a peculiar aesthetic emotion is released by contact with the panoramic – and this is perhaps why people visit the Grand Canyon or the Pyramids, and look in a certain way at the night sky – the *frisson* is again triggered by a collapse of normal awareness of scale. The measure of six feet

is experienced as minuscule; and in that overthrow of habitual measurement lies an aesthetic value. Even such work as the frescoes in the Sistine Chapel are a small-scale model, despite their impressive dimensions, since the subject they depict is the End of Time; and the same is true of the cosmic symbolism of religious monuments. However much these may approach the colossal they are still miniature in relation to those other spatial, temporal, and numinous dimensions they invoke. And the catalogue of Western arts is itself a list of renunciations: with sculpture, of texture and colour; with painting, of volume; with both, of time.

Two impulses, one to resurrect and one to renounce, seem between them to define the painting of the West. On the one hand, what Lévi-Strauss calls the 'avid and ambitious desire to take possession of the object', a desire which calls into being all those refinements within the technology of reproduction which for antiquity, as for the Renaissance, constituted painting's progressive history; and on the other hand, an impulse which runs counter to the first, demands a diminution or sacrifice of the object's original presence, and strips away from its unwanted repletion aspects which impede the release of 'aesthetic emotion'.

The most striking manifestations of the second impulse concern the removal of one or more parameters of the physical world. Less obvious is the curtailment of the image through its conversion into a site of meaning. Only rarely has the image been granted full independence – allowed simply to exist, with all the plenary autonomy enjoyed by the objects of the world. Throughout its existence, painting has sought to circumscribe and delimit the autonomous image by subjecting it, as part of the overall impulse of renunciation, to the external control of discourse.

Stylistic history takes as its mission the description of successive visual styles, following one upon the other in unbroken dynastic order. But alongside this familiar and untroubled saga of continuities lies another, semantic history, only partly visible to the stylistic eye, and full of turbulence; a history not merely of meanings, but of ceaseless conflict between the image as it seeks fullness and autonomy, and the renunciatory impulse which refuses the image that primal plenitude, and seeks its conversion from an end to a means, a means to meaning. It is with a fragment of the history of that conflict that this book is concerned.

Acknowledgements

THIS BOOK owes a debt of gratitude to many institutions and individuals without whose support it simply could not have been written: to the Confédération Internationale des Négociants en Oeuvres d'Art, and in particular to Julian Agnew and Henry Rubin in London, and to Georges Baptiste in Brussels; to King's College, Cambridge, which awarded the Fellowship enabling me to carry out the research project of which this study is one part; and to the British Academy, for the generosity that made possible a number of vital field trips to libraries and museums outside the United Kingdom. I would equally like to thank Tim Clark, John Barrell, Frank Kermode, Tony Tanner, and Anita Brookner, who read through the manuscript at various stages, and whose valuable comments I have tried to reflect in the present version.

In this respect no different from any other text, the book is mysterious about its origins. I am aware that it bears the traces of many past discussions, whose degree of influence over it I am, however, powerless to assess; I may single out with certainty only a fraction of that perhaps indeterminable number, and recall, with thanks, conversations with Alan Rubin, Nick Jolley, Neil MacGregor, Jesse Allen. In the case of the daily, yet always exceptional, stimulation of the intellectual environment at King's, things are possibly even more indistinct, though the debt itself is clear. Where osmosis is at work all lists elide, yet any list must include the names of my colleagues Colin MacCabe and David Simpson; just as I would like it to include the names of those who, in different ways, hosted me through the period of the book's writing: Ray Edwards, Charles-Henri Nabias, Peter Canadine, Marja Lew-Ostik-Kostrovicka, and Bentley Angliss.

Author and publisher gratefully acknowledge the permission of the following to reproduce their illustrations in this book: the Dean and Chapter of Christchurch Cathedral, Canterbury (1); the Mansell Collection, London (2, 3, 24, 72, 73, 88); the Governors of Dulwich Picture Gallery (4); the National Gallery, London (5, 41, 50); the Peggy Guggenheim Collection, Venice (6); Musée du Louvre, Paris (7, 9, 10, 11, 16, 17, 19, 20, 22, 23, 25, 31, 42, 45, 47, 54, 57, 59, 61, 64, 70, 76, 79, 83, 84, 90, 92, 95, 100); Musée de Versailles, Musée du Louvre, Paris (8, 18, 68, 98); National Gallery of Scotland,

Edinburgh (21, 53, 74); Metropolitan Museum of Art, New York, the Jules S. Bache Collection, 1949 (26); F.-M. Collection (27); National Gallery of Art, Washington, DC, Samuel H. Kress Collection (28, 101); Die Staatliche Schlösser und Gärten, Schloss Charlottenburg, Berlin (30, 48); the Trustees of the British Museum (32, 46); the National Trust, Waddesdon Manor, Bucks (33); New Orleans Museum of Art (35); the Trustees of the Wallace Collection, London (36, 37, 38, 39); Musée Granet – Palais Malte, Aix-en-Provence (40); Banque de France, Paris (43); Yale University Art Gallery, New Haven, Connecticut (44, 81); Metropolitan Museum of Art, New York (49); the National Swedish Art Museums, Stockholm (51, 52); State Hermitage Museum, Leningrad (55, 62); Musée des Beaux-Arts, Lyon (56); Pushkin Museum, Moscow (58, 71); Laborde Collection, Paris (60); trustees of private collection, Switzerland (63); the Portland Art Museum, Portland, Oregon, gift of Mrs Marion Bowles Hollis (65); Galerie Fischer Sale 1968 (66); the Art Institute of Chicago, Illinois (67); the Academy, Leningrad (69); Musée des Beaux-Arts, Marseille (75, 89); Collection of Sir Alfred Beit, Malahide Castle, Dublin (77); Metropolitan Museum of Art, New York, Wolfe Fund, 1931 (78); Musée des Beaux-Arts, Lille (photo: Giraudon) (80); Caisse Nationale des Monuments Historiques et des Sites © Arch. Phot., SPADEM, Paris (82, 91); Musée de Fontainebleau Musée du Louvre, Paris (85); Ecole Nationale Supérieure des Beaux-Arts, Centre d'Etudes et de Recherches Architecturales, Paris (86); National Gallery of Ireland, Dublin (87); Musée des Beaux-Arts, Cherbourg (93); Musée des Beaux-Arts de Strasbourg (94); Musée de l'Hôtel de Ville, Paris (96); Musée des Beaux-Arts de Dunkerque (97); Patrimoine des Musées Royaux des Beaux-Arts, Brussels (99); (photo copyright) Musée de l'Armée, Paris (102); Musée Ingres, Montauban (103). Van Gogh, *Wheatfield with Crows*, on pp. 5 and 6, is reproduced by permission of the Collection: National Museum Vincent Van Gogh, Amsterdam.

King's College, Cambridge
May 1980

1 *Discourse, figure*

IN THE APSE of the Cathedral at Canterbury there is a window which can tell us a good deal about the controls operating on the image in the art of Christian Europe. Approaching the window from a distance, we recognise at once that its square central panel depicts the Crucifixion (illustration 1). Placed against the sides of the square are four lesser, semicircular panels which are not so easily identifiable, and as we go up closer to the window we may simply enjoy them for their dazzling colour and design. But our disinterested visual pleasure is soon interrupted, because as we move closer still, the lesser panels resolve from abstraction and light into precise narrative scenes. Going round the square in clockwise order, we find that they represent the Passover, with a priest sacrificing a lamb and marking a lintel with a sign that is almost a cross; then a strange group of two figures who carry between them a cluster of grapes hanging from a rod; then a patriarch performing a miracle: Moses striking the rock in the desert and causing a river to appear; and finally a scene of sacrifice: Abraham sacrificing his son Isaac.[1] Obviously there is a rationale behind these juxtapositions, and just as we are beginning to work out the resemblances and parallels, we discover that our work has already been done for us. Set into the border of each semicircle is a Latin inscription indicating how the image as a whole is to be understood.

The window displays a marked intolerance of any claim on behalf of the image to independent life. Each of its details corresponds to a rigorous programme of religious instruction. To prevent the occurrence of those alternating crises of adoration and iconoclasm which had troubled the Church in Byzantium,[2] the image in Western Christendom has been issued with a precise but limited mandate: 'illiterati quod per scripturam non possunt intueri, hoc per quaedam licturae lineamenta contemplatur'.[3] Images are permitted, but only on condition that they fulfil the office of communicating the Word to the unlettered. Their role is that of an accessible and palatable substitute.[4] And not only must the image submit before the Word, it must also take on, as a sign, the same kind of construction as the verbal sign. Speech derives its meanings from an articulated and systematic structure which is superimposed on a physical substratum.[5] Its signs resolve into two components:

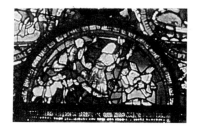

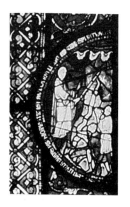

1 East Window,
Christchurch Cathedral,
Canterbury

the acoustic or graphic material – the 'signifier'; and intelligible form – the 'signified'. With the linguistic sign, interest in the sensuous materiality of the signifier is normally minimal except in certain highly conventionalised art situations;[6] we tend to ignore the sensual 'thickness' of language unless our attention is specifically directed towards it. And the Canterbury window similarly plays down the independent life of its signifying material, which progressively yields, as we approach it, to a cultivated transparency before the transcendent Scripture inscribed within it. The status of the window is that of a relay or a place of transit through which the eye must pass to reach its goal, which is the Word.[7] Qualities that might detain the eye during that transit are to be carefully restrained.

Moreover, the image is less important *in praesentia* than it is as anticipated memory: the moment of its impact may be intense, but only so that the visual impression can go on resonating within the mind after it has ceased to contemplate the actual image. Present qualities – as in advertising – are subordinated to future ones, and the qualities likeliest to endure are those that cluster around the verbal components: these will fix, while purely visual aspects, unanchored by text, will quickly fade into oblivion: such aspects are therefore to be excluded. Subordination of present experience of the image to future recollection, the stripping away of qualities which do not derive their life from illustration of the Word – it is possible to speak of a certain servility of the medieval image, whatever its degree of beauty. It expects rapid consumption – the Cathedral has hundreds of such images to be absorbed – and instead of cramming into its brief contact with the eye of the spectator as much of itself as possible, the image here follows the opposite course, towards economy and self-effacement. The path of the glance to the final destination of the signified must be smoothed of all resistance. Temporally, reduction from two sides: by the past, in that the image must recall and reinforce the family of representations of the scene already encountered, like a memorandum; and by the future, since the present existence of the image, here and now, is subordinated to a proleptic place within future memory. In the face of this double assault, its existence is reduced to that of an increment or interval.

It is an interval through which texts pour. Scripture determines the master–text: the Gospels through the central panel, the Old Testament through the semicircular quatrefoils. Next, the legends in the margins of the lesser panels, which function by question and answer, like catechism. How does the Crucifixion resemble the sacrifice of the lamb at Passover? Because, the legend tells us, 'He who was as spotless as a lamb sacrificed himself for mankind.'[8] How is the Crucifixion like

the grapes we see being carried by those two figures? 'This one refuses to look at the cluster, the other thirsts to see it: Israel ignores Christ, the Gentile adores him.' How is Abraham's sacrifice of Isaac an analogue of the Cross? Because in both cases the innocent was restored by divine intervention. How is Christ on the Cross like Moses in the desert? 'Just as the rock was riven to yield water, so the side is pierced by the spear: water is for the carnal, blood for the spiritual.' This second level of textuality, determined by the rubrics, is for the most part redundant: the connections could be inferred without the inscriptions, and in the Abraham panel where the inscription is lost, we can manage perfectly well without it. But the rubrics are essential, not only because their answers curtail the number of aspects the image can easily present, but because the act of setting up questions with absolute answers ensures a finite boundary. An image by itself might merely be contemplated; the inscriptions work to turn the image into a riddle or conundrum whose great merit lies in the idea of exhaustibility.[9] Each question is dealt with completely, so that when the answer falls into place the image has no further purpose to serve. The supply of the answer acts as a signal to pass on to the next window. With pedagogic imagery such terminal signposting is essential – left to his own devices the spectator might prolong his contemplation beyond the requirements of instruction. The inscription guarantees closure: the image must not be allowed to extend into independent life.

There is a further dimension of meaning in the image, and it is called into being by a process which closely resembles cinematic montage. The juxtaposition of two images together generates a semantic charge – Eisenstein's 'third' sense[10] – which neither image taken alone could possess; and at this point the images, whether in celluloid or in glass, break free from the external control of script or scripture, and begin to generate meanings from within. Before, the window had been a substitute or relay; now it acts as an independent source of signification. This development is a crucial one, because it marks the first claim of the image to interest and authority in its own right. Neither the Bible nor the individual legends make the global statement the image releases from its own resources: that the new Law fulfils the old. To be sure, though the image does manage to set up as an independent text, it never breaks free of text itself. Given its constructional principle of juxtaposition, liberation from textual constraint is impossible: montage inevitably generates sense, and the generated sense curtails the life of each individual 'shot'. The claim to independence is still contained by Text, through what is almost a kind of repressive tolerance.

The window at Canterbury is a good example of the

supremacy of the *discursive* over the *figural*; terms for which I at once apologise to the reader, because they may suggest a more scientific approach than he or she will find in this book, and because these two ungainly words are going to be used rather often. Part of their awkwardness comes from unfamiliarity, though for this I do not apologise. The problem I will be looking at is one which has been sadly neglected – the interaction of the part of our mind which thinks in words, with our visual or ocular experience before painting. Everyone who has visited a museum or a gallery will know the curious sensation of moving on from one painting to the next and almost before taking in the new image at all, of finding the eyes suddenly plunging down to the tiny rectangle of lettering below or beside it. Many of the paintings discussed in this book were seen for the first time by people who held in their hands a special publication which took the place of our modern rectangles of lettering – the *livret* of each new Parisian Salon, and the information there was far more elaborate than our rudimentary names and dates, though the need met in each case is similar. Even in the twentieth century, when every formerly accepted convention of art has been questioned and refashioned, one convention which has survived almost intact is the use of an inscription as a handle on the image – even when the usual content of the inscription is demolished, as in Duchamp's 'The Bride Stripped Bare by her Bachelors, Even'. We have not yet found ourselves able to dispense altogether, in our dealings with the image, with some form of contact with language. And language enormously shapes and delimits our reception of images. One need think only of the different impact[11] of the same photograph in newspapers of differing ideology; or the difference between this—

This is the last picture that Van Gogh painted before he killed himself.

By the 'discursive' aspect of an image, I mean those features which show the influence over the image of language – in the case of the window at Canterbury, the Biblical texts which precede it and on which it depends, the inscriptions it contains within itself to tell us how to perceive the different panels, and also the new overall meaning generated by its internal juxtapositions. By the 'figural' aspect of an image, I mean those features which belong to the image as a visual experience independent of language – its 'being-as-image'. With the window this would embrace all those aspects we can still appreciate if we have forgotten the stories of the Grapes of Eschol and of the last plague of Egypt, or are not at all familiar with the techniques of 'types' and 'antitypes', but are nonetheless moved by the beauty of the window as light, colour, and design. The window, of course, will engage us far more if we do work to retrieve the reading skills which have declined or been lost in the centuries between its time and our own, because it shows so clearly the authority within the aesthetic thinking of its period, of the discursive over the figural.

Now, we might think this ascendancy or supremacy of the discursive is a function of a certain limited technology – the image at Canterbury is textually saturated because it does not yet know how to be otherwise. And support for this view might be found in the 'traditional' account of the development of European painting as a series of technical leaps towards an increasingly accurate reproduction of 'the real'. A crucial figure here is Masaccio, and as a specimen of his work I have chosen the official who receives the tribute money in his fresco

in the Brancacci Chapel (illustration 2). The French critic
Francastel voices the traditional reaction:

> Placed at the edge of the space and of the fresco, his calves tense, his demeanour insolent, this magnificent *sabreur* bears no relation to the figures of gothic cathedrals: he is drawn from universal visual experience. He does not owe his imposing presence to the weight and volume of his robes: his tunic moulds itself on his body. Henceforth man will be defined not by the rules of narrative, but by an immediate physical apprehension. The goal of representation will be appearance, and no longer meaning.[12]

The opposition Francastel erects is Meaning versus Being, and it might seem that the terms 'discursive' and 'figural' repeat that opposition: that the Canterbury window, where discourse subjugated figure, has subordinated Life to Text, whereas the Masaccio, with its goal of 'appearance and no longer meaning', appeals to 'universal visual experience'.[13] Received opinion would support such an opposition: there remains a vague conception of the image as an area of resistance to meaning, in the name of a certain mythical idea of Life. Vasari's history of the progress of Renaissance painting is built on this 'common-sense' view: the progress he sees is an evolutionary liberation of Life from the repression of the textual. Italian art, he believed, had thrown off the constrictions of dogma and pedagogy, and having escaped the control of discourse, at once came to an objective registering of the visual experience common to all men: optical truth.

But let us reconsider this 'common-sense' view. At its deepest level it assumes that painting can be calibrated by degrees of remoteness from, or approximation towards, an Essential Copy. The Masaccio is near, the Canterbury window far off. Yet such a view ignores the obvious fact that there is no Essential Copy, and that the rules governing the transposition

2 Masaccio, *Rendering of the Tribute Money*

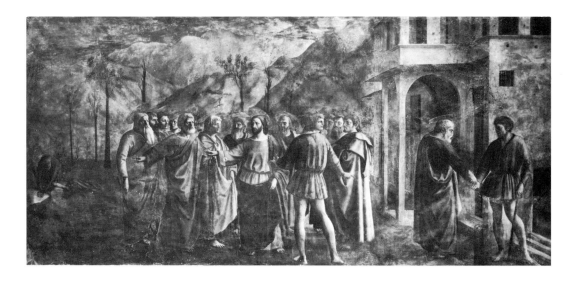

of the real into the image are subject to historical change.[14]
Obviously, we would not hesitate to describe the Masaccio as
'realistic' by comparison with the window; but such a decision
does not concern, as Vasari believed, the *distance* of the copy
from an original, but only those visual effects we currently
agree to call realistic. Husserl has a good phrase for the kind of
outlook Vasari represents: the 'natural attitude'.

I find ever present and confronting me a single spatio-temporal
reality of which I myself am a part, as do all other men found in it and
who relate to it in the same way. This 'reality', as the word already
indicates, I find *existing out there and I receive it just as it presents itself to
me as something existing out there*. 'The' world as reality is always there:
at the most it is here and there 'other' than I supposed it, and should it
be necessary to exclude this or that under the title 'figment of the
imagination', 'hallucination', etc., I exclude it from this world which
in the attitude of the general thesis is always the world existing out
there. It is the aim of the *sciences issuing from the natural attitude* to attain
a knowledge of the world more comprehensive, more reliable, and in
every respect more perfect than that offered by the simple informa-
tion received by experience, and to resolve all the problems of
scientific knowledge that offer themselves upon its ground.[15]

What Husserl says of the sciences issuing from the natural
attitude equally applies to painting: within the natural attitude,
which is that of Vasari, Francastel, and the birds of Zeuxis, the
image is thought of as self-effacing in the representation or
resurrection of things, instead of being understood as the
milieu of the articulation of the reality known by a given visual
community.[16] It is clear that the term 'realism' cannot draw its
validity from any absolute conception of 'the real', because
that conception cannot account for the historical and changing
character of 'the real' within differing cultures and periods. Its
validity needs relativising, and it is more accurate to say that
'realism' lies rather in the effect of recognition of a representa-
tion as corresponding to what a particular society proposes
and assumes as 'Reality'. The real needs to be understood not
as a transcendent and changeless given, but as a production
brought about by human activity within specific cultural con-
straints; a production which involves a complex formation of
representations and codes of behaviour, psychology, social
manners, dress, physiognomics, gesture and posture – all those
practical norms which govern the stance of men towards their
particular historical environment. It is in relation to this
socially determined body of codes, and not in relation to an
immutable 'universal visual experience', that the realism of an
image should be understood.

 This second and more accurate description of realism,
which begins to emerge once the natural attitude is called into
question, touches on a phenomenon familiar to the sociology

of knowledge. For example, in their work *The Social Construction of Reality*, Peter Berger and Thomas Luckmann comment extensively on the drive inherent in all societies to 'naturalise' the reality they have constructed and to transform a world produced by a specific socio-historical activity into a World given from the beginning of time, a Creation, natural and unchanging. In their words, while 'social order is not part of the nature of things and ... cannot be derived from the "laws of nature", social order being only a product of human activity', nonetheless the social world is typically and habitually experienced by its inhabitants 'in the sense of a comprehensive and given reality confronting the individual in a manner analogous to the reality of the natural world'.[17] In connection with the image, realism may be defined as the expression of the idea of the *vraisemblable* which any society chooses as the vehicle through which to express its existence to itself in visual form.[18] Clearly, the historically determined nature of that *vraisemblable* must be concealed if the image is to be accepted as a reflection of a pre-existing real: its success lies in the degree to which that specific historical location remains hidden; which is to say that the success of the image in naturalising the visual beliefs of a community depends on the degree to which it remains unknown as an independent form.

The terms 'figural' and 'discursive' do not, therefore, resolve into the opposition which the natural attitude institutes, between 'accurate reduplication of the real' and 'alien superimposition of intelligibility'. The Masaccio is not more 'real' to us than the Canterbury window because of a closeness to the Essential Copy; it is no closer to and no further from that than any other image. How then are we to account for the conviction that lingers on, even if we have conceded that there are no Essential Copies or absolute realities, that nevertheless Masaccio still looks far more real than the window?

Part of an answer is suggested by an interesting observation by the literary critic Roland Barthes, writing on realist fiction: that its *realism depends on a supposed exteriority of the signified to the signifier*.[19] Reading a realist novel, we quickly lose the awareness that we still possess when reading, for example, poetry, of the work of signification as a process occurring *within* the text; signification seems to enter the text from an 'outside', an outer reality which the text passively mirrors. The realist text disguises or conceals its status as a place of *production* of meaning; and in the absence of any visible generation from within the work, meaning is felt as penetrating the work from an imaginary space outside it – the 'world', whose intrinsic meanings are simply being transcribed. The Canterbury window quite patently displays how it produces its meanings, and for this reason – not because of its remoteness

from the Essential Copy – we are disinclined to call it realistic. With the Masaccio, on the other hand – at least if we are thinking like Francastel – the various meanings of the image are not visibly articulated by any patent system at work on the signifying plane.

Once realism is no longer a question of the Essential Copy, we can begin to explore the means used by the realistic image to persuade us of its illusionism.[20] We have mentioned the exhaustion of the image by the text, in the case of the medieval image. According to the natural attitude, such an image fails to record universal visual experience; it is servile and depleted. By contrast the Masaccio displays a marked *excess* of the image over the text, and because it is seen to break away from the symbolic requirements of discourse, Francastel is prepared to describe it as lifelike. In the terms of my own description, the image is neither like nor unlike Life – but it is far more figural than the Canterbury window. It supplies us with more visual information than we need to grasp its narrative content, and more than we can recuperate as semantically relevant.

With the panel that dealt with the Passover, all that was necessary to establish the idea of 'Passover' was a man daubing a mark on the lintel of a doorway: only quite minimal information had to be supplied to trigger our immediate discursive response; and with Masaccio's scene of the tribute money, all one needs are the component ideas of 'apostle', 'money', 'receiver of money', and the activity which connects them, of 'donation'. The narrative can be parsed, like a sentence, into its minimally sufficient requirements: apostle – donation – recipient.[21] And the Masaccio meets this rudimentary textual demand on the image: the halo establishes 'apostolic', the outstretched hand meeting the open palm establishes 'gives money to' (we do not even have to see the money itself; 'money' is contained in the gesture). The economy or frugality of these signalling means is medievally concise. But Masaccio supplies much more information than this. For example, the donor at the right of the fresco is bearded, white-haired, and robed; the recipient is beardless, brown-haired, and clad in a tunic. In context, these oppositions generate the semantic idea of *sacred : profane*.[22] To be sure, the pairs *bearded : unbearded, robe : tunic* and *white-haired : brown-haired* do not of necessity generate *sacred : profane*. It is possible to imagine a scene in which these polarised attributes might feature without any accompanying sense of meaningfulness. It is only when combined with the more central opposition *apostle : official* that these secondary meanings emerge from semantic latency into semantic realisation. Some parts of the image are more discursively charged than other parts; there is a hierarchy of semantic relevance.

This idea of relevance is vital, because realism insists on the

presence of the irrelevant as part of its persuasional technique. Whereas at Canterbury every detail in the window announces its signalling work with equal stress, here there is a shading from stressed to unstressed. The narrative sentence 'apostle – donation – recipient' is at an absolute centre; the image would become nonsense if it lost this kernel. But *sacred : profane* is a secondary elaboration, occurring at a distance from the absolute centre. And it is not stressed in the same way as the narrative sentence is. All apostles, within this work, have haloes: without the haloes they would no longer be apostles. But some apostles have beards, others do not: this attribute is not a necessary one, but a secondary qualification. In the same way, wearing a tunic does not in itself establish 'profane person': if a figure who wore a tunic also sported a halo, we would not hesitate to call him sacred. Nor does 'white-haired' feature as an essential apostolic quality; some apostles have brown hair, just like the soldier; and some are without beards. The permutations amongst these characteristics establishes the idea of *probability*, which is to say, absence of certainty with regard to semantic recuperation, resistance to Meaning, and a descending register from the necessary to the probable to the irrelevant.

The effect of the real in the image insists on setting up *a scale of distance from the patent site of meaning* which is read as *a scale of distance towards the real*. Of course, the real is not involved at all, but when the image purveys to us information which is not tied by necessity to a textual function, that information then constitutes an excess, and it is in this area of excess that we inscribe 'real existence'. The Masaccio succeeds in creating a threshold between two informational areas: on one side of that threshold, semantic necessity, and on the other, semantic irrelevance. The Canterbury window never manages to create such a threshold because the visual information it emits is fully exhausted by textuality. With the Masaccio, a new right is established: to incorporate the non-pertinent – semantically 'innocent' detail. In this it behaves in much the same fashion as the realist novel, with its enormous body of information concerning time-sequence and geography, and all manner of 'episodic' meanderings into the marginal and the semantically neutral.[23] The Masaccio so constructs itself that an area of neutrality is built into the image, and in that neutrality we read the innocence of the image, its refusal to be through-written – its 'real-ness'.

The great guarantee of irrelevance, since we are dealing with Masaccio, is perspective; and it is as part of a general economy of information and its distribution that the relation between perspective and realism ought to be understood. Here one is working against the natural attitude, which accepts that per-

spective actually reflects the real with an accuracy that work which does not know how to escape from bi-dimensionality cannot attain. This attitude again requires correction: there are undoubted realists who knew nothing about perspective; Van Eyck is an exemplary case. Rather, perspective strengthens realism by greatly expanding the area on the opposite side of the threshold to the side occupied by textual function, and one might even say by instituting into the image a permanent threshold of semantic neutrality. One could imagine all of the semantic charge of the Masaccio transposed into a medieval illumination: bearded and beardless, robed and unrobed, and all the other oppositions might reappear without any semantic transformation, in an image which would remain entirely bound by surface consolidation or flatness.[24] But what would be lacking would be the threshold which exact knowledge of where the apostles, Christ, and the soldier are located in space at once brings into being; that extra knowledge is precisely irrelevance and excess, the guarantee of the realism and the authentication of the real. Perspective, besides being a technique for recording a certain optical phenomenon, is also a technique for distributing information in a pattern which at once arouses our willingness to believe.

The idea of realism in the image can be said in part to depend on this characteristic ratio of the sign: on one side of a threshold, that-which-belongs-to-textual-function (the discursive); on the other, that-which-belongs-to-the-image-alone (the figural). While the natural attitude maintains that a war exists between the discursive and the lifelike, as in Francastel's claim that the Masaccio has at last broken with the laws of narrative and by the same token entered 'universal visual experience', in fact it is less a question of war than of a subtle mutuality. 'Life' can only emerge in all its plausibility by a playful escape from the constraints of the discursive. Without the patent and emphatically discursive haloes of the apostles, there could be no scale of increasing distance from semantic necessity to the comparative neutrality of the robes and the beards, and on to the absolute neutrality of all the data concerning the spatial disposition of the figures in which perspective steeps the image. The realism is not something that is established by an identity between image and world (Essential Copy), but by an instituted difference between figure and discourse: that excess of the image over discourse can only last as long as texts can – which may perhaps explain the extraordinary persistence of the textual within post-Renaissance painting, and above all the central place which history painting paradoxically assumes in a tradition which is officially committed to a project of realism.

Perspective ensures that the image will always retain fea-

tures which cannot be recuperated semantically. It thereby inaugurates a sign always divided into two areas, one which declares its loyalty to the text outside the image, and another which asserts the autonomy of the image; a ratio of the sign which is as important a fact of art history as any of its discoveries about the individual styles that form variables within this overall sign-format – the typical sign-format of painting in the West. But there is a problem which this permanently divided sign, with its divergent loyalties, soon begins to encounter, and it is a dangerous one because it threatens the overall realist project. Since the image relies for its effect of the real on the inclusion of visual information that is not semantically useful, everything which *is* semantically useful or recuperable may stand out as 'message', separate from the image, and the image may risk appearing to be the disconnected base for a detachable semantic superstructure. Perspective introduces a permanent threshold dividing the sign into distinct discursive and figural areas; but this threshold can easily become a line of fissure within the image, and threaten the sign on two sides: the discursive, cordoned off, will seem arbitrary and super-added; the asemantic remainder of the sign may seem the true subject of the work, and of interest *despite* the discursive function it is also required, half-heartedly, to support. This is the case with Francastel's reaction to Masaccio's fresco. He says that for him the scene is unlike those of gothic cathedrals, where Meaning comes before Being; it is unconstrained by the bonds of meaning and convinces *as it escapes* beyond the limits that Meaning imposes. In fact, Francastel's reaction proves just how convincing the divided sign is: having discounted the discursive aspect of the image, Francastel comes to believe all the more vigorously in the figural aspect which emerges in a pure form once the discursive has fallen away ('where Text ends, Life begins'). But this is a reaction from a different cultural milieu than Masaccio's, one that no longer accepts its discourse as truth. What would happen, if, within the same cultural configuration as the production of the image, such a separation were felt to exist? The image would fail to convince, that is, it would not be taken as 'reflecting' the real; the figural might convince, but the discursive would no longer be trusted. The naturalising function of the image, as refounding the particular beliefs and priorities of a given cultural community in an immutable Creation, would break down; the image would appear as unnatural.

Perspective in painting always runs the risk of fracturing the image into two, figural and discursive, components. Precisely because the spatial information it incorporates is seen as irrelevant to the other and plainly discursive kinds of information, those other kinds may seem to be forced on to the figural, and

not to fit. Indeed, once perspective becomes an established practice, one of the main difficulties faced by the image is that of coping with the break in the sign, at the threshold between its two domains. Yet the threshold also permits a solution: to hide the meanings in the image *on the wrong side of the threshold*, in the domain of innocence and semantic neutrality. To put this another way, the discursive can be disguised as the figural, so that instead of a dangerous interval between the two, filled at once with suspicion, there is smooth transition from the one into the other. The Masaccio illustrates this suturing process. Because the robe and the tunic are spatially convincing, because they seem to have a spatial existence which is irrelevant to the signification of the image, we are inclined to place them on the figural side of the threshold; the halo, which both lacks convincing spatial existence, and possesses a high discursive charge, we relegate without hesitation to the discursive side. Yet clearly the opposition *robe:tunic* is semantically charged; not in itself, but as the end point of a series of *sacred: profane* oppositions whose semantic weight cannot be denied. The charge invested in the opposition *robe:tunic* seems, therefore, to be coming from substance, and not from sign – the halo is a sign, but the robe and the tunic occupy the neutral, figural category of non-sign; we will tend to perceive the semantic charge of robe and tunic as emanating from the clothing itself, and not from the clothing as part of a patent and visible system for generating meanings. Subtler still is the significance which derives from posture. The apostles and Christ are all designed around a pronounced vertical axis, and their hands echo this vertical emphasis by either aligning with the axis, as with the apostle at the extreme left of the fresco's central group, or by meeting the vertical with a perfect horizontal gesture, as with Christ and the apostle to the left of Christ. The official, by contrast, lacks the axis: in the central group scene, his head tilts forward, revealing the nape of his neck, and casting into prominence his slanting shoulders; in the scene to the right of the fresco, where he faces us, the official's hands are debased by taking the money, and by gestures which, lacking the geometrical alignment of the hand-gestures of Christ, and the apostles, project to us as ignoble or vile. Now, these meanings do not seem to be articulated at the same patent level as the halo, or even the clothing: for us to put these 'subtle' meanings (nobility, baseness) into language at all requires work, and it is not everyone who will come up with Francastel's perceptive reading of the young official as 'magnificent' and 'insolent'. The meanings are there in the image, but not unquestionably there, as the meaning of a halo is: discourse – the discourse of the 'sensitive' reaction – has had to make an effortful excursion into the

enemy territory of the non-semantic to find these subtle
nuances. Yet it is just when discourse is made to feel effort,
when it has to go out of its way to convert the figural into the
discursive, that the effect of the real is enhanced. The subtle
meanings have been planted in a difficult place, hard to reach
and to absorb into language. Because the information concern-
ing the spatial disposition of the bodies of the soldier and the
apostles seemed so irrelevant and so innocent, when we dis-
cover that meanings are lurking even in this innocent territory,
we are all the more inclined to believe those meanings – and to
lose interest in the meanings that were so garishly articulated
by the halo and the clothing. These new meanings – nobility,
insolence, magnificence, and the rest – are felt as having been
found, and this confirms exactly the natural attitude, where the
meanings of gestures, clothing, physiognomy, body-typing,
and the other 'subtle' semantic codes are felt to inhere in the
objective world and are not understood as the product of
particular cultural work. Because the 'subtle' meanings are
hard to prise out, they are valued over those meanings which,
as it were, fall into the hand of their own accord; and because
the meanings are discovered in neutral territory, amidst the
innocent, perspective-based spatial information, they seem
immaculate.

There is a parallel here with the techniques of advertising. In
an economy that tends towards overproduction, a high rate of
consumption must be encouraged and maintained. It is not
enough to present commodities to the consumer: there must
be pressure; but the pressure must not be too apparent, or the
consumer will begin to resist. I choose a fairly random
example from a campaign for the sale of beer. Next to an
image of a glass of beer, the campaign I have in mind juxta-
poses further images that are apparently unrelated to the
product: a bow, an arrow, and the muscular arms of an archer
in leather. The connotations of these secondary images are
nowhere clearly stated, and the campaign depends on their
concealment; its designers believe – how bizarre a belief it is
hardly needs stating – that in his innocence the consumer will
come to perceive the connoted meanings, of strength, skill,
and virile glamour, as inherent in the product itself. The pur-
chase of the product becomes a way of incorporating into
oneself those tantalising qualities. What is happening in this
kind of case is an eclipse of signification beneath materiality:
the meanings are kept hidden, but the physical product is
spotlighted, and if the process works, it is by keeping the
consumer unaware that *meanings* are involved at all. The trans-
action seems only to concern material life and its semantic
dimension is consistently underplayed, to the point of invisi-
bility.

It is similar with the realistic image: production of meaning is effaced and naturalised into the object. The meanings that Francastel notes in the Masaccio do not seem to have been *produced* by the image, but instead are *found* within it. The discursive content has been shifted sideways, across the threshold, into the semantically neutral area of the image – its figurality. The effect of the real is heightened when by this means the figural can perform the work of the discursive without seeming to do so. Here again, it is useful if the image can be seen to perform some discursive work, as in the visual sentence 'apostle – donation – soldier': because that sentence is so patent and so distinct, it establishes an area of innocence outside itself, and it is in this innocent area that a more subtle work of signification can be performed. The level of patent signification creates the idea of everything beyond itself as Nature, and it is as the natural that the component of discourse which takes up residence in the figural is apprehended: the patent level establishes a Text against which to oppose Life, and Life emerges as what remains once the discursive has been extracted or discounted from the image.

With the 'insolence' and 'magnificence' of the soldier we were dealing with a discovered excess of meaning which could not be exhausted by the narrative kernel: the effort of retrieving those meanings from their clandestine retreat persuaded us to accept them as 'real'. Two orders of signification are at work in the example, one overt, the other hidden; the realistic effect occurs when the second comes to confirm the first. The first register is that of denotation:[25] the attribute of the halo denotes 'saint' or 'apostle' as evidently as wig and gown denote 'barrister' or 'judge'. The second register is that of connotation: it is here that secondary attributes, such as magnificence and insolence, the sacerdotal and the profane, begin to develop. Within the code of gestures, the turning of the soldier's back towards the viewer in the fresco's central scene connotes, variously, a breach of etiquette, boorishness, disdain; his emphasised shoulders connote physicality, as does the open neck of his tunic (the apostles conceal their bodies, connoting a transcendence of the physical world); the pronounced strength at the nape of the soldier's neck connotes an exaggeration of gender-characteristics – with the male, a hyper-masculinity bordering on aggression, just as with the female emphasis on the nape signals seduction (Watteau, Delacroix, Turner). Now, although these ideas issue from a specifically European cultural code and are very much the product of a localised set of conventions, they are not scanned or picked up by the viewer in the same way as the ideas which emanate from the halo, or from the wig and gown; there is no lexicon of gestures to which one can turn for a confirmation of one's reading; and

it is precisely the absence of codification that urges the viewer to place the ideas and meanings in the figural, away from the patency of the discursive. In fact, the meanings come from a diffuse body of lore which, although culturally determined and bounded, is never systematically taught. It is the same body or canon in which one might also find, if they had been codified, the code of physiognomy (the meanings of the face at rest), the code of pathognomics (the meanings of the face in movement, 'expressing' feeling), and the code of fashion (the meanings of clothing).

These codes of connotation, in the absence of any available place of definition, have as a consequence no clear origin, and the mind, in order to cope with the question 'where do these meanings come from?', takes the shortest route: the meanings have not – or so it seems – been articulated by any system, they inhere in the domain where meanings have vanished, which is to say, within the figurality of the image. The halo visibly articulates the meaning of 'the sacred', but the ideas of aggression, disdain, physicality, and so forth, seem to issue from nowhere: they are not created, they must have been found. Because of the prejudice of the natural attitude, meanings that are found enjoy the privilege of trust: no authority has thrust these connoted meanings on the viewer, no process of training or education seems to claim them. Meanings that are seen to be made are denied this privilege: they are the Text, the voice of authority which assumes, in relation to the image and to the viewer, a posture of power.

Once accepted as 'in' the figural, the connotation produces this astonishing result: it persuades us that the denotation was real. It is like the mistake in this sentence: 'I do not believe that unicorns exist, but I believe it to be the case that they have only one horn.' Because one has accepted the attribute, one believes in the object to which the attribute pertains; because I believe in the soldier's insolence and disdain, I believe in the soldier. Connotation in the image serves to strengthen denotation to the point of credibility: since I believe in the insolence of the soldier, I am prepared to believe in the existence of the apostles *despite* their haloes; mistrust of the patent register of signification is overcome. With the fresco, the thinking must go like this: because I found insolence, and the insolence seemed to have no origin within systematic articulation of meaning, I felt the insolence as emanating from the soldier (and not from a code); since he therefore exists, the apostles also exist; I believe in them despite the patency of their haloes. It was at this patent level that the only visible work of signification occurred, and the enthusiastic consumption of the connotation serves to obscure it: we are then left to enjoy, as Francastel says, an apparently system-free intelligibility, the

image founded nowhere else but in Life, in 'Universal Visual Experience'.

This last occultation completes the work of naturalisation. Once the only level at which the articulation of meaning could be seen as a deliberate and conscious process is eclipsed, the image rapidly fills up with invisible meaning. It is not experienced by the viewer as 'read' – in this it is like the realist novel; it is no longer Text, but Life. In this way that which is discursive and that which is figural fuse back together into a single unit – and the challenge raised by perspective (the breaking of the sign into two distinct components) is successfully met. The effect of the real has in fact depended on the presence of a text, but such is the power of the connotation to persuade that it effaces all traces of the production of meaning in its wake. The textuality of the image recedes before the even spreading of a connotation which is not experienced as *intelligible*, but *sensory*. Because the connotation occurred at the precise edge of the visible and patent meaning, and lay so close to the hinterland of non-meaning where the information about perspective, spatial location, modelling, surface light, and all the other cogent irrelevancies lie, the innocence of the hinterland is felt to infiltrate through the connotation into the denotation until the whole sign is colonised by what seems to be a figurality (non-meaning, Being) which is only discursivity in a palatable and unnoticed form.

Let us stay for a moment with perspective. It seems almost impossible for us not to think of it as a more accurate system than the one it replaced – a distinct technological stride towards the Essential Copy – a gift of Europe, like Newton and Einstein, to world-knowledge. There is a real problem in the persistence of this notion, even when we have in theory accepted the Essential Copy as chimerical, and agree that the rules that govern the transposition of the real into the image are historically determined. When asked to compare an image which uses perspective with another which does not, our reaction is probably still to judge the two in terms of lifelikeness; it almost looks as though our concession that lifelikeness is always conventional applies to the non-perspective case, but much less so to the perspectival image. It is a question of deconstituting a rhetoric which goes on convincing us even when we know that its central effect is *only* an effect of the real, and not its faithful copy.

Let us look at another 'break-through' Renaissance image, the *Flagellation* by Piero della Francesca at the Ducal Palace in Urbino (illustration 3). Here perspective is elevated to the status of rival subject: the scriptural scene is made the pretext for a display of spatial virtuosity that still impresses us. But let us reconsider it, not as optically-based but as rhetorically-

based – as a distribution of information. As we know, it was always possible for the pre-Renaissance image to indicate its discursive content by alteration of scale: the Virgin is colossal, the donors who kneel at her feet minute. And we might expect – particularly if we imagine that perspective actually does permit or enable more lifelikeness than any other visual system – such licence to distort normal scale to disappear with the advent of perspective. The *Flagellation* is a reminder that the right to manipulate scale remains intact through the innova-tion. Here, the archaic scheme of Virgin and donor is simply inverted: the minor figures who stand apart from the Flagella-tion are gigantic, and the figure of Christ is made small. If we were physically to cut out from a reproduction of the panel its central textual component, the minimal visual sentence 'soldiers – flagellate – Christ', ninety per cent of the image would remain. It is the extent of the residue which convinces, not through perspective as route to the Essential Copy, but through perspective as a means of aggrandising the figural irrelevance. Inbuilt into realist approaches to art is an idea of resistance and mistrust: truth cannot reside in the obvious, the central, the stressed, but only in the hidden, the peripheral, the unemphasised. When a work of prose contains a huge corpus of information which seems trivial, lifelikeness becomes an available criterion: realist prose begins with a refusal to go

3 Piero della Francesca, *Flagellation*

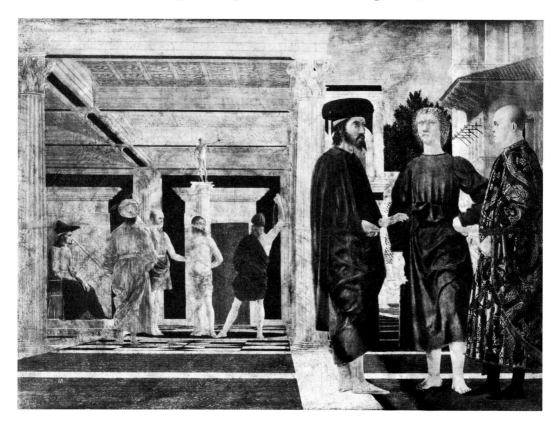

beyond the surface of the text, into significant patterning. The realist image shares this expansion of the peripheral, and the *Flagellation* shows how useful the system of perspective is as a vehicle for the expansion: perspective persuades because it creates a particular sign-format which is intrinsically persuasive; persuasive, rather than true: not one of the details a realist fiction or image supplies need correspond to actual events; it need only distribute its data in a certain proportion to have us convinced, and perspective always ensures that proportion, simply because there are so few ways in which the data concerning spatial location of bodies can be semantically important.

There is a model within linguistics which can help us to clarify the kind of response we have when we decide that a work is 'realistic'. The interpretative practice of realism involves what linguistics and semiotics (the study of non-linguistic signs) describe as a high predominance of *syntagm* over *paradigm*.[26] What do these terms mean?

As one reads a sentence, one follows simultaneously two sets of rules. The first, the syntagmatic, concerns the relationships of contiguity between individual words – how the individual words in the sentence exist as a sequence. The second, the paradigmatic set, concerns the relationships between individual words in the sentence and words outside it – the repertoire of other words from the vocabulary of the language. There is a syntagmatic relationship between the words 'Garbo' and 'laughs' which allows the words to appear next to each other, as in the sentence 'Garbo laughs (from time to time).' This relationship does not appear between 'Garbo' and 'river', or between 'Garbo' and 'ice', 'peace' or 'crystallography'. There could be no sentence beginning 'John river . . .', etc. Paradigmatic relationships concern all those essential relationships which a word has outside the syntagmatic ones, and which work to define the range of differences between words. 'Dances' possesses a paradigmatic relationship with all the other words which could replace it in the sentence – the whole class of verbs, for instance, such as 'runs', 'walks', 'eats', 'exists', and so forth. In reading the sentence 'John dances every day', I approach each word along these two axes: that of the syntagm, as I relate the word in question at each point, to all the other words that precede or follow it; and that of the paradigm, as I relate each word to all the other words available from the language. Now, while the two axes are always at work in every utterance or act of reading, one axis may predominate over another.[27] For instance, when I read poetry, I may follow the sequence of the words in the same way as I read the sequence of a newspaper article; but certain words will begin to remove themselves from their fixed position in the

sequence, and will start to set up relations with words that are not in their immediate vicinity at all. Two such words might be quite close, as is the case with rhyme – a purely paradigmatic device that cuts right across the grammatical rules of sequence; or they might be quite remote, as I begin to notice that the work is using a particular word frequently, or when I observe that certain words begin to form a family, scattered on paper, but neighbours at a conceptual level, as in an 'image-cluster'. Let us imagine respectively a newspaper article and a poem, each describing a shipwreck. With the article, I can reduce to a minimum my paradigmatic activity: it is unlikely that the words of the article will start to form rhymes or image-clusters; I can simply follow the sequence of the words, without abstracting any of them and comparing them one with another, or forming classes. With the poem, I must maximise my paradigmatic activity: it is very likely that the words will start to separate from their sequential context and start to form links and clusters with other words.

Similar procedures are involved with the image. With the Canterbury window, I can read its five panels as a sequence, and theology insists that I do just this, because it wants to show how the sequence of events described in the Old Testament continues into the New Testament and culminates there. The five panels form a compressed and elliptical sacred history. But the paradigmatic axis is far more important. I must relate each panel to something outside the sequence – Scripture; and I must rearrange features in the panels to form meanings by internal juxtapositions. Each of the four minor panels must be related to the central one, of the Crucifixion – it is much more important that this happens, than that I should get caught up in the individual scenes, and stay with them, and forget my theological duty. But with the Masaccio, the syntagmatic order is enormously expanded: while I can link halo with beard with robe as signs of sacredness, a great deal of information is presented by the image which is not susceptible to such rearrangement. None of that very precise information which Masaccio supplies, concerning the exact location of his people in three-dimensional space, fits any paradigm at all: it remains resolutely in place. And this refusal by information to quit its position in sequence is even stronger with the Piero della Francesca; only the small area occupied by the narrative sequence 'soldiers – flagellate – Christ' dislodges itself, and asks to be related to something outside the image – Holy Writ.

The figurality of the image may be described as the area of predominance of syntagm over paradigm. Let us imagine the retrieval of information as the eye glances over the robes of the three gigantic and extraneous figures to the right of the *Flagellation*. The eye receives the information as a stream of con-

tiguities: as dark passes into light at each fold, the units of information link together as a continuous chain; and that chain remains unbroken and fully *in place* in the sequence. But as the eye passes across to the tiny figures at the far end of the architectural setting, information from that zone of the fresco at once asks to be related to information outside the fresco – to other representations of Christ and of this scene, to the scriptural narratives which form its basis, and to the theology which builds significance around the fact of the Flagellation. In terms of ratio, ninety per cent of the fresco invites an exclusive application of the syntagm; a ten per cent remainder asks for the paradigm. With the Canterbury window, the paradigm was in far greater control of the image: hardly any information was irrelevant to some act of conceptual rearrangement and abstraction; it was exhausted by paradigmatic mining. The legends inscribed in the borders of the minor panels kept the paradigm going flat out: their repeated question 'what is common between this and that?' ensured that the image yield to a conceptual re-configuration away from the context of sequence.

Realism works hard to reduce the activity of the paradigm to a minimum. Any question of the kind, 'what is in common between ...?' must be silenced, because that questioning process breaks the sequentiality of the image and forces us to reconsider the image as having a purpose beyond its physical existence in the present. Into the place vacated by the paradigm steps the syntagm, and its influence is increased by a characteristic realist feature – uncurtailable addition (the '*and then*'). This 'and then' is the typical mannerism of the chronicle, where the only recognised principle of organisation of data is succession in time: there seems to be no intervention between data and their recording, no system of mediating intelligibility. The writing of the chronicle may consequently enjoy greater credibility than that of the history, because it seems raw, primary, uncorrupted by bias.[28] And this 'and then' forms the basis of the realist novel, where an unstoppable flood of information in apparently no order at all except that of simple succession, persuades us because it betrays no signs of censorship or prior ordering.[29] When Richardson's Pamela inventorises all the items she packs into her suitcase ('and then my shoes, and then my petticoat ...') the repeated conjunctions by their very artlessness – their divorce from any kind of ulterior pattern-making – assure us of the truth of what she tells us at least as much as the homely familiarity of the objects themselves.

The primacy of the syntagm, of sequences of information which seem to preclude any alternative organization that might set up in rivalry against the sequence and dismember it,

reaches its climax in still-life (illustration 4). Here an aesthetics of silence reigns, no statement is allowed to issue from the objects brought together within the frame, and if there is allegorical intent, it is arcane; a secret key is needed to unlock the discourse. Still-life takes as its inaugural act a rejection of the narrative sentence; not a rejection of language, for the image is still secondary to something outside itself – a positivist reality before which the image effaces its independent being. It has not yet attained full figurality – the liberation of the image from all constraints outside of itself. Denying the narrative sentence, still-life knows only nouns, adjectives, and conjunctions, and by insisting on these and only these remains permanently below the threshold of meaning. And the hierarchy of this infra-sentence negates the hierarchy of language. As though inverting the theory of language which locates its founding act in the bestowal of names, here the noun disappears behind an abundance of attributes.[30] The effort of the Dutch painter of still-life is not to strip the object of its accidental qualities in order to liberate its essence, but on the contrary to multiply the secondary qualities to the point where the sense of essence is lost. If there is a cluster of grapes, it is clearly subdivided into its components, and each of these is subjected to an endless qualification: meticulously preserved, they still have their bloom, which a fingerprint ties to a minute historical particularity; they reflect a distant window, whose lines become curves that qualify each individual contour; they both reflect light and absorb it, with a lovingly registered fluctuation of opacity and translucence. No question that the cluster is a noun, referring to a single mental concept; the stronger linguistic form here is the epithet, and its root form is 'this'. But over the epithet triumphs the conjunction: all the adjecti-

4 Netherlands School,
Still Life with Fruit and Bird

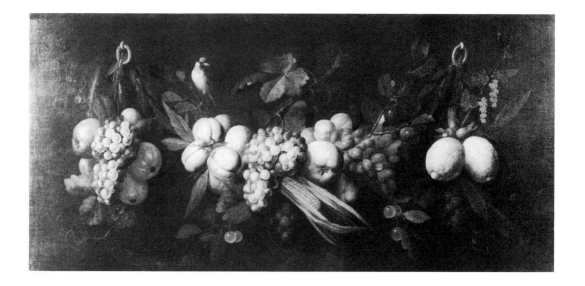

val multiplicity yields before an all-pervasive and all-fusing 'and then', which takes physical form: light. It is as though the syntagm, to which still-life is infinitely loyal, had incarnated as light source, spreading its rays equally over all the surfaces and linking them together in a seamless, unbreakable contiguity.

It is by so thoroughly avoiding the sentence, and by perpetually excluding the narrative verb, rather than by its approach to an Essential Copy, that the still-life appears to possess a *vraisemblance* which history or textual painting lacks: distance from the textual is interpreted as approximation towards the real. Just how great that distance from language is can be gauged by the difficulty experienced in supplying titles to the still-life: the formulae 'Nature Morte', 'Still-Life with x and y' are less description than the evasion of description: language has no point of purchase or insertion into the seamless syntagm. So polished is its surface that words cannot penetrate it; they fall away into a discursive void.

Expansion of the syntagm permits the development of figurality: if language cannot enter the image, it automatically attains a certain autonomy. But that autonomy is not yet complete, because the still-life is still secondary to an outer reality before which it claims to be entirely passive. The decisive bid for figurality comes when the image breaks with that reflective and secondary posture and comes to assert the irreducibility of its own material construction. A brilliant example is the Vermeer in the National Gallery in London, known as *Young Woman Seated at a Virginal* (illustration 5). At first glance it seems to belong to the sign-formation of still-life: it is a highly persuasive picture of a world, and one so free of discursive intent that it seems already well on the way to autonomy. But it goes much further towards autonomy than still-life is able to do. It contains within itself a series of adorned surfaces: the painting on the wall, the landscape inset into the lid of the virginal, the *faux-marbre* sides and stand of the instrument, the marbled flooring, and the row of representational tiles at the skirting. But not all these surfaces are represented as existing on the same level of transposition into painting. Whereas the representation of the lace in the girl's dress is based on a supposed one-to-one isomorphism between the 'original' and its 'copy', the representation of the gilding round the picture asserts considerable latitude of transcription: there is a gulf between the original and its representation. We cannot say that it is a high-fidelity transcription of an original that is out of focus, because we can see the actual strokes of the brush that articulate the representation. The signifier is visibly present on the canvas and its existence is as stressed here as it is understressed at the lace. The painted canvas of the painting on the wall is similarly elliptical: it is drained of all probable

colour, and information essential to its reconstruction has been removed in a way that cannot be explained by the appeal to focus. Very clearly in the painted figure on the left, where a featureless female head lifts to meet a male head which has not yet been robbed of its face, it is not a question of information proportionally diminishing, but of information altogether cancelled. If we move a lens out of focus, we still receive the stream of visual information intact, as in a hologram: the information has merely been scrambled. But here, information has been arbitrarily omitted, as with the gilding of the frame. The disparity between the reproductive technique used to depict the lace and its surroundings, and the technique used to depict the painting and its frame, might pass unnoticed if the image did not so forcefully insist that we attend to the problem of transposition – the effect of the real – elsewhere. With the *faux-marbre*, a new technique of transposition is brought into play: it is based on deliberately incomplete correspondence between a painted surface and the supposed original it copies, a transposition that deceives no one; unlike the real marble Vermeer is careful to include in his image. Yet by this stage, when we are already awake to the problem of reproduction, Vermeer's 'real' marble is not so real: the inclusion of so many

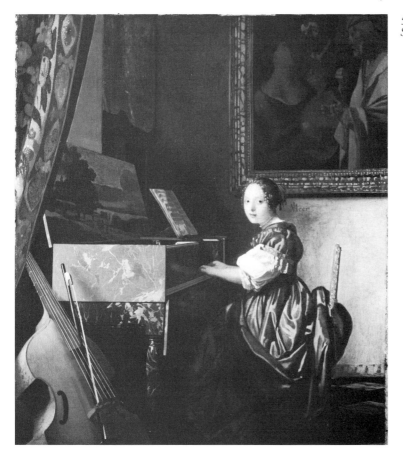

5 Vermeer, *Young Woman Seated at a Virginal*

other adorned surfaces alerts us to the *work* – the sweat – of realism, and once we are aware that the real is an effect that emanates from a precise source, we are no longer 'innocent'. To stress the process whereby we believe but at the same time do not believe in our painted illusionism, Vermeer adds his landscape to the lid of the virginal, and with this landscape there is no way of deciding whether it is a high-fidelity version of an object in partial focus, or a low-fidelity version of an object in full focus. With the gilded frame, though, we knew it was the latter; but now even that certainty is withdrawn. Framing the scene is a drape which is either faded, or robbed of information, like the faces in the painting on the wall; or so it appears until we notice that it is at roughly the same depth from the viewer as the bass viol, but as the viol is in sharp focus, we conclude that the drape has been treated elliptically. That is, the same area of canvas can be seen one way when taken alone, another way when placed against other objects: now we see the work of signification, and now we don't.

It is here that the narrative content of music and musical notation enters to complete the meditation. The bass viol has its bow, placed rather irrationally round the strings; the virginal has its music, whose notation we can clearly see. This narrative centre reinforces the attention we have been paying to the conventional nature of visual notation, and the fact of distance between the signifier and the signified. With still-life, the work of the signifier was hidden; now it comes to dominate the image. Faced with such varied distances between the signifier and the signified – minimal in the lace, deliberately separated in the false marble, apparently brought together in the real marble, separate again in the quoted painting and its elliptical frame, and totally divorced in the case of the gulf between the printed music and the sound coming from the instrument – the image as a whole forces us to recognise the independent existence of the signifiers of the painting, the strokes of paint of which it is built. The painting is not at all like a Titian or a Tintoretto, where the whole canvas announces the work of the brush, and where because the brushwork is equally evident everywhere, we can accept it as a *precondition* of the image. Here, the work of the brush in producing the effect of the real is sometimes dramatically evident (the quoted painting, the gilded frame), sometimes effaced (the lace, the viol), sometimes problematic (the drape, the landscape); and because the work of signification varies abruptly from place to place, we are much more aware of it than we are with, say, Titian, where it is everywhere, and because it is everywhere, is nowhere, or nowhere stressed.

Let us recall an earlier observation on realism: that it depends on a supposed exteriority of the signified to the

signifier. An image can persuade us that it reflects the real only for as long as it effaces the traces of its own production and conceals the independent material existence of the signifier. The Vermeer so forces our attention on to the activity and articulation of the signifier that the effect of the real is no longer generated in innocence. While that effect may begin when the image starts to assert its figurality and the impossibility of its recuperation by the textual forces that seek to infiltrate and subdue it, when figurality is pushed one step further the effect disappears; and in its wake it leaves us with the irreducible component of the image, that which can never belong to anything but the image itself: its paint.[31]

Within the natural attitude, an image will seek to record the pre-existing real unless prevented from doing so by a hostile agency. For Francastel – and there are still supporters for his view – the most powerful interference comes from textuality, and the painting of realism is seen as a progressive liberation from discourse as the technology of painting permits ever closer approximation towards the Essential Copy. The natural attitude, with its belief in a war between Meaning and Being, would polarise painting in this fashion: at the extreme end of failure to achieve the Essential Copy, it would place the sigil, the hieroglyph, the pictogram; then such an image as the Canterbury window, and then, on a sliding scale towards recapturing of the real, the Masaccio, the Piero, the Vermeer; and at the opposite pole from the discursive obstructionism of the hieroglyphic, still-life, and as the ideal expression of this category, the grapes of Zeuxis. Once the natural attitude is called into question, the polarity between Meaning and Being cannot be accepted; instead of a war between the text and the real, it is found that the effect of the real depends on a subtle mutuality and co-operation between the component of the image which declares its allegiance to discourse, and the component which refuses alignment with discourse. A new polarity emerges: the image is the site of convergence of two antithetical forces neither of which embraces the Essential Copy: what I am calling here the discursive and figural. At the pole of pure discursivity, the hieroglyph or pictogram, as before; but at the opposite pole the irreducible life of the material signifier – the *painterly trace*, and as an exemplary case of that trace, the asemantic brushwork of abstract expressionism (illustration 6). The term 'figurality' therefore requires apology: it seems to refer to figure in the sense of body, as in 'the figure of a man'; but in the definition used here, it returns to the root sense, of *figura*, formation, from *fingere*, to form. It is not out of perversity that the term has been chosen, but only to stress the more strongly that the poles between which the image moves are not from Text to Life, but from the

textual to the painterly. Even in the case of still-life, even with the grapes of Zeuxis, one is still within the shadow of a language, though it is a mutilated language, one without verbs or predicates, and one which is 'all syntagm'. But the division of the painterly sign, as with all signs, is the division between the signified and the signifier, which gives rise to the discursive and the figural; and considered at the level of sign, painting is found to have a history which is not at all the history of emergent realism we find in the natural attitude, or the history of successive visual styles we find in classical art history. Figure and discourse are perhaps unattractive terms – Meaning and Being were certainly more sonorous; but let us explore their usefulness, as we approach our chosen body of study: French painting of the *ancien régime*.

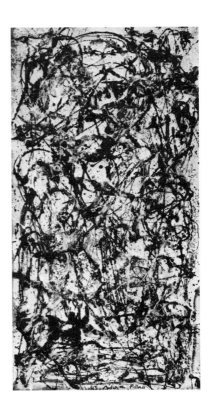

6 Jackson Pollock, *Enchanted Garden*

2 *The legible body: LeBrun*

FRENCH PAINTING in the middle of the seventeenth century faces a crisis which is at once institutional, political, and semiotic. At the level of their institutional organisation, the painters found themselves forced to choose between two equally undesirable alternatives: either corporatism, or favouritism; either to submit to the exorbitant authority of a guild (*Maîtrise*) or to rely on the haphazard patronage of the Crown.[1] Membership of the guild was essentially closed: it passed, like other artisanal franchises, from father to son; admission from the outside required apprenticeship to an already accredited master, and even here the franchise was in the gift of the guild's committee (*Juré*) and not of the individual studio. The effect of this archaic corporate structure was the monopolisation of artistic production: those who were not guild-members were in theory not permitted to paint professionally, and those who tried to do so ran the risk of having their work physically confiscated. 'One sees the arts in France reduced to a mechanic captivity, subordinated to the tyrannical rule of its own servants, and relegated to the category of mere craft (*métier*)';[2] 'In France, the fine arts are submitted to the oppression of a corporation that degrades them, chained by an avid and ignorant group of committees made up of base workmen with neither vision nor skill.'[3] The word *artiste*, with its modern connotations of spirituality, individual freedom, and a certain mystique of creativity, was not yet current: language obliged the painters to describe themselves as *artisans*.

The only recourse open to painters was direct appeal to the Crown, and here there was limited success. From 1608 chosen artists were allowed lodging in royal residences, the right to two apprentices, exemption from guild membership and dues, and *lettres de brevet* that styled them as Painter or Sculptor to the King, the Queen, or the Children of France. But by the 1640s the guild began actively to resist this challenge to its authority; in 1647 it petitioned the newly authoritative *Parlement* to restrict the number of Painters to the King and to the Queen to six, and to prohibit independent artists from accepting any kind of commission from the Church. Already a political schism was developing among the painters as a social group: the guild, weakened by the death of its leader Vouet, relied for support on the power of the Parisian bourgeoisie expressed in

the *Parlement*; the independents, menaced by that power, turned to the Crown and the Court.

One outstanding figure possessed the artistic authority, the independence, and the political support to begin to reorganise this closed-shop professional framework: Poussin. But Poussin remained committed to a life of exile in Rome, and the attempts of Richelieu and his aides to lure him to Paris had resulted only in a visit which, though brief, was long enough to persuade Poussin that administrative responsibilities were not for him.[4] By default, the task fell to a secessionist group headed by Charles LeBrun. Almost all were history painters, and almost all had connections with the Court: LeBrun himself enjoyed the direct patronage of the Chancellor, Séguier.[5] With the war cry of 'Libertas artibus restituta', in March 1648, the group founded the Académie, and in the first years of its establishment attracted a sufficient number of painters to constitute a rival body to the Maîtrise. Yet the creation of the Académie, so far from solving the institutional problem, instead inaugurated a division amongst the painters which was to have far-reaching consequences for the future. While the history painters were in the Académie, the little masters remained within the old framework. From its inception, the Académie divided French painting into two provinces, that of *homo significans*, and that of *homo faber*. The final ascendancy of the Académie over the Maîtrise marks the institutionally sanctioned supremacy of those who painted by text over those who painted without it.

The consolidation of the Académie is part of the general movement of political centralisation which began when Louis XIV made his decision, in 1661, to govern 'alone'. This, in effect, meant government by ministers with direct responsibility to the Crown; and, with the arts, the extension of the powers of the *Ministre des Bâtiments*, Colbert. In 1663 Colbert began his full-scale work of instituting an artistic state monopoly. The process is typified by the case of tapestry: before the reorganisation, the tapestry studios were dispersed in *ateliers* throughout Paris; from 1663, they were assembled together into the *Manufacture Royale des Gobelins* under a directorship delegated by Colbert to LeBrun, who in the same year was ennobled and raised to the status of First Painter to the King. Already this brought over two hundred weavers and fifty painters under LeBrun's administrative control. In the same year, the Académie received its full recognition and support from the state. Since their secession from the guild, the academicians had languished: since the great days of their emancipation in 1648 their number had been reduced by fifteen deaths.[6] The splendid isolation of the Académie failed to attract younger painters, who feared the hostility of the

Maîtrise. But with the visible support of the King, and the bureaucratic power of Colbert, the sense of threat passed from the guild to the Académie, and the younger artists defected in droves: in 1663 alone, more than fifty painters joined. The work of centralisation developed momentum. In 1667 a further decree patent grouped together all the goldworkers, engravers, mosaicists, ebenists and decorators in a single company. An imminent and colossal project required maximal submission to a common goal: Versailles; and as Versailles went into full production, the artists under the direct authority of LeBrun ran to the hundreds. It is an index of his personal power that after 1675 only his signature could authorise the decrees of the Académie, of which Colbert had made him Chancellor and Rector.[7]

LeBrun is the site of convergence of two great forces: bureaucracy, and text. Almost before he is a painter, he is a bureaucrat, and the profile of his career ('career' is the operative word) is that of the eminent civil servant.[8] He was never without an immediate state patron – Séguier, Fouquet, Colbert; and only at the death of Colbert in 1683 did he finally fall from favour. His endurance is that of a government ministry. And this bureaucrat is a man of the Word. At once he claimed for the centralised Académie a power which had hitherto been exerted only by the Church and the Crown: the right to dictate to the painters the texts which their work was to illustrate. In 1663, he instituted the Annual Prize, using as text 'the heroic exploits of the King'; in 1666, the *Prix de Rome*, where the subject of the competition is chosen from Scripture. This right not only determined the paranoid competitiveness which was to distinguish French painting for the next two centuries, but ensured the supremacy of a certain kind of painting – discursive; and the insertion of the discursive into the figural parallels both the insertion of the monarch into the community of painters through the delegation of Colbert and LeBrun, and the personal dictatorship of LeBrun within the Académie. The shape of the state and of the institutional structure of painting determine the shape of the painterly sign.

The atmosphere of the Académie after 1663 becomes fiercely linguistic. In 1648, while history painting dominated over the 'lower' genres in terms of personnel, the Académie was still basically a *cénacle*, and it had its material problems: whereas the guilds collected dues from their members, the secessionists relied on the modest payments of pupils, and on their own intermittent contributions.[9] The structure was amateur in the sense that no official policies prevailed. But after 1663, not only does painting start to emanate – for the first time on any scale in a secular context – from empowered

texts: the act of painting is surrounded by a verbal mystique. In 1666, at the instigation of Colbert, LeBrun introduced the practice of the Discourse: every month a work from the royal collection was to be discussed before the public by the Académie assembled as a whole.[10] Whereas the guilds had transmitted instruction by practical example, now instruction takes the form of codex, and an official stenographer is employed to transcribe and later to publish the proceedings of the debates. In terms of his own work, LeBrun insists for the first time on the *Livret*: his manifesto work for Louis XIV was accompanied by a lengthy treatise and description by Félibien, later the Académie's chief scribe. In 1673, the series of his paintings known as the *Battles* was displayed before the public with a complex explanatory pamphlet; and it was to be the same with the general iconography of Versailles, and with LeBrun's series of paintings for the *Grande Galerie*.

The Discourses not only, through verbal description of the works in the royal collection, focus the word on the image with an intensity that is without precedent; they reveal a bias in favour of the discursive that is at times bizarre. In 1667, LeBrun delivered a major address on Poussin's painting entitled *Eliezer and Rebecca*.[11] When the debate was thrown open, he was confronted by a strange objection: it was noted that Poussin had omitted the animals which, in the scriptural account, had attended the scene; the Biblical *camels* feature nowhere in the image; surely this constituted a breach of decorum. Had LeBrun argued that Poussin was free to omit these creatures, a dangerous precedent might be set, and hallowed by the Académie, for present and future painters to depart from the authority of the text; and since the second of LeBrun's great political advances on behalf of discursive painting, the *Prix de Rome*, was still in its infancy, such a tendency had to be nipped in the bud at once. On the other hand, Poussin could not be discredited: alone among the painters chosen for debate he represented France – the rest were Italians; and the right of the Académie to class his work with that of Titian and Raphael was part of its general chauvinist mission.[12] What is significant about the debate is that the issue of bureaucratic control of the painter and textual control of the image have fused into near-identity. LeBrun at first hedges the question: he argues that the famous beasts have been omitted in favour of the work's unity.

Now, it might seem that in taking this line LeBrun is placing a 'compositional' requirement over a discursive one; but instead of the term 'composition', with its twentieth-century abstractionist connotations, of pure formalism and asemantic figurality, we should stay with the word LeBrun in fact uses, a

word that shows the proximity to his theory of painting of classical rhetoric: disposition.[13] Whereas compositional unity is an affair of balancing forms, dispositional unity concerns the balancing of messages; and it is this sense, as a rhetorical *dispositio* or distribution of information, that we should understand LeBrun's defence. The camels would offend, not through their intrinsic oddness, their suggestion of the monstrous or the absurd, but because if included they would become a dispositional distraction: a secondary text would be generated and might come to rival the primary one. And it is on these lines that one should understand LeBrun's hostility to genre-painting. Of course, it is at the same time an institutional posture: the triumph of history painting over genre is the triumph of the Académie over the Maîtrise. Genre-painting is, after all, pre-eminently textual: it is devoted to the anecdote and the generation of superabundant discourse from the image. But though textual, genre-painting does not transmit its narrative messages in any order of priority: its humility of content is matched by a democracy of messages all on the same level, with no one amongst them subordinating the rest. In other words, genre does not understand language as a form of power over the image – and it is precisely the power-aspect of the discursive which interests LeBrun. The textuality of LeBrun is cybernetic, a form of authority which is lost amongst the proliferating and equivalent messages of the anecdotal. The unity of *dispositio* is discursive, not figural, and this centralising power of the text is defended because it precisely corresponds to the power of the Académie over the community of painters; to challenge that centralising authority is to challenge the Académie itself.

Because so much more was implied than the pulchritude of camels, the debate was resumed. Those painters who resented either the hegemony of the Académie within the professional structure, or the omnipotence within the Académie of LeBrun, or both, demanded a second hearing; not before the Académie had mobilised its hierarchical resources, and passed resolutions condemning 'the confusion that attends the public sessions' (the Académie debates had become minor *manifestations*), and had required that non-academicians seat themselves on benches remote from the arena of debate, as passive witnesses. LeBrun delivers a second defence of Poussin which reveals all the faith of the official in his memorandum. In Scripture, he declares, the famous camels are nowhere mentioned as in the Israelite camp itself, or as near the Israelites themselves; Poussin's exclusion of them does not therefore break with the letter of the Old Testament.[14] His answer is Byzantine; certainly it failed to satisfy the opposition. In the end Colbert personally intervened – and his presence as arbiter reveals the urgency of

the debate – to bring the meeting to a close, and to guarantee that LeBrun's answer be the last word on the subject; in LeBrun's appeal to the voice of the centralised state to bring to rule the dissidence of both the figural image, and the community of painters, one can see the depth of complicity between textuality and power. To question the supremacy of the discursive, before the double presence of LeBrun and Colbert, is both artistic heresy and political treason.

In LeBrun's most ambitious and extensive work, the series of eleven full-scale and eighteen minor paintings devoted *ad maiorem gloriam Ludovici* at Versailles, we meet with the following constellation: Allegory, Conquest, Monarchy. The painting of *Franche-Comté Conquered for the Second Time* (illustration 7) is at the centre of LeBrun's career, as the *Apotheosis of Homer* is at the centre of Ingres, and the *Oath of the Horatii* of David. When Largillière came to paint the portrait through which LeBrun was to be carried forward into posterity, it was this work which he chose to place on LeBrun's easel (illustration 8). It is an image which translates effortlessly, and with minimal figural residue, into narrative. Louis had already conquered the province in 1678, and returned it to Spain at the Treaty of Aix-la-Chapelle. When Spain declared a second war, the province was reconquered within three months. In the image, Mars leads Franche-Comté and its villages to the King

7 Charles LeBrun, *Franche-Comté Conquered for the Second Time*

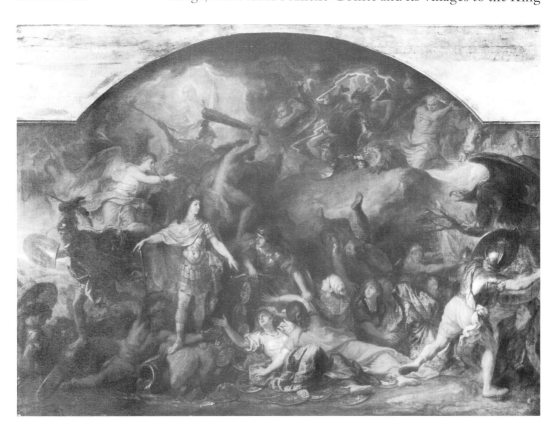

as suppliant maidens. The river Soux, alarmed at the sight of Victory attaching trophies to a palm-tree, holds on to the King's coat. Behind Louis stands the figure of Hercules, or heroic virtue. The fawning lion represents Spain, and the rock the citadel of Besançon. Germany has offered the province vain support: an eagle on a dry tree. The three months of the siege belonged to winter: there are three zodiacal signs. And Fame appears with double trumpets: the province has been twice conquered (these details are sadly obscured in the present reproduction).

With its sombre, drab coloration and thick-set, graceless figures, the work points to central deficiencies in LeBrun as a painter: lack of imagination, lack of figural involvement. But examined at the rhetorical level at which it was pitched, the image reveals a striking symmetry of intellectual design. The painting exploits a duplicity in the word 'history': in history, event and scripture fuse, for the historical is not only that which has occurred, but that which has recurred as writing. Between the figures of allegory and the historical figure of

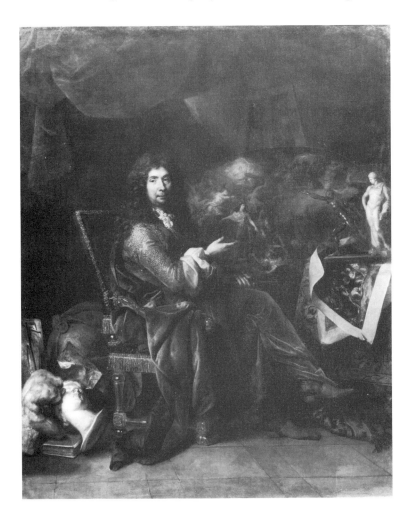

8 Nicolas de Largillière, *Charles LeBrun*

Louis, there is therefore no ontological disjunction. In conquest, event is Scripture even as it happens: the battle is already narrative at the moment it takes place, so that when Homer or Tolstoy or Stendhal[15] describe their battles, narrative is not super-added to a scene which lacks discursive intelligibility, but is instead the repetition of a discourse which is preexistent. War is perhaps the most ancient, and certainly one of the most powerful, of rhetorical *topoi*.

The epics of world literature, from the Iliad to the Upanishads, witness to an affinity between war and narrative which can be said to emanate from an inherent similarity: in war, events acquire a dimension that has already all the intelligibility, visibility, and recountability of the narrative act. It is the same at the lowest, childhood level of historiography, which consists almost exclusively in a listing of battles, and where the work of history as an interpretative discipline is at a minimum: so far from shaping event into meaning, all the historian there has to do is to repeat the writing that emanates spontaneously from history itself. In the battle, human action consolidates into a united purposiveness that is patent and visible at all points; in this it differs from guerrilla warfare and from terrorism, which rely on invisibility and concealment. These other forms of aggression are perhaps the more terrifying because they lack the consolidation of open intelligibility which the battle provides (in this sense, it is hard to image an allegory of guerrilla war). But battle possesses a spectacularity that is heraldic: each side blazons its identity with a clarity that is not at all exhausted by strategic need. And in the descriptions of battle one sees a marked tendency towards a signification that is highly abstract: the model here is the war-room, with its maps and pointers, markers and counters. Although only a simulacrum of the battlefield, the war-room is also its real theatre: in the conversion from the mud and chaos of the field to the hygienic spread of the diagram, nothing essential is lost. On the contrary, the essence of the battle is revealed in the schema. Military planning requires a glance at the body which is altogether indifferent to its materiality; the martial body is enciphered, made into a statistical entity, a vortex of abstract force. The militaristic use of the body may be heavily physical: carefully clothed and tended, trained to a pitch of physical excellence, the *superbia* of the material body borders on an eroticism which must never, however, announce itself as such.[16] But always that priority is overtaken by signification, not only in the decoration of the body with insignia, but in a final purpose for that body which is, of course, a complete betrayal of its right to physical existence.

It is, therefore, no accident that LeBrun, with his commitment to the textuality of the image over its figurality, should

also have expended such colossal effort on images of military conflict. In his *Battle of Arbela* one can see a sadism which, if it had not been so bureaucratically constrained, might have moved far closer than it did to Delacroix, who is a proleptic presence in all these scenes (illustrations 9 and 10). It is a sadism which cannot, however, be thought morbid, since it lacks the quest for privacy which marks authentic perversion. Quite the opposite: what is sought is absolute publicity, for the battle is a form of aggression that takes place without guile, deceit, or any aspect of the clandestine. In the swordplay of the duel, there is room for the artistry of fencing, which is full of feints and misdirections: but in the swordplay of battle, intention and action are far more co-extensive. It is this legibility of the body which above all interests LeBrun. In his arrangement of battle scenes there is hardly a head which does not turn in some way towards the viewer, to display fully its readable surface;

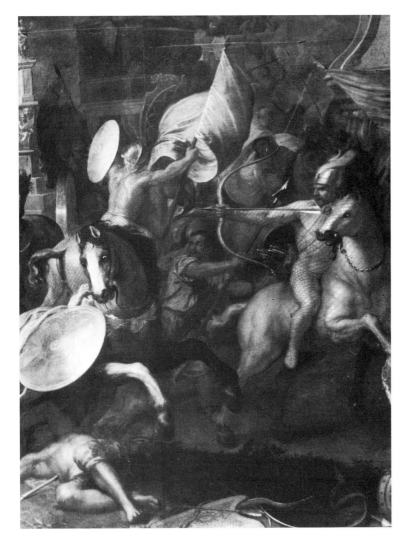

9 Charles LeBrun, *Battle of Arbela* (detail)

not surprisingly, many of the embattled figures are taken directly from LeBrun's work on the expression of the passions (illustration 11). The ethic is Cornelian, and concerns a word sacred to Corneille, to France, and to LeBrun: *gloire*; neither merit nor excellence by themselves, but these qualities caught in a double movement of display and recognition.[17] Corneille's warriors in his play *Horace* exhibit a sadism that extends, as we know, to the most brutal sororicide, and the murderous brother is incapable of the inwardness of shame; absolutely unrepentant at the death of his sister, the brother is concerned only with the possibility of a stain on glory. The heroic act is so extraverted, so insistently spectacular, that for Polyeucte martyrdom is pursued not as an abnegation of the self before God, but as a final and resplendent display of personal glory before both God and man. *Gloire* cannot exist without its spectators; it is also indifferent to the rights of the flesh, which it seeks constantly to transcend through the will.[18] Its culmination is therefore in public violence, a violence that is always observed; not just the battle, but the battle that is fully displayed and intelligible.

10 Charles LeBrun, *Battle of Arbela* (detail)

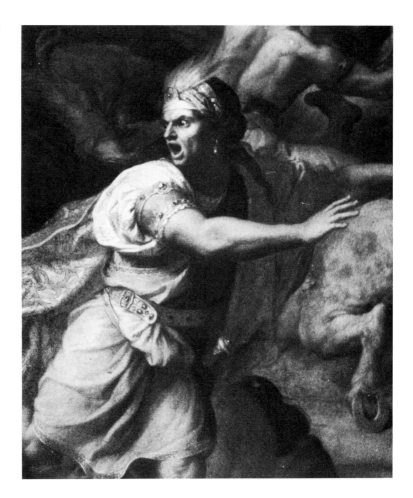

LeBrun's paintings for the *Grande Galerie*, which together form a continuous narrative of the conquests of the King, exploit to the full this collaborative relation between warfare and narrativity. Allegory is the artistic form appropriate to conquest because for both conqueror and allegorist, detail is of no importance. What the heroic invader requires from a province is not its substance or booty, but the signs of its surrender; the synecdoche of the lion for Spain, the hunched eagle for Germany, are like the exalted and manically generalised form the world assumes when Antony addresses Cleopatra as Egypt, or like the allegorical reduction of the world which Chaplin used in the *Great Dictator*, to define megalomania: alone in his study, the dictator plays with the globe as though it were a balloon.

Yet these works of LeBrun, alongside war and allegory, include always a third term, which completes their specific constellation: the body of the King. Let us for a moment return to an earlier comment on the word 'history': history is a fusion of event with writing. The historical is not only that which has

11 Charles LeBrun, *Tête d'expression: la Frayeur*

occurred, but that which has recurred as writing. The bond between event and signification grows ever stronger as we approach the presence of the King, for with the anointed King every action and every gesture is history: the actions of the King exist to be recorded. Outside the Court, there may be kingdom, and even empire, but these are silent; only within the court does the event become history, and that in proportion as the event nears the regal presence. The King is a vortex of significance and everything he touches, however humble, acquires the stamp of the historical: the plume of his hat, the glass of Burgundy mixed with water, the inflections of voice, the marks of favour and of disdain, the acts of *lever* and *coucher*. It is in the historical character which the insignificant takes on through and around the regal body that we can best see its power to transform, at a touch, even the basest into the ennobled: when Louis presents a gift to the Pretender of England at his marriage, the gift is not a province, a château, or a chest of gold, but a night-gown; the marks of absolute favour are not titles or responsibilities but admission to the bed-chamber, to witness and assist at the most creatural acts. Centre of the nation's strength, so that the force of all the ministries is concentrated into a single organism, the King is power in tangible form, converted from abstract relation into corporeal substance, from *mystique* into *physique*. The atmosphere which emanates from this distilled flesh is paranoia: not only through the King's capacity, at a nod, to inflict death, but because paranoia is a representational crisis in which nothing can exist for itself or innocently, for everything is perceived as sign. To the paranoid, all existence is plot, not only as conspiracy but as narrative: paranoid reality is entirely discursive. [19]

With the courtier it is the same: nothing around the King can merely exist, everything changes from entity into signal. Materiality vaporises as we near the King's presence, and even the images of his Court, which LeBrun supplies, take on this quality of the hyperdiscursive. Despite his archaic politics, the typical courtier remains the Duc de Saint-Simon, in whose endless anxiety over groupings we should see not only the defensiveness of an aristocracy on the wane, but the normal state of courtly consciousness. At the Court, the agent becomes the spectator, for everything is to be watched; and the spectator becomes the interpreter of signs, for everything is to be read. Courtly life is entirely filled by the space between the legible and the illegible. Preoccupied with signs, the courtier is always deciphering and never experiencing without suspicion the influx of his sensations, since his ability to survive and the degree of his success equally depend on his virtuosity as a manipulator of signs: on whether he can read clearly, and not just those signs that are patent, but the subtlest nuances of

meaning that occur precisely where no one is to expect signification.

This typical legibility of the court intensifies at Versailles to a point where one can see that any form of painting other than allegory would be out of place. The characteristic art of Versailles is allegorical because life there is, so to speak, allegory already. Institutionally, as we know, Versailles was an instrument designed to take from its courtiers real and executive power, and to put in its place, as an almost perfect replica, power's signs – a machine for the production of allegory, for the real substance is fed in at one end, to re-emerge at the other as the sign of itself. Out of context, in reproduction, LeBrun's paintings in the *Grande Galerie* may seem lexically overcharged, signification triumphing over figurality with a pressure that is crushing; yet in place, they are only at the same degree of semantic pressure as the rest of the court.

The work of interpreting gesture and inflection, as we see it in Saint-Simon, is intensified by a problem which, as we shall see, obsessed LeBrun: courtly restraint. This is not simply an affair of reserve, but a protective obliteration from the body of revealing signs. The body must be managed with rigorous control, for it is the last site of possible betrayal. The codes of gesture are thoroughly mastered, so that nothing that might imperil the body is allowed to be read there: the body, precisely because it is so charged with significance, requires an erasive grooming. The courtly body consists only of eyes, hands, and impassive facial muscles, the only muscles that require attention; a fully informational and semantic physique, and almost a *corps glorieux*.[20] Only when the courtly body belongs to the highest rank is it permitted the freedom to display before the world the truth of its inward agitations: 'Mademoiselle de Blois ... being naturally very kind, and horribly afraid of the King, believed herself sent for in order to be reprimanded, and trembled so much that Madame de Maintenon took her upon her knees, where she held her, but was scarcely able to reassure her.'[21] The offstage intimacy of bodies is allowed at court, and even encouraged, but sheer and public physicality, the taking of another body to one's own, in view of everyone, is the prerogative of only the most exalted. At its highest level, in the King, the body re-achieves a frankness that is all the more striking because it is denied everyone else: the royal physician circulates his findings throughout the Court, so that even at a distance of centuries and in another country one knows of the King's nocturnal sweatings, his long attacks of gout. One knows this: 'His stomach above all astonished, and also his bowels by their volume and extent, double that of the ordinary, whence it came that he was such a great yet uniform eater.'[22]

Knowledge of the creaturality of the King is privileged, and it is a function of power. For the rest of the Court, the body is a place of drilling, ballet, and concealment. In Racine, who was also, we remember, the Court's historian, the body is almost entirely optical.[23] It is solely through the eye that the fatal passions that ignite Phèdre and Neron are transmitted; and when a secret exists, it is above all by a tremendous concentration on the eye that its nature is discovered. The rest of the body has been erased and discarded, and all that is left of it is this all-signalling zone around the orbits of the eyes, as the last trace of a natural body which remains ungovernable by the will. Here the physical focuses its whole existence, and the glances of courtiers are like laser-beams:

Seated in my elevated place, and with nothing before me, I was able to glance over the whole assembly. I did so at once, piercing everybody with my eyes. One thing alone restrained me; it was that I did not dare to fix my eyes on certain objects. I feared the fire and brilliant significance of my looks at that moment so appreciated by everybody: and the more I saw I attracted attention, the more anxious was I to kill curiosity by my discreetness. I cast, nevertheless, a glittering glance upon the Chief President and his friends, for the examination of whom I was admirably placed. I carried my looks over all the *Parlement*, and saw there an astonishment, a silence, a consternation, such as I had not expected, and which was of good augury to me.[24]

LeBrun's gaze repeats this penetrating, avid glance of the Court. Already a connection posits itself between such a glance and allegory, for under such interrogation there can be no innocent object. And the connection points also to the characteristic desiccation of LeBrun's images. Existing only to yield up their quantum of meaning, once signification flows out of them, they are left behind for dead. Such a gaze betrays and devalues the image as no other gaze can, and if we fully expose ourselves to the atmosphere of LeBrun's paintings, we discover that they are in fact melancholic. What they reveal is the disappointment and desertion of the exhausted emblem. With the painting of the Franche-Comté, once the eagle, the lion, the rock, the keys, the urns, and the figures have released their discharge of the signified, lacking any further purpose, they linger on in desolate, drained dispersal. Nothing but the signified holds this disarray of objects together, and once it is taken away, they take on the life of husks. The world of objects always presents, with LeBrun, this face of incompletion and insufficiency: it cannot stand by itself, and a second gaze on the image may even produce the sadness and nausea that sometimes attend pomp, when we have grasped the text of the pageant and are left only with the sorrowful emptiness of the depleted sign. With

the glass at Canterbury, if we prolong our inspection beyond its designated length, the image dissolves into pure light and colour: the same is true of the frescoes of Tiepolo. But here, because the signifier has been so degraded, as the Word fades it leaves only ash behind.

LeBrun's courtly glance, however antipathetic to the independent life both of object and of paint, did produce, however, the most prolonged meditation in European art on the meanings of the human face. Given his discursive bias, the face was the only part of the body likely to have interested him; and his analysis is exhaustively systematic. The problem of psychological portrayal is, of course, a perennial one in representational art, because it involves the whole difficulty of depicting a mobile entity in a still image. Let us take the problem of a pendulum clock: how to depict the passage of time? How to depict, not the time of the dial, but time as it manifests in movement?[25] If the pendulum is painted in a vertical position, since that is also the position of rest, no suggestion of movement is produced; on the other hand, if the pendulum is painted at an angle, the result can be disconcerting, far more than is the case with a photograph, since at least the photograph is instantaneously produced; but the disparity between the instantaneous movement of the pendulum and the length of time taken to create a painting is jarring. Sculpture faces the same problem: while some positions of the moving body, when translated into matter, are visibly and harmoniously mobile, others seem immobile even when they record a particular movement with perfect accuracy; others still seem unbalanced or precarious. A characteristic sculptural solution is to freeze the body in the moment immediately prior to an acceleration, so that the mobile intention is clearly announced, but not yet delivered: Bernini's *David*, planning the trajectory of the sling but not yet inside it, is a case in point; or Myron's *Discobolos*, where several bodily positions of the discus-thrower are collapsed into a single sculptural frame. With facial expression, the problem is compounded. The realistic smile may turn, under the artificially prolonged time of the image, into a grimace; while a perfectly accurate representation of the face of a man experiencing a particular emotion may not register to the viewer with any certainty as to what the emotion has been. Since human self-expression involves parameters of moving gesture and of supporting speech which at every point clarify the emotion, and since painting lacks these parameters, the image of emotion must supply other markers to take their place.

While the problem of emotional expression is permanent, in the case of LeBrun there are particular historical pressures which made its solution imperative. The hierarchical elevation

of history painting and of the Académie required the linguistic saturation of the image; both the allegorical style of the art of Versailles, and the role played by the interpretation of signs in the life of its Court, reinforced the need for a further advance of the Word into substance. Yet the advance was blocked by an aesthetic of reticence which demanded of the courtly body a rigorous reduction of expressivity: decorum, in the sense of a vigilant monitoring and screening of the body's informational potential, creates an inscrutability that menaces the central colonisation of the body by the Word. Expressive gesture is withdrawn from the body to the head; and in LeBrun's first excursion into this terrain, the approach is exclusively physiognomic. The only notable work on the subject of physiognomy remained Giovanni Baptista della Porta's *Della Fisionomia dell'Uomo*, translated into French in 1665. This curious treatise, written at the close of the sixteenth century, is a late flower of Paracelsan thought, and exhibits a kind of reasoning which by the epoch of LeBrun was entirely antiquated. At its root is a belief in Creation as a Text from God:

The first and highest book of medicine is called Sapientia. Without this book no one will achieve anything fruitful ... for this book is God himself ... The second book of medicine is the firmament ... for it is possible to write down all medicine in the letters of one book ... and the firmament is such a book containing all virtues and all propositions ... the stars in heaven must be taken together in order that we may read the sentence in the firmament. It is like a letter that has been sent to us from a hundred miles off, and in which the writer's mind speaks to us. [26]

Knowledge is a matter of right reading of the text of creation, and a bountiful God has made this possible by repeating the sentences of the firmament, by which Paracelsus means astrology, in the *signatures* of the natural world. To take an example which also, despite its reasoning, had some success: syphilis bears the signature of the market place; the planet Mercury has signed the market place; the metal mercury, which is also signed by the planet, is therefore the cure for syphilis. In his *Fisionomia*, della Porta elaborated this Paracelsan doctrine: since there are distant species of plant whose leaves resemble the legs of the scorpion, those plants come under the sign of Scorpio and Scorpio's planet Mars; with physiognomy, a similar logic is at work in what della Porta is pleased to call the 'physiognomic syllogism'. [27] All parrots are talkers, all men with noses of a certain shape are like parrots, therefore all such men are talkers. The visual result of the theory took the form of images in which the human face is variously distorted to reveal, as far as ingenuity will permit, hidden resemblances to specific beasts (illustration 12). Each

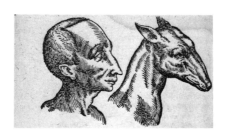

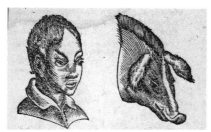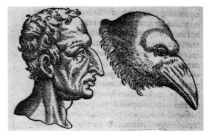

12 Giovanni Baptista della Porta, *Physiognomic studies*

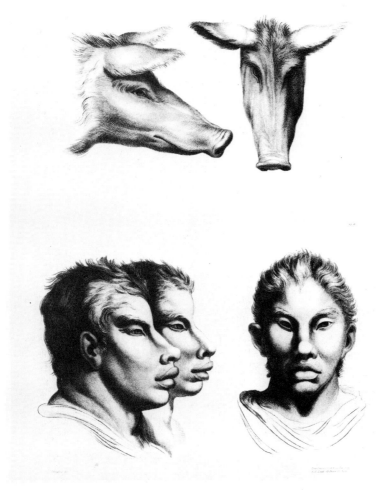

13 Charles LeBrun, *Physiognomic studies*

kind of face intersects with a particular word: that of the lion, with audacity; the hare, timidity; the rooster, expansiveness and liberality; the dog, spitefulness; the crow, austerity; the turtle-dove, devotion; the dove, domesticity; the sheep, gentleness; the goat, alertness and agility; the leopard, gracefulness; the bear, sloth.[28] It is this intersection which attracted LeBrun, and his desire to have the physical face of the world converted into signs is strong enough to persuade him to create, with dazzling success, his remarkable series of faces of beings who are at the exact mid-point between human and animal creation (illustrations 13 and 14).[29] Usually, out of the context of LeBrun's discussion of physiognomy, they are misread as experiments in the grotesque or the teratological; but the clue to LeBrun's true interest is to be found in the words which in the original manuscript he ascribes to the faces of four of his cows: *hardi*, *opiniâtre*, *stupide*, *farouche* (illustration 15). Nowhere does Porta show any concern for the

14 Charles LeBrun, *Physiognomic studies*

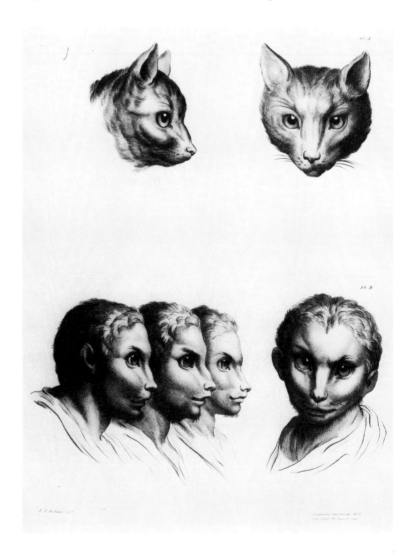

individuality of animal features; LeBrun's departure from his model indicates the real centre of his enthusiasm, which is the production of texts from even the most arcane and resistant of images. He is obsessed with the expansion of discourse into virgin terrain; even the animals in his paintings possess clear signs of personality.[30]

The physiognomic approach, however sensational its results, was limited by two obvious factors: it was not easy, without entering the realm of the grotesque, to stress the animal resemblances of the face within normal painting practice; and even where the hints of similarity between a human face and that of a beast could be stated, not everyone would be able to pass with clarity from the face to the various signifieds, of audacity, domesticity, spitefulness, and the rest. The system is too cumbersome, for it entails a double process of signification: distortions in the face have to elicit a first signified, the name of the beast ('dove'); the signified must then become the signifier of a second signified ('domesticity'). LeBrun soon abandons this unwieldy system and develops in its place a kind of semaphore. Following almost verbatim Descartes' account in the *Traité sur les passions de l'âme*,[31] he divides all emotions into two classes: emotions are 'movements of the sensitive part of the soul, which is itself made to

15 Charles LeBrun,
Physiognomic studies of cattle

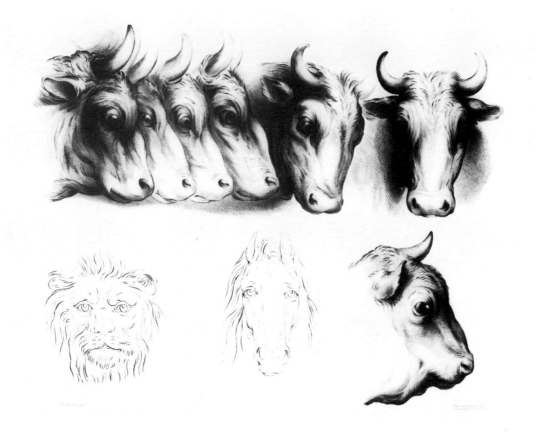

pursue that which the soul thinks to be for its *good* and to avoid that which it believes to be *hurtful*'.[32]

Within a rigidly dualistic scheme, both of these kinds of emotion or soul-movement would be invisible: consciousness, being separate from extension, can never appear in the physical world. But in the *Traité* Descartes insists on a nodal point between extension and mind, the *pineal gland*. This opens the way for LeBrun: 'And as we have said that the gland which is in the middle of the brain is the place where the soul receives the images of the passions, so the *eyebrow* is the part of the face where the passions are best distinguished, although many have thought that it was the *eyes*.'[33] In LeBrun's account, whenever the soul experiences attraction towards something outside itself, the pineal is stimulated and the eyebrows, being the part of the face at once the most mobile and the closest to the gland itself, begin to ascend; conversely, whenever the soul experiences repulsion from an outside entity, the eyebrows lose contact with the pineal, whose power declines under the negative emotion, and descend towards the baser zones of the body. 'And as we have said that the sensitive part of the soul has two appetites from which all passions are born, so there are two movements of the eyebrows which express all the movements of these passions.'[34]

Reaction is not, however, confined to the eyebrows alone. As the soul experiences positive emotion, the pulse becomes even and strong (in details like these one can detect the proximity of medical diagnostics) and the rate of digestion increases; animal spirits descend through the nerves as though through capillaries, and distribute themselves to all parts of the body, producing a sensation of spreading warmth. But as the soul experiences negative emotion, the animal spirits congregate in the muscles, causing them to become congested and swollen; the pulse grows uneven and feeble, and the work of the stomach ceases; there is a sensation of spreading cold, and in extreme instances the animal spirits flee the body altogether, back home to the pineal gland.

The emotions are gathered together into two groups whose opposition is total. When the soul is in neutral, its basic state, charmingly enough, is said to be wonderment. But it is constantly moving out of neutral into positive or negative positions, as outlined in the diagram on page 50. Entering a positive state, wonder becomes esteem – the soul has found something attractive: the mouth begins to open, and the nostrils to descend towards the mouth; the eye, mobilised by the now activated pineal, revolves upwards in its orbit. As the positive state intensifies, esteem becomes love: the brow smooths out and the head inclines towards the object of love; the cheeks grow pink and the corners of the mouth, marking

a new frontier of the magnetic pull of the pineal, begin to rise. As love waxes into veneration, the pupils begin to rise towards the eyelids and to move behind them; and as veneration finally becomes rapture, all the features are drawn upwards in a great surge towards the pineal, as though in a celestial ascension (illustration 16). When the series of emotions is negative, the pineal is conquered by the material weight of the body as though by gravity. In the first stage, scorn, the nostrils rise while the mouth remains closed; the pupils stay centrally placed. As scorn becomes hatred, the brow wrinkles, the head averts itself from the repellent object, the cheeks grow pallid, and the corners of the mouth, losing touch with the beneficent upward pineal drive, slope down. As hatred intensifies into horror, the pupil descends in the orbit, and as horror becomes terror, all contact with the pineal is lost: the bloodstream grows congested: veins dilate and muscles swell.

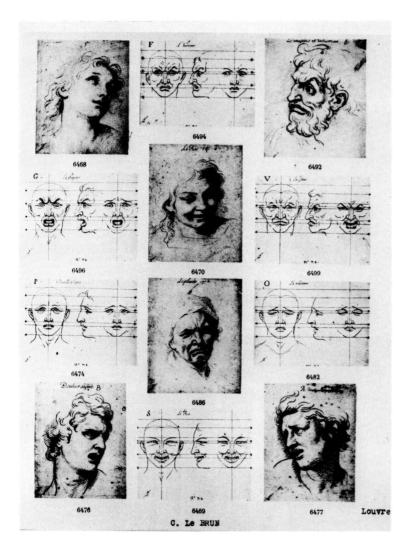

16 Charles LeBrun,
Physiognomic studies

ESTEEM	SCORN
Nostrils down	Nostrils up
Mouth open	Mouth closed
Pupils up	Pupils central

LOVE	HATE
Brow smooth	Brow wrinkled
Head towards object	Head away from object

VENERATION	HORROR
Pupils under eyelids	Pupils down

RAPTURE	TERROR
Eyes turn to pineal	Animals spirits to veins and muscles

In the illustrations to his *Conférence sur l'expression générale et particulière*, delivered to the Académie in the first cycle of its Discourses and subsequently put through numerous editions, LeBrun reduces the face to a combinatory schema which permutates a few basic semaphoric units.[35] Eyebrows have either upward or descending movement, though in complex emotions such as hope, where the soul both wishes something advantageous to itself, and also fears that the advantage might not arrive, there is double motion: the eyebrow rises where it is close to the nose, and lowers at its far end. This permits an increase in the number of expressible emotions: in fear, for example, the shape of hope is inverted; the eyebrow descends where it is close to the nose, and rises at the other extremity. The corners of the mouth and the nostrils may rise, fall, or remain in neutral; the mouth opens and closes. It is a system which, both in its constituent oppositions and its creation of meaning through those oppositions, resembles that mysterious level of language where phonetics becomes semantics, and the formal divisions and differences within the phonic stream begin to emerge as signs. The system operates at the precise frontier of the signifier and the signified, and it extends the imperial advance of the discursive into the figural right up to the point where, for LeBrun, following Descartes, substance subtilises into pure and insubstantial spirit: the pineal. LeBrun's dissective drawings of the brain and the gland (illustration 17) testify to his acute interest in this final point of sublimation of material life, and there is a sense in which the anatomical sketches are an exact counterpart to his allegories at Versailles: the enveloping layers of matter are divested and discarded to reach the ultimate non-material core, the seat of discourse.

LeBrun's project of colonising the body with signs is not unique to him: Dufresnoy and even Roger de Piles, the great

figuralist, insist on the importance within painting of the legible body. The voice behind this whole generation of painters is that of Descartes, and as though self-conscious and embarrassed that painting should be speaking in such a metaphysical fashion, its spokesmen tend to repeat the Cartesian arguments almost word for word. This is the sculptor Gerard Van Obstal, addressing the Académie on the *Laocoön*: 'In fear, all the blood of the body withdrawing to the region of the heart, the parts which are deprived of blood become pale, and the flesh less solid; thus since the limbs lack their normal heat and strength, the head of Laocoön tilts towards his shoulders.'[36] And this is Descartes: 'Sadness narrowing the orifices of the heart makes the blood flow more slowly in the veins; and becoming colder and thicker, it withdraws to the spaces near the heart, leaving the most distant extremities behind, the most visible of these being the face, which seems pale and fleshless.'[37] Again, Nicolas Mignard: 'Joy makes the heart dilate, so that the warmer and purer spirits, mounting to the brain and spreading over the face, particularly the eyes, heat the blood, extend the muscles, smoothing the brow and giving brilliance to the whole countenance.'[38] And, again, Descartes: 'In opening the valves of the heart, joy makes the blood flow more quickly in every vein, and, becoming warmer and more subtle, it enters every part of the face, making it more smiling and lively.'[39]

Printing the passions on the face in clear and distinct characters does not die with LeBrun: after a long period of reaction

17 Charles LeBrun, *Anatomical drawings of the pineal gland*

against the discursive image, when the Académie revives in the latter half of the eighteenth century, the Comte de Caylus will institute a prize which yields a whole category of French art: the *tête d'expression*. And even such non-academic figures as the nymphets of Greuze display their ascensional and pineal eyes, while the austere and impassive countenances of neo-classicism still demand a scanning of those significant units, the nostrils, pupils, and mouth (particularly evident in the minor neo-classicists who take from David a sense of theatre, like Taillasson). Correct reading of the human body in French painting of the seventeenth and eighteenth centuries is almost a lost art; yet without some rudimentary understanding of its procedures, we not only overlook the subtler part of the image's intention, but risk missing altogether that confident, seigneurial tax which discourse levies on the figural for over a century.

Application of the doctrines of the *Conférence* appears with greatest success in *The Queens of Persia at the Feet of Alexander* (illustration 18), painted by LeBrun at Fontainebleau for the King at the beginning of his reign, in 1662.[40] It has all the qualities of a manifesto piece, and at once Félibien published a

18 Charles LeBrun, *The Queens of Persia at the Feet of Alexander*

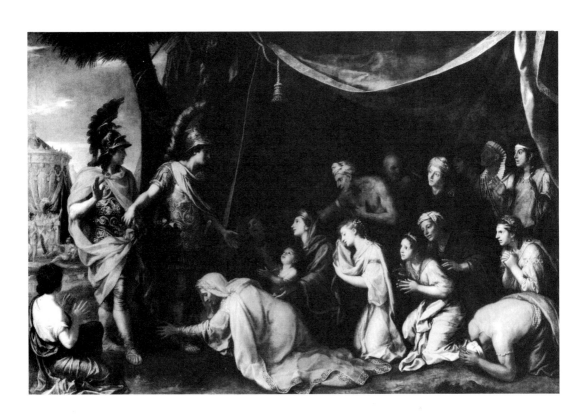

commentary on it of unprecedented length: not until the Poussin debates at the Académie do we encounter such intensity of verbal focus on any single French painting. The subject is that moment when Alexander, attended by his companion Ephestion, visits the mother and the wife of Darius, after the battle in which the royal family of Persia became his prisoners. The Queens, at first mistaking Ephestion for Alexander, on realising their mistake variously prostrate themselves, and display in clear and distinct signs their troubled inward states. The subject, being itself a double-take, acts as a lure to reading: the spectator must himself work out which of the two standing figures is Alexander. The visual clues are these: while both wear gold helmets, the metal of the cuirass is silver with one, a baser metal with the other; one mantle is carnation, the other scarlet; and, as we increase the degree of our concentration, we discover that with one, the mantle is fastened by a clasp of diamonds, and with the other, by a clasp inset with an agate cameo representing the figure of Alexander. The mind, slowly working through the clues, decides that it is unlikely that Alexander would go about wearing a badge of himself. Having by this bait triggered the reading mechanism, the image proceeds to itemise the legible emotions of each countenance. With Alexander, Félibien tells us, four sorts of expressive action:

The compassion he has for the princesses visibly appears, both in his looks and in his behaviour; his opened hand shews his clemency, and perfectly expresses the favour he has for all that court; his other hand which he lays on Ephestion, plainly shows that he is his favourite; and his left leg which he draws backward, is a token of the civility which he pays to these princesses. [41]

The courteous inclination, Félibien continues, would have been more pronounced, in keeping with the prostration of the women; but Alexander is shown at the moment when he first sees the princesses; the practice of prostration was unknown among the Greeks; and besides, a thigh-wound from the battle inhibited normal movement. The units of meaning Félibien finds planted in the different bodily zones of Alexander are therefore these: clemency in the left hand, protective assurance in the right, compassion in the face, civility in the left leg; finally, in the characteristic tilt of the head, the personal sign of Alexander. In the prostrated Queen Mother Sysigambis, 'the eyes are inclined towards the ground, to show that she relies not on her former fortune; her very garments so carelessly spread, testify her humiliation'. [42] In the wife of Darius, who is shown with her child, we find dissatisfaction mixed with hope: 'for though we may easily perceive by the motion she makes with her left hand, that she would excuse Sysigambis in mistaking herself; we see likewise very well, that in beholding

Alexander after that kind of manner, she endeavours even with her looks which are the interpreters of her grief, to affect the very soul of that prince with compassion'.[43] Princess Statira, who kneels behind the wife of Darius, is given up to grief, but also to restraint and concealment: by trying to smother her tears, and from the very nature of the emotion she experiences, the blood has caused her neck and throat to swell. Her eyes are half-closed, 'to escape the sight of the conqueror';[44] the disarranged folds of drapery connote self-negligence, while a heightened vermilion on the cheeks signifies aroused modesty. Behind Statira, a highly complex figure: in the eyes, still wet from tears, grief, 'her eyebrow, advanced, shows fear';[45] while the mouth slightly opened, and raised at the corners, indicates admiration. The hands both join (supplication) and do not join (uncertainty); one knee is on the ground (placation), while the other is raised (uncertainty); and in the clothes, an obvious disorder indicates to Félibien that 'she was not acquainted with this sort of duty, and that her imagination is so disturbed, that although she would perform punctually what her governess directs her, she knows not even what she does'.[46]

The governess indicates to her with the pointed forefinger of the right hand that she ought to prostrate herself like Sysigambis, but in the forefinger of her left hand, which hesitates even to lay a fingertip on the royal body, she also communicates a marked respect. Behind the governess, a figure who steps straight from the illustrations to the *Conférence*:

as sudden fright causes the blood to retire to the heart to preserve it, because it is the noblest part of the body, and by that means the other members become destitute thereof; we may observe this lady to be of a very pale complexion; that her lips are without colour; her eyes sunk and obscure; her eyebrows cast down and contracted; she lifts up her shoulders, and closes her hands.[47]

Beneath this picture of anxiety, a Persian completely prostrates himself, which indicates to Félibien not only barbarism, but that the Persian court has not yet heard of Alexander's famous clemency, or does not believe in it.

The half-naked figure who stretches out his right arm over the princesses, might seem a brief excursion away from discursive contraints; but even his nakedness is significant, since 'it is Persian custom to tear the clothing when under intense affliction';[48] and by the softness and slackness of his flesh, we recognise that he is a castrate; that is, a high courtier, and in far more direct danger than the princesses. Behind the eunuch, a slave, his status defined with economy by the removal of all signs of rank; and to his left, a woman whose pale complexion indicates Greek birth, an indication confirmed by the half-smile she displays on her face, as she gazes with welcome on

her liberators. To point up the pallor of her complexion, behind the Greek woman, a dark-skinned native, and behind her, an Egyptian priest in sacerdotal robes, raising his head to get a better view; being a priest, he is skilled in language, and for this reason his focus on Alexander is more attentive, since unlike the others, he can understand Alexander's speech. To the left of the priest, another standard *Conférence* image, this time of surprise: with eyebrows raised and eyes widened, mouth opened and palms facing outward, all the discursive markers are unambiguously and abundantly in evidence.

Félibien's commentary is a salutary reminder that with a painting such as this, a whole lexical dimension lies concealed from normal viewing; and especially the normal viewing of the twentieth century, with its natural bias towards a figural appreciation of the art of the past. Yet unless we attend to this dimension, the image fuses into a ponderous mass, and it is probably the sheer weight of pomp which alienates the spectator who is unaware that the image is not merely to be seen, but read. As discourse penetrates this ankylosed mass its components begin to separate, and the image regains a lightness, an *allegrezza* which one might not have suspected it capable of sustaining. The kind of discursivity to which LeBrun submits his painting is entirely conscious, and is nothing to do with naturalism. Before LeBrun, since no lexicon of the body exists to be consulted, except the virtually useless treatise by della Porta, the significance of the body seems to have no source, and in the absence of source there develops an effect of the real, as with the Masaccio earlier discussed. When I cannot consult the text of the passions, I cannot clearly place the articulation of its meanings, and since the signified seems without origin in the image and on the plane of signifiers, I invent a space of depth, 'outside' the image, to house it; the depth of perspective becomes identified with this imaginary deep exteriority. Since signification exists, but I cannot clearly attach the production of the signified to any specific pictorial signifier, I must create another realm for the meanings I 'find', away from the picture plane; and perspective, pretending to supply a space 'behind' the signifiers, and coinciding with this need for another realm, meets it, and invites the signified to step with it behind the signifying plane. LeBrun, by bringing the articulation of the physiognomic and pathonomic codes into full visibility, counteracts this occultation; meanings do not emanate from his canvases mysteriously, but in the full awareness of a coded practice. In this sense the image in LeBrun possesses a frankness and publicity of intention that make it incompatible with what we know of the image in realism. And in the next generations, as the fully discursive image falls out of favour, the reaction against discourse moves painting once again

towards that effacement of the means of signification which is an essential part of the realist project.

As an afterword, let us conclude with the painting by which, thanks to a certain hanging policy at the Louvre in this century, LeBrun is best known: the equestrian portrait of Chancellor Séguier (illustration 19). Early, thoroughly uncharacteristic of his output, and hardly mentioned by LeBrun or by his contemporaries, it shows what kind of a painter LeBrun might have become if he had not lent his brush to the hegemonising word, and the centralising state. It speaks to us today so directly because it comes so close to being surreal. Its theme, an entirely figural one, is *cloning*: not one parasol, but two, not one golden tassle but many, ribbons which irrationally twin, and everywhere these replicating, stately and square-toed slippers. The page-boys, whose hair, as it alternates from auburn to chestnut, does nothing to conceal an identity of countenance, resolve from plurality into impossible unity, and so far from forming an entourage, seem a single figure rotating in space and frozen at successive paces. The parasols, which combine an instantly available quality of the picturesque with

19 Charles LeBrun,
Chancellor Séguier

a certain occidental dream of the Asiatic, accord to Séguier the full status of mandarin, and, with the opulent shimmer of the fabrics, invest in him all the connotational magic of the word, Cathay. Although so resolutely figural, it might be taken as the emblem of the forces that between them define the moment of LeBrun: the image perfectly married to the triumphant state: a radiant and transfigured bureaucracy.

3 *Watteau and reverie*

LEBRUN'S COMMITMENT to the discursive image always tended towards extremism. In his Discourse on Poussin's *Saint Paul in Ecstasy*, we find him converting into allegory a painting that does not seem allegorical at all.[1] Of the three angels who appear with the Saint, the first, LeBrun claims, is to be read as effective or total grace, the second as aiding or intervening grace, and the third as elective grace; the sinking leg of the saint represents his sin, while the green robe he wears signifies his hope of raising himself above sin through works, and his red mantle signifies his ardent charity. Such adventurous exegesis was not without its critics. Already within the Académie, the *Conférence sur l'Expression* met with some resistance: LeBrun was accused of having plagiarised his ideas from medicine – 'on a prétendu qu'il avait tiré les idées de l'illustre M. de la Chambre';[2] at the Discourse on *Saint Paul*, there were 'des personnes ... qui parlèrent de cet ouvrage diversement';[3] and even Félibien, the spokesman for the earliest ideals of the Académie, rejecting LeBrun's complex systematisations, wrote that 'for the movements of the body engendered by the passions of the Soul, the painter can learn of them in no better way than by consulting nature'.[4] Actual assault on the discursive image comes from dangerous opponents: from Pierre Mignard, LeBrun's lifelong rival, who rather than take second place to LeBrun refused to join the Académie at all, and who became its Director in 1693 once LeBrun had fallen from political favour;[5] and from Roger de Piles, leader of the ascendant *rubéniste* party, and spokesman for a new and rapidly developing anti-academic taste.[6] Mignard's first objection was that pursuit of the discursive image had led LeBrun into impersonality: since LeBrun's work was literary and not painterly, it was natural that he should wish to delegate the execution of his paintings to assistants; but then they were no longer by LeBrun (the contrast here was with Mignard's own enormous but never delegated project of decoration in the cupola at Saint-Cloud). Mignard next objected that LeBrun's allegories were both tedious and obscure: 'Having carefully read your pamphlets,' Mignard writes, 'one finds nothing in your work corresponding to what is written.' The charge of obscurity is

repeated by Roger de Piles: in his account of LeBrun he com-
plains that 'his pictures were like so many enigmas, which the
spectator would not give himself the trouble to unriddle'.
Roger de Piles adds to this the charge of dogmatism – there are
several ways, he maintains, and not just one way, of represent-
ing a particular passion; and the charge of artificiality –
'[LeBrun] studied the passions with extraordinary application,
as appears by the curious treatise he composed on them, which
he adorned with demonstrative figures; nevertheless, even in
this, he seems to have but one idea, and to be always the same,
degenerating into habitude, or what we call manner.'

The most effective theoretical attack on LeBrun's project
arrives, however, obliquely, through the quarrel between
rubénistes and *poussinistes* (which the *rubénistes* were eventually
to win).[7] The quarrel itself is too vast a subject to examine in
detail here, and there is an important sense in which the quarrel
is in any case irrelevant to the issue of the discursivity or
figurality of the image. Even in his most vigorously *rubéniste*
polemics, de Piles insists on the importance to painting of the
parameter of expression. Evaluating the 'expressivity-level' of
the Masters, he awarded LeBrun a score (he was a great
believer in scores) that is just below Rubens and Raphael, and
rather higher than Poussin.[8] It is vital to his argument that
Rubens be seen to succeed in expressions as in every other
aspect of painting, and there is no question that expression is to
be downgraded as a parameter, only that colour is to be
upgraded. With respect to colour, Poussin's score is shock-
ingly low.[9] Yet obviously, if Rubens is to be elevated to
equality with Raphael, success in colour must count for at least
as much as success in expression, and this entails a reorganisa-
tion of priorities in which expression is effectively down-
graded. The priorities of the Académie in 1667 can be tabu-
lated, from the Discourses delivered by LeBrun, Bourdon and
Philippe de Champaigne, as follows:

LeBrun
1. Disposition
2. Design and proportion
3. Expression of the passions
4. Perspective

Bourdon
1. Light
2. Composition
3. Proportion
4. Expressions
5. Colour
6. Harmony

Philippe de Champaigne
1 Composition
2 Grouping
3 Expression
4 Colour and chiaroscuro[10]

For LeBrun, colour is not a consideration at all; but for those who do admit its importance, colour and expression are adjacent priorities, so that if *rubéniste* taste gains a following, expression will be demoted. The triumph of the *rubénistes* entails an immediate adjustment within the figural and discursive components of the painterly sign, with the discursive in full retreat.

Yet the attack is wider than this, for it threatens the whole metaphysical foundation of the painterly sign as LeBrun had conceived it. 'Reason tells us that the figure is in the objects; only a vague sentiment tells us that it is coloured.'[11] That is Descartes' position on colour, and LeBrun gives it the usual support he grants to Cartesian thinking. He sees colour as a *parasitic* quality: 'if the merit of something is the greater, the less it depends on another thing foreign to it; it follows that the merit of design (*dessin*) is infinitely above that of colour'.[12] LeBrun's argument is that design must be a logically superior category, since there can be design without colour, but there cannot be colour without design. Whether this is true is of course, debatable; certainly de Piles disagreed, insisting that in nature colour and light are inseparable.[13] LeBrun's determined philosophical tone is significant. It tells us that the issue of colour directly concerns his policy of Cartesian painting. Colour is not a quality of mind or reason, and is in fact unnecessary to reason's perception of the world, which operates quite efficiently in monochrome. Even loftier is this:

It must be considered that colour in painting cannot produce any hue or tint that does not derive from the actual material which supports the colour, for one would not know how to make green with a red pigment, nor blue with a yellow. For this reason it must be said that colour depends entirely on matter, and, as a result, is less noble than design, which comes directly from the spirit.[14]

Colour is *degrading* to the image because of its materiality, and painting ought to transcend its material base – its ignobly non-spiritual signifier. The *rubéniste* challenge threatens the whole Cartesian conception of the painterly sign.

LeBrun's dependence on Descartes has naturally been the subject of much discussion.[15] It is rare to find so close a connection between painting and philosophy, and for once the connections the art historian can make between the two do not have to be mysterious or 'epistemic'. LeBrun could hardly be

more obvious in his reliance on Descartes' work: whole
sections of the *Traité sur les passions de l'âme* are transcribed
almost verbatim into the *Conférence sur l'expression*,[16] and it is
to Descartes that we owe not only LeBrun's classification of
the passions, but in some instances the actual signs by which
the passions are to be recognised.[17] Yet the whole idea of a
Cartesian painting is strange, because strictly speaking it can-
not exist. In dualism, the self is no longer resident in the
physical universe; yet all that painting can represent is the
world of extension where the self precisely no longer resides.
The ego, like the deity, cannot be represented; only at the
pineal does the ego penetrate the physical world, and LeBrun's
fascination with dissections of the brain proves that he was
well aware of this reduction of the painter's scope (illustration
18).

But in another sense Cartesian dualism very obligingly
serves LeBrun's idea of the mission of the Académie to reform
painting in France. One of the axioms of the reform is that in
the grand style, the physical surface presented by the universe
must be transcended: to copy that surface is servility, the
province of the little masters, mere *métier*. LeBrun and Félibien
took from Poussin the vision of a French painting that would
discard the outward encumbrance of matter, and rise beyond it
into a province exclusively *de l'esprit*.[18] In perfect form, this
painting would not be physical at all, but the communication
of ideas from one consciousness to another across an image
that is altogether transparent; the image as a channel of trans-
mission with minimal redundancy or 'noise', much like the
Word as understood by the *Grammar* of Port Royal.[19] In the
absence of such a utopian possibility, the channel must descend
to physical signs, but in so far as these directly correspond to
ideas, pure transmission is still maintained. The first sentence
of the first part of the Port Royal *Logic* states that 'We have no
knowledge of what is outside us except by the mediation of the
ideas within us.'[20] The ego, as it contemplates the world out-
side itself, cannot be sure of what it sees: not only is it possible
that the world outside the ego might not exist, the face which
that problematic world presents might not correspond to what
is actually there. Let us take, as Descartes does, the example of
the body. I feel a pinprick in my finger; yet obviously the
sensation does not occur 'in' the finger, but in the brain. To the
question, 'Why, if the sensation is in the brain or in the pineal
gland, do we feel it as in the finger?' Descartes replies that such
an illusion is providentially beneficial. If the sensation were felt
to occur within the brain, the necessary action, of removing or
avoiding the pin, might not be immediately taken. But if the
sensation is assigned or reprojected 'on' to an illusory or
hallucinated finger, the necessary action, being immediate, can

be the more efficiently performed. The inference is disturbing: in painting the body, the painter is copying a phantom. However, even though everything outside the ego is uncertain, the one area the ego possesses in independence from that uncertain outside world, its stock of ideas, is entirely stable.[21] The ego can safely contemplate its ideas without that contemplation entailing any kind of commitment to the existence of anything other than the ego itself. Ideas are, so to speak, the ego's natural surroundings or *Umwelt*; and if the painter is to transcend the encumbrance of extended substance, it is this province of ideas that his work should focus on and communicate.

LeBrun's insistence on the image that fully yields up its discursive content entails a certain theology of the sign: as mind is to extension, so signified is to signifier. And for this reason Roger de Piles could not have chosen a more precise target-point through which to attack LeBrun's project than colour; for colour is the aspect of painting least susceptible to confiscation by the signified. As LeBrun's pronouncements show, colour is precisely the parameter where the image ceases to be discursive, spiritual, transcendent, and falls into a degraded materiality which it had been the ambition of LeBrun to overcome. Moreover, de Piles fully understood the rhetoric of the Académie, which, despite its theoretical and intellectual flavour, was then, and long remained, committed to a way of speaking about painting that relied heavily on the use of exemplary figures as the principal counters in debate. It is hard for us to reconstruct this rhetoric, though the task is quite essential, if only because without reconstructing the Académie's mode of discourse we shall never discover why the *Apotheosis of Homer* is so central in the work of Ingres, or what is meant by its very precise and very enigmatic *placement* of Raphael, Pindar, Racine, Shakespeare, Molière, Longinus, Poussin, and the rest (Rubens is the great absentee; illustration 20). The nearest contemporary analogy would be a coded diplomatic or political language, like that of *Pravda* (or *Pravda* in a certain Western myth), where abstract issues are not directly addressed, but by working out the implications of a hierarchy of figures, and by following who has been elevated and who denounced, one can reconstruct an ideology which it is the exact purpose of such a language to obscure. In Rubens, de Piles found precisely the counter through which to issue the challenge of the subversive signifier. And without Rubens, it is possible that the signifier might have long continued as the vital but unmentionable component of the painterly sign. Certainly the early colour-debates, which lacked this central counter, were quickly recuperated: in 1671, during – significantly – a three-month absence from the Académie of LeBrun, Blanchard delivered a defence of colour which,

despite its revolutionary potential, soon sank without trace;[22] the official historian of the Académie writes of 'discourteous visitors to the public debates' who spread 'Lombardic maxims' (pro-colourist ideas); they were soon silenced.[23] But with 'Rubens' in the balance against 'Poussin', the assault of the signifier on the signified could proceed apace, and the main issues – recomposition of the sign, redefinition of the relation of the image to the world and to the text – could be conveniently concealed beneath the acceptable disguise of a work of canonisation. After the theory of the subversive signifier, the practice: Watteau.

Watteau's painting has always, from the beginning, enjoyed a special relationship to text. Already in 1719, the first biography, in Italian, had appeared.[24] Watteau's friends during his lifetime tended to become devotees, and after his death, biographers. Antoine de la Roque, the influential editor of the *Mercure de France*, wrote his detailed obituary notice in 1721,[25] Jean de Jullienne his personal memoir in 1726;[26] Edmé Gersaint added another memoir in 1744,[27] and in 1748 the Comte de Caylus, another personal friend, delivered a lengthy discourse on Watteau to the Académie.[28] These documents between them compose a remarkably detailed record, and in them is

20 J.-A.-D. Ingres, *Apotheosis of Homer*

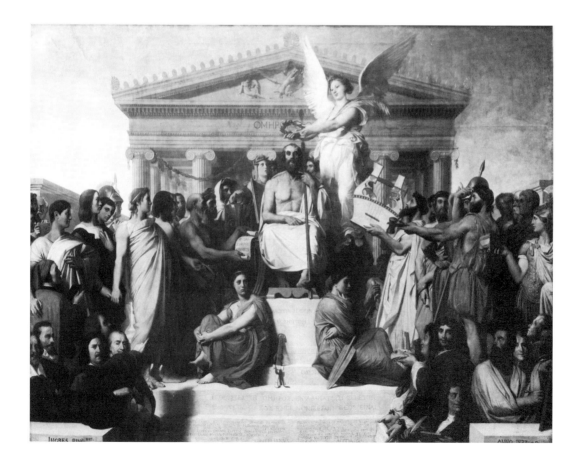

visible a tendency with a promising future – people who have not written on art before may write on Watteau: Watteau catalyses writing. The beginnings of what is almost a minor literary genre, with its own specialised rules, are to be found in two lyrical and hyperbolic poems of 1736 by the Abbé de la Marre, 'L'Art et la Nature Réunis par Watteau' and 'La Mort de Watteau, ou la Mort de la Peinture'.[29] For a century the genre is fairly dormant, during a rapid decline in Watteau's reputation; but in three articles by Paul Hédouin in the 1830s a new flowering begins.[30] The articles have very little to do with Watteau and nothing at all to do with painting, but they unveil what is to become the characteristic form of Watteau writing, in which the paintings are used as the pretexts for verbal extravaganza. Baudelaire is a major contributor to the genre; and Watteau is taken up by Banville, Gautier, Nerval and the other members of the rue de Doyenné group, who turn him into a cult.[31] This is Gautier:

> Je regardais bien longtemps par la grille,
> C'était un parc dans le goût de Watteau;
> Ormes fluets, ifs noirs, verte charmille,
> Sentiers peignés et tirés au cordeau,
> Je m'en allai l'âme triste et ravie;
> En regardant j'avais compris celà;
> Que j'étais près du rêve de ma vie.
> Que mon bonheur était enfermé là.[32]

After the rue de Doyenné rhapsodies comes the most extreme outburst of them all, the climax of the tendency they represent: the Goncourts' *French Eighteenth Century Painters*. Here they are, in full flood:

A poetry as unique as it is delightful, the poetry of sumptuous ease, of the colloquies and songs of youth, of pastoral recreations and leisurely pastimes, a poetry of peace and tranquility amid which the movements even of a garden swing die faintly away, the ropes dragging in the sand . . . it is a smiling Arcady, a tender Decameron, a sentimental meditation, a dreamily distracted courtship; words that soothe the spirit, a Platonic gallantry, a leisure given over to things of the heart, a youthful indolence; a court of amorous pre-occupations, the tender teasing courtesy of newly-weds, leaning towards each other over their linked arms; eyes without hunger, embraces without impatience; desire without lust, pleasure without desire; a boldness of gesture orchestrated like a ballet for the occasion; feminine ripostes, of the same nature, tranquil and disdainful of haste in their assurance . . .[33]

One of the more remarkable features of the genre is that it is not depleted, as we might expect, by the excesses of the Goncourts. The same compulsive rhapsodising persists through to 1920, when Camille Mauclair develops it further in

a lengthy speculation on the role of disease in Watteau's work 65
that reads like a hymn to consumption.[34] Even in 1950, René
Huyghe is keeping the tradition alive:

Visible, fictional, there they are before us. In the mirror of their false
presence, those symmetrical faces, of 'never' and 'always', recognise
each other and reconcile themselves to each other. Doubtless they
have always been like this; doubtless they have never existed. Are
they alive? In the streams, seemingly immobile, one sees the imper-
ceptible current flow, which carries everything away ... Already
they are leaving us; they [Watteau's figures] abandon us; tender and
distant, unaware of our presence, they gently pivot and, step by step,
depart.[35]

One way of dealing with this literature – and there is a
parallel English development, which culminates in Sacheverell
Sitwell[36] – is to dismiss it as irrelevant to Watteau's work. This
is a healthy reaction, but the extraordinary endurance and
excess of Watteau writing is itself an interesting phenomenon,
and one with more direct bearing on Watteau's painting than
one might think. Ultimately it is the natural reaction to an
effect quite central to Watteau's enterprise, which one might
call the 'semantic vacuum'. But before examining that effect,
and from a motive that is only partly hygienic, let us try to
break the Watteau myth down into its constituents – the
typical forms of the discourse Watteau's images have called
into such colourful and seemingly irrelevant existence. The
following is culled from a wide variety of sources.

I MUSICAL ANALOGY

In the myth, Watteau's painting is often credited with the
miraculous power of representing by material means a
spiritual domain which it seemed possible to evoke only with
music.[37] Various composers are found to have written the
music that is supposed to enter the mind when contemplating
Watteau, and the only rule is that the music is *not* the music
being played by Watteau's musicians; nor is it the music of
Watteau's own period.[38] Sibelius is perhaps the weirdest
recorded choice;[39] Ravel is sometimes cited,[40] but more usual
are Debussy[41] (sometimes chamber music, sometimes
L'Après-midi d'un Faune), and Chopin (mazurkas, ballades).[42]
The connotational meaning of these choices seems to centre on
a vague cluster of langour, dissolution, longing, and regret;
there seems to be an unstated common root in the post-coital
state. When qualities of the tragic, and of isolation of the
individual from the group, enter into description, the com-
poser is Mozart, and especially the Mozart of *Così fan Tutte*,
although moments from *Don Giovanni* have also been heard.[43]

The Watteau myth holds that his painting is the expression of an invalid of genius.[44] Only disease can account for the quality of *envoi* his work everywhere displays. In the words of Paul Bourget: 'La tuberculose? c'est un merveilleux sensibilisateur';[45] Keats and Chopin become his spiritual brothers. Several writers find much of interest in Watteau's own body, and the possible self-portrait as a bagpipe-player in the *Fêtes vénitiennes* is their habitual focus (illustration 21). It is described as fully tubercular: haggard and wasted, the face anxious and nervous, the eyes dark and restless, he is already at death's door.[46] Watteau remarks to Caylus that 'le pis-aller, n'est-ce pas l'hôpital – On n'y refuse personne'.[47] His body, insufficient in muscle and flesh, transfers all its vitality to the nerves. Deprived of their stabilising counterbalance in matter, the nerves develop an acuity that transforms everything into vibrations.[48] He dies in the arms of his friend Gersaint.

21 Antoine Watteau, *Fêtes vénitiennes*

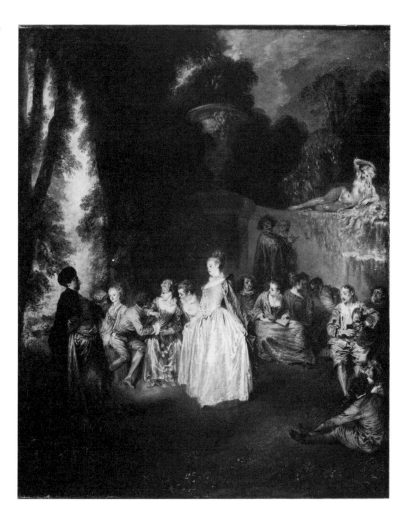

Watteau's art, like Mozart's, was once mistaken for rococo frivolity. A true appreciation develops in two stages. In the first, we see graceful, healthy young men and women; they are apparently rich, idle, gallant, and preoccupied with pleasure; 'they are acting out a comedy'; everything ugly has been banished from their world: it is all a pretence, a fantasy, a delightful flirtation.[49] But then the second stage: we begin to see the darkness. Watteau, permanently dying, tries to draw vitality from his figures by osmosis. He is the fool, whose comedy barely conceals a sadness that is profound, though not bitter. He is Pierrot, he is Pagliacci, and above all he is the portrait of Gilles (illustration 22).[50] He is sad because nature has disqualified him from love; in the *Fêtes vénitiennes* he gazes not at the female dancer (the actress Charlotte Desmares) but at his friend Vleughels (the turbaned gentleman who dances with her).[51] At the same time, we do not know why he is so sad; because of this his paintings are 'puzzling', 'evasive'.

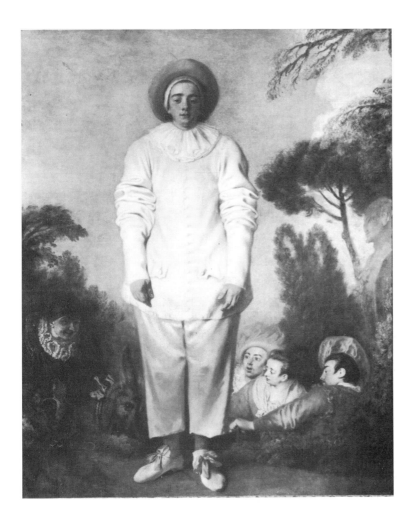

22 Antoine Watteau, *Gilles*

Unlike Pater, Lancret, Mercier, Octavien and all the other imitators of his work who lack this dimension, as well as the advantage of illness, Watteau is a profound student of the human heart.[52] It was not possible to see this before the new understanding of Mozart; also – I am citing one of the more eccentric Watteau-writers – of Pope.[53] The love he depicts is modern love with its aspirations and its crown of melancholy;[54] though it is also part of the great eighteenth-century discovery of Nature. He is a great observer of the natural world, as his first biographers noted; though it is nature raised from its base state, like the glaze over fine porcelain.[55] The moments Watteau chooses are those when two beings suddenly glimpse the essence of each other's souls. He is the historian of human passion, and in the *Pilgrimage to Cythera* (illustration 23) he records the stages in 'the achievement of relationships'.[56] In the 'autobiographical' *Fêtes vénitiennes*, Vleughels and Watteau maintain an equal and enigmatic distance from Charlotte Desmares, while Watteau has eyes for Vleughels alone: more is going on than the ostensible dancing;[57] perhaps we should remember that at one time Watteau lived in Vleughels's house. Watteau's women step from the psychologically rich comedies of Shakespeare; they are Hero and Rosalind, Viola and Olivia, and all the heroines of *As You Like It*,[58] as well as the lovers in *Twelfth Night* (Watteau is

23 Antoine Watteau,
Pilgrimage to Cythera

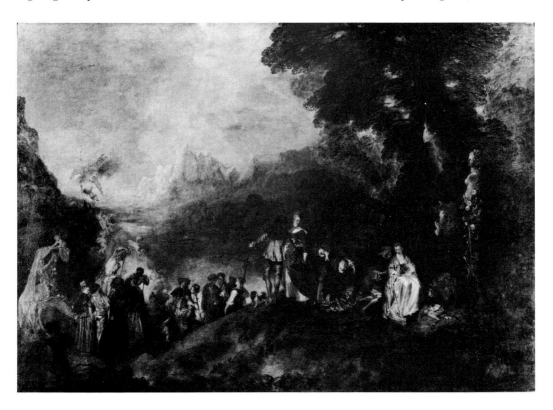

5 REVERIE

The governing principle of Watteau's oeuvre is fantasy. In this he is fully rococo, like Fragonard, another master of a dream world, whose whole painting is itself a dream, the dream of a man asleep in his box at the opera.[60] Watteau is asleep at the Comédie-Italienne. The dream he paints is a poem. He is the great poet of the eighteenth century. Produced by poetical dreaming, his work is best approached in a similar state.

Though simplified, these seem to be the main components of the Watteau myth, recurrent across the whole spectrum of writing on Watteau, from the frankly belles-lettrist to the technical study. Painful though it always is to dissect the habitual discourses that serve to stabilise our view of the art of the past, in this case the pain is greater because genuine insight is entangled in the general confusion. While one can prune away the musical analogies, the reverie, and the invalidism, one hesitates with 'psychological depth', because that is part of an ideology which still impresses us. And perhaps this is the greatest disservice the literature does to Watteau: observations of value are mingled promiscuously with the banality of *idées reçues*. This puts the late twentieth-century commentator in a position so uncomfortable it seems impossible to speak of Watteau at all: in such a situation the deconstitution of the myth becomes imperative.

Let us first consider the myth at the level of its component parts. There seems no reason at all why these various typical features should co-exist in the same place; their adjacency must derive from historical hazard. But there is an interesting under-lying homology. The recurrence of the musical metaphor offers an early clue. With music, at least in its non-technical appreciation, the listener does not normally know which tech-nical device elicits which emotional response: the emotions seem to emanate from something 'behind' the music that is being 'expressed', rather than from the material of articulated sound – the acoustic signifier.[61] In the case of literature, the long history of rhetoric and the more recent history of critic-ism alert the reader far more to the present and visible work of the signifier; but music enjoys a different status, being a com-paratively 'unlearned' art and consequently much more open to reception as a transparent medium for the expression of a dimension beyond its presence as sound. Only a minority are musically literate, and this factor alone already encourages a general disavowal of the signifier; but even when the notation is known, the signifier is still *overshadowed* by a transcending

signified, as in Suzanne Langer's dictum – which corresponds to widespread popular belief – that 'music is the form of feeling'.[62] Once understood as *that*, it can never easily assert itself as autotelic, as an end in itself, but is thought of instead as *carrier*, bearer of a signified ('feelings'), whose signifier is only the subordinate vehicle of transmission. In the Watteau literature, musical language is so readily available because his painting seems to correspond to this state of the sign: the signified without assertive source in the signifier; and in this respect the musical analogy is less off-centre than one might suppose.

In the second component, the myth of invalidism, we are dealing with a similar configuration. The paintings are thought of as *incomplete* in themselves, and in need of supplement; that supplement is biographical writing. Watteau's work is understood in the light of the myth as everywhere implying a text that is nevertheless nowhere stated *in paint*; in the same way that music is credited with the power to induce feelings without clear source within the sound. The 'real' signified of the Watteau image is illness, but no one in the paintings is actually unwell. Disease is unseen and offstage, away from the signifier of the image, which is then secondary and of interest only as it expresses this sourceless ('atmospheric') signification.

The use of biography here, as elsewhere, amounts to an institutionalised rejection of the signifier.[63] Even at a mass, so to speak Hollywood, level, painting is thought of as centred on the *artist*, his person, his life, his tastes and his passions; and the Watteau literature, faithful to this conception of the artist, confirms the view that biography is the image's natural explanation. In this conception, the signifier is necessarily subordinate and the image never figural, for always it must yield to a discourse that is its absent master. Watteau's illness is directly isomorphic with the musical analogy: interest not in the present and visible signifier, the paint on canvas, but that absent accompaniment, the biographical signified. The more recent idea of Watteau as revolutionary reinforces the pattern; as in the view which makes of him the main rococo source, the origin of Boucher and Fragonard, and one of art history's great 'originals', with minimal debts to the past.[64] A certain contradiction in the myth sets in, for the frail and forlorn invalid is also the fertile and vigorous primogenitor. But focus on the work as self-expression of the individual requires that individual to act as origin – the sole origin of the work through which the 'artist' expresses himself; an origin of meaning that instantly devalues the separate claim to origin of meaning, of the signifying plane.

Hence, too, the melancholy. In the melancholic gaze, the world is no longer apprehended as *sufficient* – as completed

presence; something is missing, but what it is can never be named, because it is, precisely, absence. The field of objects and the abundant, plenary fullness of the world fade before a sense of lack that is not capable of sustaining clear definition. Melancholia cannot state what would cure it, or what it misses; the world simply withholds that secure finality which would render it whole. With Watteau, melancholy takes on an erotic form for the reason that it is expressed most often through an imagery of desire, and because desire is the most representable of the biological states of lack – the one with a natural closeness to visual imagination. Perhaps for this reason speculation about a possible body of overtly pornographic work by Watteau has always been subversive: at the end of his life Watteau instructed that certain 'unworthy' paintings be destroyed. [65] If such a corpus were ever found to exist, its discovery would greatly undermine the critical fixation on Watteau's famous melancholia, for in pornography the goal is to put an end, however temporary, to the state of desire (desire is its enemy). But although Watteau's work obviously relates melancholy to eroticism, the paintings also forge a connection between the melancholic state and a much more traditional concern that centres on meaning. In Dürer's *Melancolia I*, the world ceases to be plenitude and becomes first allegory, existing piece by piece to transmit its emblematic meanings (illustration 24); but then once the allegory has been grasped and the content of signification has been released, the world is emptied, drained, sorrowful. [66] Its signification has gone, the world persists, but it has now lost something that can never be replaced or retrieved – its meaningfulness. After their excited discharge of meaning, its objects are *spent*, and the game of melancholy follows on the gaze of allegory. Dürer is clearly the classical source of statement of the connection between meaning and sadness, though the iconography there is not yet, as it is with Watteau, linked to sexuality. In Watteau, a whole narrative structure insists on meaning but at the same time withholds or voids meaning. Let us take the example of his characteristic theatrical costuming. In the theatre, such clothing is part of a general system of conventionalised costumes with exact dramatic and signalling functions. The diamond-patterned costume signals Arlequin, the baggy, white, ruffed costume signals Pedrolino or Gilles, the black cap and gown signal the Doctor. But outside the frame of the stage, in a *fête champêtre*, such signalling costumes lose their semantic charge, and having lost that original meaningfulness take on all the sadness of depleted signs. Again, the configuration which appears both in the musical analogy and in the biographical emphasis of the Watteau literature: a sign that insists on a signified which is absent, disconnected from the present signifier, at the same

time that the sign makes the claim for a powerful and attractive signified (melancholy) that is nowhere stated *in* the painterly signifier.

With 'psychological depth', one must tread carefully, since now the myth derives considerable force from an ideology of humanism where the presentation of inwardness is a strong positive value. But we are really dealing here with the same kind of issue that Leavis and Knights faced when they addressed the Bradleian question of 'How many children had Lady Macbeth?'[67] However valuable a view of the world where inwardness is prized, there is no automatic carry-over which entails that we ought to accord to the characters of art the prized ontology we accord to living people. 'What was Watteau's relationship to Vleughels?' is a question which denies that the figures in the *Fêtes vénitiennes* (illustration 21) are *paint*; once more, the repeated pattern of the myth, which overlooks the existence or the importance of canvas and figurality in favour of an excursion off-canvas into the discursive dimension. Far more to the point is for us to ask *how* Watteau

24 Albrecht Dürer,
Melancolia I

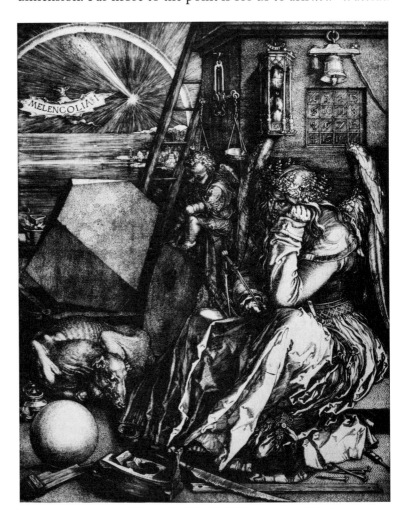

achieves his effect of inwardness: by what marks on canvas is
this signified, 'inwardness', known? The answer must be
deferred until a technical discussion of the general means by
which Watteau manages his effects; but here, as we work out
the underlying format of the myth, we can observe the persist-
ence of the features already noted: the figures of the *Fêtes
vénitiennes* 'imply more than they state', stimulate our appetite
for a psychological text without giving that text to us directly.
It is in the absence of that explanatory text that we inscribe the
value 'depth'; depth is a function of the withholding of expla-
nation.

Reverie is the typical form of the Watteau literature, from
Gautier to René Huyghe, and even in writing that addresses
itself directly to the figurality of the Watteau image, sentences
with an ancestry in the rue de Doyenné almost invariably
appear. By reverie one should understand not simply a mental
state but a linguistic activity with distinct and analysable fea-
tures. The Goncourts show this activity in its purest form; let
us return to our quotation.

... a smiling Arcady, a tender Decameron, a sentimental meditation,
a dreamily distracted courtship; words that soothe the spirit, a
Platonic gallantry, a leisure given over to things of the heart, a
youthful indolence. [68]

As with Imagist verse, those linguistic features which
language cannot easily share with the image are underplayed,
particularly the verb, for the image, being static and outside
process, has nothing that resembles it; and syntax, with its
unique and untransposable articulations. [69] Instead of connec-
tives that come from the logic of syntax, and represent a
domain separate from the image, the dominant connectives in
the Goncourt sentence are asyntactic and appositional, not
smooth links but fragmented juxtapositions. The brevity of
phrase is the index of an immersion of language in the image
by which language tries to shed the features peculiar to itself.
In the place of a complex period that might arc away from the
image into an autonomous and equipotent linguistic province,
short and broken outbursts work to 'adhere' words to the
image as far as is compatible with the rules of grammar.
Display of the independent resources of language would estab-
lish two separate realms: on the one hand the image, and on the
other text; between them incommensurability and interval.
Here, all the effort of the sentence lies in reducing that interval
to a minimum, so that text can seek a utopian extreme where it
becomes the image in another form; less the image plus text, as
in classical art-commentary or *ekphrasis*, than the image as text,
the text reincarnated as discourse.

Although from a purist viewpoint the Watteau myth is
an accidental misfortune visited upon innocent work, its

underlying format is apt – an accurate reflection of the Watteau sign. Where LeBrun produces images consumed by discourse – the figural and the discursive exactly fitting each other – Watteau's strategy is to release enough discourse for the viewer to begin to verbalise the image, but not enough in quantity or in specificity for the image to be exhausted. Instead of setting up in competition against the image, text seeks an identity with the image. LeBrun's discursive form is the catechistic question and answer, 'Why are the eyes raised towards the forehead?: Because that signifies ecstasy'; Watteau's form is the *koan* – the question without closure. With LeBrun discourse stands to the image in a relation of power: it tells the eye where to look, what to find, and not to linger. With Watteau, discourse provides a way of triggering a powerful subjective reaction in the viewer – he hears unplayed music, imagines a consumptive body at the moment of seeing only healthy ones, describes the absence of explicit meaning as 'melancholy' and 'depth', and tries to fill the semantic vacuum set up by the painting with an inrush of verbal reverie. If there is a mistake in the Watteau literature, it lies in not suspecting that the heightened verbal reaction has in fact been *required*. When we examine Watteau's discursive strategy,

25 Claude Gillot, *Scene of the Two Carriages*

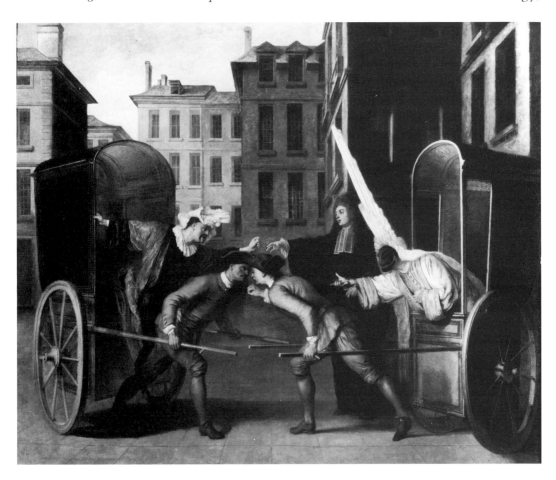

we find that this wayward and seemingly irrelevant genre of writing is exactly apposite.

In Watteau's master, Gillot, we find a late variant on the LeBrun pattern: the *Scene of the Two Carriages* (illustration 25) exactly corresponds to a text, in this case a pantomime first performed by the Italian players in 1695. The image claims to be nothing more than illustration and can be fully explained by consulting the theatrical script: it lacks the resonance of excess. Placed beside it, Watteau's painting of *Les Comédiens Français* is sheer enigma (illustration 26). When we consult the script of the play the scene supposedly illustrates – Molière's *Le Dépit Amoureux* – little correspondence is discovered; the painting blurs and elides together dramatically separate and indeed incompatible moments of the play.[70] The meaning of the scene, even when we are familiar with the Molière, remains uncertain: the painting both demands and disappoints our reading. And if we do not know the Molière, we cannot even decide whether the scene is from tragedy or comedy. The woman weeping at the left seems tragic enough – but the Weeping Woman is also a stock character from period comedy. The 'heroine' who raises her right arm in extravagant gesture may be acting a tragedy, but equally well she may be

26 Antoine Watteau, *Les Comédiens Français*

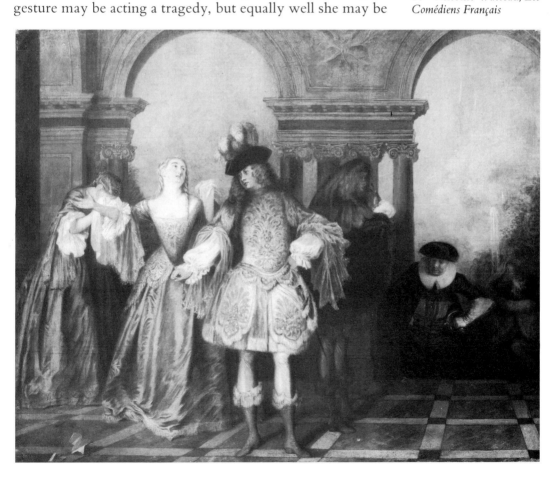

an actress parodying tragedy; nor can we be sure, if parody is involved, whether it comes from the actress's own performance, or from Watteau's caricature of a performance meant as straight tragedy. The cavalier seems, in his oversumptuous costume, to be part of an obscure satire; but the costume is also, in certain details, beautiful, and its beauty partly justifies the painting. To record so faithfully, and with such delicacy, the exact folds of material and its transitions of colour is not easily compatible with the intention to make the costume seem funny (for instance, so as to send up French stage conventions and to promote Italian ones). The gentleman behind the cavalier turns away from us and his hand-gesture is unclear; such rotation from the viewer is a favourite de-stabilising device with Watteau, and in this case it serves to obscure from us whether he is comically quizzing the figure who enters from the stairs – and how is this compatible with the woman who weeps? – or whether he is concealing a state of extreme emotion. The entering figure raises unanswerable dramatic questions: will he bring a solution to the problem resulting from the letter (bottom left)? It seems quite possible: his left arm signals assurance and executive competence. Or is he responsible for the problem? His hat, both comic and sinister, signals 'intriguer'.

In this early work, Watteau is already insisting that we read: hence the theatrical space, where bodies at once become signalling systems; and in this he is close to Gillot, whose scenes from drama and in particular from the Italian Comedy always refer us to the reading conventions of the stage (illustration 27). But whereas Gillot remains close to the original spectacle, Watteau insists on departure, partly through the scrambling of

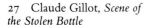

27 Claude Gillot, *Scene of the Stolen Bottle*

the original text, and partly through the uneasy relation he introduces between the theatrical frame and the frame of the picture. For this there is no counterpart in his master. A theatre frame makes everything inside it semantic, from gesture to coiffure to spatial disposition; the picture-frame does not normally do this, but when the two are so closely interrelated as here – the stage backdrop, with its fountain, trees, and sky, explicitly puns on the background of a painting – we cannot be sure which frame-system to follow: the always semantic theatre-frame, or the semantically neutral picture-frame. If the pun means 'painting is like theatre', it encourages us to find within the picture-frame all the meaningfulness we find on stage – only to disappoint us; if the pun means 'painting is unlike theatre, despite the superficial resemblance', it asks us to suspend our expectation of meaningfulness from the image – but with so much enigma around, such suspension is almost impossible to achieve.

The customary companion-piece to *Les Comédiens Français* is *Les Comédiens Italiens* (illustration 28); and one can see why the Italian theatre is so central to Watteau's work. Unlike the French drama, it does not accord pride of place to the script. Its

28 Antoine Watteau, *Les Comédiens Italiens*

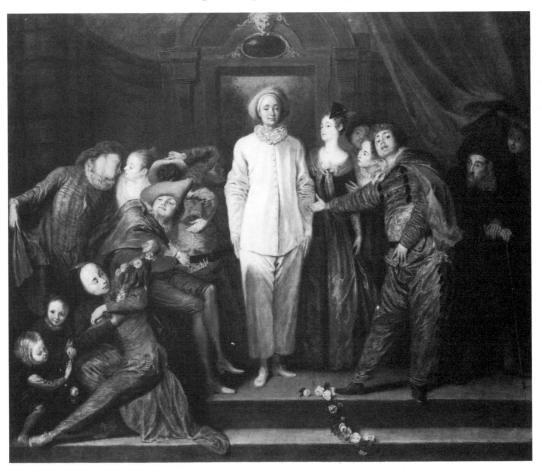

characters are fixed – Pantalone the merchant; his friend the Doctor; Isabella and Orazio, the noble lovers; Arlecchino the servant, Scapino or Mezzetino the musician, Pedrolino the comic butt. But the situations and dialogue are fluid and unpredictable, with much stress on improvisation. [71] French drama in Watteau's eyes is word-bound, like the art of LeBrun (it is possible that *Les Comédiens Français* also satirises the art of Versailles). In the acting codes of the French classical theatre, bodily movement is always the servant of speech: 'In the theatre, before breaking the silence, one should prepare one's speech by some gesture, and the beginning of this gesture must always precede the speech by a longer or a shorter time, according to the circumstances'; [72] 'the gesture on stage must always precede the word'. [73] Gesture functions only as herald of the *récit*, announcing its arrival, accompanying it with movements of only supportive function, and marking its closure with a flourish.

Although there had been a tradition that in antiquity the actor could mime whole narratives, and this tradition was revived during the baroque period, the claim for the totally legible, pantomimic body was taken up not by French baroque theatre but by its dance-forms, in the balletic theory of Menestrier and de Pure. Theatre remained bound to the body not of dancer or mime but of *rhetor*, and in the acting-manuals the anatomy of the actor is the same as that of the orator in Pliny and Quintilian. [74] He is to stand with one leg slightly forward, in the classical posture of *eloquentia*; his hands should register that he is speaking, and the position for this is prescribed – 'index and little fingers separated from their neighbours and slightly curved, with the two middle fingers set together and rather more curved', [75] as we see in the Jelgerhuis sketch (illustration 29). Hands should follow an arc perpendicular to the torso, except when stressing a point or a line, when the arm may rise and the index finger point upwards, though even then the range of movement is severely restricted. [76] Eyebrows may move, but not the head itself, and there is to be no reliance on stage-properties. The Italian Comedy breaks with this tradition. Its acting is less verbal and script-dominated and far more closely bound to somatic character-typing, and to physical exertion; whoever plays Arlecchino needs the stamina of an acrobat. Each of the stock characters has its specialised physique – Gilles or Pedrolino is rigid, his arms flat by his sides, his head never turning; the Doctor is hunched, enfeebled and arthritic; Arlecchino is always poised in the air, his feet never flat with the stage, but always pointed at the toe. Already these rules dislodge the supremacy of the script. And the Italian Comedy is also topical, cultivating an atmosphere of satire and claiming the right to touch on the issues of the day:

the main Italian company was expelled from France in 1697,
for too overt references to Madame de Maintenon, in a play
called *La Fausse Prude*. [77] Its humour is broad and centred on the
ignoble, creatural body, not transcending that body into the
logos in the manner of Racine. And pushing further this central
tendency within Italian Comedy to demote discourse, Wat-
teau breaks with the Gillot precedent of illustrating scenes
from plays, and selects instead, in *Les Comédiens Italiens*, the
moment when discourse ends: the curtain call.

Watteau hugely exploits the ambiguous space around the
curtain. In performance, the curtain divides the theatre into
two distinct zones: in front of the curtain, audience, life, the
absence of coded meaning; behind it, stage, art, the arena of
meaningfulness. But when the performance ends, the division
between the zones breaks down; and during the curtain call it
is impossible to decide whether we are still seeing the bodies
of characters from the drama, or the asemantic bodies of
actors out of role. Expanded, the ambiguous space around
the curtain becomes that of the *fête champêtre*, where the
point is that we cannot tell whether the men and women

29 Johannes Jelgerhuis,
Diagram of the histrionic body

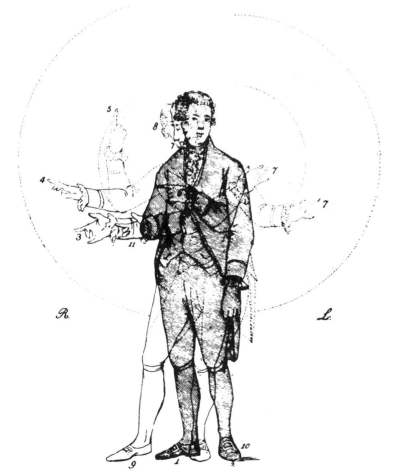

are actors still in costume but no longer in performance, or ordinary people in masquerade. In the *Concert* at Berlin, the landscape is both the non-semantic, unframed space of a park; and a backdrop, the very substance of the theatrical frame, which turns the sub-legible bodies of persons into the hyper-legible bodies of players (illustration 30). The foreground shows a group that is at the same time fully theatrical (in costume, and their instruments are those of professional performance) and non-theatrical (no performance is taking place). Watteau's transitions are meticulous: the distant group on the right is clearly within a painting, though the handling is close enough to that of the main group on the left to make us uncertain; the sylvan bust similarly belongs to both worlds; the floor is ambiguously flagstone and stage-boarding; while in the most daring area of the canvas, where a girl is seen against a cello, Watteau risks the astonishing effect of painting the instrument in a high-finish, 'Dutch' manner, with invisible brushwork and emphasised texture and reflection, while the figure of the girl is painted in broad, dry strokes that by contrast with the instrument seem elliptical, as though a painting of the girl stood next to a real cello (some of this effect is unfortunately lost in reproduction).

The result of this stage/life ambiguity is both to coax and to

30 Antoine Watteau,
Concert

disappoint the interpretative glance, a double movement
further developed in the magnificent *Meeting in a Park* (illustra-
tion 31). Whereas in LeBrun's battle scenes, the figures tended
to turn towards the spectator and to display with exaggerated
visibility their legible surfaces, here more than half the total
number of figures emphatically turn their backs – perhaps
Watteau's strongest 'illegibilising' device. The situation is still
presented as a narrative one, and the couple on the right are
signalling to us and to each other with extreme explicitness;
which not only sets in motion our voyeuristic curiosity, but
establishes that explicit and legible gestures are attainable in
this world. When legibility is elsewhere unforthcoming, we
know that we are being refused information.

Watteau's bodies are, in effect, the opposite of LeBrun's:
they tell us nothing. The face is hidden, whether by half-mask,
as with the woman who resists her suitor's advances, or by
rotation away from the viewer, or by painting the faces so
small on canvas that the markers of expression are omitted.
Emphasis descends from the all-important pineal zone of
LeBrun to the body, which is emphatically costumed, but only
with costumes that resist clear reading. Normally, clothing
emits signals that tell us how to 'read' the wearer according to
the code of fashion; often we relocate, by superimposition, the 31 Antoine Watteau,
meanings found in the clothes on the person of the wearer (a *Meeting in a Park*

quite habitual procedure in reading portraits). Yet Watteau's figures are not wearing their customary social clothing, but theatrical disguise, and though the disguises emit clear messages, we cannot then re-attach the messages to the bearer. In masquerade, the pleasure comes precisely from rejoining the message of the costume to the person beneath the disguise: here the messages fit, there they do not. But in a Watteau masquerade, only the participants can do this – all we have is one side of the equation. With LeBrun, eyes and eyebrows carry, as we know, a vital semantic function, and like the pineal act as the privileged place where flesh transubstantiates into discourse. In Watteau, where we can see this zone at all, the eyes and eyebrows are as we would expect: indefinite – Caylus censured Watteau for impoverishment of expression,[78] and in the Roger de Piles system his score would probably be quite low.

The characteristic Watteau long-shot itself works against facial emphasis – the faces are simply too small for us to follow their expressions – and probably this is the reason the long-shot is so often used. But from another point of view, Watteau is a master of the repertoire of gestures of *attention*. We may not be able to read the faces, but we see very clearly the exact inclination and mutual tilt of the heads: in this respect Watteau's only rival is Degas. Interest in recording with absolute precision the angle of the head is responsible for many of the simplifications and exaggerations he introduces into physiognomy, for 'tilting' can only be clearly established by emphasising certain details, notably the lines of the eyebrows and eyelids, the ears, and the hairline; it is also aided by defining the nose as a line ending in a point – all the 'triangulations' Watteau typically stresses (illustration 32).

Having established 'attention' as the most important, and almost the only available, emotion, Watteau exploits it by mobilising to the full its theatrical potential. 'In calm discourse, the words and gestures are nearly contemporaneous; and in high passion, the order is 1. the eyes; 2. the countenance in general; 3. the gestures; 4. language.'[79] The author of the manual from which this is taken also comments that 'when listening attentively to an interlocutor, Iffland [the great German actor] makes a point of not standing directly opposite a speaker and looking fully into his face. For very true is the remark of the French producers: to listen facing a speaker shows stupidity rather than attention.'[80] That is, the gaze from one actor to another is in general to be avoided, and reserved only for heightened scenes. In Watteau, the eyes behave as though in this theatrical representation of 'high passion' – an extreme case is the three-sided gaze of the Mezzetin, the Turk, and the female dancer in the *Fêtes vénitiennes*. But the body

does not support this 'passion' – on the contrary, a stately dance is in progress, and the Mezzetin seems preoccupied with his music-making. What emerges is a disparity between the non-signalling bodies, engaged in their physical activity, and the eyes which, within the theatrical convention, signify intense feeling through their attentive inter-crossing. The two sets of signals are contradictory, and to reconcile their opposition the viewer creates an array of meanings which are not themselves directly represented – restraint, extreme depth of emotion, tact, respect for the privacy of the other, introversion.

A whole psychological text pours into the interval between the passionate eyes and unimpassioned bodies, which in their linking of 'interpretation required' with 'information held back' typify Watteau's discursive strategy. No actual *marks*

32 Antoine Watteau, *Studies of a female head*

correspond to 'restraint', 'tact', and the rest, in the way that
with LeBrun 'admiration' or 'scorn' can be tied down to the
precise and visible signifier. The allusions to theatre force us to
read, and whether the figures are actors who have been trans-
ported from the stage into the park, or whether they are
non-actors masquerading in the costumes of the theatre, we
cannot avoid interpreting gesture, posture, and expression as
we would if we were watching a play. But the unreadable
bodies, turning their backs on us or huddling so close together
that we cannot quite see their expressions, refuse to yield the
meanings that a stage performance would supply. Hence the
repeated ploy of so linking two figures that they seem a single
compositional unit – and it is almost Watteau's only unit: the
compositional management of more than two or at the most
three figures can cause him endless difficulty.[81] This reciprocal
blending of two figures into one is a Watteau speciality, one of
the virtuoso feats Watteau's copyists can never quite carry off;
Watteau's proficiency is so great that even when we know
from sketches that two figures were conceived in isolation,
when coupled together it seems that they must have been this
way from the beginning.[82] But the resulting impression is one
of impenetrable intimacy: given such focussed attention, the
figures in the couple must be interpreting each other perfectly,
but the information they have about each other is not shared
by the viewer.

Denied the information available to the figures, but still
asked by the image to go on interpreting, the viewer pursues
the only option left open to him – reverie. The image sets in
motion a boundless semantic expansion, a kind of centrifugal
rippling of meaning that knows no boundary. The Watteau
image, unlike the image in LeBrun, is entirely open – no
scenario or exegesis could ever satisfy our discursive hunger –
and reverie is a form of thought, and of language, which
respects this infinity of possible implications; a machine for the
infinite expansion of the signified.

It is almost impossible to resist Watteau's call to interpret. In
the *Meeting in a Park*, there is a clear parallelism between the
two women who turn their backs, one accompanied and able if
she chose to turn towards the group, the other alone and facing
a void. As with Eisenstein's 'third sense', the juxtaposition
alone – and not any visible mark – starts to generate meaning
and to involve the viewer in elaborate textual commentary. An
attempt is being conducted, by a small group of highly civil-
ised people, to take the greedy, raw material of eros and
transform it into a principle of social harmony; the attempt
may succeed – the primitive advance and recoil of the couple
on the right are eventually fulfilled in the fruitful intimacy of
the couple on the left; but the attempt may also fail, and if it

does the individual is thrown back into a deep solitude, as with
the distant female near the lake. But the possible pain of such
solitude is balanced by an independence and a self-sufficiency
that the other figures lack; it may, besides, be only temporary –
the solitary female is not permanently disbarred from the
erotic game, or banished from the group – her decision to
secede is her own, and it has been respected by the others. The
remote figure has before her a panorama, and in this she is like
the viewer, who also sees panoramically, and is alone: the
viewer and the distant girl communicate through an empathy
that bypasses the social–erotic society of the foreground. The
shared loneliness allows to each a consoling awareness of
lyricism. The ability to provoke an intricate reaction such as
this is not the only way the *Meeting in a Park* behaves like a text.
By juxtaposing those three areas of the painting – the flirting
couple, just beginning to separate from the gregarious society
into the unit of the couple; the intimate couple; and the distant
solitary woman – Watteau hints that his three subjects may be
three stages in the development of a single relationship, a
successive progress of love viewed in the simultaneous time of
the image, like a strip-cartoon (at a sublime level). An interest-
ing precedent here is Poussin: the *Israelites Gathering Manna in
the Desert* similarly juxtaposes within the same image scenes of
misery from the time before the manna was found, with scenes
of youthful enthusiasm and elderly hesitation from the time
after its discovery by the Israelites.[83] This temporal dislocation
was in fact a source of criticism at the 1667 debate on the
painting at the Académie, and LeBrun produced a characteris-
tically pro-discursive defence:

The historian communicates by an arrangement of words, by a
succession of discourse which builds up the image of what he has to
say, and he is free to represent events in any order he likes. The
painter, having only an instant for his communication . . . sometimes
finds it necessary also to unite several incidents from different times,
to render his scene intelligible.[84]

In the same debate another speaker, who is perhaps Félibien,
adds the final pro-textual touch: 'The laws of theatre permit
the dramatist to unite several events from different times into a
single action . . . the diverse actions are episodes contributing
to what is called *peripateia*'; and he claims that painting is free to
take a similar latitude with the sequence.[85] Poussin is the only
painter before Watteau to have risked undermining the tem-
poral *vraisemblance* of a scene, in order to maximise its discur-
sive possibilities – even LeBrun in *The Queens of Persia* chooses
a moment when all the expressions he is so eager to record can
occur simultaneously without imperilling the realism. The
higher unity which holds Poussin's *Manna* together is discur-
sive – the Biblical text, and his loyalty to that text is stronger

than his loyalty to independent demands of the image. This higher discursive unity similarly holds together those works by Watteau where we seem to be witnessing not one event, but a succession of events collapsed into a single image.

The *Meeting in a Park*, where the distant woman and the woman in the intimate couple seem to resolve, like the pageboys in LeBrun's equestrian portrait of Chancellor Séguier, into a single figure, is a fairly extreme example, but the principle is also present in the *Pilgrimage to Cythera* (illustration 23), which collapses a 'before' into an 'after' – the beginning of the day of love, as the pilgrims make their way to the island, and the end of the day of love, as they prepare to leave. [86] Although Watteau is unlikely to have taken the principle either from Poussin or from LeBrun's Discourses, the miraculous ease with which the *Pilgrimage* was accepted by the Académie may to some extent be due to its invocation of high discursive principle, a loyalty to text over image, which harmonised with the doctrines of the ancient Académie; it would have appealed to the old guard, routed by the *rubénistes*, but still not without influence. But a more congenial precedent is Rubens himself, who in the *Garden of Love* (illustration 33) shows a couple entering the painting from the left, pushed into it by a forceful cupid, and seemingly at the beginning of their courtship; and a

33 Rubens, *Garden of Love*

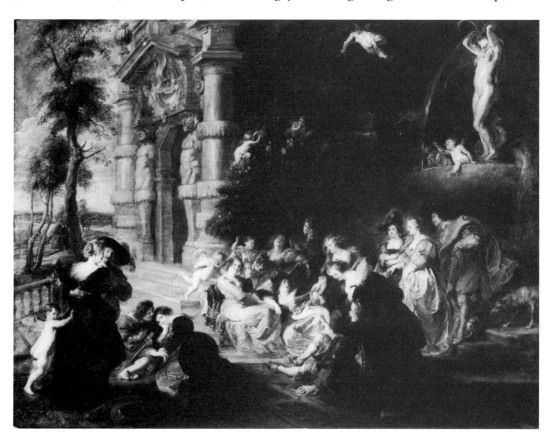

second couple descending the steps on the right, who are at a
later stage of love. The detail which is especially close to
Watteau is that in each case, the cavalier is wearing the same
kind of hat. But in the juxtaposition of the two female backs in
the *Meeting in a Park*, Watteau goes much further than Rubens
towards stating that his different groups represent phases in
the progress of love-relationships; and the implications – that
love decays before its time, that desire produces melancholy –
are of course quite alien to Rubens' 'robust' optimism. If the
cavaliers in Rubens' garden are interchangeable, it is because
love is not as individuated there as Watteau believes it can be –
and for Watteau, interchangeability marks a failure of the
personalisation of love, and of the project of its conversion
from crude biological drive into social harmony.

The equation of the accompanied female with the solitary
one in the *Meeting in a Park* sets up a whole range of meanings
which, to repeat, are nowhere explicit: the solo figure,
although isolated, is *full*, consoled by her independence, and
this complicates the basic recommendation that sexual drive
be socially integrated, since if the individual who secedes from
that project of transformation is nonetheless complete, then
eros so far from representing increase represents only desire
and lack, an attack on the integrity of the individual who may
also, if he or she so chooses, altogether withdraw from the
social–erotic game. Another implication is that the accom-
panied woman may seem to be at a summit of personal
fulfilment, but – given the 'blindness' of the crude sexual drive
– her happiness may not be as individual or as delicate as her
posture and her reticence suggest. And a further implication is
that love is not only blind – the 'crude' suitor cannot clearly see
his female's features – but fearful, another meaning of the
female's half-mask, as though the desired female were reluc-
tant to reveal her personal uniqueness in a context where the
male seems indifferent to personality.

Part of the brilliance of Watteau lies in the willingness he
induces in the viewer, to go on with a work of interpretation
that is so little substantiated by 'visible marks', and so uncer-
tain of ever arriving at a point where interpretation will have
exhausted the meaning of the image. With LeBrun, the one-
to-one correspondence of signifier with signified in effect
limited the discursive yield; *The Queens of Persia* contains a
great deal of hidden textuality, but though extensive the tex-
tual component is nevertheless quite finite, with a definite
boundary beyond which there is little or no excess. Watteau
manages to destroy that perimeter precisely by breaking with
the pattern of one-to-one correspondence; the implications of
his paintings are interminable because no longer anchored in
the precise visual signifier. From this point of view, Watteau

marks the climax of the colonisation of the image by discourse begun by LeBrun, and a refinement of its prose into poetry. Since his work effaces all the customary markers that in LeBrun required a labour of interpretation that *knew* it was interpretation, language rushes into the Watteau image as though into a semantic vacuum, taking it by surprise because the image did not seem patently to ask for interpretation at all. The inrush of language can seize the image in an embrace all the more forceful because apparently unsolicited, and in the writing of the Goncourts in particular language shows no awareness at all of the otherness of the image, but seeks instead to absorb it into itself by a process of interfusion. Yet the effacement of the patent signifier also marks the demise of LeBrun's project, because Watteau sunders the link between signifier and signified which formed its basic sign-strategy. The meanings in Watteau, having no signifier to pin them down, are experienced *mysteriously*, as moods, or atmospheres. The literary form of the reverie, which tries to articulate these vague and haunting emanations, always seems to its producers to be creative and never descriptive – 'all their own work', and at times a kind of self-display that uses Watteau as little more than pretext. The tragedy is that for every page of the Watteau literature, one finds perhaps a line on the paintings themselves. Even quite rudimentary figural questions, such as the means by which Watteau transforms the precedent of Rubens to suit his scale and his personal subject-matter, remain neglected.[87] Watteau is preferred as a Pirandellesque *metteur-en-scène* or as a Symbolist poet, and his work in *paint* is consistently over-shadowed by his subtle discursivity. In the next phase of its development, French painting will learn how to assert more strongly the independent claim of the figural image.

4 *Transformations in rococo space*

BEFORE WE CAN begin to describe the revolutionary modification of discursive and figural relations that occurs during the period we associate with the word 'rococo', a modest hygienic assault must first be conducted on two widespread and authoritatively reinforced beliefs about space in European painting. The first is a prejudice 'of the right' – that perspectival space is objectively superior to other systems of spatial representation and marks an irreversible advance towards the ancient dream of the Essential Copy – the grapes of Zeuxis. The second is a prejudice 'of the left' and concerns a mythical continuity: that 'Quattrocento' space reigns unchallenged from Giotto until Cézanne.

The first has been, however inadequately, questioned in the opening chapter, where the function of perspective was analysed as rhetorical: a means of persuading us that the image is an innocent representation of the real by introducing through the 'laws' of perspective a permanent threshold of the gratuitous. Because it is not essential for the communication of the narrative of the *Flagellation* that we know the exact spatial location of the participants and witnesses, all the information concerning their spatial disposition reaches the viewer as neutral and innocent addition, supplementary to the information we need for the narrative itself. Its uselessness, its refusal to be picked up by a paradigmatic scanning induces the effect of the real, which is always enhanced by expansion along the syntagmatic axis.[1] The case need not be further elaborated here, since actually more detrimental to the understanding of the historical development of the image than a continued belief in the objective superiority of perspective is the other prejudice: that it is not until a certain moment in the second half of the nineteenth century, or during the early years of the twentieth century, that painting begins to abandon its 'realist' space. It is a belief so ubiquitous, so much part of our accepted ideology of modernism, that it seems almost inappropriate to name those who express it. 'Spaces are born and die like societies; they live, they have a history. In the fifteenth century, the human societies of Western Europe organised, in the material and intellectual senses of the term, a space completely different from that of the preceding generations; with their technical superiority, they progressively imposed that space over the planet.'[2]

It is Francastel who 'speaks', but what is really speaking is *endoxa*, the body of discourse which establishes itself so powerfully that it seems without origin. If Alberti or Giotto or Brunelleschi form the beginning, modernism marks the end: 'Roughly speaking the history of painting *from Manet through Synthetic Cubism and Matisse* may be characterised in terms of the gradual withdrawal of painting from the task of representing reality ... in favour of an increasing preoccupation with the problems intrinsic to painting itself';[3] 'Ever so many factors thought to be essential to the making and experiencing of art have been shown not to be so by the fact that *Modernist art* has been able to dispense with them and yet to continue to provide the experience of art in all its essentials';[4] 'The aesthetic revolution brought to a head *just after the turn of the century by Picasso and Braque* thoroughly exploded the notion of the reproduction of reality as an aim for art'[5] (my italics). Names and dates may change, but the underlying belief is that, 'For five centuries men and women exist at ease in that space; the Quattrocento system provides a practical representation of the world which in time appears so natural as to offer its real representation, the immediate translation of reality itself.'[6]

What is to be challenged is the belief in a single revolution whereby a space installed in the Quattrocento is dislodged by modernism at a stroke; that it is only with a Cézanne or a Matisse that there is 'preoccupation with problems intrinsic to painting itself'. Alberti and Cézanne are, to be sure, very dramatic instances of spatial change, but it is clearly absurd to suppose that awareness of the flatness of the canvas is not at the very heart of Poussin, or that Vermeer is uninterested in 'problems intrinsic to painting', or that the space of Ingres is still Quattrocento. It is revealing that the place where the *endoxa* is most firmly installed is in screen criticism. Resemblances between the camera and the Albertian eye are striking; Leonardo's drawing (illustration 34) of the perspectival eye has looked to certain cinéastes very much like a man gazing at the cinema screen; the introduction of the easel resembles use of

34 After Leonardo, *Diagram of monocular perspective*

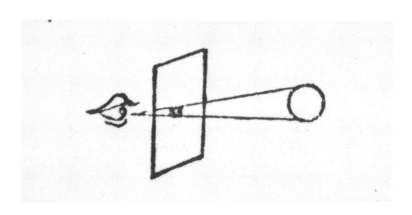

the tripod, the development of the frame as an entity separate from an architectural setting anticipates and perhaps permits the frame of the cinematic image.[7] But although the codes of cinematic representation must certainly be understood as having a precise history and pre-history, and work towards comprehension of the codes of the screen as socio-historically constructed is of vital importance in a culture where cinema is far more centrally placed than painting, nonetheless it is a high price to pay for the development of screen criticism, if painting is supposed to be static 'from the Quattrocento on'.[8] The response of art history to this challenge ought, also, to be taken up: if ideas of space are not static in Western painting, how do they change? This is not perhaps the place to institute such an enquiry, which if it were to be realised might well serve greatly to subvert the traditional account of painting's evolution. The remarks on space here concern only a tiny fraction of a history which, within French painting, would have to accord to Gros, to Ingres and to Delacroix the status of a separate, non-modernist revolution in spatial construction. Yet while it is clear that, for example, Ingres is both pre-eminently occupied with problems intrinsic to painting, and mounting a direct attack on the Albertian conventions, what is less obvious is that rococo is also a break with those conventions. Its space is radically unlike the space of LeBrun or Watteau – and it is through its newly developed space that the claim for the independent power of the signifier is most clearly asserted.

To understand the space of French rococo painting it is essential to realise the extent of its erotic focus. The erotic body is not a place of meanings and the erotic gaze does not attend to signification; on the contrary, within the sexuality of rococo painting, the image can speak to desire so directly precisely because it is no longer distracted or exhausted by signalling work. No eros in LeBrun: the fleshly body has another body placed inside it, a histrionic subtle body whose sole reason for existence is the transmission of discourse. The actual flesh in which the dramatic body is housed is of no independent interest, and in LeBrun's indifference towards flesh-tones one sees the puritanism inherent in his version of the discursive image.[9] How magical the bodies of Rubens must have seemed, after the fall of LeBrun! The erotic emerges with Watteau in proportion as this superimposed narrative body is removed: its removal is essential, because through narrative the image had been effectively decarnalised, and the zone of maximum priority, the pineal area of forehead, eyebrows, eyes, nose which Watteau effaces had assumed the status of target because it had been there that human carnality could be transcended, transubstantiated into discourse. Watteau insists on a body

that infinitely suggests but never directly transmits meaning, and in his work the pineal zone is wiped out, whether by the distance of the long-shot which renders the zone too remote to be legible, or by turning the face away from the viewer, or by half-mask, or by rendering all facial expression uncertain through withdrawal from the body of those signals normally transmitted by clothing which, in the conventional reading of figures, are then re-read in the face itself. Watteau is already half way to the erotic body of Natoire, Boucher and Fragonard in this silencing of the body's customary speech.

There is another factor at work, which stems from an opposition of logos to eros that is perhaps peculiar to European classicism: love, within the opposition, is altogether outside the domain of language.[10] It is transmitted through the eye, as plastic presence and visual spectacle, never as *récit*; love may produce *récits* – one need think no further than *Phèdre* – but the work of the *récit* is resistance *against* the body and a taming or controlling of the body by and through speech. Although in Racine the narrative is often set in motion by an encounter of bodies that may be traumatic (*Je le vis, je rougis, je pâlis à sa vue*), sheer physicality would silence speech and end the drama.[11] Faithful to the Ionian conception of the stage as arena of language, offstage as arena of bodily event (death, murder, battle, but also eating, sleeping and all the creatural functions, which include the sexual ones), the Racinian body can only be dramatic as it resists its carnal destiny; sole exception in *Phèdre* being the heroine's use of the chair, which in its recognition of the existence of the creatural body is the mark of her failure to overcome that body, with its unbearable weight, and of the impossibility of transcending its gravity through speech. And these classical beliefs persist in rococo: the creatural body can only emerge, by the same classical opposition, as it destroys the counter-erotic eloquence, or garrulity.

For its erotic content to be fully yielded up, the body must be presented to the viewer as though uniquely made to gratify and to be consumed in the moment of the glance (illustration 35). All signs that the body has other purposes, another history, are to be suppressed; it cannot even have a setting of its own. The immediate result is the removal, within rococo painting, of the body from any space that might be construed as interference with the main aim of providing a setting for the spectacle. It cannot any longer reside in a reproduced spatiality of the world, but must be transported to another space that is as close as possible to that inhabited by the viewer. Now, for the viewer, the space that is uniquely his is the picture-plane. This is most evidently the case in those rococo works designed as panels to be inset into the walls of private apartments: the wall is an actual physical part of the viewer's surroundings and

in respecting a continuity between wall and painting, the erotic image can be brought into direct contact with the viewer's *Umwelt*. The 'Quattrocento' concept of 'window' would 'take the image away'.

'Perspective is nothing else than seeing a place or objects behind a pane of glass, quite transparent, on the surface of which the objects behind that glass are drawn';[12] and precisely because perspective means distance from the viewer, recession and separation, its existence is denied within rococo. As a fairly characteristic specimen, the Boucher *Venus and Vulcan* in the Wallace Collection (illustration 36): no architectural reference within the image challenges the architecture of the viewer with an independent claim; no straight perspective lines to locate the image in a space behind the wall, and indeed scant possibility of straight lines of any kind. Venus is not placed in a context which might set up in rivalry against the setting where the image is to be consumed. The space is filled, but not with substances that come from the world – hardly with substance at all. In Boucher a mysterious filler, which looks like cloud but behaves like cushioning, occupies the zone around the figures; if it is not cloud, it is water, as in *The Setting of the Sun*,

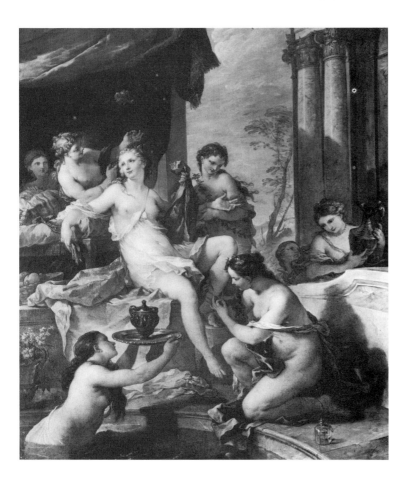

35 Charles Joseph Natoire, *Toilet of Psyche*

36 François Boucher,
Venus and Vulcan

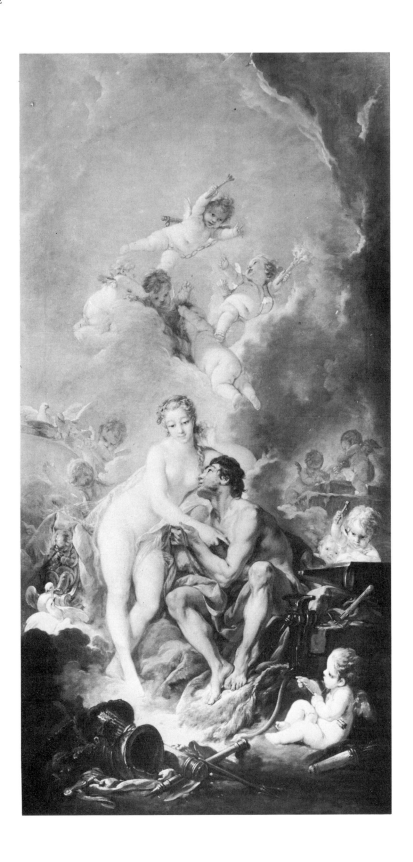

but again water that behaves as a solid (illustration 37). These substances have been invented primarily to impersonate a spatial setting, without risking the creation of a space that would threaten to exclude the spectator, for the aim of the image is appropriation by the viewer, with the least possible resistance.

Imagine a body, of whatever desirability, located in the tangibility and recession of perspective, with perspective lines running through flooring, windows, tables, chairs, anchoring the body in its own space outside the picture-plane; however erotic, the anchoring functions as erotic obstacle, for the image cannot be easily dislodged from its surrounding world and accepted by the viewer as though made solely for his possession. Such a body is engaged, busy, unavailable. Spatial dislocation in Boucher is the exact mark of sexual availability and in suppressing coherent space through the use of amorphous substances – cloud, water, tinted steam – which cannot be precisely located in space, the body is presented in the minimal form that the erotic gaze most desires: as, simply, posture.[13]

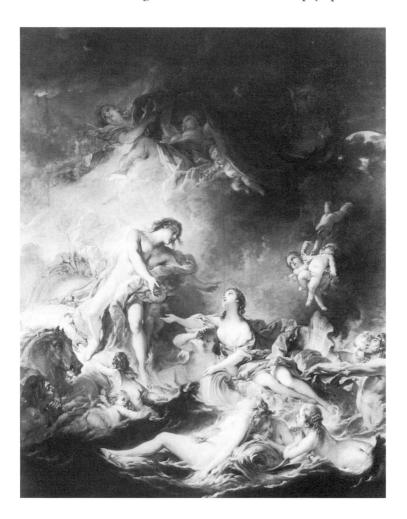

37 François Boucher, *The Setting of the Sun*

Even when rococo painting risks an external location, marks of spatial alterity are sedulously erased: there must be no horizon, and no vanishing point: recession in depth is exchanged for the planarity of backdrop – a technique Boucher assimilated without difficulty from Watteau, although Watteau's backdrops serve other functions. If there are trees, they must be all foliage – 'foliage' being precisely elimination of the spatial precision demanded by the articulation of leaf and branch; banks of formless greenery or giant parsley floating above concealed or non-existent trunks (the rococo avoidance of the base and shaft of trees is one of the more unsettling side-effects of its commitment to an elimination of coherent space).

The deconstruction of 'Quattrocento' space in Boucher, Lemoyne and Natoire is a function of an overall strategy of removal of information which does not harmonise with the aim of erotic or sensual contemplation. Once perspective is no longer approached as an instrument enabling the production of essential copies of the real, and is thought of instead as the supply of information that is permanently irrelevant or supplementary, one can see why its use is so much avoided in rococo painting. In Boucher, the threshold of irrelevance is high: the erotic image, which is concerned to present bodily postures and little more, does not want all that baggage of data describing exact location in a space from which the viewer is excluded. Its threshold, beyond which the data assume an ancillary role, does not at all coincide with the threshold of the Quattrocento image. There, the threshold is established on one side by narrative – where the text ends, the effect of the real begins; and on the other, by perspective. These are made, so far as is possible, to coincide – 'where text ends, space begins'. But in Boucher 'text' is minimal: never actions or events, but the positions of bodies; and this rudimentary requirement is soon exceeded.

There is a further concession which the rococo image makes to the space of the viewer: to eroticise the plane of the signifiers. This is already facilitated by the overall spatial illegibility, so that the image closes in on and is embraced by the viewer's own spatial zone. But it is also supported by a psychoanalytic consideration.

Within a 'heterosexual' optic where specialised functions are assigned to each sex, pleasure in looking is broken between active (= male) and passive (= female).[14] Thus in both *Venus and Mars surprised by Vulcan* (illustration 38) and *Venus and Vulcan* (illustration 36) the females lower their lids to conceal the eye, the males raise their pupils to reveal the eye. Semantically, the lowering returns to the female the meaning of 'modesty' which her general appearance enormously contradicts, to

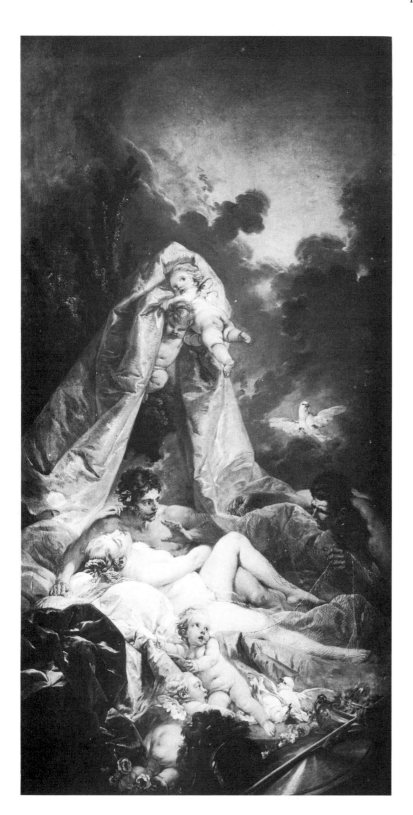

38 François Boucher,
*Venus and Mars surprised by
Vulcan*

a degree which threatens the gender-division whereby sexuality is thought to be with the male. But from another aspect it clearly announces the division of roles: Woman as Image, Man as Bearer of the Look. In Boucher the male is only admitted as visual adorer, his uplifted eyes coinciding neatly with the LeBrun root of 'ecstasy' (eyes raised towards the pineal); he is rarely allowed as object of adoration himself. Within this structure, the gaze of the male is phallic, and in this the male within the painting acts as surrogate for the male viewer, to whose sexuality the image is exclusively addressed. Perhaps the clearest instance of this is Fragonard's *Swing* (illustration 39): the viewer cannot from his angle of vision glimpse the area between the female's legs, and this gaze is passed to the transfixed male on the left. There might, indeed, be a risk of excluding the viewer too far from the scene, if the eyes of the painted male figure were clearly established as *competent*, absorbing fully the impact of what is seen and not simply the place of a relayed glance. If the visual area of the painted male were understood as fully potent, the desired glimpse could

39 Jean-Honoré Fragonard, *The Swing*

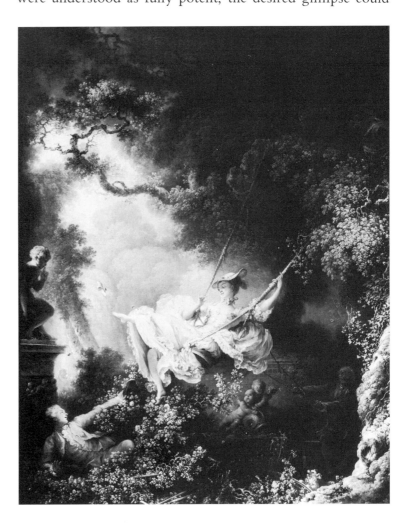

stay with him, and might not pass out to the spectator. To counteract this tendency, Fragonard reduces the eyes of both male and female to what is, in his work, a characteristic formula: little slots. [15] Because the spectator within the scene has such comically reduced visual apparatus, the glance of the viewer has no serious rival. But the emphasis on the look as phallic poses a problem, for the disrobed female signifies something the look continually disavows – explicit genitality, with its threat of 'distaste'; an end to the visual pleasure. The economy of the erotic image, within this division of labour, sets the male up as bearer of the look, but the look is probing for something which if found will unsettle the act of looking itself – it will no longer carry the visual pleasure of art. Yet the threat posed by the body of the female can be defused by disavowing actual genital difference through the substitution of a fetish object: in this case, the shoe which flies from the foot of the female towards the gazing male. [16] *The Swing* is only an extreme statement of the rococo tendency to find acceptable substitutes, and of course in this instance it fails, by deliberate comedy (the use of the comic also defuses the anxiety latent in the scene): the shoe is too obviously a displacement and the sign of disavowal; it is as inadequate for this task as it is, in the Fragonard, as a shoe (it is too small for the foot).

But there is an even more acceptable substitute object – the painterly trace; and by investing in the signifier some of the erotic charge of a signified which cannot be directly faced without threatening the viewer as bearer of the look, rococo completes the operative transformation of the sign begun by Watteau. Despite the enormous increase of implied signification we find in Watteau – his paintings seem to speak far more 'eloquently' than LeBrun – the emphasis on enigma, on the signified which is never disclosed, effectively splits the signified from the signifier and permits a new autonomy to the painterly trace which rococo, with its erotic ambition, acutely needs. Boucher, like Watteau, must keep certain signifieds at a safe distance: sexual difference, overt genitality, the displeasure of the look as it finds what it seeks – all those must be relegated to an area outside the image. In their place, the stroke of the brush 'in' the image, the material work of the signifying plane; in the absence of direct sexuality, this takes over as displacement the excess of libidinous energy. Given this emphasis, it is vital that the space of the painting refer to the signifying plane and not open out into another scene behind it. With 'Quattrocento' space, plenty of scope for the development of the window as theme: the Ghirlandaio *Old Man with Child* in the Louvre, the Titian *Isabella of Portugal*, the Dürer *Self-Portrait* in the Prado, are all obvious cases of a fascination with the idea of the painting as pane of glass giving on to a

scene outside, behind the plane of the signifiers. But with rococo, a whole code of social and psychological censorship forbids the idea of the displayed body as 'really' existing behind the signifiers (perhaps not until Manet's *Olympia* does this autonomous existence of the displayed female become fully possible). In the enforced absence of that autonomy, as of the sexual facts, the rococo image constantly euphemises and the plane of signifiers clouds over, acquiring an opacity in which it is the stroke of the brush on canvas which carries the sexual *frisson*.

This characteristic insistence upon adjustment of the image to the picture plane, so visible in the erotic rococo image, carries over to other genres where we would less expect to find it. Even portraiture is affected, and in a forgotten climax of the rococo portrait – Hyacinthe Rigaud's *Gaspard de Gueidan en Joueur de Musette*, at Aix-en-Provence (illustration 40) – one of the most breathtaking paintings of the French eighteenth cen-

40 Hyacinthe Rigaud, *Gaspard de Gueidan en Joueur de Musette*

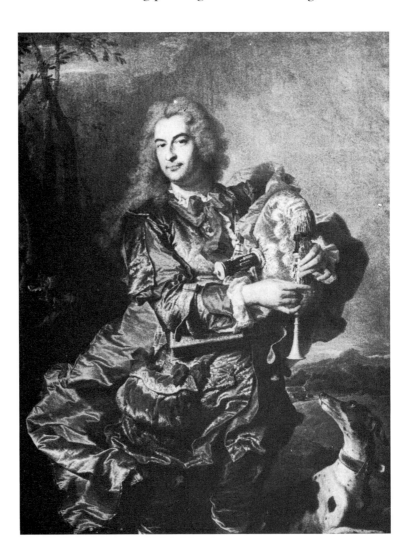

tury, and for me one of the four or five radically undervalued masterworks of France – we can see how older artists tried to adjust their technique to the new planarity. Rigaud is probably best known outside France for his state portrait of Louis XIV, which in its sombre opulence and authoritative distance seems to belong exclusively to the period of LeBrun. In the 1720s Rigaud's art is an anachronism; yet from another point of view the peculiar features which distinguish Rigaud's portraiture had always been anachronistic: the carved, unyielding but highly dynamic drapery looks back to Italy and to statuary – to Bernini, not to the new discursive painting of LeBrun, where drapery as a priority is rather low on the scale. Rigaud's idiosyncratic use of such drapery persists throughout his career, and accompanying it is a distinctive compositional technique for balancing the head in relation to the hands, which in its extreme stability and endless variability suggests a formula on which Rigaud could always rely: the head and hands are linked in triangular immobility, but the drapery is charged and unstable, and the tension between immobility and instability is the feature Rigaud exploits to the full.

Yet despite his public hostility to Boucher, in the final phase of his career Rigaud gives the formula a new rococo twist. Instead of a drapery made of sombre materials which are secondary to the stable hands, it now grows brilliant; and instead of inhabiting the space defined within the painting by the body, it seeks to escape outwards and to meet the picture-plane. The folds of brocade and satin turn towards the viewer with no concessions to naturalism; the material displays itself, like the Boucher nude, for exclusive contemplation from the spectator's point of view, and a direct transfer takes place whereby the richness of the fabric is shifted on to the surface paint, and the picture-plane becomes the place where opulence of fabric can be better displayed than in the virtual depth of the space behind it. And there is a final modification, which helps to render this work far more accessible to twentieth-century taste, where flatness is almost an intrinsic value, than for example the Rigaud portrait of *Antoine Pâris* (illustration 41). Because the figure of Gaspard de Gueidan is out of doors, the increase of light reveals the folds of fabric far more explicitly than had been possible in the dark interior setting of *Antoine Pâris*; and because we can now see the folds themselves in individual outline, where before outlines had been hidden in darkness, Rigaud's fascination with the abstract geometry of his electric fabrics – a fascination the twentieth-century viewer can easily share – becomes acutely felt. It is a geometry that exists in a peculiar space, neither absolutely two-dimensional nor absolutely three-dimensional, but 'something in between'. The clothing, of course, technically belongs to the deep space

of the figure, and the setting has the added spatial depth that comes from a rural *mise-en-scène*; but, partly helped by a suspicion that the *al fresco* setting is artificial – not quite a backdrop, but tending in that direction – the viewer begins to mistrust the illusion of depth; while the fabric, especially those lengths behind the sitter and beyond his range of vision, behaves unnaturally and tries, 'behind the figure's back', to fold against the spectating plane. The result is an image in two spatial worlds, where virtual depth and canvas planarity fuse in a manner that looks forward to the ambiguous space of the portraiture of Ingres.

Yet the portrait of *Gaspard de Gueidan*, though fully rococo in its handling of space, in another sense is quite unlike rococo, for its meticulous finish runs against an aesthetic shift which begins as early as Roger de Piles. This is the cult of the image that is incomplete – the 'non finito'. In 1699 de Piles had this to say in favour of the sketch: 'Imagination supplies all the features which are missing or which have not been finished, and

41 Hyacinthe Rigaud,
Portrait of Antoine Pâris

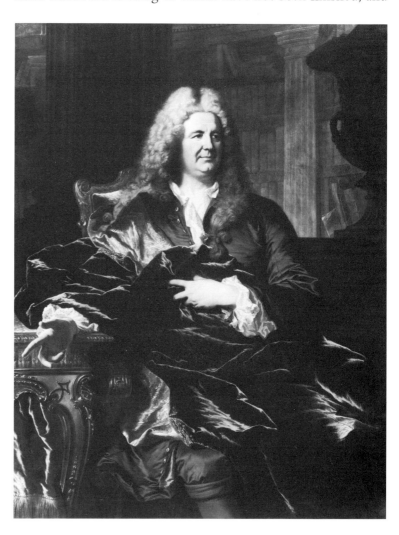

each person who sees the sketch fills them in according to his taste'[17] – a relativism of which de Piles strongly approves. Such praise of incompleteness is shared by both the visual arts and literature, and from our point of view the most systematic exploration of the possibilities of the incomplete is Watteau. Such a description of Watteau might seem modernist in bias if it did not, in fact, accord so accurately with contemporary accounts of artistic pleasure. Père Bouhours, while generally demanding clarity and artistic expression, adds this rider: 'great art consists ... in leaving others to perceive more than one says';[18] and Père André similarly claims that 'There is a kind of beauty in expression which comes from saying only as much as will allow *personnes d'esprit* the pleasure of supplying the rest.'[19] Of the finest poetry, du Bos writes that 'it is full of figures which depict (*peignent*) so clearly the objects described in the verse that we seem to hear them, and our imagination is constantly filled with pictures (*tableaux*) that succeed one another in proportion as the sentences of discourse succeed one another'.[20] Du Bos's appeal to the capacity of literature to translate itself into visually intense images within the reader's mind typifies a tendency on both sides of the Channel: of Vergil, J. M. Lambert writes that 'one seems to see before one's eyes what the poet has painted for the mind';[21] a sentiment that corresponds to Joseph Spence's praise of Homer's landscapes – 'they make everything present to us; and agreeably deceive us into Imagination, that we actually See, what we only Hear.'[22] What such remarks illustrate is the developing tendency to animate the artistic product so that instead of being perceived across a single channel of sense, the whole perceptual and emotional organism of the receiver is brought into play.[23] Moses Mendelssohn writes that if the reader 'can render the discourse palpable ... the exposition becomes animated, and the objects depicted are immediately represented to our senses. By this general rule, one should judge the merit of poetic images and metaphors, of descriptions and even of individual poetic terms.'[24] It is within this context that one should place the accounts, to us apparently exaggerated, of contemporary readers' responses to drama and to the novel: Partridge's enthusiastic comments in *Tom Jones* on Garrick's Hamlet[25] may strike us as naïve and overdone, but placed alongside accounts of the writing of Diderot's *La Religieuse*[26] in which author and reader alike seem entirely taken over and possessed by a fiction, and the French reactions to Richardson, which praise the complete absence of opacity in this new kind of literature, and its ability to transport us into an imaginary world the reader perceives as intensely real, one begins to see that for the generations of rococo and beyond, the art-work is beginning to be considered as an instrument that permits vivid

hallucination. Diderot's *Eloge de Richardson*, which describes how his life was invaded by the characters from *Pamela* and *Sir Charles Grandison*, is sufficiently well known for it to be worth quoting instead from Laurent Garcin's similarly beguiled and enthusiastic response: 'Richardson places one at his characters' side, he conducts (*promène*) my gaze on to their every movement. I am in their bedroom, and beside their chair, their table or their bedstead; I watch their attitudes, their gestures: I know their secret tastes and humours, their plans, their deliberations; I know in advance what they are going to say, and because I see their actual existence I concern myself actively with their fate.'[27]

The doctrine of an ideal presence, half-transmitted by the art-work but requiring for its full existence the imaginative participation of reader or viewer, begins here to elide with the emotionalism of the phase that succeeds rococo – with *sensibilité*. Yet the hallucinations of Partridge, Diderot and Garcin are only the culmination of the belief which so insists upon the value of animation in the art-work (Bouhours, André, Lambert, Spence) that a corollary is that art must not be complete in

42 Jean-Honoré Fragonard, *The Abbé de Saint-Non as an Actor*

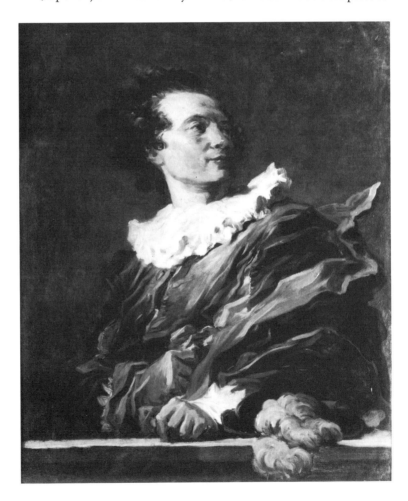

itself, but acquire completion in the receiver's mind, and this cultivated insufficiency is at the heart of the rococo image, and its concept of space. From one point of view it induces the *fa presto* of Fragonard, most garishly visible in *The Abbé de Saint-Non as an Actor* (illustration 42), 'done in an hour'. Precisely because the image has been prematurely abandoned, is only a calligraphic trace of a possible image which the viewer is left, in the phrase of de Piles, 'to complete according to his taste', it remains flat on the picture plane. We see the work of the painterly trace and are encouraged, because it has quit the image long before closure, to take up its effort at the point of abandonment, and to prolong its life within a separate mental space. In this, the Fragonard *rapidissimo* harmonises with the taste for the work of art that is not self-sufficient in itself, but calls into play for its full realisation the active co-operation of the viewer's imagination, as in those slightly unbelievable accounts of the 'hallucinability' of Vergil, Homer, and Richardson. Strictly speaking, the bi-dimensionality of Fragonard's oil sketch ought not to be considered in itself, since its incompletion is there to call into play a supplementary space in which the participating imagination can flesh the image out into three dimensions. But in itself the image insists on its place on the plane of signifiers, and on the work of the signifier in conjuring forth a signified which the viewer's active collaboration then extends. We may eventually dissolve the brushwork in imaginary space, once the co-operative labour of our own imagination gets underway; but certainly as we approach the image initially, the plane of the signifiers is what we see, and what impresses us.

Similarly, in the *Fête at Saint-Cloud* (illustration 43), the figures are entirely elliptical and laconic, requiring much imaginative work on the painterly signifier if the human figures are not to remain as uncertainly animated as the marionettes; and by so stressing the marionettes, Fragonard makes us aware of the whole issue of the power of the imagination to animate the dead matter of art. The presence of a stage in a park may remind us of Watteau, but the informational distribution of the *Fête at Saint-Cloud* is entirely different from that of the Watteau *fête champêtre*. In Watteau, we are always given enough information about the figures to make us feel intrigued; but here the figures are so robbed of information that the work we have to do is more primary, not yet the subtle work of interpretation and of following the implications ('reading between the strokes'), but the much cruder task of filling out the rudimentary figures so that they can become acceptable as depictions of living human beings in the first place. The Watteau long shot, hiding faces and expressions, is extended to such distance that the difficulty lies in making the

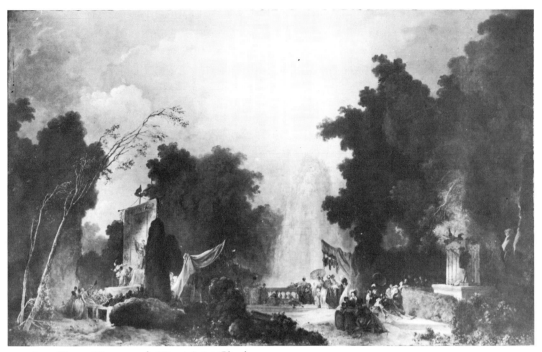

43 Jean-Honoré Fragonard, *Fête at Saint-Cloud*

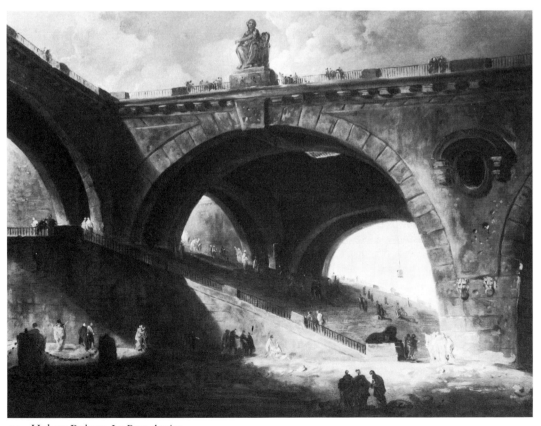

44 Hubert Robert, *Le Pont Ancien*

most basic perceptual sense of the scene. The *Fête at Saint Cloud* as a visual idea is all about dwarfing human beings so that they approach a point of non-recognisability. Usually this is recuperated as a proto-Romantic effect – 'humanity seen as puny beside the forces of nature'.[28]

But while it is undoubtedly true that distortions of scale are an essential feature of French Romantic painting, and absolutely central for example in Gros, there is no need here to go so far outside the period or to invoke a new aesthetic climate, precociously anticipated. In his play with the thresholds of recognition, Fragonard is far closer to his friend Hubert Robert than to the Romantic movement; and the exploration of the possibilities of that threshold of recognition focusses much of our attention on the signifying plane, which is what Hubert Robert wants from us (illustration 44). To take a modernist comparison: the sculpture of Giacometti is intensely interested in the moment at which an advancing shape becomes recognisable as a human being, and in that other moment when at a closer distance we are able to recognise in the advancing figure an individual face; the sculpture expands out of those liminal moments when its own material, clay, comes to acquire the charge of the signified. Fragonard and Hubert Robert are similarly interested in the moment when a painted trace becomes a recognisable human form; and their spatial handling, especially the long shot with tiny figures, centres on recognition-thresholds similar to those that fascinated Giacometti.

The same principle informs the Fragonard sketches (illustrations 45 and 46): there is recognisability, but what we recognise is so surrounded by the independent existence of the signifier that it is this latter component of the sign we finally attend to. The shapes of the sketch are partly exhausted by their signifying work, but much remains, and indeed in the rococo sketch a broken, palsied outline is often cultivated so that we always remain aware of the residue of the signifier – what cannot be recuperated by the information the image is supposed to transmit. The Goncourts are fascinated by this focus on the signifying material and vividly picture it:

[Fragonard's] effects suggest that he used a chalk without a holder, that he rubbed it flat for the masses, that he was continually turning it between his thumb and forefinger in risky, but inspired, wheelings and twistings; that he rolled and contorted it over the branches of his trees, that he broke it on the zigzags of his foliage. Every irregularity of the chalk's point, which he left unsharpened, was pressed into his service. When it blunted, he drew fully and broadly ... when it sharpened, he turned to the subtleties, the lines and the lights.[29]

Perhaps the Goncourts' reaction ought to be placed in its later historical context: if they had obeyed the de Piles injunction

45 Jean-Honoré Fragonard, *The Pasha*

46 Jean-Honoré Fragonard, *The Herdsman*

about the sketch, so far from imagining the activity of the
signifier they ought to be at work expanding and completing
the signified, a task for which with Watteau they demonstrate
such skill; and it is unlikely that so much investigation of the
signifier would have been described by the rococo critics
(though it may nonetheless have had an important place in
their actual experience of contemporary sketching practice). If
we are to believe the words of du Bos and Lambert, Moses
Mendelssohn and Père Bouhours, rococo viewers would have
valued the Fragonard sketch for the challenge it presented to
their own imagination, and the opportunity provided by its
laconic imagery for making every perceiver into an artist – a
personne d'esprit.

Between rococo and the Goncourts, a crucial shift in the
conception of the 'artist' has occurred: for the eighteenth-
century critic, ellipsis and insufficiency in the image ask for a
supplement in the discursive work of perception – an expan-
sion of the signified; for the Goncourts, the same kind of image
asks for a focus on figurality. And a difficult question of
historical relativism is posed by the twentieth-century viewer
confronted by rococo laconism, since we can be fairly sure that
his glance will be a figural one: sketches by Fragonard will
now fetch astronomical prices at any auction; we find them
highly attractive because our own visual practices are at home
with Fragonard's 'abstraction'.

Yet, briefly to address the problem of relativism, we can say
that the only component of the painterly sign guaranteed to
survive is figural: the context of discursivity has to be recon-
structed and the accuracy of our archaeological endeavour can
never be certain. The problem is part of the whole issue of
intention: are we to place the work in relation to the unknow-
able, irretrievable mind of its producer, or in relation to our
own alien time?[30] Dilemma without resolution, but this much
is clear: classic art, art that is not exhausted by its period, but
can travel forward in time, derives its durability from what is
figural. The figurality that comes from laconism, from the
planned incompletions and gaps so evident in the Fragonard
sketch, has a classic status entirely denied the far more obvi-
ously 'classical' art of LeBrun. LeBrun's bid for classic status
hinges on the power of a legibility which he no doubt con-
sidered timeless and inherent within the world as a natural
language; yet obviously the codes of legibility are tied to a
specific socio-historical milieu, and the bid fails, since the
component of the sign LeBrun believed to be most transcen-
dent is in fact its most vulnerable and by now most eroded
aspect. LeBrun comes down to us as ruin, Fragonard as
incompletion which through its openness of image, its refusal
to be exhausted by limited signalling work, its avoidance of

finish (in a wide sense of the word) and its insistence on being examined on the material plane of its signifiers, acquires the limited plurality of all classic art, which survives for as long as the signifier remains both intact and 'open'.[31]

Although discussion of Chardin's role in the anti-rococo reaction, which finds its major polemical expression in Diderot's art criticism, must be deferred until a late chapter, it is in the present context of rococo painting that his work ought first to be placed. We do not normally think of Chardin as rococo at all: if he belongs anywhere in the French tradition – and where then to place him in that tradition was the great problem his work posed for Diderot – it would seem to be with the hallowing of domestic virtues and routines we associate with Richardson, Rousseau, and Greuze – early *sensibilité*. But it is important to realise just how early Chardin's production – which never changes its stylistic essentials – actually begins. As *morceaux de reception*, Chardin submitted to the Académie in 1728 two still-life subjects, including the incredible *Skate* (illustration 47), which is already at the height of his mature style.

Although general public discussion of Chardin does not get underway until the Salon of 1753,[32] when Chardin is already

47 J.-B. Chardin, *The Skate*

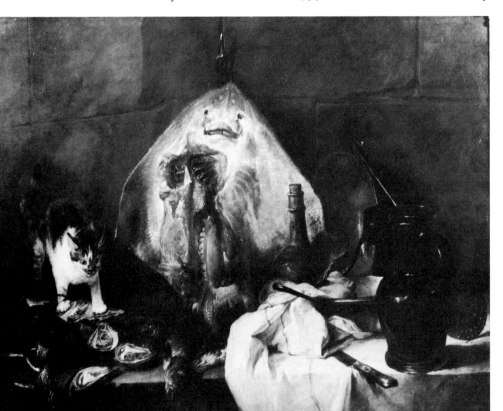

being absorbed into the anti-rococo party, his production during the 1730s and 1740s is in no major respect different from the work that came to be so admired in the 1750s. A case in point is *Le Dessinateur*, originally executed and ignored in 1738, but accorded enormous critical acclaim when re-shown at the Salon of 1759;[33] another is *Un Philosophe occupé de sa Lecture*, whose subject, first painted in 1734, and still being passed over at the Salon of 1744, became a public success at the Salon of 1753.[34] Greuze does not feature in Paris until 1755, *La Nouvelle Héloïse* (the great text of *sensibilité*) and Greuze's *L'Accordée de village* (its manifesto painting) appear in 1761. Chardin forms his style in the 1720s and 1730s, as rococo itself is taking shape; and however much one may want to believe in Chardin as indifferent to the rest of painting in France, there is evidence that he was, in fact, eager to follow its trends. A work of 1732, showing a girl sealing a love letter (illustration 48) is

48 J.-B. Chardin, *Girl Sealing a Letter*

intelligible only as an approximation to the then immensely fashionable de Troy; and so far from displaying the noted Chardinesque frugality, the materials it depicts are opulent – a dress not of linen but of silk, a gilded chair, a brocade canopy, braided rugs – and its central interest is crypto-erotic; not at all the Quaker restraint we would expect.[35]

Yet Chardin's position in rococo is less a function of such early, de Troy-style aberration than of his archaic and in a sense tragic relation to signification. Chardin's objects – a straw used to blow bubbles, cards to make a house, a spinning top, a feather, a feather-ball – seem to us scenes from child-hood, handled with the gravity of still-life. Our primary conception of Chardin's work is that it is a celebration of material existence, where objects of no intrinsic value are raised to the level of the highest art by sheer force of technique. Certainly that is what the Goncourts thought: 'Chardin paints everything he sees.'[36] Yet these same objects which seem to us part of delicately observed *Kinderszenen* were once infused with the heaviest semantic charge. They all come from emblem-books.[37] The spinning top appears in an emblem-book of 1610 as a symbol of human sloth: 'It is characteristic of the low and base man, in all his activities, to insist on seeming all effort and labour, unless he is whipped on. Without the whip, no movement.'[38] From emblem-book to emblem-book the meanings vary, but in each case the top is charged with significance, as legible as any attribute from mythology or any grimace from LeBrun's *Conférences*. The feather might similarly strike us as neutral; yet within the emblematic tradition it is a symbol of carnality, blown every way by the currents of desire.[39] Perhaps the only scene that still transmits to us a residue of its original moral meaning is the *Boy Blowing Bubbles* (illustration 49) – we can still sense that the idea of Vanity lurks somewhere in the image; but this is because this meaning comes to us independently of the forgotten emblematic tradition (where it conspicuously features) and reaches us by other channels, notably from northern painting of a previous epoch, from versions by Frans van Mieris, Caspar Netscher, Pieter de Hooch and Nicolas Maes, that hover at the back of the mind as one contemplates Chardin's late – his terminal – reworking of the ancient *topos*. Besides the canvases themselves, one should consult the engravings through which Chardin established his European reputation, with their strange appended rubrics.

To the *Boy Blowing Bubbles:*

Contemple bien jeune garçon Et leur éclat si peu durable
Ces petits globes de savon Te feront dire avec Raison
Leurs mouvements si variable Qu'en celà mainte leur assez
 semblable

To *The Schoolmistress:*

Si cet aimable enfant rend bien d'une maîtresse
L'air sérieux, le dehors imposant,
Ne peut-on penser que la feinte et l'adresse
Viennent au sexe, au plus tard en naissant

To *The Spinning Top:*

Dans les mains du Caprice, auquel il s'abandonne
L'homme est un vrai tôton, qui tourne incessament;
Et souvent son destin dépend d'un mouvement
Qu'en le faisant tourner la fortune lui donne.

The tragedy is not only that Chardin's emblematic roots are pointed to in verses which seem too slight to have much bearing on the image, but that they have to be added to indicate that a discursive content exists at all. These tacked-on maxims, apparently unworthy of the paintings, exist in a disconnected space of legend, and if attended to at all are taken to connote

49 J.-B. Chardin, *Boy Blowing Bubbles*

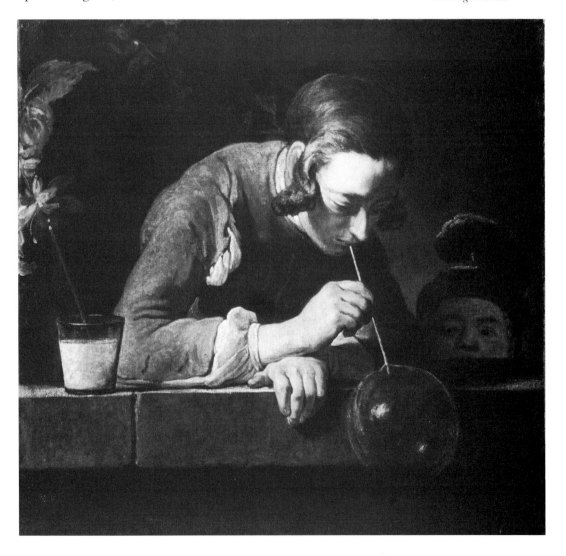

Chardin's naivety, the humility with which he produced what many believe to be the greatest paintings of his age, that innocence of his which in the usual accounts of his life at times seems to border on stupidity.

But the implications are wider than this: Chardin undoubtedly succeeded in raising a lowly secondary genre to the level of high art, but our usual explanation for this – that it was achieved by technique alone – conceals that the miracle of elevation is likelier to derive from the high moral seriousness with which Chardin regarded his subject-matter. It is hard for us to imagine what kind of didactic mission the paintings fulfil because for us didacticism means, within France, the discursive apparatus of the Académie. Looking always to Rome, with LeBrun and Félibien eager to reproduce in Paris an academy to rival the Roman Academy of St Luke, the iconographic tradition of the Académie remains committed to the classics: the texts to be illustrated are accounts of heroic action and concern always the expressions of the human body. Entirely ignored is that other tradition, Dutch, Spanish, and above all German, which takes the objects of the world and not the parts of the body and charges them with discursive content; hence the long misunderstanding of the didactic tradition within northern still-life, where the apparently mute objects of the world are in fact often manipulated to yield 'sentences' as precise, as elaborate, and as elevated, as *The Queens of Persia*. Within Germany, the emblem-books lie behind the whole allegorical structure of the *Trauerspiel*;[40] in England, the traditions of meditation on symbolic objects are an essential structure within the work of Southwell and Donne, Herbert and Quarles.[41]

Yet for the Académie, it is the Italianate iconography that reigns: how to represent *eloquentia* is fully understood, but the didactic dimension of northern still-life remains an unknown. With Chardin, this alternative iconographic tradition, object-based and unconcerned with the expressions of face and body, reaches a close; a century earlier his symbolism might be understood, particularly outside France (and we must remember that Chardin's following was remarkably international); but in France, as it was entering its high rococo phase, his moral purpose was bound to be ignored. Chardin's conception of the still-life may be northern and didactic, but his position within the Académie is still of the humblest – 'painter of fruit and flowers'; the irony is that in his discursive ambition, his wish to convert the materiality of the world into signification, he is a direct successor to LeBrun and maintains the discursive image through a period in which the signified is effectively in exile. All that Chardin can do is to append to the engravings of his work these simple-minded rubrics, which

seem in their ungainliness to confirm one's suspicion that
the appreciation of Chardin by the connoisseurs of his
contemporary France was an act of supremely discerning
condescension.

Yet the tragedy of Chardin's isolation in space and time
from the only tradition which knows how to value still-life for
more than its realism, and from a public which would recog-
nise the moral earnestness of his statements, produces also a
subtle gain: it is, in fact, the essence of his atmosphere. Despite
the apparently exclusive concentration on technique, there is
still the faint resonance of didactic intent; and because that
intent is no longer supported by a repertoire of emblematic
images that everyone would know and recognise, it becomes
much more inward and private. The image of the boy blowing
bubbles has a gravity which seems without motivation; the
signified of Vanity, no longer directly accessible, becomes a
nostalgic absence, and in its status as absent implication joins
Chardin to the tradition of the reticent sign inaugurated by
Watteau – the tradition invoked when Père André claims that
'there is a kind of beauty in expression which comes from
saving as much as will allow *personnes d'esprit* the pleasure of
supplying the rest'. In a sense, the official signified of vanity,
once we learn it, kills the delicacy of the image; just as the
Fêtes vénitiennes becomes banal when critics tell us that it is
all about tuberculosis, Vleughels, and Camille Desmares.
With the boy who so patiently constructs his house of cards
(illustration 50), it seems crass to speak of firm foundations,
bürgerlich prudence, or the vanity of human wishes: that kind
of glaring symbolism belongs to Greuze. Chardin's strength
lies precisely in not making, and in not being able to make,
such reductive discursive use of his painting; and here he
rejoins rococo, with its exiled meanings, its laconism, and its
'classic' incompletion.

Chardin's involvement with the actual stuff of the signifier
derives, as with Boucher, a powerful rationale from his
subject-matter. In Boucher, the signifier takes over an erotic
charge from the signified of the displayed body; and since
presentation of that body is in various ways censored, the
liquid materiality of paint, its tint, its lubricity and its caress
against the canvas become a substitute sensuality for what the
image is unable directly to address. With Chardin, the sensual
charge has another source: the relation of the body to its
material surroundings, a relation that is always operative,
never passive, always active and never hedonistic, and can be
summed up in a word: work. The body in Chardin is por-
trayed in poses where eyes, no longer an expressive zone, have
to attend to an object that requires practical concentration. It
may be a task, whether intricate, like the balancing of

playing-cards, or simply demanding, like drawing water or lifting plates; or it may be a person, usually a child, whose welfare demands a constant level of vigilance. Only rarely do the eyes of the Chardin figure stray from the object of their attention, and if they do, it is only into the vacancy of rest. The hands, occupied with tasks requiring varying degrees of dexterity, are in direct contact with the material world on which it is their sole purpose to act. They combine two primary economic qualities: skilfulness, and when the emphasis is on this, the ends of the fingers are stressed and described as performing precise functions, of winding wool, holding a needle, lifting a knife; and strength, in which case the stress passes from the fingers to the back of the hand and the forearm, as in *A Woman Drawing Water from a Tank* (illustration 51). Feet are placed firmly on the ground, where they are seen at all, and serve only as a stable support for the executive upper body. The posture is almost wholly determined by these primary zones of the body as it comes into contact with matter – feet, eyes, hands – and the rest of the body conforms to what is demanded by the operative zones. The body is thought of as a

50 J.-B. Chardin, *The House of Cards*

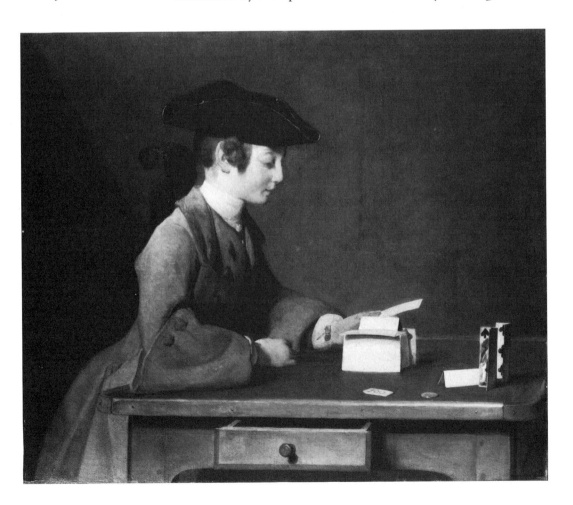

system of functions performed economically and deriving whatever incidental beauty it has from its working efficiency; this frugality naturally extends to the clothing, which is selected according to usefulness, and worn to free the body for its limited range of essential movements. Face and body are, above all, *absorbed*; no excess of expression or gesture allows the body to stray into the domain of communication or discourse, and Chardin's attitude towards language is that it is simply another material obstacle and task, to be taught as one teaches any other practical skill. This absorption extends outwards from the body into its immediate surroundings. All the objects have been sanctified by contact with the body, and the space seems charged with tactility: surfaces are polished, floors swept, linen is starched and carefully ironed; furnishings are restricted to those objects that have been hallowed by repeated use, and more exactly, by touch. From this stems a prime aesthetic value, of intimacy: body and material world exactly adapted to each other, with no excess on either side, and a

51 J.-B. Chardin, *A Woman Drawing Water from a Tank*

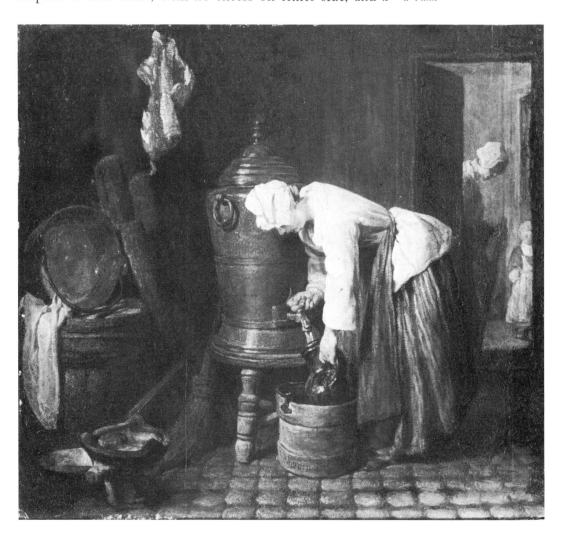

maximum of co-operation between the two. A placid harmony reigns between people and things, and this is the utopian aspect of Chardin's vision (illustration 52).

The harmony extends towards the paint itself, for it too must carry the intimacy of the body and its habitat, and the continuity this affords between the space behind the signifying plane and the plane itself is the first stage in the development of a spatial structure of considerable intricacy and originality.

Partly as a result of the secrecy with which he enshrouded his technical processes (no one was allowed into his atelier) the legend grew up during Chardin's lifetime that he applied the paint with his fingers. Although obviously untrue, the paint everywhere reveals the traces of its management: it dribbles, it is applied like cream-cheese, is buttery, is an almost comestible substance which announces unequivocally that it has been *worked*, consecrated by the same operation of body on matter which Chardin's subjects take as their theme. Because in both the subject matter and in the work of the brush the activity *on* matter is stressed, the eye is almost secondary to the hand, and

52 J.-B. Chardin, *Le Négligé*

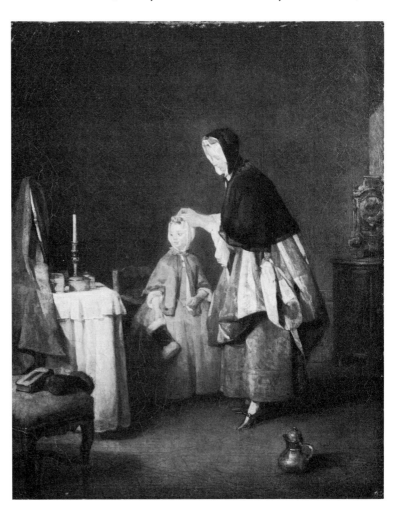

this is confirmed by an unusual compositional technique that avoids priorities. No hierarchy either of objects or of the glance presents itself: no arrangements whereby some objects dominate over others – almost a reversal of the fundamental idea of composition, as regulation of the look of the viewer. Usually the eye is commanded by visual cues to arrange the various areas of the canvas into major and minor importance, and to prevent this Chardin presents everything as evenly out of focus, as in *Le Négligé* (illustration 52). This is an extremely difficult technique, since both within the economy of vision and within the tradition of painting, certain areas are naturally accorded a greater stress than others. In *The Laughing Cavalier*, for example, the expensive and complicated lace of the subject's cuff is depicted in minute transcriptive focus, while the negligible linen above it has been generalised into broad and unfocussed strokes; in Greuze's *Boy with Lesson Book* (illustration 53), in which he is possibly trying to rival Chardin, everything is kept out of focus, everything except the fingernails, which are polished and in high focus, and the sleeves,

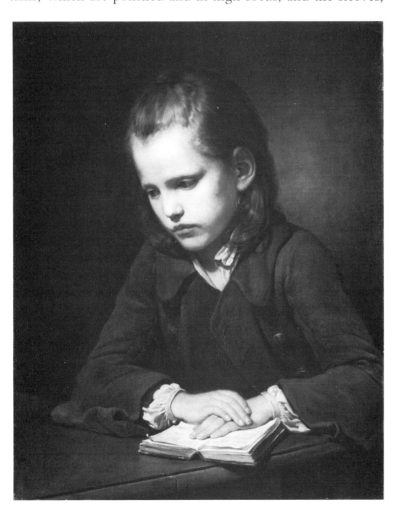

53 J.-B. Greuze, *Boy with Lesson Book*

with their exact recorded folds – what used to be called 'Dutch highlights'. [42]

Chardin's problem is to present areas of traditionally high focus – for example, eyes, fingertips, fabric, reflections – as unfocussed or at the same degree of indeterminate focus as the other areas the eye usually ignores – walls, floors, all the dull, flat surfaces; and he must do this without seeming to 'leave holes', that is, without conspicuously under-supplying us with information we normally expect. In most Chardin paintings every square inch of the canvas evenly attracts our attention – the potentially uninteresting wall-surfaces in *Le Négligé* have been enormously enriched by colour, and by a technical manipulation of paint which I do not believe we yet fully understand; the areas that threaten to dominate the painting – the two faces, the candlestick with its reflections, and the textured, informationally high-content zones of the clothing – have been correspondingly effaced or erased. And because the entire surface approaches equivalence, the virtual space 'behind' the canvas can then be put through the first of its transformations: identification with the picture-plane.

Although in Chardin we still perceive depth, because the composition is rigorously 'democratic' and the quantity of information transmitted by each area of the painted surface is more or less equal to the quantity transmitted by every other area, the space already comes forward to meet the plane of the signifiers – there is no dominant object to detain us in the virtual space; in this advance towards the plane of paint Chardin is spatially cognate with both Rigaud and Boucher. And once the image has been brought forward to the signifying plane, Chardin is able to perform his second spatial transformation: to work the surface of paint so that it is no longer flat and ignored, but on the contrary hugely emphasised: through the dribbles, the impasto, the stippling, the layering of successive strokes, that plane is broken and begins to develop a contour which rises out from the painting towards and into the viewing space. The Albertian eye, used to a window-like canvas, comes up against the impenetrable barrier of opaque pigment. And the image is adjusted to accommodate to this new space, the space of the viewer, by varying according to the distance of the viewer from the plane. It was this effect that fascinated Diderot, and his fascination continues in the Goncourts: 'Look at it for some time, then move back a few paces; the contour of the glass solidifies, it is real glass ... In one corner there is apparently nothing more than a mud-coloured texture, the marks of a dry brush, then, suddenly, a walnut appears curling up in its shell.' While this parameter of painting had of course always existed, with the French tradition it is Chardin who first exploits its possibilities: up to a certain

distance, paint and only paint; beyond that, access from the viewing space into the virtual space, but access no longer transparent or fenestral, but aware always of the intervening, carved sheet of pigment.

An interest in the duplicity of the image – now representational, now abstract – is one of the outstanding attributes of the twentieth-century viewer, and it is natural that for us, Chardin should be much more comprehensible than Fragonard or Boucher, whose alternation between these two poles is less pronounced and less calculated than it is in Chardin. But Chardin's experimentation with spaces that permit the absolute visibility of the signifier is, despite our categories, part of a whole trend within French rococo, of liberating figurality from the controlling grasp of the signified. It is with Chardin that we see that liberation most clearly, but our failure has been to isolate Chardin from his age; his work is part of the same overall project of a figural painting, which also includes Natoire and Boucher, Fragonard and even Rigaud.

After Chardin, a reaction sets in which, by the time of the French Revolution, entirely reverses the direction followed by these painters: the return of the discursive image. But before passing on to that return out of exile, and to its first herald, Greuze, there is something which should not, with Chardin, be left unsaid. French painting will never again be so conscious of its life as *paint* and at the same time so untroubled by the consequences of that independent life. When Ingres comes to realise that the image is not, as had been thought, a window on the world, but a separate and autonomous entity, with its own particular, and strange, history, his reaction will be one of increasing anxiety. If painting is not mimetic, what is it? Ingres discovered an answer which terrified him: if painting is not a copy of the world, then it forms a field without origin except in other paintings. To Ingres the contact with source which earlier artists had possessed is no longer available: instead there are only traces made by the hand, in a gesture of sourceless and endless inscription. When painting next realises and releases the independent power of the figural, and comes to assert the autonomy of the act of painting, there will be an accompanying sensation of shock and loss. Chardin releases the power of the signifier in all innocence, and he has not yet lost the world as origin of his image: he is not alone, cut off from nature or from mimetic source. His play with the painterly trace has no implications other than beauty. It is still rococo.

5 Greuze and the pursuit of happiness

OF ALL THE painters whose work this book discusses, Greuze is the most remote from ourselves; so remote as to be almost irretrievable. Even LeBrun is more accessible, since his enquiry into the process whereby the physical body becomes a place of articulated meanings is an interest many of us share, whether we are sociologists seeking to understand the non-verbal presentation of the self in its social world, or ethologists studying the transactions of information-exchange that occur outside language, or critics analysing how certain forms of art manage to structure patterns of meaning without ever seeming to break with illusionism. In its peculiar and specialised attitude towards the erotic, rococo painting is so alien to the eroticism of the late twentieth century that it no longer annoys us as it did Diderot, or titillates us as it was still able to do at the beginning of the present century; and because its content tends to leave us indifferent, we are free to attend to its qualities of formal design. But Greuze does not allow us this position of indifference, because his work insists on an ideology of family life that we are still hotly debating. On one side range its defenders, who see in the family the basic civilising unit of our traditional culture, and even the only institution strong enough to resist an encroaching centralised state. On the other side range the critics of the family, who see it as the natural opponent of the individual's right to choose the pattern of his or her adult life; the central institution for the oppression of women; the natural political ally of conservatism and reaction; and even as a prime incubator of mental disorder. The issue of the family is so much with us that it is almost impossible for us to put Greuze's ideology into suspension, and apply the magical, dissolving gaze of the twentieth century, which can recast almost any image into pure constituent form. With Greuze that magic fails. and even the most enthusiastic supporters of Greuze tend to feel embarrassed by him, as though they had fallen into low company, and to offer apologies for what seems almost a secret vice.

Greuze also suffers as a result of the habit endemic to art history, of categorisation by visual style. The three great 'macro-styles' of the period we are looking at here – Baroque, Rococo, Neo-classicism – are normally thought of as following one on another without a break, like successive dynasties;

and outside French art this dynastic typing of styles may sometimes seem the best initial approach, at least for rudimentary pedagogic purposes (though I doubt whether many art historians any longer have much faith in the categories). Yet Greuze comes under none of these headings, and belongs instead to the anomalous phase which in France somehow intervenes between Rococo and Neo-classicism – *Sensibilité*. Unlike the others, it is not an international visual style; and again differing from the macro-styles, it is defined as much by content as by purely formal management of imagery. The system of typing painting by the eye alone, by formalism unaided, has such a strong inbuilt resistance to the analysis of the discursive content of the image that the distinctive feature of the painting of *sensibilité* in general and of Greuze in particular – an intense 'literariness' – is not easily scanned and detected by the formalist apparatus. As a result it is hard for us to understand why it was that for two decades – the 1760s and 1770s – Greuze was believed by some critics and by many collectors to be the greatest living painter in France; or how there was a time when his paintings were eagerly sought by Catherine of Russia, the Emperor Joseph II, and Gustav III of Sweden.[1] Our machinery for inventorising painting by style alone (as though painting did not also concern the signified, as though it were already what the twentieth century will claim it to be, a class of sign that is all signifier,[2] which is to say not *sign* at all), our famous formalist *ascesis*, makes such celebrity seem entirely mysterious and aberrant: a 'phenomenon' – a word often used of Greuze, as it is of those occurrences in nature that are not easily accountable within prevailing theoretical models.

A third factor in the neglect of Greuze is our current ignorance of the cultural context of which he is a part. The manifesto painting of *sensibilité*, Greuze's *L'Accordée de village* (illustration 54), appeared at the Salon of 1761 and became a colossal overnight success: Greuze was the most discussed painter in Paris, droves of spectators crowded round the painting every day of its exhibition (even Diderot, who became Greuze's most influential supporter, had to elbow his way through the mob to see the painting for the first time)[3] and in terms of sheer public impact the only rival to *L'Accordée* before the Revolution will be David's *Oath of the Horatii* of 1785. But the phenomenal success of this work should be understood as part of the whole situation of triumphant *sensibilité*, for 1761 is the year also of Rousseau's great novel *La Nouvelle Héloïse*, which similarly took Paris by storm.[4] Something we tend to forget is that, after Voltaire's *Candide, La Nouvelle Héloïse* was the most widely read literary work in France until 1800: it ran through a number of editions that seems to us quite incredible;

and its appreciation was very broadly based.[5] In the early 1760s the theatre was also revolutionised by the appearance of Diderot's new dramatic genre the *drame bourgeois*, whose ascendancy during the decade is partly to be attributed to the fact of mutual reinforcement from the parallel successes of Greuze's painting and of Rousseau's novel.[6] But who now reads *La Nouvelle Héloïse*, a text almost a third of a million words long? Who reads the novels of Richardson, except in university courses; Richardson whose acclaim in France paved the way for *sensibilité*? And what producer would ever risk reviving the *drame bourgeois*? Greuze's success in the 1760s occurs in a context that has been lost to us, when the contextual support was precisely what was interesting about his work: painting had formed a link with the other arts the Parisian public supported; the Greuze people were familiar already, from Richardson and from Rousseau; the viewer at the Salons could see the same figures of Father, Mother, Daughter, Son, come to life in the new wave of stage-production. The arts had merged and adopted a common iconography – a convergence that was not to occur again until the Paris of the Terror.

The concept which this literature, this drama, and this painting choose as their convergent point is *le bonheur* – the pursuit

54 J.-B. Greuze,
L'Accordée de village

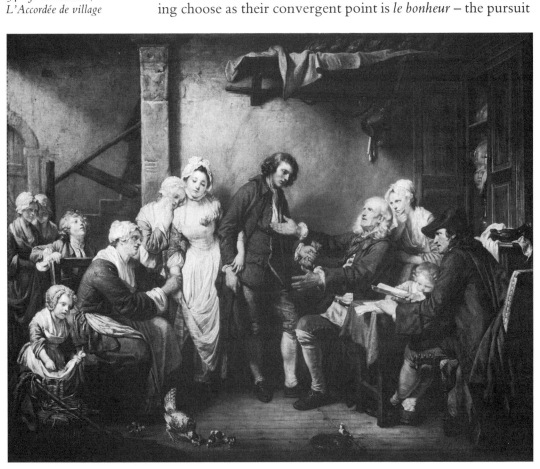

of happiness. Well, every age pursues that. But in the 1760s and
1770s the French pursued it in a specialised form and with a
single-mindedness that were exceptional. Perhaps I can begin
to describe the strange shape that happiness seemed then to
take by citing a parody, from the magnificent and bitter *Les
Liaisons Dangereuses*, of Laclos.[7] Valmont, the novel's anti-
hero, is staying in the country at the house of the Président de
Tourvel. The Président is away, and in his absence Valmont
decides to seduce his wife, the Présidente; and not just to
seduce her – that would be too easy a victory – but to use
seduction as a means of destroying the beliefs that to Valmont
seem to make the Présidente so unintelligent, so gullible, and
at times so sub-human. For the Présidente is a great believer in
sensibilité, and in particular in that component of sensibility
which maintains that emotionalism and virtue are so close as to
be one and the same thing. The mere sight of a virtuous act is
enough to arouse her feelings to a pitch where she is no longer
in full possession of her faculties – an ideal time to pounce.
Valmont decides on the following strategy: to seem cynical,
disillusioned and world-weary in the Présidente's company,
but to play upon his hostess's desire to rescue him from his
condition; to induce in her the idea that beneath his cruel
exterior, the heart of *sensibilité* throbs. The friends of the
Présidente warn her of the danger of allowing Valmont to stay
under the same roof during her husband's absence, but the
Présidente prefers to believe that Valmont's bad reputation
masks a secret virtuousness. Valmont has been going off for
mysterious walks in the afternoon, and the Présidente decides
to send out spies. Valmont, who has his own spy-network,
knows about her plan, and stages a scene in the neighbouring
village which he knows the Présidente's emissaries will wit-
ness and report back to her; just as he knows that the scene will
have enough *sensibilité* in it to ensure that the Présidente will
succumb. In the village, the tax-collector is seen confiscating
the last possessions of a poor family unable to pay their debts:
Valmont steps forward and hands the tax-collector a purse of
gold coins. Saved from ruin, the entire family, which numbers
five people, weeps for joy and gratitude; tears flow, joyous
tears which illuminate with happiness the faces of even its
oldest and its youngest members. The villagers throng round
the group, murmuring their benedictions, and Valmont finds
himself at the centre of a happiness that spreads out in widen-
ing circles towards the family kneeling in thanks before him,
out into the community, and on into the surrounding world:
the Présidente will be his.

It is a scene that might have come from the brush of Greuze,
and in fact it was used by the Goncourts to illustrate their
version of the Greuzian ideal.[8] It believes, as Greuze does, that

virtue is not only a matter of reason or calculation, but of the heart; that the heart, like reason, needs its own sentimental education; and that the central instrument of such an education is the *exemplum virtutis*. We need only witness the virtuous act to be uplifted and improved. In its purest form, as Laclos gives it to us, the virtuous act is always accompanied by happiness – 'happiness' appealing at the same time to the emotions and to the intelligence. The witness of the spectacle will be convinced of the rationality of virtue, because he sees how many people are helped – not just a solitary beggar, but an entire family.[9] There is a quantitative calculation at work, as though happiness were a substance that could be measured by volume or weight (and in this quantitative aspect we can see how *sensibilité* will shade into utilitarianism). And the witness to the scene will be convinced because the happiness generated will touch his heart; the more happiness there is, the greater will be the throb of his response, and its intensity will be emotional proof of the validity and power of goodness. Both the intellectual and the emotional components of happiness demand maximisation if the pedagogic work of the *exemplum* is to be effective, and from this need to present happiness at a moment of repletion and abundance, a specialised structure or staging, shared by all the arts under *sensibilité*.

To ensure the efficacy of the *exemplum*, its content is proffered all at once, in the concentration of a *tableau*. Both the novel and the *drame bourgeois* tend also towards moments of peak-intensity, when the maximised happiness can be taken in at a glance: the family at last re-united in *Le Père de Famille*; the scenes of bliss at the garden of Clarens; the death-scenes, at once stoical and spectacular, of Richardson's Clarissa and of Rousseau's Julie d'Etanges. To embrace within the *tableau* as much of the quantity 'happiness' as possible, a principle is invoked which might be called 'ensemblisation'.[10] Everyone and everything must be included, the very young, the very old, all the biological epochs – the innocent pleasures of childhood, the conjugal contentment of maturity, the tranquil detachment of age; every variety of happiness from within the family structure – that of parent, that of child, that of sibling. It is like an encyclopedia; or worse, an inventory – there is more than a trace of a shop-keeping mentality here, contemplating its securities and felicities as though they were hoarded and accountable goods. But unconvincing and distasteful though the 'ensemblising' of happiness may seem to us, there are at least two guiding principles at work which we can more respect. First, that happiness is visible because rational, and rational because quantifiable; the generation of *sensibilité* had only just sensed the possibility of moral calculus. And beyond this, the idea of Humanity – all the categories of human life

must be represented, because only by this means can the idea of a Humanity emerge.

Let us turn to Greuze's *L'Accordée de village* (illustration 54). All the roles and epochs are there. Childhood – in the little brothers and sisters of the village bride, who do not yet understand the significance of what is going on, and whose attention drifts off elsewhere – the girl on the left, attending to her hen and chicks; her younger brother, bored and tired, leaning on the arm of the notary; and the eldest brother, behind the mother's chair, gazing vacantly at the ceiling. Old age – the mother is worn out by it, with her red and swollen hands, and exhausted expression; the father, a venerable, white-haired ancient for whom the ceremony is another nail in the coffin. And maturity – the betrothed couple who form a distinct and separate central group. To make absolutely plain the ensemblisation of happiness, Greuze has created specialised somatic types – so specialised, in fact, that the scene becomes perplexing. How can this aged, defeated man possibly be father to the horde of young children who swarm the painting? How can the mother, whose hands and features are those (I am citing contemporary commentary) of a fishwife, be the mother to such an exquisite daughter? To appeal to 'co'l tempo' is not enough: time does not behave in this way. But the temporal exaggerations are necessary, because for the *tableau* to work, for it to produce the requisite charge of emotion, it must be completely legible; and at this point Greuze joins company with LeBrun. The Greuze child is *all* child: the figure at the lower left edge of the painting has cheeks that are just too chubby, a head that is disproportionately large, and arms that are far too short for the body – because only by carrying further than nature the 'marks of childhood' can the legibility of the stereotype be guaranteed. The young couple seem to belong to a different social and somatic world from the other figures: their idealisation clashes with the gross, caricatural handling of the rest of the family. The girl struck certain visitors to the Salon of 1761 as a chic Parisian shopgirl entirely out of place in the Lyonnais peasant interior;[11] and her young man is similarly too refined or effeminate (though there may be private reasons for this, as we shall see) – he will never age into the physical type of the notary, for example, whose heavy jaw, pronounced nose and sunken mouth belong to a different bodily species. But the stereotype of 'youthful maturity' is defined by the attribute of 'physical gracefulness', and to guarantee the legibility of the scene Greuze will go to almost any lengths; just as he inflicts on the parents failing sight, arthritis, loss of mobility, and all the other recognisable marks of decline, and again with an excess that ends up by interfering with the credibility of the scene.

The ensemblisation of happiness – bringing every kind together into a single place – asks for a gamut, a totality of human types from whose variety the idea of 'humanity' with its powerful emotional and didactic charge, can be generated. Greuze's next great Salon success – *The Dying Grandfather* (illustration 55) – repeats the formula: every age group is present in its specialised somatic representative, and from the gathering together of the divergent types there emerges a mysterious sense – one of Greuze's more original perceptions – of the body as contemplated under genetic time. Greuze never painted landscapes, and his petit-bourgeois families are entirely cut off from the world outside their happy (or unhappy) home; no views of streets, no exteriors – not even doors or windows; the family is hermetically sealed. In this isolation from society, genetic relationships take over and at once dominate the image, since everyone is linked by procreative ties: grandmother, grandfather, father, mother, sister, brother – the biological roles are the only ones available, and curiously the insistence on familial definition is so intense that the emotional atmosphere of the Greuze family, even in its moments of joy, is cold, because friendship and amicability

55 J.-B. Greuze, *The Dying Grandfather*

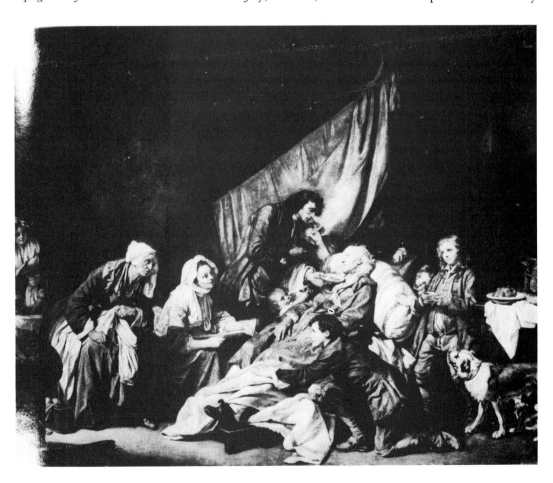

seem to have no possible place – the Greuze family has no neighbours or friends, only servants. This cordon or cartouche thrown around the family again enables a heightening of narrative clarity. Without it, the figures might be taken simply as children, old people, people in their prime; and in fact there are no recognisable marks that in our culture correspond to such meanings as 'daughter', 'son', 'father', 'mother' – no badges or cues which ensure that a figure taken alone can be read as belonging to these positions within the family. With LeBrun's *Queens of Persia*, a whole code of gestures and facial expressions enabled us to translate the image into discourse; but Greuze does not have to rely on elaborate reading techniques such as those LeBrun exploits – all he needs to do is seal his group off from the outer world, throw his cartouche around the image, create a system of somatic typing by age, and 'father', 'sister', 'parent', 'child', and the rest will emerge spontaneously. To be sure, the vanishing of the outer world corresponds to a certain view of the characteristic social experience of the petit-bourgeoisie – its sense of exclusion from the greater society, its recourse to self-sufficiency in the absence of social support. But although we can reclaim the hermetic atmosphere of the Greuze household along class lines, this should not conceal from us the narrative usefulness of enclosure. When combined with Greuze's 'ageist' body-typing, the enclosure makes narrative legibility certain. [12]

If ensemblisation asks for a gamut of human variety, it also asks for the distinct categories it calls into being to dissolve together in the felicity and fusion of *le bonheur*. The scene from Laclos shows us human types or stereotypes as clear-cut as those in Greuze – the aristocrat and the villagers, youth and age, power and helplessness. The people who gather round the scene of Valmont's magnanimity are specialised and visually distinct: if we were to translate the Laclos into pictorial language, no difficulty – at the level of costume (the finery of Valmont, the rags of the family, the intermediate dress of the official) they are fully legible already; and if Greuze had painted the scene, added to the categories of social class, we would see the further categories of age. Ranking by age is less important in Laclos than ranking by economic power, and at the moment prior to Valmont's intervention, an enormous gulf had opened up between rich and poor. The presentation of the gift changes all that: it reunites a society broken into non-communicating economic groups, into a Humanity where everyone is rediscovered as fundamentally the same. Rich and poor, young and old, aristocrat and commoner, all elide together in the access of happiness, and happiness becomes definable precisely as the bringing together of people separated by divisions of category (wealth/poverty,

youth/age) into a higher unity. It is like a policy of adventurous hospitality: as many people as possible will be invited to the gathering, and they will be as different one from another as they can be, but from that very disparateness a new harmony will be forged. The hospitality in Greuze is, of course, a family affair: strangers are not on the whole admitted. But in *La Dame de Charité* (illustration 56) he does tackle Laclos's theme of economic separation – a woman of means, accompanied by her little daughter, visits the sick-bed of one of her impoverished charges. A fusion occurs across the division between riches and poverty; and at the same time a second, much more Greuzian fusion, of biological epochs – age, maturity, and childhood, somatically distinct, and reunited at the level of shared humanity.

It is this moment of fusion that fascinates Greuze, and his interest in that moment is much stronger than his feelings of sentimentality about old age. The problem of age, like the whole issue of the family, is so much with us that paintings such as *La Dame de Charité* or *The Dying Grandfather* are likely to cause us considerable embarrassment: our society does not feel much real respect for the condition of age; on the other hand, it tends to feel guilty about the oppression and exclusion

56 J.-B. Greuze, *La Dame de Charité*

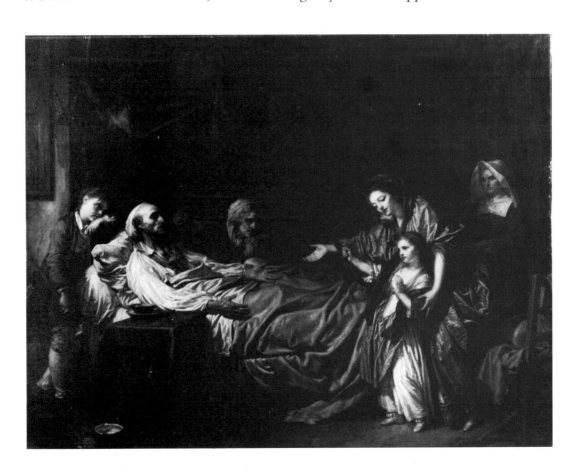

from the so as a
result of ou the
moment no the
level of m: ited
through an ion
with the u any
oppressed g age
tends to arc n to
The Dying not
believe in lves
practise it, not
practising i ze's
painting as nity
that Greuz ogi-
cal momen The
Dying Gra the
Bible is out ould
be round – it of
marriage. L tant
Lyonnais n euze
freezes his d, as
the dowry the
state of spi pera
can protra aria,
Greuze ex then
that essent es or

categories of age, can be seen. The girl in L'Accordée is neither daughter nor wife; she is both of these, and so she is neither, but simply a point of Humanity. She experiences at the same moment the fullness of happiness that comes to her as daughter and as sister, and that second happiness which is destined to sever her from the first, but has not yet done so. The image ensemblises the two incompatible moments of happiness, fuses them, and allows us to see past the biological categories (wife, daughter) to a category-less state that transcends those divisions. And similarly *The Dying Grandfather* insists on its exaggerated somatic typing and distinct familial roles, but by focussing on the moment between life and death it also opens a vista that overcomes those lesser, ageist divisions of humanity by epoch in a higher unity of human essence.

And the same is true of the most perplexing of all the Greuze images, the so-called 'Greuze girl'.[14] The Louvre *The Broken Pitcher* (illustration 57) is one of the more acceptable examples. The oppositions here are manifold. The girl is a stereotypical Greuze child, with her infantile and 'innocent' hand-gesture, her wide eyes and disproportionately enlarged head. But at the same time she is obviously Woman: the marks of initiation

and availability – carmine lips, tumescent breasts – are as exaggerated and hyper-legible as the marks of childhood. Just as the moment of death and the moment of marriage established thresholds where categories that normally cancel each other out can be experienced simultaneously, so here Greuze dwells on and prolongs the hymenal moment when the female is at the same time Child and Woman, Innocence and Experience. The image ensemblises both varieties of happiness and both estates, and we can see it exploiting the strategy of 'divide and elide' present in the Laclos scene: the two distinct somatic stereotypes are superimposed on one place.

In another version of the Greuze girl, *La Colombe Retrouvée* (illustration 58), the strategy is carried to unacceptable lengths. The oppositions are Child/Woman and Innocence/Experience (or Available/Unavailable), as before, but to these is super-added a further pair – Sacred/Profane – which makes the image finally unbearable. The diadem is clearly religious, just as the pineal stare is *spirituel*; but the dove cannot possibly be glossed as 'Holy Spirit', nor even as 'dove', because it so coyly unites an idea of childhood game ('she has found her pet bird') with

57 J.-B. Greuze, *The Broken Pitcher*

an idea of sexuality (the dove, in its suggestive position, establishes connotations of palpitation, smoothness, roundness, that are dangerously close to 'virginal breast'). The image yokes these oppositions together in a scandal at once of logic and of sexuality, where the fused happinesses of *sensibilité* have become open transgression.

I mentioned earlier that the pursuit of happiness in *sensibilité* anticipated some aspects of utilitarianism, particularly in its conception of happiness as a substance that can be measured: utilitarianism also maintains that happiness is quantifiable, so that an individual confronting a moral choice need only work out which of the two courses of action contains the greater amount of happiness, and follow that. It has an immense faith in the capacity of reason to calculate the sum of happiness, and its vision is a consoling one because it so simplifies the real complexity of moral choice – reduces it, in fact, to arithmetic. If happiness is quantifiable, then I can simply add one variety of happiness to the next – bring them all together into one place, by 'ensemblisation': what could be more reasonable?

58 J.-B. Greuze, *La Colombe Retrouvée*

But there is an irrational side to the project, and in *La Colombe Retrouvée* we can begin to see its workings. There is a technical term for the system of ethics that makes happiness the test of rectitude – 'eudaemonism'; the word is useful here, because it has an aura of non-rationality that exactly fits the productions of *sensibilité*.

In *La Nouvelle Héloïse* Rousseau's heroine Julie d'Etanges lives by eudaemonist principle – she wants every kind of happiness, all at once, all in the same place; she believes you can just go on adding one form of happiness to the next, to attain a maximum of abundance. She has no conception of quality that might complicate her calculations by quantity – and this eventually turns out to be her undoing: Rousseau saw through eudaemonism long before the technical philosophers.[15] At an early stage in the novel, she finds herself falling in love with her tutor, Saint-Preux. Her father, who is a Baron, opposes the idea of her marriage to a commoner, but Julie is undeterred. She wants it both ways: wants all the happiness of being her

59 Prud'hon, *Le Premier Baiser*

father's daughter, with its attendant privileges and filial joys; and all the happiness of being mistress to Saint-Preux. Enlisting the aid of her obliging cousin Claire, she lures Saint-Preux into the arbour of her father's house for a strange triangular ceremony: Saint-Preux is to kiss first Claire, then herself; this he does, and during the second kiss Julie promptly faints away – a moment beautifully imagined by Prud'hon (illustration 59). Rousseau's novel progressively criticises the dangerous fusions that dominate Julie's thinking about choice (which he relates to the psychology of incest), and some of her later attempts to possess both father and lover at once are plainly pathological. The rendezvous in the arbour does not yet have the full irrationality of her later fantasies, but it already shows the double-think of her eudaemonism. Unwilling to leave *la maison paternelle*, yet in love with a man who comes from outside the family circle and whose natural habitat is the wilderness, Julie simply elides the territories of father and of lover into a mediating middle ground – the arbour, neither wholly 'of the house' nor wholly 'Nature'. Julie intends to remain loyal to her family, yet also to renounce the family for the stranger Saint-Preux, and so she chooses as accomplice her cousin, where the place of the cousin within the family structure corresponds to the middle ground of the arbour, for cousins are both 'exofamilial' and 'endofamilial'.[16] And she wants her affair with Saint-Preux to be both Platonic and passionate; hence the ruse of the asexual first kiss, which will make the second one both legitimate and exciting. All eminently rational, but also blind: the fusion is built on a negation of the prerogative of mature choice, a negation that seems dangerously regressive. And Greuze behaves in the same way. The girl in *The Broken Pitcher* superimposes or ensemblises both estates, of childhood and womanhood, innocence and knowledge, purity and danger.[17] The bride in *L'Accordée* is at the same time fully daughter and fully wife – just as Julie would like to be. But there is a non-rational undercurrent at work in both images, and eventually this comes to interest us more than the official celebrations of eudaemonism the paintings claim to be.

The felicity of *sensibilité* can only exist by denying the possibility of fractures or incompatibilities within *le bonheur*. But strangely Greuze does nothing to conceal the idea of incompatibility in one of his most disturbing images, *La Mère Bien-aimée* (illustration 60); indeed, he seems shockingly unaware of the incompatibility that must strike every viewer. The mother, I need hardly say, is all mother: Diderot remarked that the painting 'preached population',[18] and Madame Geoffrin spoke of a *fricasseé d'enfants*.[19] And the father is all father, lost in rapturous contemplation of his progeny. But at the same time

the two are very clearly man and wife: Greuze shows them in a state of amorous undress – although the husband has merely returned from shooting, his clothes seem as ready to fall to the ground as his wife's, and there is an actual discarded dress in the foreground.[20] The additive logic of *sensibilité*, like the eliding imagination of Julie D'Etanges, believes that you can simply place one happiness over another. But not in front of the children: that is that irrationality of the image – it brings together in one place that which must be kept apart, like incest (which might be described as an extreme instance of 'ensemblisation'). Greuze cannot resist his dangerous fusions, and it begins to emerge that for him the image is *the* place where the happinesses that reality keeps separate may be returned to blissful unity. Commenting on his painting of a married couple snuggling up together over the cradle of their offspring, the Goncourts voiced their united shock: 'When he would depict conjugal happiness ... the parents seem to smile with the smile of sensual pleasure, the gesture of the mother is the caress of the *demi-mondaine*'; and Diderot had no doubts at all about the atmosphere of perversion in *La Mère Bien-aimée*: 'that half-open mouth, those swimming eyes, that relaxed position, that swollen throat, that voluptuous mixture of pain and pleasure, obliges all decent women in the place [the Salon]

60 J.-B. Greuze, *La Mère Bien-aimée*

to lower their eyes and blush with shame'. But for Greuze it is simply Abundance: he has no sense of qualities and incompatibilities amongst the varieties of happiness, or if he has that sense it has been suppressed. In painting his beloved Greuze girls, he shows no awareness at all, that he has become the Humbert Humbert of painting.

We have not so far addressed the problem of the place of unconscious or repressed desire in the formation of images, but with Greuze that confrontation is essential, and only by working out some of the psychology behind his paintings can we really make sense of them. From one point of view, Greuze creates entirely discursive images. The heavy somatic typing and the enclosures thrown round the family unit ensure that we read his work as clearly as we read that of LeBrun. His contemporaries were delighted by this heightened expressivity: he was called 'le Molière de nos peintres';[21] it was remarked that his output formed what was almost a continuous narrative sequence – 'the subjects that this young painter imagines and executes so well might one day form a complete treatise of domestic morality';[22] *The Dying Grandfather* was enthusiastically greeted as 'the *final instalment* of a *pastoral* poem of which the *author* had provided earlier *episodes* in preceding Salons' (my italics).[23] Greuze answered a demand for a new discursivity in painting that we can date from du Bos;[24] just before Greuze made his first appearance at the Salon, Baillet de Saint-Julien had been saying 'I know that the composition of a picture is important, its colour affects me greatly, its drawing even more; but more than all this, I ask for truth, character, expression.'[25] Greuze was so successful so quickly because the climate of opinion had been waiting for a high-discursive painting for some time, as part of the emergent anti-rococo taste: Floding at once compared Greuze to LeBrun;[26] Diderot hailed him as 'your painter and mine, the first to serialise events in such a way that one could write a novel about them'.[27] And Diderot very nearly did write a novel, or at least a novella, about the *Girl Mourning her dead Canary*. He found Greuze enormously stimulating to the literary imagination, and his tribute to Greuze was to say what Greuze does not say, like the Goncourts before Watteau, and to offer a written space into which the images could fully expand.[28]

But although narrativity is so important in Greuze, his paintings are often complicated by forces that cannot be articulated at an explicit narrative level. We sometimes think of the unconscious mind as a storehouse or repository of dream-like images, which may at times surface into paintings; the idea of an image-bank was central in Jung, and for a long time that Jungian way of thinking coloured much of our perception of,

for example, Surrealism: the Surrealist painter was reputed to have found the key to that hidden vault. But psychoanalysis has never believed in that vault, and as the analyst listens to the analysand's speech, he is not trying to gain access to a bank of stored contents, but listening rather for the moments when the surface of the speech deforms or breaks under the pressure of fear or desire. The unconscious is a field of distortion, not a repertoire of contents, because the point is that the unconscious is precisely that which cannot be spoken (or painted): it is outside language, beyond the limit of retrievability – we cannot just translate the unconscious into images. Its very existence is a matter of inference, from observed distortions of normal continuities. For example, in dreaming, the continuous stream of waking experience is submitted to a process of deconstitution and rearrangement in which the normal logic of the real can be subverted to fit the conflicting demands of desire and of censorship; again, when the analysand speaks, the continuity of his *récit* is constantly threatened at the points where it nears the locus of his desire or his pain. Greuze offers us eminently intelligible texts – serialised novels, treatises on domestic morality, *drames bourgeois*. But the clarity of his text is constantly coming up against charged areas or topics that cannot themselves be directly expressed. The most glaring instance is the Greuze girl: he has blurred and elided two distinct images of the female that cannot, logically, co-exist: 'virgin' and 'non-virgin'; and two mutually exclusive attitudes towards the female body – unavailable child, available adult – whose elision is prohibited. But in the image, the two can and do co-exist, and for Greuze the image is prized precisely because it can overcome the restraints and contradictions of the real: it is the place of sanctioned transgression, where the bans and proscriptions of external and psychic authority can be negated at will.

A rather more subtle field of distortion centres on the figure of the *paterfamilias*. Greuze offers us an apparently unbroken continuity of generations – from infancy to childhood, to adolescence, to maturity, through to age and old age; because he offers us this continuous fabric of time, we can see very clearly where the fabric becomes warped; and it warps at the point of the potent male in his prime. It is as though Greuze could never bring himself to paint that figure. Often he senesces his fathers, so that we find it impossible to believe that these white-haired, moribund relics could possibly sire their tribes of small children: this is the case with the father in *L'Accordée*, and also in *Le Fils puni* (illustration 61). Or he manages to bypass the potent male altogether, and to form a curious link between very young women and elderly patriarchs: in *The Widow and her Curate* (illustration 62), the

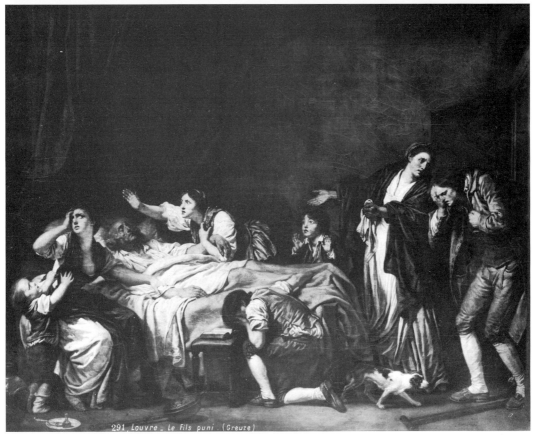

61 J.-B. Greuze, *Le Fils Puni*

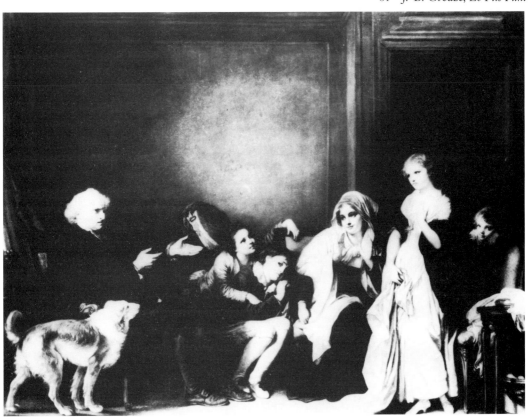

62 J.-B. Greuze, *The Widow and her Curate*

husband is dead, and now that he is out of the way his place can be taken by a figure of extreme age, with whom Greuze feels less anxiety. It is the same with the *Hermit* (illustration 63): a harem of nubile maidens swarm around the patriarch, but the male has been depotentiated by age, and perhaps also by priestly celibacy. When Greuze does come directly to address the image of the father, he thinks in terms of excess. The father is either incredibly potent, like the tyrannical avenger in *The Paternal Curse* (illustration 64) who by a single gesture reduces his son to quivering wreckage; or he is not powerful enough, like the wastrel who staggers into the frightened and de-stabilised household in *The Drunkard's Return* (illustration 65). The father is either disproportionately destructive – even in old age, his curse is still totally damning, as the Lucerne version of the curse theme shows (illustration 66); or he is all feeling, a source of absolute forgiveness and grace, as in *The Paternal Blessing* (illustration 67).

Greuze cannot paint the father with dispassion, and even when his subjects are not necessarily paternal at all, but simply powerful males in their full maturity, again he distorts by depotentiation. No one has ever painted a more extraordinary

63 J.-B. Greuze, *Hermit*
(Le Donneur des Chapelets)

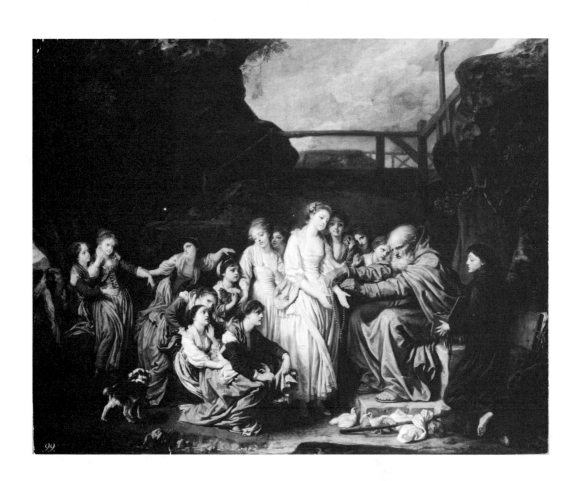

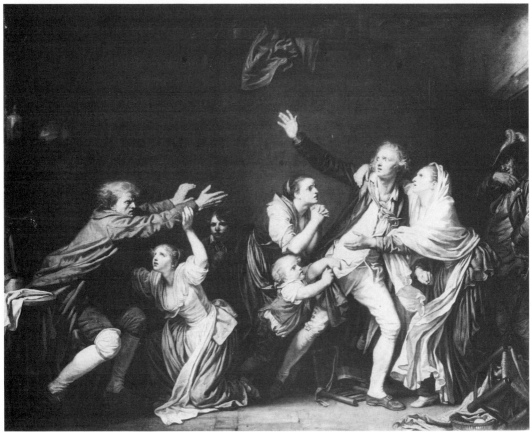

64 J.-B. Greuze, *The Paternal Curse*

65 J.-B. Greuze, *The Drunkard's Return*

66 J.-B. Greuze, *The Paternal Curse*

67 J.-B. Greuze, *The Paternal Blessing*

likeness of Napoleon (illustration 68): the First Consul is rendered as a girlish schoolboy. The Leningrad study of the head of a mature male shows a similar process at work, only the ageing works the other way (illustration 69): instead of forcing the figure back into adolescence, as with Napoleon, here he is propelled forward in epochal time, and beneath the face of a man still young we can see the hollow cheeks, the haggardness, and the loss of strength, of the Greuzian ancient.

Greuze's anxiety in the presence of the virile male is responsible for a remarkable stock of gestures. They often resemble those in David, who is closer to Greuze than we tend to think; though it must be said that in David the excessiveness of the gestures is defused by making the whole context consonant with their intensity. The key gesture – which will dominate the *Oath of the Horatii* (illustration 92), the *Oath of the Tennis Court* (illustration 88) and the *Distribution of the Eagles*, is the outstretched arm – the thunderbolt of potency. *The Paternal*

68 J.-B. Greuze, *Napoleon Bonaparte*

Curse shows it in its full, Zeus-like power; in a milder form it becomes the commanding come-hither of the curate. Another variant is the arm of the Emperor in *Severus and Caracalla* (illustration 70), as he inflicts the patriarchal curse on his renegade son, a curse that reduces him to swooning effeminacy. This is a painting that caused Greuze a lot of trouble: he submitted it to the Académie and hoped thereby to be raised to the rank of History Painter; but his plan misfired, the Académie admitted him only to the rank of genre painter, ignoring the wider claim of *Severus and Caracalla*, which became the butt of much critical ridicule. 'The son is an idiot; I say an idiot because he is not stricken with remorse, as an illustrious criminal should be, but shamefaced, as if he had been caught stealing lead from a roof.'[29] The thunderbolt gesture has miscarried and it was observed that 'the Emperor stretches out an arm a yard long, and in the process dislocates his wrist'.[30] Because the arm is so disproportionate Greuze has been forced, it was said, to lengthen the Emperor's leg 'beyond

69 J.-B. Greuze, *Study of a man's head*

all reason; the right thigh and leg seem to go on forever'.[31] Everyone could see the absurdity of the painting except Greuze, who went on and on defending it publicly, and making such a fool of himself that his work after 1769 is far more academic and dignified than before (it even aspires to an early and impressive neo-classicism), as though he were constantly atoning for his lapse. And one possible reason for Greuze's blindness to the inadequacy of his painting is that his feelings about patriarchal power were both so intense, and so unacknowledged, that he was unable to perceive the reality of his image as visual design.

It is only in a very late work, *Le Premier Sillon* (illustration 71) that the patriarchal arm manages to transmit its authority to the succeeding generations harmoniously. The father, standing immediately behind his son, raises his arm into the thunderbolt position, but the potency is now carried forward to his offspring in this, his first and rather belated attempt to furrow the soil. The image is trying to restore the genetic continuity which had for so long been broken at the point of the father, and significantly, it is an exhausted, enfeebled work: Greuze needed that anxiety to energise his enterprise. In old age he is no longer troubled by the issue, and he really can see the continuum of genetic time; but by now he is out of the

70 J.-B. Greuze, *Severus and Caracalla*

running. In an earlier treatment of the same theme, the sketch of the *Three Ages of Man* at Tournus, he is still agitated, and beneath the sketch there is the following rubric:

> Je t'ai porté
> Tu me portes
> Il te portera

It is rather a riddle, but the 'Je' is the patriarch who is being carried on the shoulders of his Aeneas-like son; the image refuses even in its gloss to identify with the middle-epoch male. And whether they are receiving the wrathful malediction or the paternal blessing, the sons in Greuze are always lesser than their sires. In the *Paternal Curse* (illustration 66) the raised arm and out-turned palm signify helplessness and abjection; just as the returning son in *Le Fils puni* (illustration 62) seems to have aged a decade since entering the scene, and it looks as though he will never get over the shock.

Although committed to explicit, rational narratives and to an ensemblisation of happiness that does not in itself seem to have any connection with the irrational, the images in Greuze often contain an emotional charge that cannot be directly faced at their overt narrative level. The 'neurotic' Greuze cannot articulate his anxiety over the question of virile potency, nor can he be honest about his interest in 'nymphets'.[32] He is not fully self-conscious – this is his most disquieting characteristic;

71 J.-B. Greuze, *Le Premier Sillon*

the Greuze girl could only have been produced in such shame-
lessness, and in such quantity, by a man unaware of the odd-
ness of his obsession. As a result his paintings have an uneasy
relationship to text, a relationship that in many ways resem-
bles that of the analysand to his *récit*. An inexpressible second
'text', of neurosis or at least of unacknowledged emotional
involvement, lies outside the first, which is that of conscious
and regulated narrative. And this makes his work, despite its
highly discursive aspect, strangely non-discursive: Greuze
becomes aroused, and his paintings become increasingly
interesting, when the overt discursivity is menaced or
deflected by distortive forces he does not apparently recognise
or understand – when the rational discourse becomes
impaired.

In nearly all the paintings we have discussed in this study,
discourse has acted as a control acting on the image, but with
Greuze the *dirigisme* of text is at last under challenge. What is
left of the image beyond its discursive content, its 'being-as-
image', outside the requirements of legibility and narrative
clarity – that other aspect of the image, which we have been
calling figurality, is now *at odds* with the official discursive
project. And in this Greuze is the founder of a conflict between
official discursive purpose and figural actuality which will
develop fully in Romanticism. David's paintings everywhere
show a strange conflict between the genders: he divides
humanity not just into the two sexes, but into two distinct
species, where the males are concerned only with political
action, heroism, and self-sacrifice, and where the female loyal-
ties invert the male ones – family before state, the rights of
children before the rights of the polis, peace before war. Some
of this conflict can be articulated into the acknowledged and
overt narrative, but much cannot; and again as with Greuze, in
old age, when the conflict between the genders or between
'male and female psychic principles' (our vocabulary here is
pitifully limited) is more or less passed, there is a loss of
tension, sadly evident in the boudoir mythologies of David's
declining years. Gros will also develop to an extreme where
the intelligibility of the image is directly threatened, a contra-
diction between discursive intent and figural reality: *Napoleon
at Eylau* officially celebrates the Emperor's victory, but the
emphasis given to its colossal, agonised figures of dead and
dying soldiers in the foreground belies the official purpose,
and the contradiction cannot be resolved at a textual level
(Gros cannot accuse the Napoleonic adventure of cruelty or
misguidedness).

The breakdown of discourse under the pressure of that
which can be neither admitted nor abolished makes Greuze a
far more figural painter than the painter with whom he is often

compared: Hogarth. Greuze was clearly influenced by Hogarth, or at least by the Hogarth of the engravings, which were all he could be known by in France; and in particular by the set of engravings known as *Industry and Idleness*. There, a systematic contrast of the fates of the 'good' and 'bad' apprentices generates such a powerful semantic field that, in fact, no one believes in it. The device of antithesis, in itself one of the most powerful mechanisms for the production of meaning, is so overweening that the viewer becomes sceptical, reluctant to accept the glaring official text (of the rewards of industry, of the terrible punishment that awaits vice), and he begins to look instead for the traces of an inversion of the official text, where industry is criticised (as mercenary, hypocritical, obsequious) and vice admired (as vivacious, tragic, human). The fascination of the series lies in Hogarth's play between 'official' and 'unofficial' readings – he is the great master of shifting textual levels. Greuze comes closer to Hogarth than any other continental artist, and his projected series *Bazile et Thibault, ou les Deux Educations* seems modelled directly on Hogarth's set. Here are the project's two closing sections.

Bazile marries. Bazile marries Manon Baster. Tender farewells from Manon to her mother: the scene takes place in the presence of several girls from the village. Some weep, others laugh, each expresses pain or pleasure in her own way. The mother, standing by the horse on which her daughter, dressed in a riding habit, is mounted, holds her hand and turns her head away to hide her tears; her father seems to be wishing her happiness. The daughter seizes her father's hand and kisses it. Bazile, on horseback beside his bride, impatiently awaits the end of all these congratulations.

Thibault's Tragic End at the Age of Thirty. Thibault is visited in gaol by his father and grandmother. The gaoler stands by the door; he holds a large dog by a chain and a set of keys; in the other hand a torch which illuminates the scene. The grandmother stands on the bottom step of the staircase leading down into the dungeon; she is bent by age and misfortune. The father, standing by his son, addresses him thus: 'Lift your head and look at me; look on your father for the last time. The Sword of Justice does not strike fathers guilty of their children's misdemeanours. It is I who cast you into the terrible abyss in which I now see you by not reproving your wretched instincts when you were a child. You will serve as an example to thoughtless fathers, and as for me, to show posterity the extent of my despair, I shall kill myself before your eyes.' He kills himself and falls into the arms of his wife, who succumbs a few minutes afterwards. The gaoler turns his head away in terror and appears to be crying for help.[33]

The two scenes seem to be pure Hogarth (cf. illustrations 72 and 73). But there are crucial differences. In Hogarth there is always that second level of reading – if there were not, we would find the series lacking in interest. At this second, darker level the antitheses of the official text are turned upside-down:

72 Hogarth, *Industry and Idleness*

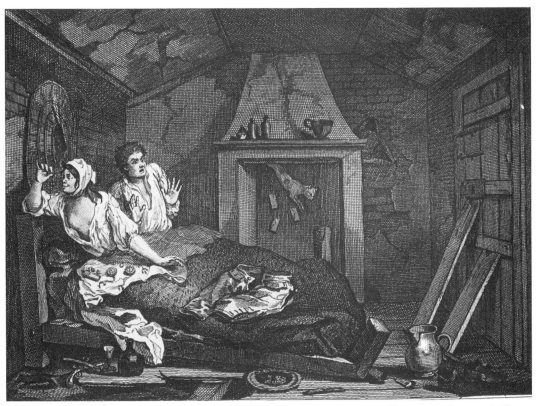

73 Hogarth, *Industry and Idleness*

the virtuous apprentice, the Thibault-figure, becomes in-sufferable, and the idle apprentice, the Bazile-figure, emerges an anti-hero. Between these two signifying levels, of official morality and its unofficial counterpoint, the Hogarth image is entirely *exhausted*: what cannot fit the first level drops to the second and is processed there, and as we gaze at the series we are asked to perform, repeatedly, and in two different regis-ters, an act of extraction which is always the same and ends by finally emptying the image of all of its content. Irony in Hogarth – the interplay between the two textual levels – works as an instrument for subjecting the image to an absolute con-trol by text: despite its apparent playfulness it is authoritarian, expropriative, and entirely anti-figural.

Greuze has a mania for textuality but it never fully masters the image, because those aspects of his emotional make-up which he cannot fully confront never rise to the explicitness or patency of the Hogarth text. They remain outside discourse, and the viewer registers them by noticing, like the analyst, those things Greuze cannot see or say; by attending to the area of the image unoccupied by discourse – its figurality. The viewer does not drain the image dry, as he does with Hogarth's series, because there is no second text waiting below the first, to accomplish the full disposability of the image. Hogarth has placed the ironic second level in such a way that we trust it: by a process that was discussed in the first chapter, his second level is actually thought more realistic (distance *from* official text is read is approximation *towards* the real); more in keeping with the literary context Hogarth found himself working in – more 'Hogarthian'. But Greuze has no awareness of a second level; he is painfully self-censored (and humourless). In *The Broken Pitcher* (illustration 57), the defloration he wants to contemplate is translated into the rather appalling symbol of the cracked vessel, and in another image from another brush the effect might remain at a level of acceptable banality; but Greuze goes on to linger over the exact fracturing into shards of the vessel, and to point to the censored zone of defloration almost with arrows, so that his reticence becomes the vehicle for an insistence that is obsessively overcharged. It is the same with the girl who mourns the loss of her canary (illustration 74): we do not have to be Diderot to realise what that signifies, but the point is that whereas Diderot is relaxed enough to bring what Greuze does not state into the full consciousness and visibility of discourse, Greuze is inhibited, and his crude symbolic language is the nearest he can get at all to articulating his erotic interest at all. The image is useful to him exactly because its figurality allows him to contact sexual pleasure without having to make the forbidden sexuality explicit. Painting manages to evade the psychic censorship: although so

much of his imagery is offered up to publicity and discourse, some he keeps for private purposes; or private to Greuze, obvious to everyone else.

The pursuit of happiness is at the centre of Greuze because painting supplies him with a context where his disavowed desires and unacknowledged anxieties can be indulged and resolved without personal risk: utopia. If Greuze had decided to remain within a Northern realist tradition, the disparity between official discourse and its unofficial hesitations and distortions might have been less apparent; but Greuze insists on a didactic role for his images, he wants to raise genre to the level of history painting, he is fascinated by *exempla* – and so his outlawed libidinal energies are thrown into relief. Yet in at least one respect Greuze is fortunate: we cannot tell just how exhortative his images were meant to be. Diderot commented that *La Mère Bien-aimée* 'preached population', and of course he intended this remark ironically: he was fully aware of the disturbing side to the painting. But if we ask exactly what it is Greuze does preach, the answer is that we cannot be sure. It cannot be the doctrine of the happy home: there are too many

74 J.-B. Greuze, *Girl Mourning her dead bird*

images of pain for that to be true, and Greuze owes much of whatever current accessibility he has to the dark side of his family histories, and the quality of genuine nightmare he is able to introduce into the bourgeois hearth. But if he is not preaching family, it is not clear what else could form the didactic centre. And the effect of this uncertainty is to lessen the gap between public and private aspects of his imagery: he is not placing discourse in a position of such exalted authority that his own private reworking of the image visibly clashes with the official textual controls, as it does in Gros.

Greuze is also protected by the idea that bourgeois realism is in itself a moral style. In the *Eloge de Richardson* it is at times almost impossible for us to decide which Diderot is praising, Richardson's morality or his illusionism. Because he is persuaded to identify himself with the evil as well as the good characters, it seems that illusionism might be a morally dangerous instrument: but he also states that identification with characters of even negative moral complexion can be improving, in that abnegation of self is beneficial in any form; the loss of self that occurs when reading Richardson is good *per se*.[34] This places the act of empathy outside considerations of right and wrong, and the same dislocation of empathy from moral co-ordinates colours Greuze: it is enough that his scenes of domestic horror move us – he is not making a further didactic statement about the desirability or otherwise of the family, and the absence of exhortation prevents the private, extra-discursive use of the image from moving so far from official purpose that the distance between the two becomes openly disruptive. It is only when Greuze aspires to history painting, as in the *Severus and Caracalla* (illustration 70), that such disparity becomes unbearable, at least if we look at the work through eighteenth-century eyes; though even then the gulf is less between a didactic intent and its subversion – *Severus and Caracalla* preaches nothing at all – than between public and private uses of the image: Greuze had taken a scene that belongs equally to everyone (in the sense that we are all legatees of the history of Antiquity), and introduced into it the scandal of his own personality; that is the essence of the shock, as it will be with Delacroix's *Sardanapalus* (the domestic scenes, because tied down to a specific social milieu, cannot rise to the publicity and impersonality of the historical subject, and Greuze's intrusive personality is accordingly less visible).

But even though Greuze's didactic mission is obscure, enough of it is evident for us to register that the discursivity of his paintings issues some form of command to the viewer, if only the morally neutral order, to empathise; and there is enough exhortation in such an order for subversion of the command to appear as anti-discursive. We cease to obey the

order the moment we recognise that language is not in full control of the image: as soon as an aspect of the image is recognised as incongruent with the discursive control, we reject the whole apparatus of control, and instead of allowing the discursive order 'empathise!' to guide our reception of the image, we start to attend to the pathology of the image and of its producer; and once we do that it is we ourselves who are in control of the image, and not its official discourse. Unlike Greuze, we can see the unacknowledged emotional charge of the image and can bring that charge into full discursive visibility; the language of our description takes into account what the overt narrative level was unable to state. This amounts to saying that the language of criticism steps in to take over the image whenever its own official language falters, and given what we have seen of the repressive aspect of the work of discourse on the image, there is a sense in which we can never allow an image to stand outside discourse for too long; and I think that this is true. Once an image such as the *Sardanapalus* is re-cast in an officially sanctioned language that aims at full possession – for example, the language of psychoanalysis – its disruptive effect is contained; it remains a masterpiece, but a masterpiece of pathology.

The work of Greuze is by no means at the same level of technical accomplishment as Delacroix, but their fates have been similar: the real power of such images as the *Sardanapalus* or, for example, *La Mère Bien-aimée* lies in the spectacle of collision between a public, familiar and consoling discourse meeting desires and fears that cannot be articulated within that discourse; the impact comes from the collapse and the destruction of the official language. But only a moment away is the re-ordering, rehabilitating language of pathology, which comes in to restore the primacy of discourse, this time using a discourse that will 'work' more successfully that the one so painfully destroyed. The half-life of the image as image – as a visual experience that cannot be linguistically contained – is incremental; and also indescribable – to bring into language the experience of discursive breakdown is already to have surpassed the stage of shock. The real power of Greuze is to embarrass, to disturb our normal categories, to flirt with abomination, to confront us with the libidinal forces Greuze himself will not acknowledge; but the moment we articulate our embarrassment and our distress, Greuze's images have been overcome: it is their sorrowful destiny to be returned to the state of equilibrium Greuze himself probably believed had always been theirs.

6 *Diderot and the word*

THE *SALONS* were conceived by their author, Denis Diderot, and by Grimm, their impresario, as an act of unprecedented and magnificent waste. It is important to grasp the scale of the opportunity they both seized and so spectacularly threw away. Diderot, at the height of his powers, and celebrated throughout Europe as the guiding force behind the now completed *Encyclopédie*, was invited by Grimm to write, without restraint of length or of content, on each of the biennial Salons in Paris. Increasingly the French public believed the school of Paris to outrank painting in any other European nation,[1] and increasingly the visitors to the Salons *were* the public, all ranks of French society attending an event which cost them nothing, anyone, in fact, interested in seeing and judging painting for himself. Diderot's language was immediate and intelligible to everyone who could read; far more accessible than the literary pamphlets, by Daudet de Jossan, by Mathon de la Cour, by the Abbé de la Garde, which were beginning to appear round each Salon, in response to the growing public interest. And the public were far more involved in the new painting than before, in the years of Diderot's first *Salons*: in Greuze, the star of the *Salons* of 1761, 1763, and 1765, they could see that painting was no longer an isolated art, but one deeply allied on one side to literature and on the other to the stage. The phenomenon of alliance across the arts, mutually strengthening the impact of each, made the Salons far more interesting than before: a whole iconography, shared by the stage, the novel, and painting, linked each area of artistic experience, all three moving in formation and supported by an enthusiastic metropolitan public. Yet despite this unique cultural situation, Diderot and Grimm made their decision: the *Salons* would never reach the public; would never, in fact, be printed, but only circulated, to an exclusive subscription of patrons; patrons who did not live in Paris or even in France, but far away, across the Rhine, patrons who might never see the paintings Diderot, in his nine *Salons*, was writing about.

Their loss, others' gain. Gain first for the nineteenth century, which rediscovered or discovered the *Salons* (none was published before 1798) and continued to admire in them a balance between the activities of painting and of writing which in the art criticism of the nineteenth century was becoming

increasingly unattainable.[2] As the Parisian Salons advance into the Romantic era, the writer of Salon-criticism finds himself in an ever more precarious position: it is the painter who has the Romantic *mana*, and the critic is only an uninspired and secondary commentator, mediating between the works of inspirational genius and a benighted or inert bourgeois public; a galvaniser who is neither of the public nor in prestige anything like the equal of the painters it is his task to promote or defend. To Stendhal and to Baudelaire, the *Salons* of Diderot mean language and painting *on a par*, and, specifically, a precedent for the kind of art criticism where word and image can mutually react one against the other as equals and as partners – the kind of art criticism Baudelaire and Stendhal in their different ways both aspired towards. And the *Salons*, in the twentieth century, offer a similar utopia and nostalgia: although a Greenberg or a Rosenberg may exercise considerable critical influence, it is largely through presenting unified, coherent, and indeed militant theory that their work succeeds and comes to its position of authority. Diderot, writing for a small, select, and non-theorising audience has no need to erect a corpus of theory to justify his criticism; he enjoys to the full what no critic writing today can afford, the pleasure of changing his mind and the freedom to ignore theoretical constraints. Utopian also, within the professionalised (if not bureaucratised) world of twentieth-century writing on art, is Diderot's occupancy of a language which is not yet 'policed' and where it is still possible to speak *à son gré*; the enhanced and enviable freedom of the pioneer.

It is impossible to divorce Diderot's views on painting from his sense of place-within-language – the place of the writer, of the painter, and of art criticism; if, behind the volatility, mobility and fluidity of Diderot's *oeuvre* there is any centre at all, it lies in a meditation on the nature of language and of signs, conducted at a level so deep that its influence can be detected not only in the *Salons* but even in genres as different one from another as the *Encyclopédie* entries, the dramatic dialogue, and the pornographic novella. And here, despite his disadvantages, the present-day reader of the *Salons* is in a position more clearly to discern consistent features and tendencies within the *Salons* than the reader of previous generations, simply because we have given so much thought to the nature of language, and have begun to extend that interest towards systems of signs outside language. At a fairly unsophisticated level, Diderot's language seems either very *lively* or very *literary*; either the work of a voice which has somehow managed to translate itself into writing without loss of its original vitality and freshness; or the opposite of this, the rambling penwork of an entertaining but highly self-conscious belles-lettrist. And for a

long time it was believed that there were two Diderots: Sainte-Beuve insisted that there was a 'good' Diderot, full of energy, and a 'bad' one, full of extravagance;[3] Dieckmann argued that at some moments Diderot's expression is 'adequate to his ideas', but at other times 'il écrit comme il parle ... Trop mauvais artisan pour être un très grand artiste ... Le facilité de la plume suffit'.[4] For as long as Diderot's work was divided into two such classes, understanding of Diderot's work was limited and it was only with Leo Spitzer's famous study, in *Linguistics and Literary History* (1945), that the claim was advanced for a uniform Diderot, not two but one, and for a unitary prose style, great precisely because it was so unified.

Spitzer's position is similar to the one put forward by Erich Auerbach in *Mimesis*, and between them the two works exemplify an attitude towards language which Diderot is well-suited to illustrate: that the patterns the critic perceives in a literary text are not 'style' in the sense of adornment, but style as the expression within the work of conditions operating *on* the work *from outside* itself – conditions that may be political, historical, or psychological. This is Spitzer:

I had often been struck, in reading Diderot, by a rhythmic pattern in which I seemed to hear the echo of Diderot's speaking voice: a self-accentuating rhythm, suggesting that the 'speaker' is swept away by a wave of passion which tends to flood all limits. This pattern (which is a feature quite at variance with classical style) is apt to appear, with varied nuances, anywhere in Diderot's writings, didactic as well as narrative (or epistolary). The conclusion seemed obvious that this rhythm was conditioned by a certain nervous temperament which, instead of being tempered by style, was allowed to energise style ... It would then appear that, in this writer, nervous system, philosophical system, and 'stylistic system' are exceptionally well attuned.[5]

The idea of 'attunement' amongst different systems is crucial to Auerbach/Spitzer stylistics: if all the systems are attuned properly (this becoming a central aesthetic requirement), if the language *within* a literary text is tuned in a harmonic series to the systems *outside* it – to the personal psychology behind the text, to the historical process behind the personal psychology – then by analysing one system you are analysing them all; by exploring 'style' you are in fact exploring psychology and history – an enormously increased field of study from the restricted German philology which formed the intellectual background to Spitzer and Auerbach.

Clearly this approach, with its idea of work as hologram (each fragment or detail is reputed to contain the pattern of the Whole) runs easily to mystification and excess: soon one encounters claims that the break-up of regulated Ciceronian

syntax 'matches' the break-up of the *pax romana*, that the preterite tense is the appropriate verbal form of the bourgeoisie, and so forth. And the Spitzer/Auerbach approach is committed to ideas of 'reflection' (the work perfectly mirroring conditions outside itself) and of holism (culture and work sharing a continuous 'common shape') which exclude other, equally interesting possibilities: that there is no such reflection, or if there seems to be it is only under certain conditions;[6] that culture and text are not linked in a seamless Whole, or if they are, it is only when the text is platitudinous.[7] Yet despite its difficulties, the Spitzer analysis yields *with Diderot* interesting results – it seems the best available approach; and a version of the Spitzerian analysis will be undertaken here, to explore both its successes and its limitations.

I will state my conclusions now: that such analysis works best on the 'transparent' Diderot, the Diderot who tries to write as though he were speaking aloud, the Diderot who performs hygienically on language to remove from it the *impediment* of the sign and to clarify it to the point where it can incorporate the actual motion of mind and of body; but that this is not all of Diderot, because besides this magician who manages to write as though language were purely fenestral, there is another Diderot, for whom language, like all other forms of the sign, is *opaque*, not relay but independent producer of meaning, not reflector but autonomous generator of signification. What I discover is an oscillating Diderot who both dreams of limpid, unmediated communication, and calls that dream illusion; a Diderot whose oscillation between the two positions persuaded him first to champion Greuze and then to dissociate himself from Greuze; to praise Chardin first as a naturalist and then to turn round and call him a master-technician: to revere painting throughout the 1760s as a uniquely efficient and satisfying mode of communication, and in the 1770s to lose his interest in painting altogether.

ENCYCLOPÉDIE ARTICLE, 'JOUISSANCE'
JOUISSANCE, s.f. (gram. et morale). Jouir, c'est connaître, éprouver, sentir les avantages de posséder: on possède souvent sans jouir. A qui sont ces magnifiques palais? qui est-ce qui a planté ces jardins immenses? c'est le souverain: qui est-ce qui en jouit, c'est moi.

Mais laissons ces palais magnifiques que le souverain a construit pour d'autres que lui, ces jardins enchanteurs où il ne se promène jamais, et arrêtons-nous à la volupté qui perpétue la chaîne des êtres vivants, et à laquelle on a consacré le mot de *jouissance*.

Entre les objets que la nature offre de toutes parts à nos désirs, vous qui avez une âme, dites-moi, y en a-t-il un plus digne de notre poursuite, dont la possession et la *jouissance* puissent nous rendre aussi heureux que celles de l'être qui pense et sent comme vous, qui a les mêmes idées, qui éprouve la même chaleur, les mêmes transports,

qui porte ses bras tendres et delicats vers les vôtres, qui vous enlace, et dont les caresses seront suivies de l'existence d'un nouvel être qui sera semblable à l'un de vous, qui dans ses premiers mouvements vous cherchera pour vous serrer, que vous élèverez à vos côtés, que vous aimerez ensemble, qui vous protégera dans votre vieillesse, qui vous respectera en tout temps, et dont la naissance heureuse a déjà fortifié le lien qui vous unissait?...

La propagation des êtres est le plus grand objet de la nature. Elle y sollicite impérieusement les deux sexes, aussitôt qu'ils ont reçu ce qu'elle leur destinait de force et de beauté. Une inquiétude vague et mélancolique les avertit du moment; leur état est mêlé de peine et de plaisir. C'est alors qu'ils écoutent leurs sens, et qu'ils portent une attention réfléchie sur eux-mêmes. Un individu se presente-t-il à un individu de la même espèce et d'un sexe différent, le sentiment de tout autre besoin est suspendu; le coeur palpite; les membres tressaillent; des images voluptueuses errent dans le cerveau; des torrents d'esprits coulent dans les nerfs, les irritent, et vont se rendre au siège d'un nouveau sens qui se déclare et qui tourmente. La vue se trouble, le délire naît; la raison, esclave de l'instinct, se borne à le servir, et la nature est satisfaite.

C'est ainsi que les choses passaient à la naissance du monde, et qu'elles se passent encore au fond de l'antre du sauvage adulte.

Mais lorsque la femme commença à discerner, lorsqu'elle parut mettre l'attention dans son choix, et qu'entre plusieurs hommes sur lesquels la passion promenait ses regards, il y en eut un qui les arrêta, qui put se flatter d'être préferé, qui crut porter dans un coeur qu'il estima l'estime qu'il faisait de lui-même, et qui regarda la plaisir comme la récompense de quelque mérite; lorsque les voiles que la pudeur jeta sur les charmes laissèrent à l'imagination enflammée le pouvoir d'en disposer à son gré, les illusions les plus délicates concoururent avec le sens le plus exquis pour exagérer le bonheur; l'âme fut saisie d'un enthousiasme presque divin; deux jeunes coeurs éperdus d'amour se vouèrent l'un à l'autre pour jamais, et le ciel entendit les premiers serments indiscrets.

Combien le jour n'eut-il pas d'instants heureux, avant celui où l'âme tout entière chercha à s'élancer et à se perdre dans l'âme de l'objet aimé! On eut des *jouissances* du moment où l'on espéra.

Cependant la confiance, le temps, la nature et la liberté des caresses, amenèrent l'oubli de soi-même; on jura, après avoir éprouvé la dernière ivresse, qu'il n'y en avait aucune autre qu'on put lui comparer; et cela se trouva vrai toutes les fois qu'on y apporta des organes sensibles et jeunes, un coeur tendre et une âme innocente, qui ne connût ni la méfiance ni le remords.[8]

ENJOYMENT, n.f. (gram. and moral). To enjoy means to know, to experience, to feel the advantages of possession. One often possesses without *enjoyment*. Who owns these magnificent palaces? Who has planted these immense gardens? The sovereign. But who enjoys them? I do.

Let us leave these magnificent palaces that the sovereign has constructed for other people than himself, these enchanting gardens in which he never walks, and stop to contemplate pleasure that perpetuates the chain of living beings and to which we have consecrated the word *enjoyment*.

Among the objects that nature everywhere offers to our desires,
you who have a soul, tell me if there is anything more worthy of your
pursuit, anything that can make us happier than the possession and
enjoyment of a being who thinks and feels as you do, who has the
same ideas, who experiences the same sensations, the same ecstasies,
who brings her affectionate and sensitive arms toward yours, who
embraces you, whose caresses will be followed by the existence of a
new being who will resemble one of you, who will look for you in
the first movements of life to hug you, whom you will bring up by
your side and love together, who will protect you in old age, who
will respect you at all times, and whose happy birth has already
strengthened the tie that bound you together . . .

The propagation of beings is the greatest object of nature. It
imperiously solicits both sexes as soon as they have been granted
their share of strength and beauty. A vague and brooding restlessness
warns them of the moment; their condition is mixed with pain and
pleasure. At that time they listen to their senses and turn their
considered attention to themselves. But if an individual should be
presented to another individual of the same species and of a different
sex, then the feeling of all other needs is suspended; the heart palpi-
tates; the limbs tremble; voluptuous images wander through the
mind; a flood of spirits runs through the nerves, excites them, and
proceeds to the seat of a new sense that reveals itself and torments the
body. Sight is troubled, delirium is born; reason, the slave of instinct,
limits itself to serving the latter, and nature is satisfied.

This is the way things took place at the beginning of the world,
and the way they still take place in the back of the savage adult's cave.

But when woman began to discriminate, when she appeared to
take care in choosing between several men upon whom passion cast
her glances, there was one who stopped them, who could flatter
himself that he was preferred, who believed that he brought to the
heart he esteemed the very esteem that he had for himself and who
considered pleasure as the recompense for some merit; then, when
the veils that modesty cast over the charms of a young woman
allowed the inflamed imagination the power to dispose of them at
will, the most delicate illusions competed with the most exquisite of
senses to exaggerate the happiness of the moment; the soul was
possessed with an almost divine enthusiasm; two young hearts lost
in love vowed themselves to each other forever, and heaven heard
the first indiscreet oaths.

Yet how many happy moments existed before the one in which
the entire soul sought to spring forth and lose itself in the soul of the
person loved! *Enjoyment* began the moment that hope was born.

Nevertheless confidence, time, nature, and the freedom of caresses
led to the forgetfulness of self; one swore after experiencing the final
ecstasy that there was no other person who could be compared to her
(or to him); and this was true in these circumstances each time people
had sensitive and young organs, a tender heart and an innocent soul
unacquainted with either mistrust or remorse.[9]

The passage seems at first to confirm Spitzer's observation that
Diderot's prose is energised by a 'self-accentuating rhythm,
suggesting that its "speaker" is swept away by a wave of
passion which tends to flood all limits';[10] a rhythm emanating

directly from Diderot's 'nervous system', to which his 'stylis-
tic system' is so finely attuned. Not only is the language
obviously close – as close as it can get – to speech: the whole
piece seems to be evoking the act of enunciation and to treasure
the actual bodily equipment of utterance. We know that,
within classical rhetoric, there existed a whole set of protocols
to govern the *actio* of a discourse, its pronouncement by the
body of the orator; not only gestures, but breathing, lubrica-
tion of the throat, control of the diaphragm, regulation of
volume, pitch, timbre and phrasing; an art resolutely of the
body and according it the reverence due to a fine instrument – a
non-intellectual, wholly material art, dedicated to the physi-
cality of speech, and viewing language as the interface of the
substance of the vocal organs with the substance of the phonic
stream.[11] Diderot's display of *actio* does not begin fully until
the third paragraph (*Entre les objets . . .*). In the first, he places
the *récit* which is to follow as the work of a writer who is also a
speaker by sending to the reader signals of an unmistakable
and even quite crude kind, announcing to him that he is now in
the presence of rhetoric (rhetoric in its customary, debased
sense: *A qui sont . . .? qui est-ce qui . . .?*). At the same time he is
also warming up, like a musician. In the second paragraph, he
takes up and toys with a 'democratic' idea well suited to the
Encyclopédie: 'while kings possess gardens but do not enjoy
them, each of you has an enchanted garden that is the gift of
Nature'. But the idea is soon dropped and we can see that the
second paragraph is in fact hastening towards something else –
towards *jouissance* in its restricted sense of sexual delight. The
change of direction occurs at *volupté* – it is specifically sensual
pleasure which is deflecting the writing from its lofty and
'intellectual' opening. The rapid intensification from *volupté*, a
word already heavier with sensuality than its English counter-
part, to *jouissance*, the extreme of erotic excitement, is the
moment of lift-off. The prose becomes vitalised as soon as it
touches on sexuality, and we can see, with Spitzer, that style
and content are inseparable here: the prose is affected and even
shaped by what it describes (the bodily, 'nervous' rhythms of
an organism in a state of excitation).

The third paragraph is unmistakably, and brilliantly, a
mimesis in Auerbach's sense, where the form in which the
utterance is cast seeks to copy its (erotic) subject. As *jouissance*
is more fully entered into, the sentence accelerates, proliferat-
ing its short bursts of relative clauses in repeated surges of
energy (*qui a . . . qui éprouve . . . qui porte . . . qui vous enlace . . .*);
its pace is increasingly urgent, and in terms of *actio*, we now
encounter breath and breathlessness. So driven is the prose that
it is actually becoming confused and confusing; not just one
batch of subordinate groups, but two, the first referring to '*un*

objet' (*qui a les mêmes idées*, etc.), the second to 'un nouvel être' (*qui dans ses premiers mouvements ... que vous élèverez ... que vous aimerez ... qui vous respectera*). The 'unclassical' carelessness, the running together of two separate periods in one, implants the suggestion of an excitation too urgent to attend to detail; even – it is not so far-fetched – 'the rush of young lovers towards bodily union'. Within each of the clusters of relative clauses, intensification and increasing physicality: from *comme* to *même*, from *idées* to *chaleur* to *transports*; at *transports* the prose begins to hallucinate – the arms of the beloved are imagined stretching out towards the lover in a seductive embrace. In the second cluster of relative clauses, a compressed lifespan which again turns into a hallucination; from infancy (*ses premiers mouvements*) to growth (*que vous élèverez*) to maturity (*qui vous protégera*); the tenses shift – *dont la naissance heureuse a déjà fortifié le lien* – the child is here already. The fourth paragraph repeats and continues the idea of sexual excitement in an even higher key: *le coeur palpite; les membres tressaillent; des images voluptueuses ...* No attempt at periodic syntax, no effort towards complex articulation; instead, a 'throbbing' in the prose, a desertion of the linguistic complexity which before had suggested a mind excited, but still in control of its material. Now it is under the full sway of passion and parataxis (juxtaposition) is the mode: the rhythm of feeling symbolically rendered in the pulsating rhythm of the language.

And so we might continue. But if we were to do so it would become increasingly difficult to make sense of the article. Although in the fourth paragraph we seem still to be with Spitzer's gushing Diderot, all *frisson*, in fact a disturbing note of parody has crept in. The paragraph continues and intensifies the breathlessness and urgency of its predecessor, but within a new and discordant vocabulary: *membres, images, cerveau, nerfs, irritent*. This is a quasi-scientific group and the writing, despite the driving parataxis, is rapidly cooling. The terms may seem unscientific to us, but to the reader of the *Encyclopédie* they would have registered as modernistic, rational, and, above all, detached. The reason for the rapid lowering of temperature emerges at the end of the paragraph: *la raison, esclave de l'instinct, se borne à le servir.* For reason to be enslaved by anything is, for an Encyclopédiste, bad enough; to be enslaved by *instinct* is close to the worst imaginable state. The introduction of Nature's approval – *et la nature est satisfaite* – renders the whole passage problematical. There can be no doubt that in the *et*, Diderot implies serenity, culmination, fulfilment, and even the hint of a benign world-order. But these are now held within irony: how could Nature possibly condone the enslavement of reason by instinct? The implication is that Nature, although we may presume ultimately rational, is

prepared or compelled to stoop to irrationality to implement her lofty commands; a Nature turned on itself, with a lower unreason serving a higher rationality. This perplexed view of Nature explains the clinical vocabulary: the fourth paragraph is no longer *inside* passion; on the contrary, it is observing passion voyeuristically, or at least coldly. In the earlier paragraphs, *coeur* would have meant 'emotion', here – placed in the medical group – it is also, reductively, the anatomical muscle: in the earlier paragraphs, the *siège d'un nouveau sens* would have been intended lyrically; here it is a circumlocution for puberty or genital arousal. The retrospective effect of this new view of passion is to undo the rapture of the ecstatic, palpitating third paragraph: although so spontaneous-seeming to the young lovers, their feelings are an *effect* (epiphenomenon) of these organs and for the lovers to have thought otherwise was naïve. There is certainly a wisdom in describing the raptures of the third paragraph before the later entry of irony: innocence first, knowledge later. But there is also a trick being played on the reader, or at least on the Spitzerian reader. Diderot had seemed entirely caught up in the passionate urgency of the third paragraph, but once the irony and medical detachment are with us, there is the possibility, almost the certainty, that he was only acting; impersonating spontaneity, like the actor of his paradox. And once we have registered that possibility, we can no longer read in the Spitzerian way – Diderot is *not* the palpitating nervous system incarnated into speech, but a literary technician of enormous wiliness. Just as Nature duped the lovers, so Diderot has duped us (or the Spitzerian reader in us).

The slight trick played on our sensibility might pass unnoticed if the article did not go on to emphasise deception. Although lust may be refined – the female takes the initiative away from the lust-blinded male, and discrimination and choice enter into the mating process – these attempts at civilisation are not wholly successful. All the veil of modesty can do is to provide a blank screen on to which the male can more easily project his inflamed imaginings – the transaction concerns fantasies, not persons. Worse, the lovers experience this depersonalised mechanism as divine enthusiasm – two hearts lost in love (*éperdus d'amour*: the note of parody is now very clear) whose first vows are heard by heaven (that is, by Nature, now an amoral motor force uninterested in the truth of the vows she hears, and concerned only with the propagation of species). The point is that to emphasise his superior, clinical understanding of the process the lovers perceive so naïvely, Diderot satirises their gullibility by using ironically the language of sentiment. The penultimate paragraph (*Combien le jour...*) is unmistakably a distanced quotation – this is exactly

the rhetorically exaggerated style the effusive Saint-Preux will
used to address his Julie, and its placing reveals that style as
absurd. It is the language used by the lovers and experienced
by them as transparent to their feelings – the language Spitzer
attributes to Diderot; but it is now openly parodic.

It is not simply that such effusion misrepresents the feelings
of the lovers towards each other and is to be despised as
inaccurate; this kind of language, because it is empowered by
the erotic, has energy: it is to be reckoned with. Its words are
not the counterparts of the truth, but to the lovers they seem to
be; they are words which have taken on an autonomous vital-
ity. Diderot associates that language with hallucination – the
projections of the male on the veil of modesty, but also the
kind of hallucination Spitzer falls for – words absolutely trans-
parent to the beating heart. Diderot's effort is to demonstrate
the dangerous effectiveness of such words, and also their dis-
sociation from what he believes to be the real facts. Increas-
ingly this, and not *jouissance*, is the subject of the article: *un
coeur tendre et une âme innocente*, speaking without the obstacle
of the sign, or so it seems to them; in fact, *organes sensibles et
jeunes* – almost disembodied bodily components, producing
sounds which only add to the already alarming quantity of
illusion in love. These exclamations of the lovers, which seem
to unite *everything* – body and soul, feeling and avowal, even
separate persons in the union of a linguistic caress – in fact
emanate from *organs*; it is here that the anatomical vocabulary,
with its itemisation and denial of the holism of the body, has its
full impact. The article, having started with democracy, and
moved on to sexuality, approaches its real centre: the
difference between true and false signs.

At first it looks as though we will be able to tell them apart:
the lovers experience the false language of sentiment, but we
have access to the objective or scientific language of the *Encyc-
lopédie*, in which we will find the truth. Irony is often a guaran-
tee of access to a true higher discourse, operating at a level
superior to the discourses quoted within irony – and so it
might be with Diderot. But he denies us the consolation of
authoritative language (of encyclopedia, of knowledge) by
dislocating the vocal tone of the article's close. We notice that
the last two paragraphs are increasingly bitter: Diderot sees
remorse and suspicion as built into the erotic system and the
sincerity of the lovers as betrayed by Nature, a cruel and
indifferent Nature, like the Aphrodite of the *Hippolytus*. He
does not for a moment question the sincerity of the lovers –
they seem to believe completely their sentimental utterance.
But Diderot also sees his superior wisdom as only a function of
time. In due course, the lovers will come to see things as he
does. And this means that both the lovers' naïvety and

Diderot's wisdom are only relatively true; there is no absolutely superior discourse, as the irony might lead us to expect. Diderot juxtaposes two languages, one sentimental, the other 'clinical', and in the opening phase the second language seems to be the master-language of the first, incorporating it and raising it to a higher plane of truth. But the bitterness at the end comes in part from regret, as though the sentimental language had more purity and truth than the quasi-scientific language Diderot finds himself using now. Regret and bitterness, the progressive darkening of tone towards the article's end, so destroy the stability of irony that the reader cannot, in fact, feel the security an encyclopedia entry might be expected to offer, and in particular the basic security that encyclopedia assumes as its enabling foundation: that a discourse of pure truth is attainable.

The article ends in a position that is in many ways the inversion of its opening. The first three paragraphs had established Spitzer's Diderot, language transparent to the peculiar body of the orator, with its specialised anatomy: larynx, diaphragm, heart, genitals, lungs. The middle section – paragraphs four to six – shows a clouding of that transparency; the subject is now deceit, and deceitful signs, and the tone is increasingly parodic. We are still in the presence of an *author*, authority, and although the mood is darkening, we know where we stand: a disabused, rationalistic voice is dominating a gushing, sentimental voice. But at the end the writing is problematic, and no vocal tone determines how we are to read that last phrase, *ni la méfiance ni le remords*. The voice and its inflections have controlled and anchored the whole piece: once that voice disappears and we are left simply with *print*, the text becomes alarmingly indeterminate. We know exactly how the third paragraph should sound; the last, not at all (an actor speaking the article would have to make an arbitrary decision at the close). And what, finally, is the centre of the piece? Each possibility has been displaced: democracy pushed out by *jouissance*, that by an attack on the gullibility of love, that by an assertion of the relativity of experience. Each paragraph undoes the work of its predecessor. The piece begins by asking to be read as a mimetic enactment of its own excitement – the language has 'behind' it the physique of the writer and also a fixed subject which it is to treat, as any encyclopedic article treats (processes, summarises) its pre-existing material. Progressively we lose our bearings and discover that what at first seemed to be the climax of emotional potentiation of the prose was in fact a ruse; we are invited to discriminate between signs that are 'full', backed by facts, by wisdom and by the writer's position of authority as site of knowledge, and signs that are 'empty', mere words that seem charged but are merely inflated

(the language of love). But the empty and the full signs emerge as equally valid, and Diderot, withdrawing his vocal control of the meaning of the article, leaves us with a piece which has itself been cut adrift from its subject and from the fabled pulsing *corps diderotique*. The passage is from transparency (Spitzer: language isomorphic with something outside itself) to opacity (language backing on to nothing outside itself, occupying its own self-sufficient space). It is, I believe, the typical movement of Diderot's work, and ultimately the movement which determines the transparency/opacity oscillations within the *Salons*: but more examples are needed.

Here is the scene from *La Religieuse* in which the fugitive nun reveals her woes to the lesbian Mother Superior.

Je commençai donc mon récit à peu près comme je viens de vous l'écrire. Je ne saurais vous dire l'effet qu'il produisait sur elle, les soupirs qu'elle poussa, les pleurs qu'elle versa, les marques d'indignation qu'elle donna contre mes cruels parents, contre les filles affreuses de Sainte-Marie, contre celles de Longchamp; je serais bien fâchée qu'il leur arrivât la plus petite partie des maux qu'elle leur souhaita; je ne voudrais pas avoir arraché un cheveu de la tête de mon plus cruel ennemi. De temps en temps elle m'interrompait, elle se levait, elle se promenait, puis elle se rasseyait à sa place; d'autres fois elle levait les mains et les yeux au ciel, et puis elle se cachait la tête entre mes genoux. Quand je lui parlai de ma scène du chachot, de celle de mon exorcisme, de mon amende honorable, elle poussa presque des cris; quand je fus à la fin, je me tus, et elle resta pendant quelque temps le corps penché sur son lit, le visage caché dans sa couverture et les bras étendus au-dessus de sa tête; et moi, je lui disais: 'Chère mère, je vous demande pardon de la peine que je vous ai causée, je vous en avais prévenue, mais c'est vous qui l'avez voulu...' Et elle ne me repondait que par ces mots:

'Les méchantes créatures! les horribles créatures! Il n'y a que dans les couvents où l'humanité puisse s'éteindre à ce point. Lorsque la haine vient à s'unir à la mauvaise humeur habituelle, on ne sait plus où les choses seront portées. Heureusement je suis douce; j'aime toutes mes religieuses; elles ont pris, les unes plus, les autres moins de mon caractère, et toutes elles s'aiment entre elles. Mais comment cette faible santé a-t-elle pu résister à tant de tourments? Comment tous ces petits membres n'ont-ils pas été brisés? Comment toute cette machine délicate n'a-t-elle pas été détruite? Comment l'éclat de ces yeux ne s'est-il pas éteint dans les larmes? Les cruelles! serrer ces bras avec des cordes!...' Et elle me prenait dans les bras, et elle les baisait. 'Noyer de larmes ces yeux!...' Et elle les baisait. 'Arracher la plainte et le gémissement de cette bouche!...' Et elle la baisait. 'Condamner ce visage charmant et serein à se couvrir sans cesse des nuages de la tristesse!...' Et elle le baisait. 'Faner les roses de ces joues!...' Et elle les flattait de la main et les baisait. 'Déparer cette tête! arracher ces cheveux! charger ce front de souci!...' Et elle baisait ma tête, mon front, mes cheveux... 'Oser entourer ce cou d'une corde, et déchirer ces épaules avec des pointes aigues!...' Et elle écartait mon linge de cou et de tête; elle entr'ouvrait le haut de ma robe; mes cheveux

tombaient épars sur mes épaules découvertes; ma poitrine était à demi nue, et ses baisers se répandaient sur mon cou, sur mes épaules découvertes et sur ma poitrine à demi nue. [12]

So I begin my story, telling it in much the same way as I have written it to you, Sir. I cannot describe the effect it had on her, her sighs, her tears, and her indignation against my cruel parents and the horrible nuns at Sainte Marie and Longchamp. I would be extremely sorry if they ever suffered the smallest part of what she wished on them, because, for my part, I would not wish to harm a hair of my worst enemy's head. From time to time, she interrupted me. She rose, walked about, and then sat down again. There were other moments when she lifted her eyes and hands to heaven, and then hid her face in my lap. When I spoke about my stay in the punishment cell, my exorcism, and my public confession, she almost shrieked aloud. When I had finished, I fell silent. She remained for some time with her body bent over the bed, her face hidden in the blanket, and her arms stretched out over her head. I said to her:

'Dearest Mother, forgive me for having caused you pain. I had warned you. But it was what you wanted.'

She only answered: 'The vile creatures! The fiends! It is only in the convent that humanity ever dies out so utterly. When hatred is linked with habitual ill-humour, there is no limit to how far things will go. Luckily, I am gentle, and I love all my nuns. They have all, more or less, come to resemble me, and they all love one another. But how could your weak health stand so much ill-treatment? How were these little limbs not broken? How is it that your delicate health was not ruined? How was the brightness of those eyes not dimmed by tears? The brutes! To tie such arms with ropes!' She took my arms and kissed them. 'To drown such eyes with tears!' And she kissed my eyes. 'To make such lips sigh and moan!' And she kissed my mouth. 'To condemn such a charming little face to perpetual sadness!' And she kissed my face. 'To wither the roses in these cheeks!' And she kissed my cheeks, stroking them with her hand. 'To harm such a head! To tear out such hair! To load such a brow with worry!' She kissed my head, my forehead and my hair. 'To dare to put a rope round such a neck! To tear these shoulders with pointed spikes!' And she pulled away my neckerchief, opening the top of my dress. My hair fell about my naked shoulders, and my breast was half bared. She covered my neck, my naked shoulders and my half-bared breast with kisses. [13]

The passage must be placed in the context of its production. In 1759, Suzanne Saulier (or Simonin) attempted to break her vows. [14] A friend of Diderot's, the Marquis de Croismare, busied himself on her behalf; but she lost her case. Shortly after this, de Croismare left Paris to live on his estate near Caen. 'M. Diderot', writes Grimm,

resolved to re-open the affair to our advantage. He pretended that the nun in question had had the luck to escape from the convent, and in consequence wrote in her name to M. de Croismare to ask for help and protection. We had every hope of seeing him arrive as rapidly as possible to help his nun, or, if he saw through our plot at once, we

were sure at any rate of a good subject for a laugh. But the matter took on a very different complexion . . . [Diderot] was persuaded that the Marquis would never admit a young person into his house without knowing her, and so began to write out in detail the story of our nun.[15]

The resultant work, *La Religieuse*, proved immensely interesting to Diderot's contemporaries, and not just to Grimm (or de Croismare); it provided the anti-clerical faction, who were to triumph in 1791, with proof of the inhumanity of the conventional orders; Germain Martin described the novella as a book without which no atheist's library was complete.

The pleasure of the novella, and of this passage, lies in its mixture of machination and spontaneity – a pleasure to be refined still further by Laclos. The text is woven of distinct vocative strands, each with a different objective or goal; it is useful to itemise each in turn.

(I) DIDEROT TO THE READER

Diderot never prefaced *La Religieuse* as Laclos was to preface *Les Liaisons Dangereuses*, and we can only surmise the official motive he might have used to justify the book. We know, however, that the novella was used immediately as a tract against convent rule, and though the book cannot be construed as fully consistent with this purpose, it is clear that for Diderot the abuse of convents by dishonest parents who profit by nunneries to get rid of inconvenient children, is to be deplored: the goal here might be said to be polemical indignation. It would be naive to deny, however, that in addition to this admirable Enlightenment purpose, the text was used for less exalted ends; it veers repeatedly towards the pornographic, and besides its propagandist rationale it has a strong erotic interest. This is reinforced by the clandestine, *samizdat* circulation of the book; it went the rounds in script until its first publication, in 1796, and such underground changing of hands would have added to its crypto-pornographic attractiveness.

(II) DIDEROT TO DE CROISMARE

From one point of view, this strand is not supposed to exist: if the ruse is successful de Croismare will not have realised that Diderot is behind the nun's memoir. The goal here is the return of the Marquis to Paris; hence those distortions in the narrative which the reader may take as bait; the nun's desirability, innocence, previous history of persecution, her 'rescuability'.

Her goal is escape from incarceration within the convent. Having lost her case, legal methods of appeal are now closed to her. She must make a direct personal appeal to the Marquis and do everything she can to secure his interest in her case. This strand might seem indistinguishable from (II) but in practice it is independent. Given her situation, the nun need only exaggerate the horrors which surround her, and her persecuted status; the sexual appeal would be out of place (for example, the repeated *demi nue* of the final paragraph). If it is the nun herself, and not Diderot, who is believed by the reader to be responsible for the added and unnecessary sexual allure, the reader must view her as a hypocritical manipulator; if it is Diderot, she becomes the victim of the author's – and the reader's – humour; which possibility the text equally permits.

(IV) THE NUN TO THE MOTHER SUPERIOR

The objective here is, again, protection and refuge: she must win over the older woman, obtain shelter at the new convent and protection from the nuns of her previous convent; yet she must move diplomatically – she cannot, for instance, directly accuse the other nuns of cruelty, or openly state her goal; the Mother Superior must be led to want to rescue the nun without feeling either the pressure of persuasion, or that the nun is prepared to calumniate convent rule as a whole.

(V) THE MOTHER SUPERIOR TO THE NUN

Her objective is, obviously, a sexual one; yet this cannot be openly admitted. Her behaviour is prescribed by her position and the sexual advance must be carried out under the guise of sympathy, kindness, and emotional exaltation. It may be the case, moreover, that the Mother Superior is genuinely unaware of her sexual interest – a possibility to which the text also extends its 'generosity'.

The main constraint on the writing is that it must simultaneously satsify all five of its component vocal and vocative strands while seeming to recognise only one, namely the address of the nun to the Marquis; the kind of ingenuity that will accomplish the task is musical – it must create a self-sufficient or free-standing melody that at every note will accommodate itself to the shape of a supportive four-part canon. The circumscription is enormous and at times the weight of harmonic density threatens to paralyse the writing, as it does at the line *je ne voudrais pas avoir arraché un cheveu de la*

tête de mon plus cruel ennemi (I would not wish to harm a hair of my worst enemy's head). The demands of all the levels are met, but only at the cost of enormous and visible effort. In so far as this declaration of innocence is to be believed, it serves the triple purposes of securing the aid of the Mother Superior, of interesting the Marquis in a tale of unwarranted persecution, and Diderot's objective of luring the Marquis to Paris. And the line also addresses its other obligations, for in so far as the declaration is exaggerated, it will arouse our suspicion, and suspicion will convert the declaration of innocence into its opposite ('this nun is less virtuous than she makes out').

Encouraged by this inversion to read all manifestations of virtue as vice in disguise, the polemical aim of discrediting convent rule is furthered, while at the same time the idea of a vicious nun is both part of Diderot's game with Croismare (and our enjoyment as witnesses of the game) and part of the book's pornographic, transgressive dimension (virtue as vice, as in Sade). But although the line does technically satisfy its many harmonic requirements, strain is evident in the break with *vraisemblance*: it is simply unlikely that at this point the nun would come up with so immodest a declaration of clemency. And even if the line were credible, it is not speakable – one cannot determine what vocal inflection could satisfy all the goals and all the addresses at once. In such a highly vocal context as this, the impossibility of finding an appropriate inflection accents the incongruity of the line, and in proportion as we lose awareness of its existence as voice we come to see it instead as *writing*; and once this happens we can no longer take it as an *objet trouvé*, for it has been made, and made with difficulty. The work of production enters into the field of visibility: we realise the complexity of the task the writing is to carry out, the enormous difficulty of working on five levels simultaneously without losing fluency, the skilfulness with which Diderot conducts himself. Once we begin to read analytically, the status of the language changes from raw or unworked to literary and wrought: we come to observe the game of literary strategy as we would watch a game of chess, or attend to the *entrelacement* of a fugue.

The contradiction is between this fugal, self-conscious virtuosity of language and the spontaneous emotionalism of the language on which that virtuosity is called to work. Although it contains so much evidence of bias and manipulation within languages, *La Religieuse* is accompanied by a sense of language as idyllic transparency, a limpid medium through which the contents of the heart and the world pass without alteration or impediment. According to the conventions of *sensibilité*, as the speaker becomes emotionally excited, his inner being is reputed to become refulgent and visible: speech clarifies and

through it we glimpse the real interior world which the social conventions of language normally conceal. The *récit* of rapture is the hallmark of *sensibilité*: in *La Nouvelle Héloïse* we see it most clearly in the effusive and confessional letters of Saint-Preux, and his dream of developing language to a pitch of complete spontaneity and sincerity where 'each will behave with others as he does alone';[16] in the *drame bourgeois*, it is speech so filled with feeling that the obstruction of language – which is equated with social formality, blockage of feeling, coldness – will disappear in the communion of the heart. Here, a cult of sincerity is certainly apparent: the Mother Superior behaves as though swept away altogether on the wave of passion; indeed, it is possible that there is not a shred of manipulation in her behaviour with the nun, that she is less predator than victim, of her uncontrollable feelings, of this possibly vicious girl. Equally, the nun's tale seems all innocence; no matter how much bias we may think she introduces into her memoir, for the memoir to succeed it must be possible for Croismare (if not the reader of the novella) to take everything she says as sincere. And from Diderot's point of view, complete effacement of the text's signs of production is of the essence: though at every point we know the text to be Diderot, it must behave as though it were *trouvaille* rather than *travail*.

In terms of the sign, the passage explores an area where the means by which people communicate are at the same time plenary and vacant: backed by a content behind the sign (feeling, pain) and at the same time backing on to nothing (self-sufficiency, the 'literary'). The worst fate is to believe that a sign is full when it is empty, real when it is fabricated. While this credulity is officially a source of humour – the practical joke Diderot is playing on the Marquis – in the Mother Superior's speech there is a darker tone. It might be called sign-automatism. As the older woman runs over each in turn of the parts of the nun's body that have been abused, we have a grotesque parody of religious practice, of the *exercitium spirituale* which consists of visualising in turn each stage of Christ's bodily sufferings; with the Mother Superior, the exercise is perverted into an *exercitium corporale* – but the law of the exercise is the same: mechanical repetition. The Mother Superior seems hypnotised and even dehumanised by her ritual. Each utterance (*Serrer ces bras avec des cordes...*) is accompanied by a gesture (*Et elle me prenait dans les bras, et elle les baisait*) where the gesture seems an extension of the utterance, as though once these words have been spoken they impel the body to move. Speech takes the body over, and in this novel words are accorded an enormous autonomous power: it is through speech that the nun arouses the Mother Superior,

that the nun is to be rescued by Croismare, that Diderot will
lure Croismare to Paris. The threshold of resistance to speech
is low and Grimm's anecdote about Diderot in floods of tears
as he wrote the memoir, weeping and miserable over his tale, is
typical of what is everywhere happening. There is so much
verbal manipulation because, despite the dream of a trans-
parent discourse, language is so palpable, has such *épaisseur*;
there is so much credulity – Croismare's, Diderot's, ours –
because the individual is so vulnerable to the force of language
and has a natural tendency to believe that behind the sign,
something stands. Pornography is only a more extreme
instance of the power of the sign to absorb vitality into itself, as
the individual hands over his libidinous energy to the sign: the
pornographic undertow in the novel is simply a stronger
expression of the central activity in this text where everyone is
losing control to the sign: Diderot, who at the centre of the
web ought to be in a position of mastery, weeping over his
work; Croismare hastening to Paris; the Mother Superior
succumbing, like Desdemona, to a story, and passing control
of her body to a mesmerising verbal ritual. Every addressee
believes he or she is hearing a sincere language; every addressee
is deceived. And the only possible line of resistance to this
attack by duplicitous signs is for Diderot to demonstrate and
weaken the strength of the natural belief in the limpidity of the
sign by first reinforcing and then undermining it, by first
conjuring up hallucination and then dispelling it (the novel as
practical joke), by displaying so much verbal agility that the
reader, unlike the lesser and more gullible addressee, will hold
out against transparency (style as shield).

 La Religieuse approaches the problem of the sign at a level of
comedy where credulity is never allowed to become a serious
concern: the illusion of the sign can always be banished
through humour. But in the dramatic dialogue *Le Neveu de
Rameau* its power is more sinister and less curtailable, because
for the nephew laughter is no longer enough: the automatism
of the sign has become an affliction for which there is no
cure.

(Puis il se remettait à chanter l'ouverture des *Indes galantes* et l'air
Profonds abîmes, et il ajoutait:)
 Le quelque chose qui est là et qui me parle me dit: Rameau, tu
voudrais bien avoir fait ces deux morceaux-là; si tu avais fait ces deux
morceaux-là, tu en ferais bien deux autres; et quand tu en aurais fait
un certain nombre, on te jouerait, on te chanterait partout; quand tu
marcherais, tu aurais la tête droite, la conscience te rendrait témoi-
gnage à toi-même de ton propre mérite, les autres te désignerait du
doigt. On dirait: C'est lui qui a fait les jolies gavottes (et il chantait les
gavottes; puis, avec l'air d'un homme touché, qui nage dans la joie et
qui en a les yeux humides, il ajoutait en se frottant les mains:) Tu

aurais une bonne maison (et il mesurait l'étendu avec ses bras), un bon lit (et il s'y étendait nonchalamment), de bons vins (qu'il goûtait en faisant claquer sa langue contre son palais), un bon équipage (et il levait le pied pour y monter), de jolies femmes (à qui il prenait déjà la gorge et qu'il regardait voluptueusement); cent faquins me viendraient encenser tous les jours (et il croyait les voir autour de lui: il voyait Palissot, Poincinet, les Frérons pere et fils, La Porte; il les entendait, il se rengorgeait, les approuvait, leur souriait, les dédaignait, les méprisait, les chassait, les rappelait; puis il continuait:) Et c'est ainsi que l'on te dirait le matin que tu es un grand homme; tu lirais dans l'histoire des *Trois Siècles* que tu es un grand homme; tu serais convaincu le soir que tu es un grand homme; et le grand homme, Rameau le neveu, s'endormait au doux murmure de l'éloge qui retentirait dans son oreille; même en dormant, il aurait l'air satisfait: sa poitrine se dilaterait, s'élèverait, s'abaisserait avec aisance, il ronflerait comme un grand homme; et en parlant ainsi, il se laissait aller mollement sur une banquette; il fermait les yeux, et il imitait le sommeil heureux qu'il imaginait. Après avoir goûté quelques instants de la douceur de ce repos, il se réveillait, étendait ses bras, bâillait, se frottait les yeux, et cherchait encore autour de lui ses adulateurs insipides.[17]

(He fell once again to singing the overture to *Les Indes galantes* and the air *Profonds abîmes*, and then went on:)

Something inside there is talking to me and saying: Rameau, old chap, you would have liked to compose those two pieces and if you had composed those two you would do two more, and when you had done a certain number you would be played and sung everywhere, and you could hold your head high as you walked along. Your own mind would tell you your own worth, and people would point you out and say: 'That's the man who wrote the pretty gavottes;' (thereupon he sang the gavottes, then, looking like a man whose overwhelming joy has moved him to tears, he added, rubbing his hands:) 'You would have a fine house (measuring the house with his arms), a good bed (nonchalantly stretching himself thereon), good wines (tasting them and clicking his tongue against his palate), a fine coach (raising one leg to step into it), pretty women (fondling their bosoms and gazing at them voluptuously), a hundred lick-spittles would come and pay court to me every day (he seemed to see them all round him – Palissot, Poincinet, the Frérons, father and son, La Porte – and he gave ear to them, swelled with pride, bestowed his approval on them, smiled, treated them with disdain or scorn, sent them packing, called them back and then went on:) And so it is that you would be told in the morning that you were a great man, and by the evening you would be convinced that you were one; and the great man, Rameau the Nephew, would fall asleep to the soft murmur of eulogies in his ears, and even in sleep he would look satisfied, his chest would fill out and he would snore like a great man.

(And while saying all this he sank softly upon a seat, closed his eyes and mimed the happy slumbers he was imagining. Having sampled the sweetness of this repose for a few moments he awoke, yawned, rubbed his eyes and went on looking about him for his fawning flatterers.)[18]

With the Mother Superior, the condition of sign-automatism was less advanced: although her gestures were automatic, this could be attributed to hypocrisy (if she is taken as predator) or self-repression (if she is taken as victim). But here the speaker is neither hypocritical nor self-repressed, and instead of a break between words of sympathy and deeds of molestation, word and gesture are continuous – the nephew's gestures simply enact what his words imply: speech once uttered becomes autonomous, self-potentiated, no longer bound by the control of the speaker (it is an exemplary case of 'being spoken' rather than 'speaking'). The signs of speech unleash gestures by which they are expanded, prolonged, and multiplied: the gestures are the reverberation of the sign as it acts on the body from a place outside controlling consciousness. And the negative cost of surrender to the autonomy of the sign is high. The nephew starts from a hypothetical situation – 'if I had written my uncle's music' – which he expands upon with increasing involvement, accompanying each new invention with appropriate dramatic gestures, until he is not only physically exhausted by his performance, but psychologically self-estranged. The gestural accompaniment, conjured by the enthusiasm of a vivid imagination, is at first only an ancillary adornment whose significance and whose validity are determined by the significance and validity of the discourse: at the beginning there is no area of excess of accompaniment over speech, and the situation of the sign is stable. The sign is regulated from within the controlling centre of the speaking subject, to which the two aspects of the dramatic sign – word and gesture – are in full thrall. In the course of the elaboration, however, the gestures depart further and further from reality and breaking away from the control of the subject declare allegiance to the autonomous reality conjured by the sign. Re-centering themselves around the sign, they come to react upon the speaker himself, who is convinced by his own gestures: by the end of the passage he has been seduced by his own imaginative pantomime.

From a limited point of view, Diderot is only making a comment on bad art. The nephew is not without a certain genius. In the *Encyclopédie* article *Génie*, Diderot writes that the hallmark of genius is instantaneous creation: '*ce qu'il produit est l'ouvrage d'un instant*'; rapid, it will risk mistakes: '*il (y) répand fréquemment de brillantes erreurs*'; it has no need for self-discipline and is quite without *sang-froid*: '*cette qualité, n'est-elle pas absolument opposée au génie?*' Yet for the Diderot of *Le Neveu* genius is not enough: the artist must know exactly where his creation departs from reality or he will fail to embody his gifts in a form that has objective validity. The tragedy of the nephew is that he has lost the ability to draw the line between

what is real and what is fiction, and unable to distinguish between the two planes, he is like the bad actor of the *Paradoxe sur le Comédien*, so self-identified with his role that he cannot perceive his performance as the audience perceives it. As the nephew listens to himself singing his uncle's music, he feels that he is a creator like his uncle, with all the pleasurable consequences that would flow from that new position; everything he then imagines is in the shadow of that real creativity, which demands self-awareness.

But besides the point about bad art Diderot is obviously making a wider claim, and it is this claim that has most interested his commentators, from Hegel to Lionel Trilling. For Hegel, the nephew's performance – which may still be an artistic failure – demonstrates pure self-consciousness and the emergence of the possibility of a new freedom for the human spirit.

The language expressing the condition of disintegration, wherein spiritual life is rent asunder, is, however, the perfect form of utterance for this entire realm of spiritual and cultural development, of the formative process of moulding self-consciousness (*Bildung*), and it is the spirit in which it mostly most truly exists. This self-consciousness, which finds befitting the rebellion that repudiates its own repudiation, is *eo ipso* absolute self-identity in absolute disintegration, the pure activity of mediating pure self-consciousness with itself. It is the oneness expressed in the identical judgment, where one and the same personality is subject as well as predicate. [19]

It is not a part of my intention to attempt to paraphrase or disintricate Hegel's contorted phrases, but one point that emerges from his discussion with comparative clarity is that there is something *heroic* about the nephew's self-alienation – it carries psychological self-estrangement to such an extreme that we are aware of it, we the readers of *Le Neveu*, and the nephew himself may be aware of it also, if his behaviour on 'waking up' is in fact an ironic and self-aware meta-comment on his performance (and not the intoxication of the player who has come to accept the fiction as real). Hegel was fascinated by *Le Neveu* because for him it was the first text to explore the alienness of the sign-systems human beings use to communicate, and he believed that by revealing the sign in all its estranging power Diderot's dialogue paradoxically exposed an agent untouched by the sign's deceptions and tyrannies – an observer who can watch the process of estrangement and because able to witness that process, able also to stand outside it.

I am not sure whether Hegel's larger claim – that *Le Neveu* marks the emergence of an entirely new stage in the evolution of the Spirit – has any meaning. But we do not have to agree to Hegel's more grandiose pronouncements to see that Diderot is making, now in an extreme form, the point that underlay both

the *Jouissance* article and *La Religieuse*. It is precisely in the excessive ambition of speech that seeks to incorporate the subject's inner being *in toto* – the speech of complete abandonment and spontaneity, the speech of the throbbing heart, of *sensibilité* – that we can *best see* the impossibility of this utopian sign which would lay bare before the world the subject's inwardness. The dialogue states the case by exaggeration. In normal speech, we are not aware that the sounds we utter have their own density and specificity, or that once released the word is no longer an extension of ourselves, but a separate *thing*, part of the world of phenomena. Everyday conversation, the basic functional language through which we cope with the world, seems viably limpid to ourselves; there may be misunderstanding, but even when our utterance has been completely misunderstood by the person we have been addressing, we can rephrase or correct what we have said to bring the communication in line with our inner state: we still experience potential command of the discourse. But within certain situations we see more clearly that the word is irrevocable – in swearing an oath, in benediction and malediction, in declarations of love, in theatrical performances – to cite only those situations that most frequently recur in the period of *sensibilité* (Greuze, Rousseau, Diderot, David). In such situations, the word behaves *like a deed*, that is, as objective and palpable phenomenon; it no longer embraces the speaking subject or behaves as though conterminous with subjectivity.

The fascination with these situations of interaction between subjective and objective worlds across a janus-faced sign (fully self-present, like thought, but at the same time exterior and separate, like a deed) attests to a crisis within the sign that goes far beyond Diderot. It is the crisis which precipitates the tragic close of *La Nouvelle Héloïse*, the destruction of the utopian community at Clarens, where the participants had tried to put into social practice their dream of a form of communication so efficient and limpid that every word would bare the heart and no obstacle would impede the flow of thought and emotion from one individual to another; and where everyone reaches despair as the impossibility of such utopia finally becomes clear. It is the crisis which leads to *Les Liaisons Dangereuses*, where the emotional *récits* of *sensibilité* are refashioned as counters in a military-erotic wargame in which to survive and to conquer, each player must learn to see that speech is not and never can be the transparent window on the human heart that to the inexperienced, the virtuous and the stupid it seems to be. And it is the crisis which leads to Sade, where the two faces of the sign are polarised and exaggerated until, at their most transparent, words and *récits* (and particularly the *récits* of the master of ceremonies) seem entirely backed by (sexual) facts,

little windows or peep-holes on the world, which we look through to glimpse the referent with such immediacy that our bodies will be aroused as though in the actual presence of the scenes described; and on the other hand, where at its most opaque, the sign presents itself as autonomous, arousing us not because the text is so full of an original presence behind the scenes, but because, sign-automatons that we are, to read certain words is enough for us to spring into action, and for the friction of the signifier to act as a source of stimulation entirely divorced from its signified.[20]

Le Neveu is of a piece with these literary developments in which an Enlightenment (or Port Royal) dream of pellucid language – a language which so exactly fits the movements of the mind that the mind can exteriorise its contents without hindrance – breaks up against a realisation that the sign is alterity, is *something else*. It is important to realise how far Diderot's realisation of the crisis went. It shapes his whole theory of perception. In tackling the Molyneux problem[21] – what will a man born blind perceive once he recovers his sight? – Diderot follows a wholly original line of thought; instead of treating the problem as a conflict between innatist and empiricist theories of perception, as we might expect, he reaches the following conclusion:

People born blind, deaf and mute grow up, but they remain in a state of imbecility. Perhaps they would have experienced some ideas if they had been made acquainted from infancy to understand in a fixed, determined, constant and uniform manner; in a word, *if someone had traced on their hand the same characters that we trace on paper and to which the same significance remains invariably attached* (my italics).[22]

Unless people are introduced to a system of signs, they lack mind – 'remain in a state of imbecility'. Only when inserted into a language can the individual develop the essential qualities of thought; the implication is that the 'fixed, determined, constant and uniform' processes normally attributed to the faculty of reason are in fact introduced into the formless and chaotic *ur*-mind by the sign, and that the fixity, determinacy and constancy of reason are in fact the consequence of these qualities within the sign-system.

It is necessary to agree that we ought to perceive in objects an infinity of things that neither the infant nor the man born blind (and who recovers his sight) perceives in them at all, although they are equally painted on the ground of his eyes; that it is not enough that objects strike us, that it is necessary besides that we be attentive to their impressions; that consequently, one sees nothing the first time one uses one's eyes.[23]

For Diderot, sensory experience is a flux without any intrinsic structure or coherence; there are no innate patterns

which will scan the perceptual field of the blind man who regains vision and bring the retinal confusion to order. Nature supplies no such innate mechanisms; only when reason operates on the flux does the fog lift and individual objects emerge within the perceptual field distinctly. But this work of rationality upon perception is itself the effect of the sign-system into which the individual is inserted – people born blind, deaf and mute, lacking the sign-system, can never structure their experience, and remain 'imbeciles'. The model here is of two tiers:[24] a lower tier, a reservoir into which unstructured sensations flow – all of them:

I am inclined to believe that everything that we have seen, perceived, heard ... exists in us without our knowing it; even to the trees of a great forest, what am I saying? even to the disposition of the branches, to the form of the leaves, and to the variety of colours, of the greens and of the light.[25]

And an upper tier, which derives its structures from the structure of signs, and 'fleshes out' that structure with sensations drawn up from below. This means a perceptual psychology perpetually divided on itself: a mass of experience will never be raised from the depths, but is still ours, 'ourselves', even though it is not attached to a sign and cannot be spoken of or inspected by the mind. So that when we speak, we not only risk the danger that what we have put of ourselves into our utterance may be misunderstood or ignored by those we address; we cannot put *ourselves* into our utterance at all. We do not fit our discourse; a speaker may say *Je*, but that word is not replete with a subjectivity which may then be misconstrued; it is charged with only part of our selfhood and omits the lower tier which is still ourselves but cannot be drawn into language. 'Autre chose est l'état de notre âme; autre chose, le compte que nous en rendons, soit à nous mêmes, soit aux autres.'[26] Diderot's epigram might be mistaken as a lament that we cannot easily convey to others the plenary contents of our mind. But in terms of his theory of the sign, the lament is deeper than that: our minds are not plenary because they can never contain the lower tier, the area of ourselves outside the sign-system; we are always incomplete and the only part of our experience which we can know is the region shaped by signs – by a force introduced into us *from the outside*, like the braille drawn on the hand of the blind. Perhaps the most succinct statement of this self-estrangement through the sign is the presentation of the *dramatis personae* of *Le Neveu de Rameau*: *Moi* and *Lui*, both Diderot, but two halves cut asunder, and each presented accusatively; what Hegel calls a 'selfless reality given over to others'.[27]

Faced with the extremism of Diderot's conviction that we

are all, even to the depth of our perceptions, self-alienated in the sign, we can understand why, with the optimistic half of his being which he shares with the Enlightenment, he dreams of some perfect form of the sign which will correspond exactly to inner state and restore the lost congruence between feeling and avowal. We can also understand why he sees this restoration as impossible.

7 *Diderot and the image*

THE NAME Diderot gives to his dream of the transparent sign is *hieroglyph*. [1] That is, not a *linguistic* sign at all, but one that has managed a partial exit from the self-alienating trap of language and has drawn into itself some of the advantages enjoyed by the image.

Our mind is a *tableau mouvant*, after which we are endlessly painting; we take up a great deal of time in rendering it faithfully; but it exists as a whole and all at once: our mind does not move in stages, as does our expression. [2]

Whereas discourse is distributed in time, mind is simultaneous; it is only when the seriality of discourse has been overcome that a communication of the contents of consciousness from one being to another can occur. This can be achieved only by means of a picture, an image, evoked in the hearer's imagination by the hallucinatory power of speech, that 'subtle hieroglyphic which rules over a whole description', [3] and which enables the hearer to visualise the scene of a description within his mind and to bypass the inherent obstructions of language. When language behaves prosaically, no such image is forthcoming, and instead of experiencing the translucence of discourse before the image, we experience instead the alienness of language to the human mind – those intransigent forms intrinsic to language and without counterpart within consciousness. Seriality is one such form; another is syntax, which distorts the shape of the normal train of thought within the mind – a train that works continuously and without the breakages or fractures whose articulation is the province of the syntactic laws of language. [4] When language approaches the state of the hieroglyph, it becomes poetry, where 'at the same time the soul is moved, the imagination sees and the ears hear what is to be represented, and discourse is no longer simply a suite of energetic terms which expose thought nobly and forcefully, but a tissue of hieroglyphs gathered one upon the other which paint what is to be represented' (*un tissu d'hiéroglyphes entassés les uns sur les autres qui la peignent*). [5] Once discourse reaches the hieroglyphic state, it begins to project directly into the mind and to summon into existence an image whose formation is proof that the inherent impediments and defects of language have been overcome. When left to itself

and not galvanised by the energy of the hieroglyph, language blocks real communication from one simultaneous consciousness to another: instead, only opacity, prosaism, alterity. But when discourse becomes hieroglyph a bridge is formed from one mind to another in a communication that corresponds so exactly to this natural tendency of mind to work in images that the disagreeable sensation of linguistic convention and arbitrariness can be banished in an ultimate limpidity.

Discourse alone is not enough. On the contrary, 'I fall into error at every moment, because language does not furnish me with the means of expressing the truth. I have one thing in the depth of my heart, I say something else.'[6] Part of its inadequacy lies in the fact that it has lost touch with the sensations and the images which are the natural stuff of the mind's *tableau vivant*. This has not always been the case: 'Why is it that one can easily put the imagination of the child into play, and that of the grown man only with such difficulty? It is because at each word, the child seeks the image, the idea; he looks in his head; for the grown man this coin has become habitual.'[7] In terms of the two-tier model, the adult has ceased to draw into the upper tier the necessary sensory content which alone can keep the signs of the upper tier alive. The hieroglyph acts as a kind of Artesian well which irrigates the arid terrain of the sign. Left to itself, the linguistic sign simply dries out, subject to an entropy or desiccation which destroys the original sensory charge the sign had at birth. The hieroglyph recharges the upper tier and restores valid or plenary communication. Stylistically, this restorative action is responsible for Diderot's most personal creation, the *corps diderotique*: language is re-embraced by the body of the writer to save it from atrophy and decay. Return of language to the living body (larynx, heart, diaphragm, lungs) is essential because at every turn, signs die. Constant effort is needed to hold the signs in contact with the regenerative speaking subject: that is the *work* of Diderot's 'style' – less the irrepressible outpouring of high spirits that Spitzer sees than a continuous molestation of the discourse to prevent it from clouding over, from taking over. (It is here, perhaps, that Diderot's 'breathlessness' should be placed; a very obvious stylistic feature, and one that seems part of a whole psychic problem of 'respiration'.)

Even before Diderot began work on the *Salons*, the *tableau* was acquiring the status of hieroglyph in his work, and whenever in his intimate correspondence Diderot wishes to reinforce or to emphasise the bond between himself and his addressee, he asks the reader to visualise a scene:

You see them drawing lots. Imagine the scene and the cries of the fathers, mothers, relations, friends and children as their fatal numbers appear. Imagine the different expressions, the firmness and

weakness of those who are condemned by fate. Imagine that the man who holds the helmet from which the numbers are drawn is the governor of the town, that six victims are needed and that when five have drawn their numbers, he condemns himself to death.[8]

The scene is from a play that Diderot has witnessed, and all his effort is to reduplicate the simultaneous spectacle on stage and to overcome the sequentiality of his description: the repeated word 'Imagine' induces a stasis, for what Diderot wants is an accumulation of small acts of imagination within a single space – *hiéroglyphes entassés les uns sur les autres* – until the *Bildung* emerges.

The *drame bourgeois* is an ideal vehicle for this kind of activity, since it too takes as its basic dramatic unit the *tableau*, and the sweep of the drama through its various acts is constantly interrupted by a stroboscopic effect, in which the characters freeze in their gestures – the moment of arrest coinciding with expression of heightened emotion – and the spectator can take in 'as a whole and all at once' the full significance of the stage-spectacle. Yet even more effective as hieroglyphic art is the novel, which interests Diderot almost exclusively as a means towards visual hallucination.

... my eyes filled with tears, I could no longer read, I got up and began to lament, apostrophising the brother, the sister, the father, the mother, and the uncles and talking out loud, to the great astonishment of Damilavile, who didn't understand a word of my passionate speeches and asked me what was wrong.[9]

Whereas moral instruction in Montaigne and La Rochefoucauld remains abstract and 'cannot by itself imprint any sensory image in our soul', Richardson projects and imprints immediately. The characters in *Clarissa* are, in short, as real as real persons, and this remained in Diderot's eyes the novel's greatest virtue. But far more interesting to Diderot than the nature of the hallucinated world is the act of hallucination itself. He is not in the least concerned with the moral life of Richardson's characters: the vividness of the *tableaux* which a reading of *Clarissa* produces in his mind excludes almost any other kind of reaction. Of course, Diderot does make a rather half-hearted claim for the morality of hallucination: the virtuous act is a selfless one, and in reading Richardson one loses the sense of selfhood; but it does not follow from this that hallucination is intrinsically connected with virtuous acts, and it comes as no surprise to find Diderot 'becoming' the villainous Lovelace, alongside the book's virtuous personages, without any disquiet over the moral implications of a genre in which one identifies oneself so effortlessly with evil. Such implications do not occur to him because his mind is infatuated with the power of the novel to fill his mind with *tableaux*. He has found his first hieroglyphic gold-mine.

His second is the Louvre. We have said that the hieroglyph avoids the arid trap of language by converting discourse into image. And before anything else could be done, before passing judgment or digressing into aesthetics, the basic task of the *Salons* had first to be carried out, of creating a language to describe the paintings on exhibition at the Louvre in such a way that they could be mentally pictured by Grimm's distant clientele. Diderot could not simply comment on the works; nor could he supply illustrations. The basic act of the *Salons* is the translation of an image into language, into a specialised and hieroglyphic language which will allow a mental picture to emerge out of itself and to preside over it. And in this he is entirely successful: although our own editions of the *Salons* accompany the text with reproductions of the paintings Diderot describes, the inclusion of reproductions is redundant; worse – we often find that Diderot's descriptions are more vivid than the paintings themselves.

Potiphar's wife had thrown herself from her pillow to the foot of the bed; she lies on her stomach and detains with her arm the beautiful, bashful slave who has taken her fancy. We see (*on voit*) her throat and her shoulders. How beautiful that throat is; how lovely those shoulders! Love and scorn, but more scorn than love, cover her features ... Joseph is in inexpressible anxiety; he is not sure whether to stay or to flee; his eyes turn to heaven, calling for aid; he is the picture of agony.[10]

When we turn from this to Deshays' *Chastity of Joseph* the effect is one of anticlimax. I don't think that this is entirely due to Diderot's descriptive skill, because in fact his transformation of the painting into discourse is strikingly unspecific: when we read such a phrase as 'How beautiful that throat is', it is we who must do the work to make that phrase come to life, and if we are not prepared to supply what the description leaves out the *Salons* soon become tedious; for they are not so much descriptions of the paintings on the walls of the Louvre during a specific Salon, than verbal scores which it is then up to us to perform; machines for the production of mental images. As dispassionate description, they are often quite wide of the mark: if we compare description against original we are often struck by discrepancy and reduction, as our projection comes up against the facts and loses the private colouration and glamour we have invested in it. This is especially true when Diderot emphasises the physical charms of the figures he claims to describe: at this point we are invited to conjure up a fantasm that accords precisely with our idiosyncratic erotic ideals, and Diderot is well aware that of all scenes the easiest to visualise are erotic ones. But the frequent recourse to this device should make us aware that in a deep sense Diderot is describing irresponsibly: by stimulating our erotic-spectacular

apparatus, he is inviting the creation of an image of which if anything is certain it is that such an image will *not* correspond to the painting in the Louvre. If his task really were the miraculous recreation of identical versions of the paintings of the walls of the Louvre within the eidetic space of his reader, he would not use the device at all: it opens the floodgates of distortion. But that does not worry him: on the contrary, the fascination of the game for Diderot is that the Salon-piece furnishes him with a language satisfying to all parties. From his point of view, a language entirely backed by visual fact: each word has behind it a demonstrable piece of canvas; no verbal counter is empty or opaque; everything is saturated with an original presence and in this respect the language of the Salon-piece is already ideal – it will never become like the language of Rameau's nephew, where words have separated from reality and have come to supplant it. And from the point of view of the reader, satisfaction again: as he reads the description a mental image will emerge on the eidetic screen, and the state of hieroglyph will have been fully achieved. On both sides of the communication, plenitude.

A gauge of the degree to which Diderot is interested in the hieroglyphic possibilities of the Salon-piece is his willingness to include, alongside his descriptions of the paintings actually in the Louvre, 'descriptions' of paintings that exist nowhere except in his imagination.

If I had had to paint the descent of Venus into the forge of Lemnos, I would have shown (*on auroit vu*) the forge blazing beneath massive rocks; the goddess, naked, passing her hand under her chin; the cyclops halting their work; some looking towards their love-smitten master and smiling ironically; others striking sparks from the red-hot iron; sparks would have flown.[11]

Such ontological aberrations – paintings possessing only verbal reality – ought to jar with the empirical descriptions which form the *Salons'* official purpose; but they do not. Instead, such imaginary paintings emphasise the fact that for the subscribers to the *Salons*, all the paintings are like this – not paint and canvas at all, but the hieroglyphic marriage of discourse and image. These phantom-paintings of Diderot are useful in that they give us the fullest account we could wish for of what it is Diderot wants from painting.

In addition to the Venus of Lemnos above, here are three other specimen word-tableaux:

(1) EXECUTION OF JOHN THE BAPTIST

First of all, [Herodias] should be beautiful, but with the kind of beauty that merges into cruelty, into tranquillity and ferocious joy … This is the text I would want to read on the face of Herodias: 'Now preach at me; now call me adulteress; at last you have won the prize of your insolence.' The painter (Pierre) has not felt the effect

that would have been produced if blood had streamed along the arm of the executioner, and even dripped on to the body of the Baptist. I hear someone saying, 'Who would dare to look at such a thing?' But I love paintings where I have to turn away, provided that it is with horror, and not disgust. What could be more horrible than the act and the *sang-froid* of Rubens' Judith?[12]

(2) JUDGMENT OF PARIS

Let the scene unfold at the edge of the world; let the horizon be hidden all round by high mountains; let everything announce the seclusion that fosters indiscreet glances; let a bull bellow and chase a heifer; let two rams lock horns over a ewe grazing quietly beside them; let a goat play alongside a she-goat . . . Let the three goddesses appear before Paris: Venus seems most to arrest his gaze; all so beautiful that I myself would not know to whom to award the apple; each has her special beauty; all are naked; Venus has only her veil, Pallas her helmet, Juno her diadem.[13]

(3) PHRYNE CHARGED WITH IMPIETY BEFORE THE AREOPAGITES

I would make [Phryne] tall, upright, fearless, like the wife of the Gallic general in Tacitus who walks with nobility and pride, her eyes lowered, between the ranks of Roman soldiers. When the orator tore the veil from her head, her whole body would be revealed; her beautiful shoulders, her beautiful arms, her beautiful throat; and by her attitude I would have conveyed what the orator declaimed to the judges: 'You who sit in judgment as the avengers of the angry gods, behold this woman the gods have been pleased to create, and destroy their fine work if you dare.'[14]

It hardly needs stating that these *tableaux* inhabit a utopia of transparency. When the sign begins to exhibit the features that tend to arouse Diderot's anxiety or displeasure, it is usually the case that the signifier has become visible: he becomes aware of its existence as sign, as a copula between signifier and signifier, and can no longer apprehend it as unmediated presence. But the phantom-pictures are protected from that contingency for the simple reason that they *have* no signifier. There is no physical pigment or brushwork around to announce or establish the *work* of the sign; it is as though LeBrun's project of a painting that transcends the materiality of brush and pigment had been realised. In terms of the sign, Diderot's imaginary paintings are 'second-order semiological systems', where a sign in the first system becomes a signified in the second.

Signified I	Signifier I	
Sign I SIGNIFIED II		SIGNIFIER II
SIGN II		

15

The global sign II, Diderot's descriptions in the *Salons* of paintings that are wholly imaginary, breaks into two components: the signifier II (language, words on the printed page) and the signified II (the phantom *tableau*). And this signified II is itself a sign, which breaks into its two component halves: the signified I – the image; and the signifier I – the paint from which the image is made (if physically actualised). But the phantom *tableau* achieves the following and desirable result: it altogether eliminates signifier I (the paintings do not have to actualise in the physical universe); and it makes sign I so intense that in attending to it collaboratively, by visualisation, signifier II is also eliminated. This amounts to form of sign that is 'all signified' and 'no signifier', which is precisely the effect Diderot wants: a sign that has nothing *of itself* that might interfere with the project of transparent communication from one point (Diderot) to another (the visualising reader).

To preserve this form of the sign, Diderot subjects his imaginary paintings to various protective constraints. The first of these is that the picture must be entirely legible. Diderot becomes impatient when he cannot translate an image into discourse: Restout's *Ahasuerus* fails because its narrative is obscure: there should be, Diderot claims, a crowd that parts to make way clearly for Mordecai, but Restout's painting so intermixes the figures from the Ahasuerus–Mordecai story with ancillary bystanders that 'we look in vain for the main figure'; Diderot's verdict is 'no expression' and because the image has resisted verbal translation – because it had remained figural – it is rejected.[16] Hallé's *Trajan* (illustration 75) does translate, but into a ludicrous text: Trajan seems to Diderot to be saying, 'My good woman, I can see that you are exhausted and I would willingly lend you my horse, but as you see he is too damnably skittish.'[17] On the other hand Hallé's *Race of Hippomenes and Atalanta* is entirely legible – Hippomenes seems to be saying to the crowd, 'I am not tired at all; if I have to start the race again, I can; you think that I am tired, but it is nothing' – and because the image successfully generates this complex narrative sentence, Diderot approves.[18] This is the principle invoked in the imaginary paintings of Herodias and of Phryne: the face of Herodias is imprinted with a text as elaborate as that in Hallé's *Race*, and the declamation of the orator before the Areopagite judges is readable by looking only at the bodily postures of the orator and of Phryne.

The tendency to reduce an image to a core text is marked in all the early *Salons* (1759, 1761 and 1763): Diderot not only takes pleasure in the verbal reductions (which can be devastating); he clearly thinks that the capacity of an image to be distilled into a core-text is itself a mark of excellence; an

excellence he finds in abundance in Greuze. This might be taken simply as a colonisation of painting by the literary mind, but in fact almost the opposite is true. The 'texts' Diderot finds in the *Race*, or in *L'Accordée* or the *Jeune fille qui pleurt la mort de son oiseau* are not *linguistic* at all, but somatic; a 'natural' language, but not a 'linguistic' language (in contemporary terms, not digital but analog).

The variety of expressions makes up for poverty of words ... The quantity of words is limited, that of expressions infinite; it is thus that each person has his own individual language and speaks as he feels, is cold or warm, hurried or tranquil; is himself and only himself, while as far as the idea and the terms are concerned he appears to resemble another ... Although this language of expression is infinite, it is mutually understood. It is the language of nature.[19]

When Diderot translates a work on the walls of the Louvre into discourse, he is not destroying this analogical, somatic language and in its place substituting the superior digital code of articulated verbal commentary; on the contrary, Diderot's

75 Noël Hallé, *Clemency of Trajan*

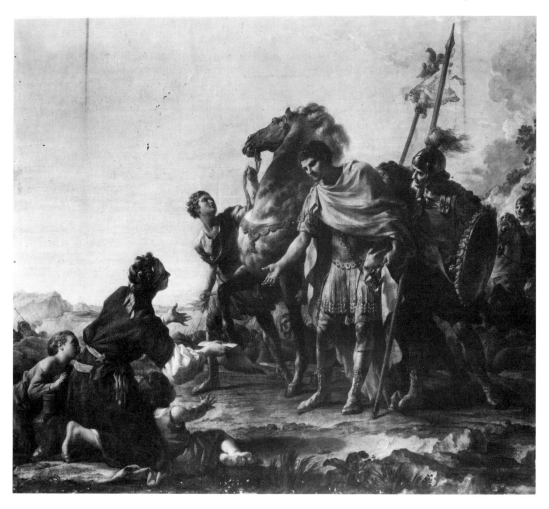

peculiar stance in the *Salons* aims at destroying the alienating digital code and replacing it with the apparently uncodified 'natural' language of the body and of the image: he is if anything colonising the digital by means of the analog language. The creation of the *corps diderotique* is itself an attempt to go outside conventional and arbitrarily coded language towards an extra-linguistic space where the sign is natural ('the language of nature') and restored to plenitude by contact with the living organism of the speaker. This is to place gesture, in a large sense that includes everything the body does while speech is going on, over language, and to hallow this transparency over the opacity of the linguistic sign. The central narrative statements Diderot discovers in the paintings he praises for expressivity are built of the same exalted subtextual or extratextual material, and in performing the reduction Diderot is really correcting the inherent flaws of discourse and writing 'in hieroglyph'. It follows from this that painting which cannot be verbally distilled is problematic: however fine as an image, if it cannot serve as Diderot's route to hieroglyphic writing, it cannot fully enter the *Salons* (the key figure here will be Chardin).

The second major constraint on the eidetic image is that it represent a dramatic climax or reversal – a *peripateia*. This is true of each of the examples. Before the appearance of Venus on Lemnos, Hephaestus is an active and aggressive hammer-god, with all the machistic equipment of forges and anvils, muscles and sweat; at the moment Venus appears, this exaggerated masculinity transforms into passivity and amorousness, as he yields before the equally exaggerated feminine charms of the goddess of love. Before the execution of John, Herodias had been the lesser figure, accused and calumniated by the Baptist; now her accuser is dead and in the moment of victory she moves from shame to triumph and from adultery to monstrosity. The decision of Paris, which seems so remote and idyllic, will nonetheless precipitate the Trojan War. As the orator displays Phryne before the Areopagites, the judges become the accused, and injury against the gods becomes tribute to the gods.

Part of the emphasis on peripateia can be attributed to straightforward sensationalism – it ensures the hieroglyphic reaction. But also contributing to the demand for peripateia is Diderot's need for heightened legibility, and here the peripatetic moment enjoys the advantage of being the only moment in the drama when all the forces at work in the situation enter visibility and can be read at once. At the moment of change or reversal, what had been concealed now fully reveals itself to the reading eye; after the turning point, another distinct configuration will emerge; but at the actual pivot of change,

everything can be seen – two sets of expressions where before and subsequently there had been and there will be only one. In this Diderot is close to LeBrun, who also favours the peripateia for reasons of intelligibility:[20] Poussin's *Manna* was selected for Discourse at the Académie precisely because its double focus on the moment before and the moment after the manna was found made it behave even more like a text than like a painting; it demanded interpretation, close reading, and represented exactly the kind of discursive saturation of the image LeBrun had come to advocate.[21] And so it is with Diderot: as the mind visualises the peripatetic moment, each aspect of the scene is maximally determined and even overdetermined by discourse; but nonetheless it will be entirely immediate – no cumbersome reading apparatus is needed to decode the image, as is the case with images such as the *Manna* or *Darius*, because the image is fully legible already, and at the same time it is also fully sensory: peripateia ensures the hieroglyph.

The third constraint on the word-tableau is that it engage the senses to the greatest possible degree: only by drawing up from the reservoir of sensory memories a heightened investment or charge can the tableau produce the desired effect of seeming so vivid that it will eclipse the sense-impressions coming into the organism from the outside. Diderot's strategy here takes two typical forms. The first exploits what might in other hands prove a hindrance or a liability to the project of description: erotic imagination. Venus, Herodias (who will be drawn on the sadistic area of sexual imagery), the goddesses, Phryne – none of these creatures is described so specifically that the reader will find Diderot's account interfering with his own libidinal visualisation: on the contrary, Diderot disclaims authority – 'I myself would not know to whom to award the apple' – and leaves these figures conspicuously underdetermined. Diderot has no scruples about asking the reader himself to supply the contours and the postures that will most engage his interest, and he knows that every reader will be happy to oblige: the exercise, which might in a different context be salacious, is sanctioned by the unquestionable respectability of the *Salons* themselves and guilt for once will not obstruct the now legitimised indulgence. The erotic imagination possesses the advantage, besides, of not being exclusively optical, but interconnected with the whole sensory apparatus: its images are reinforced by the secondary channels of sense: the resultant kinaesthesia will strengthen the vividness to the point of hieroglyph. And this consideration explains Diderot's second typical strategy, of deliberately deranging normal perception. This emerges most strongly in the recurrent *topoi* of the seascape and the landscape, and the painters here are Loutherbourg and Vernet: 'the sailors cry out; the sides of the vessel

open; some hurl themselves into the sea; others, dying, are stretched out on the shore'.[22]

This kind of scene, to which Diderot returns again and again, serves to destabilise the usual domination of sight over the other senses; the sounds of human cries, crashing waves, sundering wrecks, and the feel of wind and spray combine to prevent the image from being built up of only retinal memories – the whole organism is brought into play. Had it been Diderot's aim to describe, accurately and without avoidable distortion, the actual painting of the storm – Vernet's work in paint on canvas, now hanging in the Louvre – he would not have risked activating in this way the reader's kinaesthetic responses, because that would have been to lose Vernet's painting in the inrush of sense-memories entering the mind from all sides. But that is exactly what Diderot chooses to do, and that he does so is itself proof that the *Salons* do not behave in accordance with their official descriptive project. The paintings are pretexts for hieroglyphic extravagances that have only a contingent bearing on the images actually on display in Paris. When it comes to storms at sea, the reader will be unable to resist replaying his stored memories of spray, tempest, and sea-voyage; just as when it comes to landscape, he will want to re-experience the scenes that have already supplied him with vivid and pleasant experiences.

In the *Salon* of 1767 Diderot produces his most extended landscape-piece[23] – writing so vivid that Diderot is able, as in *Jacques le fataliste*, to make fun of the reader's willingness to accept his verbal landscape as real; landscape that is three-dimensional, not flat, and passing itself off as an actual piece of 'Vernet country', when it is clear that the creator of this terrain is neither Vernet nor Diderot, but the self-gratifying hieroglyphic reader. In such set-pieces, Diderot is subtly subverting the classical role of the descriptive critic. In conventional Salon-criticism, there is customarily a double hegemony, of the eye over the rest of the body, and of language over the eye; but in the stormscapes and landscapes what Blake called the tyranny of the eye is overthrown, as responsibility for the production of the image is passed to the other senses; while the image itself is no longer made to emanate from information supplied by the writing, but on the contrary writing is only the score which the reader's perceptual apparatus must realise, and by that realisation achieve what has always been Diderot's intention: a return of the sign from incipient atrophy and decay to the full potency it at once re-achieves when backed and filled by sensory presence and plenitude.

While they are still being written from within the configuration of transparency, the *Salons* elevate and depress the work of exhibiting artists according to these hieroglyphic criteria, of

legibility, peripateia, and hallucinatory vividness. Almost any work that clearly translates into discourse and is capable of yielding a core narrative sentence is found praiseworthy – all of Deshays' religious paintings, Hallé's *Race*, Doyen's *L'Epidémie des ardents*.[24] Loutherbourg and Vernet gain the highest scores for 'hallucinability' and Diderot's usual tribute to their work is to pretend that their images have sprung to life around him. But the artist who manages to combine legibility and vividness with peripateia, who possesses and possesses in abundance all three virtues, is of course Greuze. All Greuze's paintings exist to be read and Diderot's tribute here is not so much to dwell on the hallucinatory vividness of the scenes Greuze depicts as to expand their understatements into fully explicit narratives: the short story written around *La Jeune Fille qui pleurt* marks the fullest expression of this tendency. All of Greuze's major pieces are peripatetic and Greuze is as fascinated by moments of threshold and transformation as Diderot himself: the moment of transition from childhood to maturity in *The Girl Mourning her dead bird* and *The Broken Pitcher*; the moment of death, in *Le mauvais fils puni* and *The Dying Grandfather*; everywhere, moments of transformation within the household – benediction and malediction, departure and return. And many of Greuze's images covertly appeal to the erotic imagination, certainly to the erotic imagination of Diderot, who shares with Greuze a specialised interest in the charms of young girls whose immaculacy has only just been stained. Greuze exactly meets Diderot's set of criteria and by illustrating his hieroglyphic programme with Greuze's paintings Diderot is able to make that programme much more persuasive than it would have been if he had been forced to rely only on Deshays and Vien, Vernet and Loutherbourg.

But there are two problem areas: Boucher and Chardin. Boucher is at first, in the *Salon* of 1759, praised for his 'beauty', although he lacks 'truth'.[25] Diderot claims that his work is appreciated by two distinct groups of people: by the *gens du monde*, and by artists; and although in the early *Salons* Diderot is by no means blind to the side of Boucher that appeals to the hedonistic or licentious viewer, it is clear that he considers that his own interest in Boucher places him in the other camp. But such an appreciation becomes increasingly difficult to maintain in the 1760s, for the reason that in so far as Boucher is an artist, a craftsman or technician working in pigment on canvas, he cannot yield the hieroglyphic delights of Greuze or Loutherbourg or Vernet – delights that Diderot is beginning to insist upon. Once the *Salons* attend to the material work of the signifier, they lose their capacity to communicate to the reader 'in hieroglyph': the hieroglyph can only come to life when the image is fully discursive, and when the incarnation of

that discursive image occurs within the reader's visualising imagination and nowhere else; in so far as emphasis on the figural component of the image returns it to the walls of the Louvre, it cannot come into existence within the reader's mind. The kind of sign Boucher presents is the opposite of the sign Diderot seeks: it has no legibility – Boucher is un-interested in 'expressions' and complaint against the impassiv-ity and inscrutability of his figures was rapidly becoming standard;[26] Boucher's work is not remotely peripatetic – the situations which appeal to him are far more centred on posture than they are on action; and although the erotic image admir-ably serves the purposes of hieroglyphic expression, it is not as a supplier of erotica that Diderot values Boucher – his reaction is less that of the *gens du monde* than that of the connoisseur who knows how to value technical brilliance. Whereas the form of sign that Diderot seeks lacks the signifier – that is the precon-dition of its hallucinatory vividness – the work of the signifier in Boucher is exactly what Diderot finds most praiseworthy. There is a contradiction between the emergent taste for trans-parent signs, a taste that will elevate Greuze to the summit of French painting, and this recalcitrant aestheticism of Diderot the connoisseur; a contradiction which Diderot never will resolve, because his interest in hieroglyph, and in Greuze the master of hieroglyph, finally makes Boucher unacceptable:

The degeneration of taste, of colour, of composition, of characters, of expression, of design, have followed, step by step, the depravation of morals. What do you want this artist to put onto the canvas? What he has in his imagination. And what can a man have in his imagina-tion who spends his life with prostitutes of the lowest kind?[27]

Diderot's charge of immorality must always strike his readers as unlikely or as lacking in conviction, particularly when, as so often, we find him lingering over beautiful shoulders, beautiful arms, beautiful throats – and since he is so carried away by what we can only take to be the perverted eroticism of Greuze. Diderot's sudden wave of puritan feeling has all the marks of extemporisation: he wants to reject the kind of painting and the kind of sign Boucher offers, and he has Greuze at hand to replace him; it becomes simply a question of how best to effect the changeover, and the actual point of attack – Boucher's lewdness – is almost incidental. Contem-porary feeling had already begun to turn against Boucher's work; the Boucher supporters represented the taste of the court, of la Pompadour and Marigny, where Greuze belonged to the Salon public – to the patrons of the *drame bourgeois*, to the readers of *La Nouvelle Héloïse*, and to the inhabitants of a metropolis interested in escaping into a fantasy of rural sim-plicity and virtuousness. Since the tide had already turned

against Boucher, his replacement by Greuze could be accomplished without difficulty.

This is not the only occasion when Diderot's interventions seem inconsistent with his overall outlook – his behaviour and pronouncements during the affair of Greuze's *Severus and Caracalla* will seem similarly out of character. And when we try to account for such inconsistency – and how could the author of *La Religieuse* accuse anyone of salacity? – a great deal falls into place if we observe exactly how much Diderot stood to gain by replacing Boucher with Greuze. Just as the championship of Rubens against Poussin served to conceal the radicalism and the full extent of the aesthetic change de Piles wanted to bring about, so here a demand for a quite new form of sign could be given the acceptable guise of straightforward promotion. The shift that de Piles envisaged – from a sign based on the signified to a sign based on the signifier – was enormously disruptive, but with 'Rubens' in the balance against 'Poussin' the subversive and innovative side of the project could be underplayed and contained. The shift Diderot wants to see – from a sign that insists on the fact of the material signifier to a sign that effaces the signifier in the hieroglyph – goes in the opposite direction to de Piles, but the strategy is the same: to present what is in effect a revolution as a peaceful change of administrations, and even as a simple question: *aimez-vous Greuze?*

Chardin is in fact the more interesting case. The threat posed by Chardin to the hieroglyphic system is insistent – quite as insistent as with Boucher. Obviously there can be no question of peripateia in Chardin, whose serenity is based on a preclusion of any form of emotional or experiential 'peak'. Nor is there anything remotely erotic about his work – even his fashionable and early de Troy style is solemn and restrained. And so far as we can tell, Diderot had no sense at all of Chardin's legibility. Although we come so much later, paradoxically we are much more aware of the emblem tradition than Chardin's contemporaries – it was his tragedy to be out of his time; and although it does not require much effort of historical reconstruction for us to see that Chardin regards himself as a frustrated moralist and didactic painter, this aspect of Chardin seems to have been altogether lost on Diderot, who never thinks of reading a Chardin as one would read a LeBrun or a quotation from Ripa. Diderot's criteria, in other words, ought to make Chardin completely devoid of interest. And there is more. Chardin insists on the materiality of painting even more strongly than Boucher: all his subjects centre on work, all his figures are involved in some kind of labour, and this concern at the level of subject is matched by the striking evidence of work within the construction of the image.

Chardin's paintings 'cost him infinite pains', and no one who looks at a Chardin – even the Chardins that glaze over the brushstrokes and conceal the actual stuff of paint – can be unaware that it is a miracle of technique. But the hieroglyph is supposed to have no signifier: it is transparent, and the hieroglyphic moment is precisely brought about when the sign ceases to seem to be a sign and instead presents itself as a place of relay of unmediated presence and representation. Chardin is obviously great, and it is to his credit that Diderot at once perceived the greatness. But how to reconcile the artistry of a master-craftsman with the demand for hieroglyphic, hallucinatory painting? How to *describe* a Chardin without referring to the worked surface on exhibition at the Louvre, a surface interesting for reasons that cannot be communicated unless the reader has the original Chardin before his eyes?

At first Diderot is forced to place him in the same category – it is almost incredible – with Loutherbourg and Vernet. The claim is that Chardin is great because hallucinogenic. With other painters, Diderot claims, one must adjust one's eyes in approaching the painting; here, one needs only one's natural sight, because it is not pigment that Chardin mixes on his palette, but 'the actual substance of objects' – 'light and air gathered on the brush and applied to the canvas'.[28] It is nature itself. Forcing on Chardin what is actually a terrible distortion, Diderot goes on to say that the objects in a Chardin still-life are *hors de toile* – off the canvas, existing in an imaginary three-dimensional space behind the signifying plane. If the reader of the *Salons* wants to see for himself what a particular still-life looks like, he need only assemble on a table the various objects that Chardin has brought together in his painting:[29] there will be no difference between the assemblage and the painting, because Chardin is the 'grand magician'[30] of naturalism, who has found the secret of presenting the objects of the world to perfection – '*Chardin et Vernet, mon ami, sont deux grands magiciens.*'[31] In the early *Salons* Diderot's typical form of description is simply to inventorise: imagine the following objects as though someone were placing them before you, and you will have exactly the sense of the original. Diderot is thinking, in other words, of repeated presences and re-created plenitude: he omits the fact that Chardin has a technical side by calling his technique 'magical', which is to say that we have no idea how the trick was done: we are caught up in the spell of illusionism. To be sure, there are moments in the earliest *Salons* (where the taste for the hieroglyph is not yet fully developed, and where Greuze still belongs to the future) when Diderot refers to a grandeur of manner which is *separable* from Chardin's subjects.[32] But it is as the master of *trompe l'oeil* that Diderot first responds to Chardin's work, and I think genuinely so. One

difficulty that Chardin's work presents to the perceptual apparatus of the viewer is the effect we earlier called the 'democracy' of detail: Chardin's composition is in a sense anti-compositional in that it regards every square inch of the canvas as equally important; areas that within a northern tradition usually acquire heightened focus and stress – hands, cuffs, fabrics, reflections, textures – are purged of that traditional emphasis and made equivalent to areas that composition customarily makes tangential and secondary – wall- and table-surfaces, flooring, background. Chardin's problem, which is enormous, is to exclude the visual information the spectator normally expects from these zones without seeming to 'leave gaps'; and for us, whose gaze is far more attentive to the signifying plane than the early Diderot, he seems fully to succeed. But in the same breath that Diderot tells us Chardin is a magician he also tells us that Chardin is lazy and leaves his work 'unfinished';[33] which is exactly what we would expect from the spectator who has not grasped the importance of the signifying plane within Chardin's painting. Diderot is not being disingenuous when he complains of Chardin's *non finito*: he is simply unaware of the significance of the signifier; when it appears – when Diderot becomes aware of the sheet of pigment worked by the brush – he assumes there must be something wrong. What Chardin *ought* to be doing is presenting the objects of the world in all their immediacy and plenitude; deviation from this project is failure. But in so misunderstanding Chardin (though Diderot makes up for it in the later *Salons*) it is clear that Diderot is repressing part of his visual experience; critics as perceptive as Diderot do not fall into such misjudgment unless the pre-established grid of theory intervenes between the image and the eye. And this tells us something important about the early *Salons* (1759, 1761, 1763): they are written by a Diderot that is incomplete. In his writing, he is always aware of the alienness of the sign-system: whether writing on *jouissance*, on the nephew's extravagant impersonations, or on the goings-on inside convents, that other Diderot who at every turn feels the presence of the Word as opacity and alterity is always present, in competition with the optimistic Spitzerian Diderot for whom the Word is sheer transparency and exuberance. But the early *Salons* are escapist: they want only transparency and they have no scruples about getting it; but in the process important visual perceptions are being screened out.

From 1765 onwards, the *Salons* begin to change.[34] Everyone has noticed it: Diderot becomes far more interested in the technical side of painting, words whose provenance is the *atelier* begin for the first time to appear in quantity, and in the *Salons* of 1765 and 1767 Diderot is unprecedentedly

thorough: every painting that is listed in the official catalogue also appears in his commentary. And alongside this heightened technical sensitivity, readers of the *Salons* have also observed a certain decline: by 1769 he is apologising for the brevity of his work,[35] the descriptions become indistinct, and paintings that we would have expected to provoke an enthusiastic response five or seven years earlier now leave him unmoved. From 1771 onwards, a full decadence: Diderot has become disenchanted with Greuze but has no one to replace him; David does not arrive until it is too late. The usual explanations for this double change – the increased technicality and the decline in energy – seem wholly inadequate.[36] The claim is that during the middle and late 1760s, Diderot has been visiting the studios of the artists, watching them at work, and asking questions about technical processes; and this is accompanied by a second and separate claim, that Diderot is tired. But this manner of explanation remains deeply unsatisfactory. Whatever else he may be, the author of the *Le Supplément au voyage de Bougainville, Le Paradoxe sur le comédien, Est-il Bon? est-il Méchant?*, and above all of *Jacques le fataliste* (all written after 1769) is not tired. And Diderot had been familiar with artists for years; since the 1750s he had been very aware of the importance of the use of materials, as his *Encyclopédie* entries on the colours *Blanc* and *Bleu* and *Le Secret de la Peinture en Cire* clearly show. The reason for the change – the technical hardening and the progressive alienation from Salon-criticism – lies deeper than the usual accounts allow; it concerns the perennial problem of the status of the signifier and the intransigence or recalcitrance of the sign which resists the desired translucence. This emerges very clearly in the long digression at the centre of the *Salon* of 1765: the dream of Plato's cave.[37]

Diderot has spent the day looking at the paintings in the Louvre, and the evening reading some dialogues of Plato. He passes the night tormented by a strange vision. It takes place in a dark cavern which is evidently Plato's cave. He and a crowd of men, women, and children are chained hand and foot, their bodies so gripped by wooden vices that they are unable to turn their heads. But everyone seems contented; they laugh, sing, drink, and give no thought to freedom. Behind the prisoners and invisible to them stand the rulers; kings, ministers, priests, doctors, politicians, charlatans, and the whole crew of 'merchants of hope and fear'. Each of these has a stock of little coloured transparencies, appropriate to his vocation; by the light of a great hanging lamp, they project on the wall of the cave images so lifelike that the prisoners mistake them for real, laughing and crying at the fate of the figures floating in the void. A few prisoners are suspicious of what they are forced to see, and try to turn their heads around inside the vice; when

this happens, the rulers cry out with loud and terrible voices and order them to look back at the images. Diderot describes in detail one of the images projected on the wall of the cave, and 'Grimm', to whom all the *Salons* are personally addressed, interrupts Diderot's account to tell him that what he is describing is actually Fragonard's *Corésus and Callirhoé* (illustration 76). The two engage in dialogue about the painting and related subjects, until the real Grimm ('Grimm' had been one of Diderot's personae) intervenes to say that he has allowed Diderot to impersonate his voice long enough (Seznec's edition makes it clear that the second Grimm is indeed the real one); he comments on the Fragonard from the point of view of craft, and especially its use of 'light-echoes'. His last sentence reads: 'This term (*écho de lumière*) is technical, and it is in a technical sense that artists use it.'

The digression is no longer the work of the Diderot who worships the hieroglyph: on the contrary, it inverts the hieroglyphic doctrine and maintains that instead of being humanised by exposure to the sign that seems to be alive (the sign that lacks the signifier), people are enslaved by its illusions. 'Transparency' materialises as the actual slides the rulers use to distract and manipulate their subjects, and it operates by

76 Jean-Honoré Fragonard, *Corésus et Callirhoé*

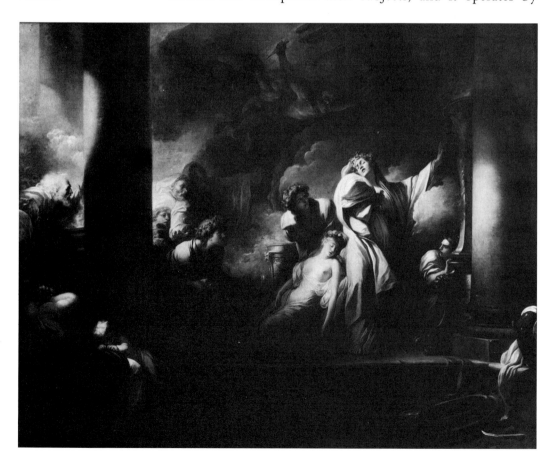

exploiting a deadly sign-automatism in which we are all impli-
cated: the rulers, whose power depends on the success and
invisibility of the exploitation; Diderot, who responds to the
dream itself as though it were one of the slides in the cave, and
needs the *réveil* of Grimm to dispel the fantasm; and the reader,
who as he absorbs the text of the digression is denied know-
ledge of the planes of reality and unreality at work in the
writing, and who has to rely on editorial help to determine
whether 'Grimm' is real or a fabrication. Associated with this
helplessness before the magical simulacrum are political
oppression, loss of humanity, loss of freedom, dignity, intelli-
gence; the signs rule over their victims in a world-order
that has become perverted and in a reign of confusion and
night whose atmosphere resembles the close of the Dunciad
(where Dullness is the name given to the alienating power of
the sign).

But although incoherent and at times sinister, the dream of
Plato's cave is never allowed to get out of hand. Diderot's
digression is not moving *in* to darkness but *out* of darkness; the
opposite of Pope, it grows increasingly wakeful until finally all
the illusions are banished in the light of full consciousness. At
first, hallucinated presence dominates – pure hieroglyph; but
then, as 'Grimm' – the messenger from the other side – inter-
venes, the hallucination is culturally placed: it is a dream, the
dream of a painting in the Louvre. From painting as vision –
écho de lumière in its resonant sense – the text moves to painting
as technique – '*écho de lumière* is a technical term and it is as such
that artists use it'. The whole passage, with its ontological
games and impersonated voices, anticipates *Jacques le fataliste*,
where however interesting and absorbing the individual narra-
tives may be, our willingness to lose ourselves in the story is
constantly disrupted by awareness of the act of narration itself,
its constraints, its skills, and its disconnection from the prior
reality on which it pretends to be based. Fragonard's painting
is wholly appropriate: it does have a visionary quality, but that
quality is at once called into question when we recall the
material circumstances of the painting's production – this was
Fragonard adjusting his manner to the conventions of the
Académie, and to the visitor to the Salon of 1765 its interest
would have resided in the question of how Fragonard could
possibly manage it: the focus on technique undercuts the
image's apparitional quality. From illusion, and the fear of
illusion, the *Salon* moves to the banishing of illusion through
attention to technics: the prisoner will be free the moment he
can see the manipulation that lies behind the 'transparency'.
From now on, it will be the anti-hieroglyphic Diderot who
will take over the task of writing the *Salons*.

After 1767 there is little reference to the emotive or

transportative effect of a work of art, even when the subject is as elevated as the *Oath of Brutus* at the *Salon* of 1771.[38] We can gauge the degree of change in the *topos* of the storm at sea. In the *Regrets sur ma vieille robe de chambre*, which appeared in February 1769, before the Salon had opened, his approach to Vernet's *Tempête* is pitched in a very high key: he even calls out to God – '*Sois touché de la tendresse de ces deux époux. Vois la terreur que tu as inspiré à cette femme.*'[39] Writing his *Salon* later that year, apart from one reference to 'regards furieux' Diderot produces description that is without emotion of any kind: '*Les figures sont un peu colossales . . . Ce sont des passagers qui s'échappent les uns après les autres.*'[40] The wife and her terror have been displaced by formalist terms which deliberately avoid the usual synaesthesia Diderot cultivates in his sea-writing. The two battle-scenes by Casanova in 1771 are similarly defused: despite their intensity of subject, Diderot restricts himself to comment on the efficiency with which they resolve difficulties of composition and drawing. By 1769 Diderot has come to mistrust the whole movement of *sensibilité*: having been the pioneer reader and supporter of the novel, he now moves

77 Claude-Joseph Vernet, *Shipwreck: mid-day*

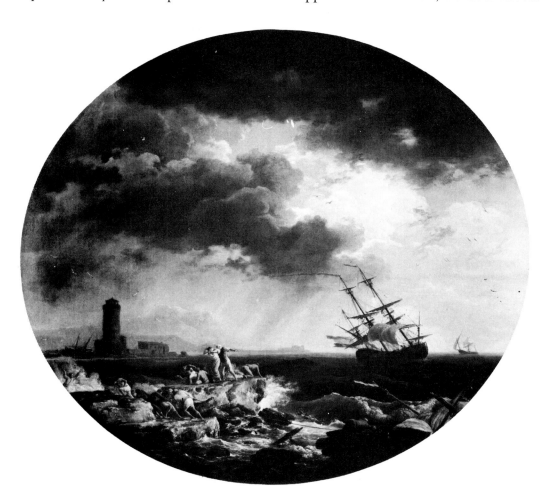

towards Sterne and parody of the novel's realist assumptions: *Jacques* can be read, and I believe should be read, as a post-realist fiction in which belief in the limpidity of the novel before emotional and empirical facts is replaced by a sense of disconnection of the discourse from origin in the real; the writing occurs in a void of language emptied of all original presence.[41] Diderot is interested only in illusion that presents itself as illusion:

In the *conte merveilleux*, nature is exaggerated, truth is only hypothetical; the tale that is meant to entertain, that I approve – let it be amusing, ingenious, varied, original, even extravagant; the *conte historique*; that is something that tries to deceive you ... It studs itself with tiny details of life so close to life ... and always so hard to imagine, that you are forced to say to yourself, My goodness, that is true, no one could have invented that.[42]

In theatre, he is indifferent to the success of his own *drame bourgeois* and resists invitations to write more, and so far from advocating emotion on the stage, he produces the *Paradoxe* to prove that emotionalism undermines good acting. *Sensibilité* is denounced in terms that almost anticipate *Werther*: 'this quality which everyone so admires, and which leads to nothing great; if it operates strongly, it leads to pain; weakly, to boredom'.[43] Where ten years before, emotional arousal before art had at least some connection with morality – 'I must be good, to be so moved' – now he looks on such arousal as self-deception: 'the citizen arrives at the door of the theatre and deposits all his vices; he collects them again on his way out'.[44] And the only defence against what are now seen as the misguided excesses of *sensibilité* is the solution of Plato's cave: to attend to and to expose, repeatedly, the material work of the signifier.

The great victim of the change is Greuze. To the Salon of 1769 Greuze sent his ill-fated *Severus and Caracalla* (illustration 70). Diderot had previously enthused over a substantially inferior sketch, and had urged to Greuze to make of it a 'fine painting'.[45] Now he joins the ranks of the Académiciens in condemning it, and on the most orthodox grounds: '*Greuze est sorti de son genre.*'[46] There is something mysterious about this display of reactionary zeal. Diderot had already broken with the hierarchy of the genres by claiming greatness for Chardin; and if there were any continuity in his thinking, his current speculation on material monism would have pointed towards the uselessness of all division by *genus*: if every animal is more or less a human being and every mineral more or less a plant, if the marble of a Falconet is as *sensible* as Falconet himself, if nature is uninterested in category, then the metaphysical foundation for the categories of painting is also undercut.[47] But it is easy to see why the *Severus and Caracalla* had to be rejected. Diderot was increasingly turning away from the

painting of the hieroglyph, whose master he had declared Greuze to be; what interests him from 1769 onwards is the aspect of the image that resists translation into discourse – figurality.

But the *Severus and Caracalla* seeks to aggrandise the domain of the discursive image. Greuze has already succeeded in colonising the usually non-discursive category of genre-painting and has raised it to the level of history painting. Before Greuze, it had been history painting that held the discursive monopoly over the image, while genre was the mutist hanger-on; with Greuze the roles are reversed: genre is saturated with discourse, and by comparison the *grand tableau* can seem entirely painterly. The *Severus and Caracalla* asks Greuze to be admitted into the Académie as a history painter: Greuze wants not only confirmation that what he is doing can be counted as history painting already, he wants the division of category between genre and history to be officially dissolved. That is the historical significance of Greuze's unlovely and unlucky painting: it asks for a discursive colonisation of history painting from below, and for a removal of the barriers which separate discursive painting from non-discursive painting that will not be acceptable until the last decade of the eighteenth century – it is a work whose unprepossessing exterior conceals a wild ambition. But the advance of discursive painting, with its lack of interest in the material signifier, is now, for Diderot, to be halted, at whatever cost – the friendship of Greuze, inconsistency, and even the acrimony of concurring with the Académicians in a decision which, to them, probably concerned only the narrow issue of the professional pecking-order.

In the re-alignment of the later *Salons*, if Greuze is to be exiled, Chardin is to take his place; but it is a new Chardin, not the magician, but the master of *harmonie*. This word and the related terms *rapports* and *accords* arc at the centre of Diderot's post-1769 aesthetic. If it were true, as Diderot had begun to argue in the 1766 *Essai sur la peinture,* that nature knows neither perfection nor imperfection, then the idea of beauty could never be derived from nature: it must be a novel and exclusively human conception, deriving from laws of formal harmony without relation to the laws of the universe. Nothing in nature is either ugly or beautiful; even the cripple is a perfect being of his kind in the eyes of creation; only when an organism can no longer support life does nature regard it as defective. One consequence of this view is that the idea of the beautiful, having no foundation in the natural world, must originate exclusively with art, from those internal relations or *rapports* amongst different parts that harmonise away from nature, within the novel and artificial context of artistic pro-

duction. Here, as we know, Diderot runs counter to a prevailing current within the aesthetics of his time (and reveals, among other things, his debt to Shaftesbury); opposes Batteux, for whom beauty depends on recognising, selecting, and reproducing the beautiful object; and, on the other side of the Channel, Burke and Hume, for whom beauty is a quality resolutely *within* bodies:[48] in Britain we must wait until the Glasgow lectures of Thomas Reid for full investigation of those qualities within the image which are distinct from subject.[49] But it is not, simply, a cult of formalism ahead of its time; Diderot's thinking is more intricate than that.

For Diderot perception is not thought of as an immediate process. The blind man who recovers his sight will at first perceive nothing coherently, because the organism has received no programme from nature with which to structure the perceptual field. Perception is dependent on the mediation of sign-systems, and these are shaped by our needs, which are changeable – those of the blind, for example, vary enormously from the sighted and produce a radically different field of consciousness; and shaped also by the internal structure and laws of the sign-system, so that thoughts which manifest clearly inside one language cannot be translated into another (the subject of the *Eloge de Térence*). Beneath what we have called this upper tier of the sign-system, resides the raw flux of sensations which subtends conscious perception. The flux is not yet human: it is only through his ability to break up its continuity and to establish *rapports* of significance between elements that man is able to raise himself above the world-stream to the stability of mediation, system, and consciousness; human beings unlucky enough not to be introduced into a sign-system remain imbecilic. The meaning of the perceptual model is that it is *rapports* – internal structures independent of the fluid contents of the lower tier – which define consciousness. And this modifies the status of the *rapports* which Diderot finds increasingly interesting in painting.

On the one hand, the painter who introduces the quality of aesthetic harmony into the image, in independence from the natural world that has no place for considerations of beauty; on the other, the perceiver who introduces system into the world-stream of the lower tier. In neither case is nature directly carried over into its destination, whether the canvas or the mind. Nature cannot be carried over into the one any more than into the other; in neither case is there immediacy, and there is therefore no essential difference between aesthetic and ordinary perception.[50] The *rapports* and *accords* of Diderot's precocious formalism are not an artificial gridwork laid over the raw flux of sensations. It could be claimed, if Diderot had pursued that avenue, that the grid of art is a second set of

constraints laid over the quite separate grid of ordinary perception. But that is the line Diderot chooses not to follow; he claims instead that the two systems may coincide, and the point of their happiest coincidence is Chardin.

In his *Encyclopédie* entry *Harmonie* Diderot had written: 'The effect or harmony of light and colour can exist in a painting independently of the imperfection of the objects represented.'[51] Harmony, in other words, can be a purely painterly reorganisation, occurring exclusively on the picture-plane (in which case he *is* presenting art as a second set of constraints superimposed on the previous set of habitual perception). But harmony of light and colour can *also*, in Diderot, be the harmony of those subtle effects of light and colour which reside in the original objects and cause a unifying effect to be perceived in independence from the picture-plane. Even the most imperfect of objects, for example Chardin's *Skate* (illustration 47), contains *reflets*, reflections from one object to another, subtle accommodations of colour and light that are only brought out, not created *ab novo*, on the painted surface. *Harmonie* is, in fact, a pun. In one sense it refers to the harmony of light that is already present in nature, to those elusive effects of radiation and reflection which are the province of the realist and the hyper-realist painter. But in another sense it refers to a new, purely aesthetic harmony that is introduced into nature from the outside: to qualities of composition, to the disposition of marks on canvas, to symmetries and asymmetries that belong exclusively to the plane of signifiers.

Chardin is the master of both kinds of *Harmonie*. He *endows* composition with 'a harmony which insinuates (*serpente*) imperceptibly into his compositions' and which is 'like the Spirit of the theologians, everywhere felt and at each point invisible'.[52] The claim is that Chardin adds or insinuates harmony, not only into his *subject*, but more surprisingly into his *composition*: his picture is already a *composition* (in the sense of substantially complete work) before this new and finally completing quality is introduced. But at the same time, the quality is not entirely of the paint: rather, it is the registering of *rapports* amongst the objects themselves: 'See how the objects reflect amongst themselves . . . We look in vain for light and dark, and they must be there, but they are not striking in one place more than another.'[53] Light-echoes: reverberations of light as it travels in the space between one object and another. *Harmonie* in Chardin belongs both to the original order of perception and to the new order of painting, without disjunction between the two. We are fully aware of both, and at the same moment: '*Chardin est entre la nature et l'art*.'[54] As Chardin introduces that final and completing quality we cannot decide which kind of

work we are watching: that of the observer recording the elusive facts of his retinal impression; or that of the formalist, insinuating a quality that derives exclusively from the internal relations amongst different components within the frame.

Let us isolate these final strokes of *harmonie* which Chardin adds to his *composition*; they will tell us why it is that Chardin is so important to the later Diderot. Each stroke is saturated in perception; going beyond the little masters, Chardin is now recording his last subtle observations on the original colour and light that habitual perception normally screens out. Each stroke is backed by and has as its referent a distinct visual impression which it limpidly records; the mark is transparent to that original presence and behaves like the hieroglyph. And each stroke is a visible tracing of paint on canvas; it can be attended to separately, or Diderot could not state its existence. No alienating excess of signifier over signified: the trace is still representing a prior sensation; and no concealment of the signifier in the work of the signified – Diderot can isolate and appreciate the *harmonie* that is independent from the original object. The sign has finally found its point of balance.

8 1785

RECENTLY I FOUND myself in conversation with a history
graduate interested in the popular art of the French Revolution
– the posters, engravings, and propaganda images produced in
quantity between 1789 and 1795, an exhibition of which he had
seen at the Musée Carnavalet in Paris.[1] He complained that
while he often came across choice specimens in histories of the
Revolution, he found that art history largely neglected this
fascinating area of visual design. When I asked him why this
might be so, he paused to reflect, and then suggested that one
reason might be that art historians, feeling a need to classify
works by style alone, had no easily available stylistic category
in which to place the popular imagery of the Revolution. The
period from 1785 to 1795 is generally understood, he main-
tained, as having a uniquely appropriate style – neo-classicism;
and one artist within that style whose work is from every point
of view outstanding – David. But these Revolutionary images
seem to have little to do with either neo-classicism or David.
This was the reason, he felt, for their neglect, rather than the
more radical explanation, that art history is a conservative
subject which tends to restrict itself to masterworks produced
by an élite of artists for an élite of patrons, and tends to regard
as beneath its consideration more 'populist' art.

My friend apparently did not know of David's extremely
populist artistic activity during the Revolution – he might
have been surprised to learn that the Neo-classical master had
himself commissioned a number of the broadsheet images he
had been admiring, and had designed at least two such images
personally, in the most anti-élitist style. But I was more
interested in his remark that the period from 1785 until the
Directoire had a style 'appropriate' to itself – neo-classicism.
Why 1785, I asked: because that is the year David exhibited his
Oath of the Horatii (illustration 92), the work which marks the
triumph of the Neo-classical style in France. Pressing him
further, I asked him more about the significance of 1785; he
answered with a brief history, for which I could guess the
sources.

The neo-classical style triumphed with David's *Oath* of 1785
because at least three streams of influence converged upon that
work. First, the influence of Rome, where the circle around
Winckelmann and Mengs, reacting with enthusiasm to the

discovery of antique painting at Herculaneum and Pompeii, had launched unprecedently thorough scholarly enquiry into the art of antiquity, and had promoted antiquity as the inspiration for a stylistic reform of painting whose first expression is Mengs's ceiling decoration for the Villa Albani, and whose greatest expression will be the *Oath* itself. Second, the influence of the *philosophes* and enlightened amateurs in France who, rejecting as frivolous and base the excesses of rococo, advocated a new, grand style, full of moral purposiveness, and a whole didactic programme in the arts; as their ideas took root the neo-classical style became the stylistic expression of their purposed reform, and 1785 marks the culmination of their policy: it was tragic that Diderot, the first to criticise the degeneracy of rococo and to advocate a return to the *grand tableau,* died before he could see David's masterpiece. Third, the activity of the administrators of the arts in France, who translated the ideas of the *philosophes* into practice: first Marigny and then d'Angiviller, the bureaucratic executors of a government policy which stretches back as far as the 1740s and which comes to fruition in 1785. These three streams of influence, my friend claimed, came together in the work of David in the 1780s; he added that the austere, virile style of the *Oath* was the perfect accompaniment to the moral purpose of the painting, which urged personal self-sacrifice for the good of the state; and the perfect accompaniment also to the political self-expression of the class rousing itself to action in the years immediately before the Revolution. The *Oath*, the *Death of Socrates* (illustration 78), and the *Brutus* (illustration 79) reinforced this message of individual self-renunciation and severe political morality: Brutus would become the guardian spirit of the Revolutionaries.

There was so much truth mixed up with so much misunderstanding in this account that I began to reflect on the difficulty of disentangling the two; and to wonder whether what I had just heard might not correspond to widespread belief about painting in France in the years before the Revolution. The view my historian friend expressed is one which for a long time has made me extremely uncomfortable, because it seems to me so completely to distort the significance of David's work in the 1780s. The case is a difficult one to argue, and in a single chapter only a fraction of the ground can be covered; but I can begin by pointing back to another year besides 1785, in fact to 1769, the year of Greuze's *Severus and Caracalla* (illustration 70). Place it beside two other images: Greuze's *The Drunkard's Return* (illustration 65) and David's *Belisarius Begging Alms* (illustration 80). David and Greuze seem strikingly similar. David's painting, which our historian would probably see as a major advance towards the neo-classical severity of 1785, so

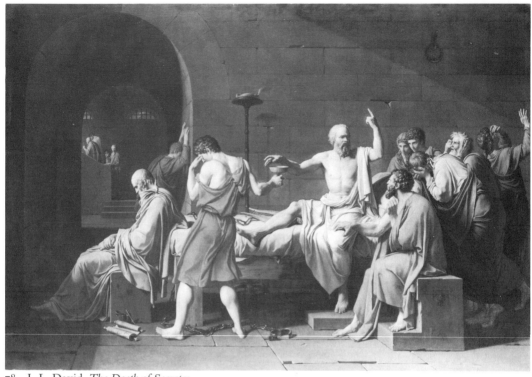

78 J.-L. David, *The Death of Socrates*
79 J.-L. David, *The Lictors Bringing Brutus the Bodies of his Sons*

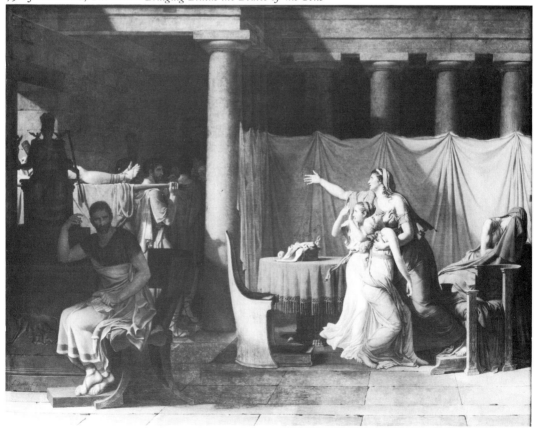

far from looking forward in time looks backwards towards Greuze: the gestures of the woman who gives the *obolum* to Belisarius and those of her child have in fact been lifted from Greuze's *Drunkard's Return*. And David's theme of salvific charity, cutting across the barriers imposed by age and by fortune, issues directly from *sensibilité*. Greuze's *Severus and Caracalla* was accused of being a scene from his repertoire of bourgeois homiletic subjects, dressed up in antique garb; but the same charge can be levelled against *Belisarius*. David and Greuze, even in these eminently neo-classical works, are still operating within emotional conventions established in the early 1760s. And now consider the style: behind both *Belisarius* and *Severus and Caracalla*, not Winckelmann (whose disciples would have been surprised to find a Byzantine general stranded in this anachronistic Roman setting), but Poussin. In his defence of *Severus and Caracalla* Greuze risked making a public spectacle of himself by describing how deeply and for

80 J.-L. David, *Belisarius Begging Alms*

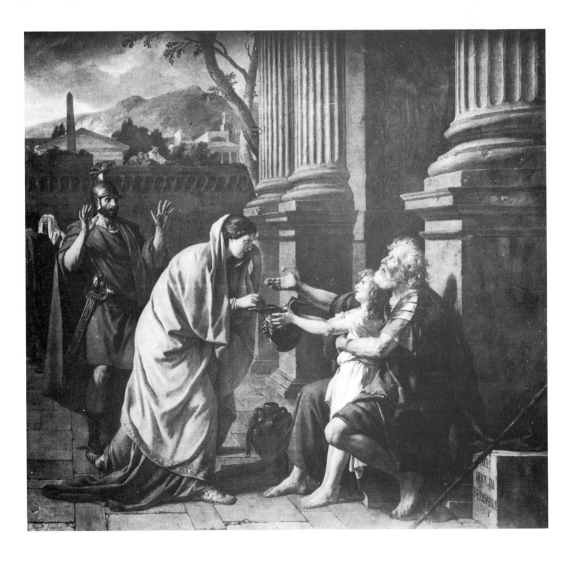

how long he had studied Poussin: he even hoped to create a new style in painting by returning to this source. Poussin is apparent in Greuze's planimetric composition, frozen gestures, and even the use of the drape in parallel to the picture plane; and Poussin is apparent equally in David's painting, with *its* frozen gestures, its arms in parallel with the picture plane, and above all in its resolutely neo-Poussinist landscape. To be sure, both paintings go behind Poussin, back to antiquity itself: the head of the Emperor comes directly from Roman sources, as Greuze was proud to point out;[2] just as Belisarius owes something to the type of warrior David had seen on the Trajan column.[3] But both works seem far closer to the seventeenth century than to the classical world; if we call these paintings 'neo-classical' we may be beguiled by a word if we think that the rediscovery of antiquity is behind them.

But the crucial question is that of the dates. *Severus and Caracalla,* 1769; *Belisarius,* 1781. The interval is large enough to make us aware of a delay which, if our historian's account were true, must seem mysterious. That account, we remember, listed at least three forces which culminated in 1785. But why the gap? The discoveries of Herculaneum and Pompeii were made in 1738 and 1748; Winckelmann's ideas gained international currency in the 1760s. The influence of the *philosophes* is at work very clearly in the same decade: one thinks at once of Diderot's rejection of the immorality of Boucher, and his promotion of Greuze. Although Diderot abandoned Greuze after 1769, he is the real force behind the *Severus and Caracalla*; he had personally encouraged Greuze to tackle a classical subject, and had even recommended, in 1769, not 1789, the subject of Brutus condemning his sons to death. As to the influence of the state administrators in the 1760s, this too was vigorous. Even Lenormant de Tournehem, the minister in charge of the arts in the late *1740s,* had cut the price for portraits, increased the rate for history paintings, and convened a special committee, composed largely of history painters, to judge the work submitted to the Salon. Tournehem's contribution to the reform of painting, and the ascendancy of history painting, is usually overlooked because he was the uncle of Mme de Pompadour; but even here we ought to hesitate before we sound the cry of 'Van Loo, Pompadour, rococo'. Mme de Pompadour may have been the patron of Boucher, but it must not be forgotten that it was she who ordered from Vien, the originator of the first neo-antique manner in French painting, a drawing celebrating the French victory at Fontenoy, and showing the King, dressed as a Roman Emperor, on a chariot beneath the figure of Victory; and who herself ordered an image of Peace and Victory contesting for influence over the

King, who has turned his gaze from the victorious battlefield to view the crops – an interest in agriculture that comes directly from the injunctions of the *philosophes*.

If our conception of the Pompadour style is too entrenched for us to take seriously these deviations from the stereotype, let us return to dates and recall that after his death de Tournehem was replaced as *Directeur général des bâtiments* by Marigny, who in 1764 inaugurated the official policy of encouraging a morally elevating neo-antique manner by commissioning a cycle with the following subjects: Augustus closing the doors of the Temple of Janus; Titus before the ruins of Jerusalem, lamenting the fate that has forced him to such destruction; Trajan stopping in mid-campaign to extend the Imperial charity towards a supplicant (see illustration 75); Marcus Aurelius consoling the people during famine. When our historian observes that these forces – the promotion of moral subjects by the *philosophes*, the resurrection of antiquity through Winckelmann-inspired scholarship, the redirection of painting by the artistic administrators towards an elevating neo-antique grand manner – culminate in 1785, our immediate objection is this: all these forces are present in the 1760s, and a claim can even be made that the convergence supposed to occur in 1785 actually takes place in 1769. And these forces do not exhaust themselves in 1769; quite the contrary. They continue to be operative and to seem ascendant: why then do they not produce more work comparable to 1769, until 1785?

This 'problem of the delay' becomes quite striking when we consider the enormous progress of neo-classicism in the Anglo-Saxon world. Textbooks usually beg the question by describing it as 'precocious'. That word seems entirely just when we look at an early work by Benjamin West, the *Death of Socrates,* painted in the remote forests of Pennsylvania. The urge there is precisely to wed a moral subject with antiquity: West does not yet command the technical means to realise the urge, but by the time of *Agrippina with the Ashes of Germanicus* (illustration 81) he has succeeded. The year is 1768, and a great deal of 1785 is already present: the use of bas-relief to inform the grouping of figures; a purge of the diagonal and a banishment of melodrama in favour of 'noble calm'; and an exhortative narrative address to the spectator. In particular, didactic intent combined with austerity of form seem to 'anticipate' David, as historians of the Anglo-Saxon painters working in Rome always point out. A crucial figure here is, of course, Gavin Hamilton, whose *Oath of Brutus* is sometimes cited among the sources for David's *Oath of the Horatii*. Already in 1764 Hamilton is planning and executing his series of Homeric subjects which, through the medium of Cunego's engravings,

circulate throughout Europe and establish Hamilton's inter-national reputation.[4] Now, unlike the French, the Anglo-Saxons had no Academy in Rome; until 1762, no Academy anywhere. The British state was not remotely interested in cultivating painting as an 'emanation from the throne'. And while the *philosophes'* promotion of didactic painting may not be without its influence on West and Hamilton, we would expect that influence to have been much more intensely felt by French painters at the Académies in Paris and in Rome, than by the untheoretical, unacademic Anglo-Saxons working within the disorganised framework of the Roman colony.

As to the influence of Mengs and Winckelmann, we have not yet decided amongst ourselves how much the precocious British neo-classicism owes to this source; but it may be that the debt is less than is usually allowed.[5] Nathaniel Dance, whose *Death of Virginia* (1761) pioneers the neo-classical *topos* of exalted antique death, was a pupil not of Mengs but of Mengs's rival, Pompeo Batoni; he seems to have spoken of Mengs 'with disdain'. Benjamin West arrived in Rome in the spring of 1760 and made straight for Mengs, who advised him first to tour Florence, Bologna, Parma, and Venice, and then to return to Rome to do a history painting. West, following Mengs's advice, set off without delay for Florence, where he promptly fell ill and spent most of 1760 bedridden. By the time he returned to Rome, Mengs had left to become Court Painter

81 Benjamin West,
Agrippina with the Ashes of Germanicus

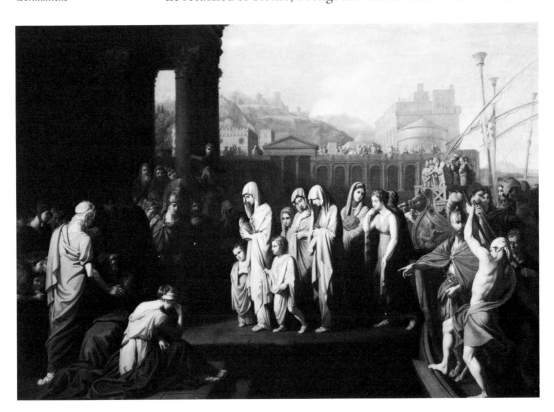

to the King of Spain. Angelica Kauffmann arrived in Rome in 1763 and left in 1766; throughout that time Mengs was absent abroad; and the same holds for James Barry (in Rome 1766–71). The neo-classicism of the British in Rome would seem to owe less to an imaginary neo-classicising influence radiating outwards from the Mengs–Winckelmann circle, than it does to the native need, in the late 1750s and 1760s, for a reform within British painting, and the experiment of a British history painting, in this period of the foundation of the Royal Academy. In 1758, John Parker is already defining the canon of subjects which enters the mainstream of French painting only in the middle 1770s: the Deaths of Socrates, of Agrippina, of Epaminondas, Hamilcar swearing Hannibal, Catiline swearing the Conspirators. This didactic programme is motivated by an independent, London-based demand for an English Grand Manner; yet the programme is not, as our historian would lead us to expect, avidly taken up by the French painters in Rome; for that we must wait for almost a generation. It seems that forces stronger than those listed in his account are actively blocking the French absorption of a didactic neo-antique manner.

How did it come about that barbarians from *ultima Thule* succeeded where their more sophisticated colleagues from Paris seem to have failed? In fact the question is a false one, presupposing a historical drive 'towards' the manner of 1785, a drive that is then 'countered' by various resistances. That is the problem with the *Oath*: it is so enormously superior to the work surrounding it that it encourages one to think in supra-individual terms; its colossal force must come from History. Certainly this is the reaction of a good many viewers: of Locquin, for whom the *Oath* culminates the programme of administratively encouraged history painting which he traces back to 1747;[6] of Hautecoeur, for whom the *Oath* is the climax of the influence of Rome on Paris;[7] of James Leith, who sees the *Oath* as the great, the only successful work in the history of 'the idea of art as propaganda' – an idea he sees as largely sterile in its results, apart from this one masterwork;[8] and of the viewer who, standing before the work and exposing himself to its full impact, may feel that its forcefulness is in a mysterious way connected with the French Revolution. But while it simplifies art history to think in terms of teleologies – of great drives towards certain works, of artists summing up in their painting the epochal forces of history, or of particular styles expressing the spirit of their age – the true situation is too complicated to permit such sweeping generalisation. To help us unravel the complexity, let us remove the teleological bias and ask why French painting seems to be *uninterested* in the kind of didactic neo-antique manner that fascinates the

Anglo-Saxons: that is at least an improvement on 'What forces prevented French painting from accomplishing its historical mission until 1785?'

The answer has already been found, I believe, by Locquin. Government intervention in the arts, and the idea of didactic history painting, is of an importance in French painting that can never be overestimated: it is that programme which makes French painting in the latter half of the eighteenth century so different from the work of the other European schools. But the requirement that painting *teach* is quite separate from the requirement that painting assume a particular visual style. Didacticism has everything to do with the kind of sign painting should become – what the relation should be between word and image: didactic painting must be discursive painting, and all of its interest centres on the signified. But didacticism does not necessarily prescribe or proscribe its styles. On the contrary, it may use any style, so long as its characteristic sign-format is preserved. This emerges clearly when we consider the successive cycles of state-supported commissions in the 1770s and 1780s. Marigny and his adviser, Cochin, did a great deal to encourage history painting: the 1764 cycle of paintings for Choisy (subjects listed above) is sufficient proof of that. But there was strong opposition: Louis XV was not anxious to be surrounded by homiletic imagery and Cochin was forced after two years to replace the four paintings actually achieved with works by Boucher.

The moment of change is 1773, when Marigny, Pompadour's brother, retired as *Directeur général*, to be replaced by the Comte d'Angiviller. The new *Directeur* was quick to issue the pronouncement that 'the King will view with particular interest the painters of his Academy as they depict the deeds and the events which honour the nation: what more worthy use can there be for the arts, than to become associated with the legislation of morality?' In 1775 d'Angiviller commissions from his painters four scenes destined to become tapestries at the Gobelins: the City of Randan honouring the valour of the Constable du Guesclin; the Chevalier Bayard returning a prisoner to her mother after giving her a dowry; President Molé seized by rebels in the capital; the would-be assassins of Coligny falling to their knees in respect. The point is that not one of these is a classical subject, and given d'Angiviller's chauvinism, his belief that the arts should be an 'emanation from the Throne' and should celebrate the national *gloire*, subjects taken from antiquity would inevitably have seemed less engaging than those taken from the nation's past.

In this, the *Directeur général* seems to be catching up with the latest Atlantic developments. In 1771 West had produced his *Death of Wolfe*, the first British history painting to break with

antiquity and to experiment with a specifically patriotic sub-
ject; in its wake will come John Trumbull's *Death of General
Montgomery* and *Death of General Warren*, and Copley's *Death of
Chatham*.[9] D'Angiviller deviates from this tradition in that it is
past, not present, heroism which is to offer instruction; but
that instruction similarly takes precedence over stylistic con-
siderations. In a project of 1777, he plans a cycle of eight
subjects, with six from ancient and two from French history;
his taste in national material inclines him towards such scenes
as the Courage of Eustache de Saint-Pierre and of his compat-
riots during the Siege of Calais, du Guesclin honoured for his
Virtue.

Vincent's *Président Molé* (illustration 82) typifies the kind of
painting d'Angiviller is eager to encourage; nationalistic,
emotionally simple scenes glorifying on the one hand the

82 Vincent, *Le Président
Molé arrêté par les factieux
pendant les troubles de la
Fronde*

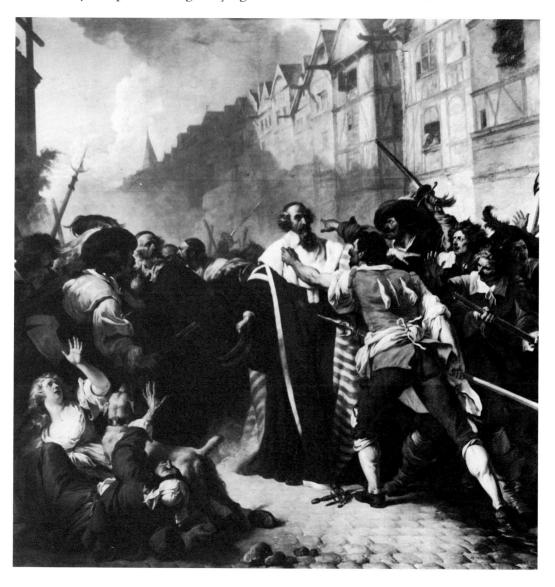

heritage of France and on the other the virtues of civic altruism and discipline. It is the first of these that infuses what is d'Angiviller's greatest single achievement, the statuary cycle of illustrious Frenchmen commissioned for permanent installation in the Louvre (d'Angiviller was concerned that the National Museum become a vehicle for public instruction). These survive and in most cases survive in mint condition: Julien's *La Fontaine* (illustration 83) and Clodion's *Montesquieu* (illustration 84) are the real and exquisite culmination of the programme our historian believes to occur in the *Oath*.[10] Julien and Clodion are in harmony with the rest of the series in their

83 Julien, *La Fontaine*

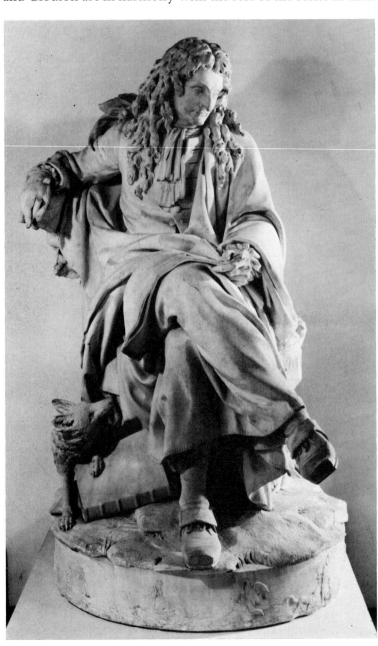

minute attention to the particularity of period detail: for the
sense of Heritage to emerge historicism must be manifest. But
the corollary of this is that neo-classicising tendencies are to be
suppressed: d'Angiviller is intent upon precise historical plac-
ing and so far from generalising the forms or subduing sculp-
ture to the style of antiquity, these works are to be accurate
reconstructions with minimal classical flavour. The cycle is
d'Angiviller's most personal contribution to the didactic pro-
gramme, and it shows the idea of the arts as propaganda in all
its disconnection from neo-classicism, and almost from any
style. All the styles are equivalent, because pedagogic concerns
take precedence over stylistic ones: if any style is to be
excluded, it would be because it interfered with instruction –
and neo-classicism, by denying the desired historical specifici-
ty, is just such a style. Hence the spectacle, disconcerting to the
historian who believes neo-classicism to be *the* style of the
pre-Revolutionary period, of the Louvre filling up from 1781

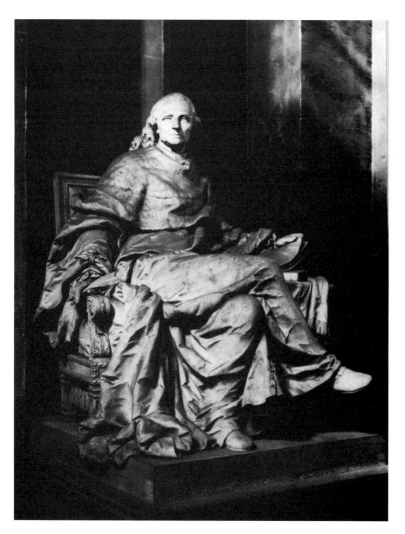

84 Clodion, *Montesquieu*

with propagandistic work that actively opposes neo-classical principles.

One answer to the query about the delayed assimilation of didactic neo-classicism into France is this disconnection of style from instruction. French artists might go to Rome, might even enter the circle of the Winckelmannians; but given the ethical rather than stylistic drive behind artistic policy in Paris, the study of antiquity would seem a marginal concern. Winckelmann's neo-classicism is, besides, only partly moralistic.[11] It is true that he claims that the superiority of Greek art has behind it the political health of the Greek social organism, which allows more freedom than policed societies that produce inferior art, such as Rome or Peru; he does connect external beauty with internal state – the beauty of the Laocoön comes from tranquillity and detachment beneath the turbulence of passion, and the physical excellence of the Greeks, which Winckelmann believed was an important factor in the capacity of Greek art to produce the beautiful, derives in part from healthy moderation or frugality. But alongside moralistic claims such as these are purely aesthetic claims, that beauty is the absence in a representation of individuality or specificity, that beauty comes from the artist's adherence to codified practice, that beauty is contour. For a French artist working inside an increasingly moralistic and didactic climate, the aestheticism of Winckelmann would seem irrelevant or alien (and would remain alien until the didactic programme itself declined, as it did after 1795, under the Directoire, the first major period of French enthusiasm for Winckelmann's work and ideas).

But there is a second reason for 'the delay'. The neo-classical style did not look, to the French in the 1760s and 1770s, moralistic at all; in fact it looked decadent. When Mme du Barry rejected Fragonard's *Four Seasons* as appropriate decoration for her new and severely neo-classical Pavilion, and chose instead to decorate it with designs by Vien, we can see the guise in which neo-classicism first appeared in France: as a slightly purer, and much more fashionable, rococo.[12] Vien has, of course, looked at antiquity, and his figures are far more sculptural than before; but they are hardly severe, and their appropriate destination is clearly the private apartment. His *Sale of Cupids* (illustration 85) closely follows the design of a freshly excavated find at Naples; it was even hailed as a 'rigorous imitation of the antique'.[13] But the heads are small and doll-like, the proportions sleek and tapered, and the subject matter seems perfectly *Louis seize*. French neo-classicism remained for a long time doomed to recuperation by rococo: an incredibly daring and severe design by Ledoux for a Parisian residence becomes the house of Mlle Guimard,

the *Opéra* star; the painter commissioned to produce its decorations is Fragonard (a commission later taken over by David).[14]

So far from allying itself with severity and morality, neo-classicism in France is discredited as the frivolous style of expensive mistresses. The only artist successfully to exploit its potential equation of severity of style with severity of morals, is, oddly enough, Greuze. The daughter and the mother in *The Drunkard's Return* (illustration 65) wear their hair *à la grecque*, and in *La Dame de Charité* (illustration 56) Greuze introduces into his bourgeois scene quotations from Poussin's *Sacraments*.[15] Greuze is himself a further reason for 'the delay'. The demand for a new, morally elevating form of painting had already been met in Greuze's work, and the case of Greuze proved that painting could be edifying without being antique, while that of Vien proved that the antique could be far from edifying.

What, in fact, could history painting do that neither Vien nor Greuze was doing? The answer was that it could pursue the Grand Manner, and renouncing both the bourgeois moralism of Greuze, and the discredited lessons of the classical

85 Joseph-Marie Vien, *Sale of Cupids*

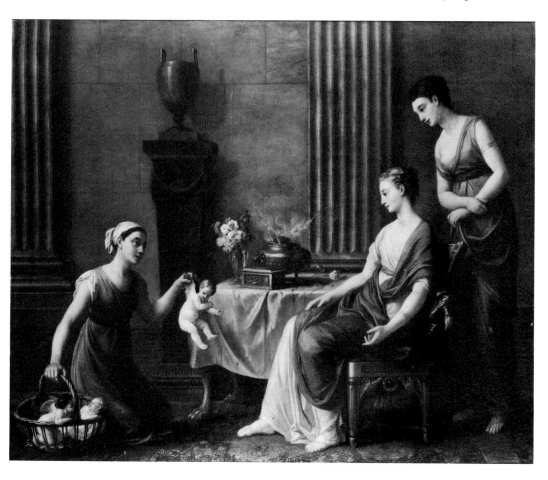

world, it could project itself backwards in time, and throw itself with some hope, and as much desperation, on the *seicento*.

If David's early career teaches us anything, it is the irrelevance of antiquity to a painter working at the frontier of French taste in the 1770s – a decade during which, let us remember, at least three forces, according to our historian friend, are at work to bring about the triumph of didactic neo-classicism. David begins by following Boucher, as we see in his early *Jupiter and Antiope*. This is just what our historian would want – surely it is fitting that the future creator of the *Oath* should begin with a fully rococo manner, all the better to overthrow. David intended to become Boucher's pupil, but Boucher deciding that he was too old to teach, he was passed on to Vien instead. One might have expected David to be discontented with Vien's insipid neo-classicism, to react against its frivolity, and to embark on the serious neo-classicism which will culminate in the *Oath*. Nothing of the kind happens.

Instead, he becomes increasingly involved with the baroque. In the *Death of Seneca* (1773) we can see a new influence, from anatomy: the figure of Seneca shows considerable effort to master musculature and flesh-texture, and this probably comes from Vien, who insisted – this is his real claim to innovative status – on working from the model; but the swirling, agitated composition, based on pyramid and ellipse, shows the same *seicento* revivalism as *Antiochus*. The *Antiochus and Stratonice* (1774) is a straight reworking of the same subject by Pietro da Cortona, down to the quite minor detail of the type of diadem Stratonice wears;[16] David may have banished Boucher, but not by a return to the antique, or even to Poussin.

The tendency becomes quite marked during David's stay in Rome, from 1775 to 1780. During this period David was filling sketchbooks with pages which show a developing interest in classical sculpture: he is reputed to have been converted to the neo-classical cause during a visit to Naples with Quatremère de Quincy ('I have been cured of a cataract'.) But the large-scale sketches of this period, where David is thinking pictorially and not simply jotting down notes, show increasing non-classical tendencies. *Alexander at the Tent of the Queen of Persia* (illustration 86) is clearly inspired by LeBrun; in the weeping females, he seems to be thinking of Greuze, and if there is a single aim in the sketch, it is to link the grandeur of French baroque with the emotionalism of *sensibilité*. One tends to underestimate the originality of this direction in David's art: back-projecting from the *Oath*, such an aim seems off-centre. But one of the forces our historian claims as responsible for the

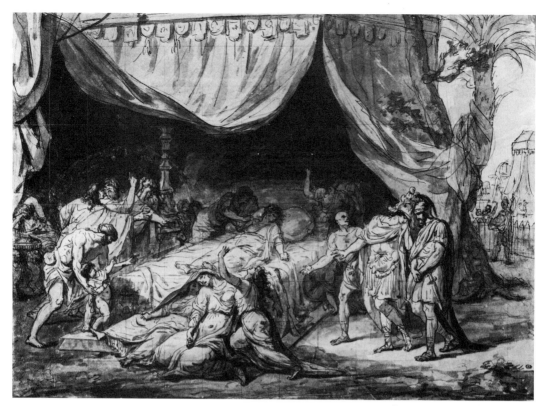

86 J.-L. David, *Alexander at the Tent of the Queen of Persia*

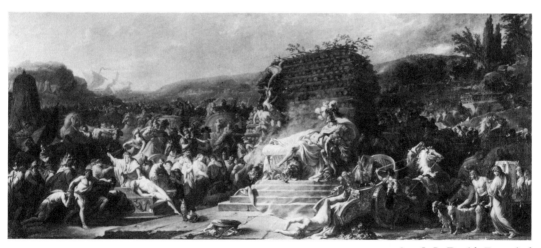

87 J.-L. David, *Funeral of Patroclus*

Oath – a government-sponsored programme for the creation of an exalted and edifying history painting – is entirely satisfied by this side of his work, which if it had been successfully executed would have joined the emotional and didactic style of Greuze with the grand manner of the *tableau d'histoire* – just what was wanted (and just what Greuze in 1769 had failed to achieve).

The *Funeral of Patroclus* (illustration 87) carries still further this approach. It is a work of great compositional daring, and risks innovations to my mind as extreme as those of the *Oath*: instead of one centre of interest, three – the pyre, the altar on the left, the advancing figures on the right; in addition to these, and complicating still further the already sub-divided image, the ship on the horizon, and a profusion of crowded, turbulent extras, forgotten in French painting since the *Batailles* of LeBrun.

It is unlikely that David could have successfully transformed the sketch into a finished work: it is really over-ambitious, and David seems to be displaying here the same taste for subjects too vast or too remote from his skills to be fully realisable, which he will display in the project for *The Oath of the Tennis Court* (illustration 88), and in his remarkable decision to undertake for the Convention a painting of a Revolutionary sea-battle. One thing is clear: antiquity, severity, virility, sculpturality, all the qualities we would expect from the future painter of *The Oath of the Horatii* are absent. Yet the historical forces supposedly behind *The Oath of the Horatii* are all present.

Let us imagine our historian friend defend his case. 'It is true that David's conversion to neo-classicism is belated. You have not mentioned the *Saint-Roch* of 1781, which owes far more to the *seicento*, and to Bologna, than it does to antiquity, and to Rome; nor the portrait of *Count Potocki* (1782), which recalls Rubens and Boucher, and not in the least the classical world. But all these are wayward divagations. You cannot deny that the *Oath* is the climax of neo-classical painting; what you say about other works does not affect my claim for this one.'

Our historian obviously has a strong case. David before *Belisarius* (1781) may have been pursuing non-classical goals of his own, but his contemporaries were becoming increasingly interested in a neo-classical style that comes within inches of *The Oath of the Horatii* itself. *Curius Dentatus Refusing the Gifts of the Samnites* by Peyron (illustration 89) may look back to Poussin, but the anatomy has a new vividness and accuracy, and the lighting a new starkness and dramatic force; the architecture is 'as austere as the subject', and it creates an enclosed, *Oath*-like space, rectilinear and walled, that avoids the diagonals and spatial openness present in a more orthodox image of two years later, Brenet's *Continence of Scipio* (illustra-

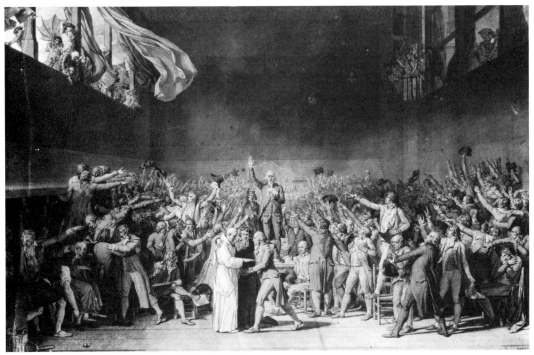

88 J.-L. David, *The Oath of the Tennis Court*

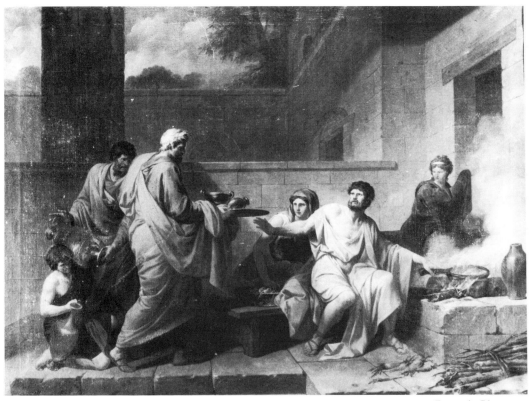

89 François-Pierre Peyron, *Curius Dentatus Refusing the Gifts of the Samnites*

tion 94). Peyron's *Cymon and Militiades* of 1782 (illustration 90) has even starker architecture and lighting, and the anatomy is now so striking, particularly in the musculature of the arms, that the distance from here to the *Oath* and even to the *Death of Marat* (illustration 99) is slight. Drouais's *Prodigal Son* (1782) shows the same tendencies (illustration 91), and adds to the repertoire a centrally-focussed perspective regression on a chequered floor, and the device of figures seem in emphatic and unnatural profile, which lead directly into 1785. The evidence of these works suggests that David's stubborn non-classicism runs counter to the practice of his rival contemporaries at the Académie; even the *Belisarius* is archaic, far more Poussinist than these works, and much closer to Greuze. In the *Oath of the Horatii* David returns to the course his peers are following, and at once he outstrips them. He produces, at a stroke, the definitive neo-classical painting (illustration 92).

But how neo-classical *is* it? If we mean by 'neo-classical', painting that looks like *The Oath of the Horatii*, the question is circular and absurd; but that is often just what we do mean by the term, and when we look at those works by Peyron and Drouais, it is the *Oath* we have in mind. These paintings indeed form a group, and we may feel the need to find a label for them; but is neo-classical the right label to use? I raise this question because some of the strongest features of the *Oath*, as of this group, have little connection with the revival of antiquity. First of all, the lighting, with its extreme contrasts of light and dark, its insistence upon the tenebral, and its rejection of soft transitions in the modelling of flesh. How are we to relate such an innovation to antiquity? Antique painting largely ignores the question of lighting; the sculpture of antiquity or of any other period necessarily excludes lighting as a parameter. Yet clearly for Peyron, for Drouais and for David, lighting is of the essence – a new discovery. With David, at least, it is possible to retrace the route to the discovery.

When I arrived in Italy with M. Vien I was at once struck, in the Italian paintings I saw there, by the vigour of their tones and shadows. This was a quality absolutely opposed to the weakness of French painting in this area, and this new relationship of light to dark, this imposing vivacity of which I had until then no idea, so struck me that during the first period of my stay in Italy, I believed that the whole secret of the art of painting lay in reproducing, as the Italian colorists of the late sixteenth century had done, the undisguised and decisive modelling which nature almost always presents. I felt ... my eyes were so unrefined, that so far from being able to exercise them profitably by exposure to delicate work, like Andrea del Sarto, Titian, or the subtle colourists, they could only really take in and understand work brutally executed, but nonetheless of merit: Caravaggio, Ribera, and le Valentin their pupil.[17]

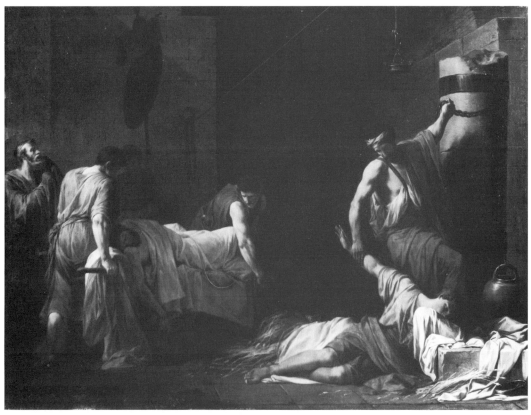

90 François-Pierre Peyron, *Cymon and Militiades*

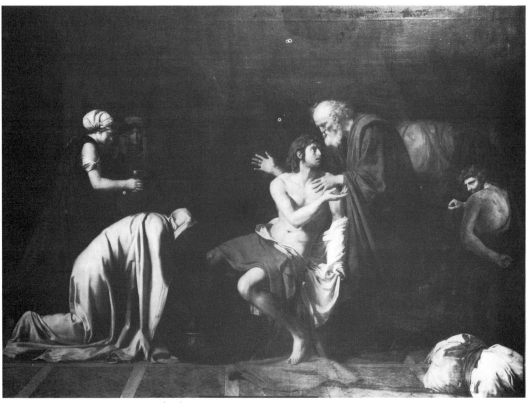

91 Jean-Germain Drouais, *Prodigal Son*

This statement is backed by the academies David sent from Rome to Paris during his first Italian sojourn (1775 to 1780). Brutal? In certain respects, not at all: the *Academy* ('Patroclus') (illustration 93) is a study work, part of David's self-education in the handling of lighting and of the nude, areas of painting that his earlier affections for Boucher, Pietro da Cortona (*Antiochus and Stratonice*) and for Poussin and Greuze (*Hector and Andromache*) had left neglected. But there is something if not brutal, certainly dramatic and even melodramatic, about the extreme polarisation of light and dark in David's Roman academies: he has deliberately exceeded the 'academic' requirements of study, and the image of 'Patroclus' hovers uncertainly between self-effacement and self-assertion, between the impersonality of training in desired skills, and the personal extremism of the lighting, which goes so far beyond the official mandate and purpose of the image as to contradict and subvert that purpose – which contradiction only adds to the brutality, or violence, of the image as a whole.

The second innovation of the *Oath*, already apparent in the academies, and perhaps a consequence of the new interest in lighting, is an increased importance attached to transcriptive painting from the model (the Romantics will accuse David of being unable to paint from imagination, of *having* no imagination). Vien had claimed that he was the first to reintroduce the model into studio practice, after its long rococo absence, and it is probably Vien's encouragement that lies behind the anatomical accuracy of David's figure of Seneca. But clearly Vien betrayed that studio practice in his own work, and his pupils took it upon themselves to investigate independently the properties of the model. The sculptor Giraud, a contemporary and friend of David at Rome, undertook to study anatomy at the Hospital of the Holy Spirit precisely to unlearn (*désapprendre*) 'academic routines', and this reliance on the model came to mean a great deal to David, as it did to Peyron and Drouais. Tischbein, who visited David's atelier during the painting of the *Oath*, relates that to paint his scene David relied heavily on studio simulation and properties;[18] Delécluze describes David's studio during the Directoire as full of furniture by the great *ébéniste* Jacob, furniture designed specifically to aid painting practice.[19] When one reads the considerable literature on the sources of the *Oath*, one should bear in mind that the final image owes far more to direct transcription of visual experience (or, to be precise, to the rhetoric of transcriptive realism) than would have been the case with David a decade earlier, when the influence of sources lacked this competition from the real world.[20] But the use of the model is not an intrinsic part of neo-classicism. Benjamin West's *Agrippina* is an example of a fully neo-classical work which shows no

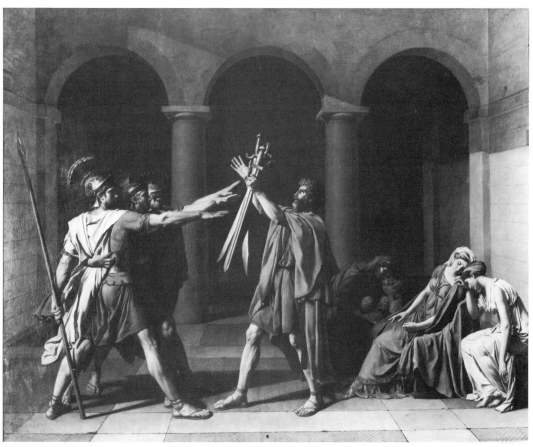

92 J.-L. David, *The Oath of the Horatii*

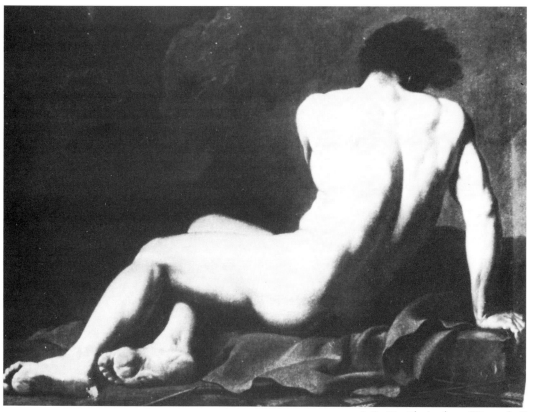

93 J.-L. David, *Academy* ('Patroclus')

interest at all in the qualities of real flesh; it lacks animation precisely because the poses of the bas-relief have not been filled in by the techniques and devices of 'transcription from the real'. Part of the shock of the *Oath* is that while its male figures seem so close to bas-relief in pose, the quality of their flesh seems derivable only from direct observation from nature; which is to say that the impact derives from departure from the forms of antiquity, and not their repetition.

The third innovation of the *Oath*, an innovation which becomes David's normal practice in the major work of the 1780s, is broken composition. *Belisarius* probably shows the beginnings of this tendency, in the lack of relation between the gesticulating soldier on the left, and the figures of Belisarius, the donor, and the child; but David seems to show a general uncertainty about this image – the decision to repaint the donor's robe in white was both radical and belated – and the lack of co-ordination between the soldier's 'frozen' gesture and the other figures' stable and statuesque gestures (a difference between a 'high-speed' and a 'low-speed' register) may well be uncalculated. But with the *Socrates* there can be no doubt; the disparity between near and far is part of the painting's intention, and the separation of the three zones of the *Brutus* is by now fully self-conscious – the zone of the lictors, the zone of the women, and the zone of Brutus and the statue of *Roma*.

Viewers' reactions to these split compositions have always been uneasy. It is likely that Grimm's incomprehension was widely shared: 'all the figures which form the grouping of the scene are isolated, and fail to participate in the central action.'[21] The assault on unity attacked a belief in the intrinsic worth of unity in the image that was so unquestioned as to be almost invisible – there was no need for critics to stand up and promote or defend it; David's subversion is deep. Our own continued disquiet about David's disunifications is evinced by the variety and mutual contradiction amongst our own explanations: the disunification is the product of David's psychic polarisation of 'male and female principles',[22] or it is the result of a precocious appreciation of trecento painting, with its ability to place within the same frame quite distinct narrative episodes,[23] or it derives from David's appreciation of Herculanean painting, with its large voids between figures.[24] My own argument will be that it has a narrative, rather than a visual, rationale. But an assault on compositional unity is a strong characteristic of the Peyron–Drouais–*Oath* cluster. Drouais's scene of the *Prodigal Son* (illustration 91) is accompanied at its margins by distractions emphatically distinct from the central scene of forgiveness – the ghostly female servant on the left, behind the female seen in profile and contradicting her

unnaturally exact profile with an equally exaggerated full fron-
tal position; and the powerful and beautiful image at the right,
of the son who has been passed over and who seems to plan his
revenge. Peyron's *Curius Dentatus* (illustration 89) disturbs
pictorial unity by extreme simplification: the painting is
united, but by means so rudimentary that it is clear that pictor-
ial unification is no longer a *donnée* of painting, but an area up
for re-investigation. Compare it with Brenet's more orthodox
Continence of Scipio (illustration 94): there, the oblique angle of
the architectural setting, and the ease with which the necessary
spatial adjustments are calculated, shows a lack of concern
with the whole issue – it is simply taken for granted. *Curius
Dentatus*, on the other hand, tilts the setting round into full
frontality, and insists on spatial unity of a reduced or elemen-
tary kind – frontality is a much more basic solution to the
problem of spatial articulation than Brenet's complicated
accommodations, and though simple it is much more striking:
we cannot ignore it, as we probably do with Brenet's work.
Again, Brenet interlocks his extensive crew of figures by a
network, or rather a random entanglement, of glances; the
Curius Dentatus divides into two halves, with three of the
figures looking in one direction and three in the other; by this –
again – almost rudimentary solution the fact of the central axis
is emphasised (and given support by perspective). But the

94 Nicolas-Guy Brenet,
Continence of Scipio

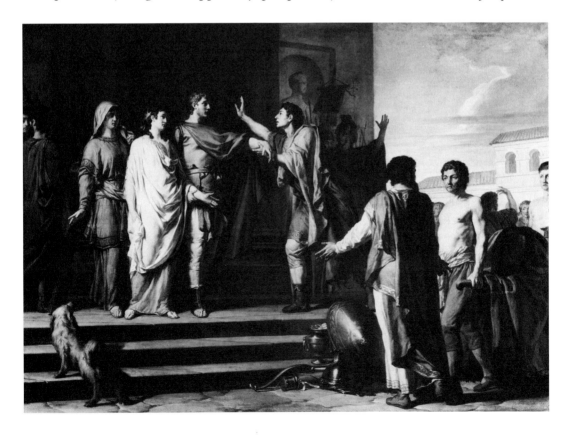

point is that unity is now an area of questioning and change: Peyron is reducing it to its bare essentials and investigating its deeper assumptions; it has entered the arena of innovation, where Brenet has taken it for granted. And having turned his attention towards the nature of unity and having offered the deliberately simplified solution of the *Curius Dentatus*, Peyron goes on to subvert his simplification. *Cymon and Militiades* (illustration 90) centres on a void flanked by two distinct and non-communicating scenes: the stretcher-bearers on the left, the figures on the right. So stressed is the separation that it even goes so far as to threaten narrative intelligibility (David will stop short of this extreme): the problem for the viewer is that there seems to be no way to relate the two side-scenes across the dark void that holds them apart, except by way of the echoed motif of the arm – a potential re-unification that has no narrative significance, and seems too arbitrary, too exclusively visual, and too bizarre to fulfil the promise of return to unity.

The emergent taste of these advanced works of the 1780s is towards fragmentation of the unity of composition. David had already, in the multi-centred *Funeral of Patroclus* (illustration 87) explored this vein, but the idiom there was a kind of neo-baroque agitation. This new disunification occurs in a processional, relief-like space, and because we are used to the idea that reliefs are guaranteed unity through the fact of their single plane, the effect of fragmentation is all the more striking. But is it classical? Herculanean painting is centreless, but it is neither united nor disunited: its space is not coherent enough for such considerations to arise. It is only when lighting and anatomical accuracy insist on a coherent, three-dimensional space that the effect of deliberate incoherence becomes evident. And although Poussin is sometimes seen as an influence behind these works, to look for Poussinism is really to miss what these paintings concern themselves with. Poussin is preeminently unified, not only by undisrupted planarity, by continual awareness of the picture plane, but by an elaborate system of checks and balances which works at every point to create and preserve unity. The young Turks of the 1780s want none of this: they are trying something which is, I believe, unprecedented, shocking, and nothing to do with either antiquity or 'neo-classicism'.

The fourth aspect of the *Oath* which I want to stress is the vigorous use, or rather manipulation, of perspective. The textbooks often maintain that a characteristic feature of works called neo-classical is the use of relief space: the figures are placed in a plane parallel to the plane of signifiers. What Peyron and Drouais seem to have discovered before David is the combination of this relief space, which negates depth, with

regression towards a vanishing point, which insists on depth.
The resultant space is one full of conflict: we are drawn into the
painting and kept out at the same time. Peyron seems to have
been the first to have discovered this device, in the *Curius
Dentatus*. The two halves, with three figures facing in from the
left and three from the right, insists on the fact of the centre,
and a strange trough-like opening at the bottom of the paint-
ing draws our attention to flagstones, weathered by age,
whose lines plunge in towards a centralised vanishing point.
The motif of fugitive lines is taken up by the plunging wall on
the right, and the sense of inward plunging is reinforced by the
idea of an invisible courtyard we cannot see into, beyond the
present scene. At the same time, the figures dispose themselves
in a relief space, with the right arm and chest of Dentatus, and
the arm of the servant crouched at the extreme left, as well as a
whole series of other bodily surfaces, all flat to the picture
plane; while the frontal architecture also insists on its perpen-
dicularity to the viewing eye. Peyron's spatial thinking reaches
genuine brilliance with the earthenware flagon on the right.
Semantically, it means frugality – that is its narrative
justification – in contrast to the useless golden gifts; but spa-
tially it resolves the conflict between lateral and regressional
spaces by relating the cross-sectional profile the eye sees, to the
satisfying in-depth volume of the flagon that the hand knows.
The contradiction between the processional, relief-like space
and the plunging perspective space would be pitched too high
if the painting did not include this object: just as a sphere
participates equally in cross-sectional and depth spaces, so the
flagon harmonises the relief and regressional spaces. Peyron's
subtle work here anticipates David's similar resolutions of
spatial conflict, for example the circular table and the three
variously curving chairs of the *Brutus*, which interrupt the
harsh gridwork of rectilinear space with welcome roundness,
and resolve the conflict between recession and relief in the
harmony of the circle. The *Cymon and Militiades* lacks that kind
of subtlety, as does Peyron's *Death of Socrates*: it simply
opposes, without any attempt at objects or sites of transition,
the fugitive lines of the flagstones, plunging in towards the
vanishing point, with stark, frontal, planimetric walls.
Drouais's *Prodigal Son* similarly overstates the conflict. The
kneeling woman is in absolute profile, like the servant bearing
the cup, and the father's right hand – a relief so frontal that it
verges on becoming cameo-space; and contrasting with that
flatness, a dramatic perspective plunge, clear in the flooring,
which David will take over for the *Oath*.

But none of these works carries the conflict to the extreme
of David in 1785. His expanse of flooring is much greater than
Drouais's, and extends now behind the figures. The space is a

simple box, with lines plunging in on the two side-walls, and with no feature or object to interrupt them or distract the eye from the recession. This marks a return to the fundamentals of quattrocento space, and to the origins of perspective as a visual system; the courtyard looks, despite its primitive columns, very Florentine. Given the enormous tension of the scene, these fugitive lines take on an emotional quality: the unity of the vanishing point is like the human unification of wills, towards which everything accelerates. Contradicting perspective, a frieze of male limbs compresses the three warriors into an improbably constricted and flattened space. David was no master of perspective; in fact, he was always being criticised by the Académie for his weakness in this respect, and a highly simplified or crudified perspectival system was probably congenial at a technical level. I have never been sure whether there are concealed errors in the disposition of the bodies of the three brothers: shadow hides the difficult areas. But I am sure that the handling of space is rudimentary, in that there is hardly any attempt to link the frieze and perspective spaces; and sure, equally, that the absence of articulation is spectacular.

But is such an innovation neo-classical? After 1795, French artists turn increasingly towards planar or cameo-space, and perspective is effectively banished; internationally, the trend is towards what Rosenblum calls 'linear abstraction'.[25] This brief reign of recession-lines and vanishing points seems confined to the cluster of paintings around the *Oath*, and to David's work through to the final statement in *The Tennis Court Oath*. The manipulation of frieze against perspective is vital to the *Oath*, and to the other works cognate with the *Oath*, but largely as an aberration from the overall neo-classical tendency towards contour and flatness – a tendency evident in the work of artists as different one from another as Blake, Flaxman, and Ingres.[26]

Lighting, reliance on the model, broken composition, spatial conflict: these are the arresting features of David's *Oath*. But they exist in independence from the main directions of neo-classicism: they have little to do with antiquity or its rediscovery, or with Poussin, still less with Winckelmann. Of course, it would take much more work than is offered here to begin to dislodge the label, and in a sense it is not the label I object to, or even the misunderstanding of the innovations in the *Oath* which the label gives rise to. The painting is still an incredible achievement if we ignore everything that is new about it. My real objection is to the idea that the *Oath* is the climax of propaganda-painting, and it is a more serious objection, because the propaganda claim seems completely to distort the significance and subtlety of David's work in the 1780s. Let us return to our historian, who asks us to accept that *The*

Oath of the Horatii is a didactic work, meant to instruct us in the path of virtue. What can such an image really teach us?

Every Frenchman knows from Corneille the basic story, and the *Oath* presupposes such knowledge. To settle the conflict between Rome and Alba, it was decided that each side send into combat representative warriors. Rome elected as its representatives three brothers, sons of Horatius – the Horatii; Alba elected as its team another set of brothers, the Curatii. Horatii and Curatii were linked by love as well as feud: a sister of the Curatii, represented in David's painting as the woman in the draped curule chair, had married one of the Horatii, while a sister of the Horatii, Camilla, was betrothed to one of the Alban warriors. The story ends strangely. The Horatii won the battle but on hearing the news, Camilla accused her brother of murder – the murder of her future husband. Whereupon the brother just took out his sword and killed her. The grief-stricken father appealed to the king for clemency for his son and after some hesitation the king gave his pardon.

Corneille's version of the story is already problematic and dark. Before her death, Camilla utters a ferocious denunciation, not only of her murderous brother, but of the whole Roman cult of military valour, which she sees as brutalised and inhuman (her betrothed had been the only male character in the play whose feelings were not centred exclusively on *gloire*).[27] But since the play ends with clemency, we are effectively being asked by its conclusion to forget Camilla and her speech and to condone the Roman system. This is particularly difficult for us to do, not only because Camilla is such a heroic character – unlike her brothers, she dares to oppose her own society and not simply the official enemy – but because the authority of the king is by now so compromised. His continued reign has in fact depended on the Horatian victory, and if the brothers had not displayed such extreme military prowess, Rome would have been lost to Alba. The king can hardly condemn excess of the military valour and commitment to Roman honour which has preserved the throne. On the other hand, he is a Cornelian monarch, supposedly above compromise. The issues are, in fact, too complicated to allow us to react to *Horace* in any single or simple way. David is visually uninterested in Corneille's play and the brothers do not in fact swear an oath at any point during its action. But when David says that he owes his subject to Corneille, we have reason to believe him. Corneille's play is problematic, not propagandistic, and the official doctrines both of *gloire* and of monarchical clemency are severely qualified; this subversion of official didacticism is already a clue to the narrative of the *Oath*.

When David first tackled the subject, he chose to depict a

scene where the father defends his accused son before the Roman people (illustration 95). Again, this departs from Corneille and indeed from history: this was a Rome of kings, not of democracy, and *Horace* is full of disdain for the rabble. David's image defines a problem, and even a binary choice, but it does not point towards a solution of the problem or try to influence our decision. Should the young warrior be granted clemency? On the one hand, the state, having been saved by his victory over the Curatii, is greatly in his debt; and Camilla, by denouncing Rome, had become a political enemy, just like the Albans and their representatives. On the other hand, the murder of a sister is an act of barbarism and opposes natural law. Is sororicide a greater crime than treason? Are the ties of blood and of Nature higher or lower than the ties of loyalty and Culture? David ensures that both sides of the question retain equal weight by his ambiguous portrayal of the accused son: he is arrogant, unrepentant, full of *superbia* (note the exaggerated design below the navel of his cuirasse); but these are qualities continuous with the military virtues, and shade off without a break into confidence, resolution, and martial strength.

David's sketch shows an advance over the earlier and thematically multiple image of *Belisarius*. There, a woman and

95 J.-L. David, sketch for *The Oath of the Horatii*

her child had been shown giving aid to the blind and derelict
general who in his prime had saved the Byzantine state. In
what direction does the image point? Is it towards the sad fact
of mutable fortunes, as is suggested by the soldier who raises
his hands in horror and surprise at seeing the once celebrated
general so reduced? Or does the image criticise the state for
betraying its defenders in their hour of need? Or does it simply
say that human charity is the highest virtue – a sort of Greuzian
homily? In this uncertain image the relation between text and
image lacks stability: we cannot easily account for the image
thematically and reaction to *Belisarius* has usually bypassed the
problem of reading and centred instead on the relationship to
Poussin, an exclusively painterly concern, and one which
might well have lost in visibility had David developed the
sophisticated textual techniques he shows in the remaining
major work of the 1780s. But the Horatian sketch is much
tighter in its application of text to image: the text *does* organise
the image, and its features at the level of visual construction
exactly fit a binary, questioning text. But can we say of either
Belisarius or the sketch, that it is didactic? In didactic painting,
broadly speaking, the viewer is passive and the image active.
Here, the roles are exactly the other way round – the image
elicits a response from the viewer, but it is passive before his
decision, or before his effort to decide.

David's work throughout the decade continues in this
ambiguous vein. Socrates (illustration 78) was a polemical
figure in Enlightenment France because he raised the question
of whether a high standard of morality could be achieved
outside Christianity. For supporters of the Church, his final
stoicism was admirable, but being pagan, of limited worth; for
those who opposed the Church his death was exemplary.[28]
Stendhal relates that during his youth, his tutor lent him a copy
of *Emile*, and was greatly worried because beside Rousseau's
statement that 'the death of Socrates is that of a man, the death
of Jesus Christ is that of a God' he had gummed a slip of paper
containing a comment 'which drew the opposite conclu-
sion'.[29] Such thinking was dangerously advanced, and
Stendhal wondered at his tutor's temerity. David's image
presents both views and refuses to adjudicate between them.
Socrates is still the pagan philosopher, and David has done
more than his usual amount of homework to get the pre-
Christian setting right. In the painting, pagan stoicism is
backed by the stoicism of Poussin, the closest source for the
work (*First Sacraments, Last Rites*). But the atmosphere of
the painting is not stoical at all, but eucharistic: the cup, the
heavenward-pointing finger, and the presence of twelve disci-
ples bring the Christ/Socrates parallel to the fore.

The ambiguity of the image is confirmed by its subsequent

fate. Re-exhibited at the Revolutionary *Salon* of 1791, it could be read programmatically, as all of David's work of the 1780s was after 1789, as confirmation of the virtuousness of the non-Christian past; France was in the grip of anti-clericalism and David's painting could be interpreted as fully Revolutionary (David himself practised a kind of rationalistic deism). But Socrates could not actually qualify as a Jacobin martyr-hero, because his death also dramatised the tyranny and irrationality of antiquity; and in fact after Thermidor an engraving of the painting was circulated and made to serve a quite different political purpose: Socrates is now a martyr to state oppression and folly, like the victims of the Terror.[30] That the painting could be put so quickly to such divergent uses should in itself warn us against thinking of David as a straightforward didactic painter issuing clear and unambiguous discursive pronouncements.

After 1789, the meaning of *Brutus* seemed clear to everyone: like Challier, like Lepelletier de Saint-Fargeau, Marat, Barra and Viala, Brutus had placed the good of the state above all personal considerations. Between 1790 and 1794 it would have been virtually impossible to look at the painting in any other way: France was flooded with Brutus imagery.[31] But, significantly, the propaganda made no use of David's painting, even though David was recognised as the great painter of the Revolution, and indeed was personally in charge of its propaganda machine;[32] for the most part Revolutionary iconography bypassed David's painting and went directly to the Roman sculpture used as a source for the central figure, known as the Capitoline Brutus. David's painting was, in fact, too complicated – too subversive – to be serviceable. The Revolutionaries may have convinced themselves that the painting celebrated Brutus's self-sacrifice, but were they right? The male world of heroism and political action is not shown as superior to the world of the females and their emotionalism: it is true that while the men do great deeds, the women are at home sewing, that on seeing the body they react but do not and cannot act, that they are cordoned off or coralled inside the house and seem without access to the outside world; all this is obvious, and equally obvious is the sinister quality of Brutus. He seems to be in communion with the primitive statue of *Roma*, which should face into the room, but instead faces Brutus alone; beneath the statue we see a frieze of the wolf suckling Romulus and Remus, indicating the origin of Rome in the abrogation of the natural family – a motif which will be taken up on the shield of the warrior in the *Intervention of the Sabine Women*, where it will have the very clear semantic function of placing negatively the dedication of the Roman male to State over Nature. While the extreme shadow sur-

rounding Brutus conveys the inward withdrawal of stoicism, it also suggests a quality of *terribilità*, supra-human or non-human grandeur; this is confirmed, at the level of source, by the dependence on the Sistine *Isaiah*, which besides the Capitoline Brutus is perhaps the single most important inspiration behind the figure.[33] 'Either the greatness of his virtue raised him above the impressions of sorrow, or the extravagance of his misery took away all sense of it; but neither seemed common, or the result of humanity, but either divine or brutish.'[34] That is Plutarch, and surely Plutarch's comment on Brutus is exactly the comment David would have wished to apply to his figure. Either brutish or divine – the same binary and unresolved interrogative stance as the *Socrates* and the Horatian sketch; first one side (law, state, reason), then the other (blood, family, emotion); and since neither side is able to win our approval, we are forced to abandon the whole judgmental process the painting at first sets in motion; forcing judgment into an *impasse*, the image goes beyond the mutual exclusions of binarism into a real moral dilemma where a figure can be both brutish and divine at the same time, both heroic *and* monstrous, noble *and* unnatural; in a word, where Brutus exits from our normal categories and enters the Sublime. But the Sublime and the didactic, Burke tells us, cannot co-exist.

Let us remind ourselves of what an unarguably didactic work looks like: Brenet's *Continence of Scipio* (illustration 94). Clearly qualities of restraint and kindness, and the merciful exercise of power, are preferable in a ruler to tyranny, but Brenet does not allow Scipio much choice. He cannot. If he were to show Scipio as wrestling with a dark, selfish side of his nature, Scipio would lose his exemplary status. And the path of virtue must seem obvious: it would be of no use if the painting suggested that there might be something surprising about Scipio's continence. The net result is to destroy the representation of choice. This is only to be expected. Didacticism in the arts supposes that the mere exposure of people to virtuous scenes is enough to persuade them to act in accordance with virtue. It assumes that if people act wickedly, it is not from choice; it is just that they have not seen enough of goodness. If their museums were full of noble scenes, they would change their ways. The argument is identical to the argument in favour of censorship: that since people (but not the censors themselves) mechanically repeat whatever human actions they are exposed to, only socially useful acts must be depicted. The thinking behind such didacticism is thoroughly behaviouristic: people act in the ways they do because they are always repeating and never initiating action; and although didacticism is extremely concerned with those moments when

an individual comes to morally forking paths, and is anxious that he follow the one that is right, nevertheless it also believes that when he comes to the fork, the individual's choice will be pre-determined by inertia – he will generally follow whichever path looks familiar. It does not really trust in the individual's intelligence or capacity to decide for himself. The Scipio we see is not making a decision: where is his alternative course? Such instructional programmes as the one supposed to culminate in 1785 must always crudify the representation of human choice, the genuine complexity and difficulty of the issues which being human involves us in. Basically, the programme does not trust the act of decision; and to make its lessons palatable the force which is overcome in the virtuous act cannot be represented (even though, paradoxically, its existence is insisted on: there must be vice for virtue to exist).

The significance of the *Oath* is that it *breaks* with this simplistic and single-minded tradition. In place of its certainties and reductions, David offers us genuine moral difficulty, in images that respect the individual's capacity to make moral decisions by refusing to tilt the balance in one direction or the other in advance; instead of *exempla*, he gives us problems for us to explore, problems which tempt us towards judgment, but by striking so fine a balance prevent us from drawing from the image the firm conclusions which the didactic tradition demands. The heroism of the Horatian brothers is not at all like the heroism of Scipio; it is undeniable, but it is not a moral quality at all.[35] In the ancient literary conception of the hero, the performance of great acts of virtue or courage is only one element in the hero's constitution, and though essential, it is not definitive. The hero is a man so raised above average humanity that his status is wholly manifest in word and deed, physique and comportment. The hero of Greek drama can perform deeds that are monstrous, like those of Ajax, or unworthy, like those of Achilles; this in no way detracts from heroic stature. We are not asked, in classical drama, to emulate the hero; on the contrary, he is exalted and inimitable. The heroism of the Horatii has something of this morally neutral quality: we cannot forget that of these three who make themselves into one, only one will return, and he will kill his sister. Like the sacrifice of Brutus, the sacrifice of the Horatii is not something 'common, or the result of humanity'; it is 'either divine or brutish'. We cannot translate the image into imitable action without ourselves leaving the realm of normal ethical categories.

Far more than it is instructive, the image is tragic, not only because of our foreknowledge that two of the warriors and one of the women will die, but because of its unmitigated sense of pain. The world-order is revealed as perverted: men and

women lead lives so specialised and separate that humanity seems broken in two; and though I do not myself find anything too interesting in the idea of a male/female psychic split within David's personality, I do think that the theme of gender-alienation is very close to the centre of his work, right until the end.[36] In David's conception of gender-specialisation, the males are incomplete because they lack awareness of the loss of individual outline that is the price they must pay for their united strength; and the females are incomplete because although they retain personal outline they are denied the power to influence the action (Corneille's Camilla was a fury by comparison with these drained, exhausted women).

David's vision is a tragic one because it shows humanity turned against itself in perpetual incompletion (he has none of Greuze's faith in a Humanity). And tragic because even the most noble of actions is presented as linked with, or even inseparable from, the opposite of man's noble nature: the destructiveness of his group-mentality, the violence of his political institutions, the monstrosity of his idealism.

Didacticism in painting seems the extreme case of subjection of the image to discursive control. But it is more accurate to say that the rigour of didacticism extends also to the *kind* of control to which the image is subjected: the text yielded by the didactic image must be of a certain kind, univocal, unambiguous and exhortative. In breaking with an unwieldy didacticism, David was by no means intent on a general banishment of discourse from painting. On the contrary, he was reforming the use of discourse in the image as much as he was reforming style, and creating a new discursive format built on a genuinely intricate and engaging kind of text. While I find it unacceptable to associate the David of 1785, 1787 and 1789 with a propagandist programme, I concur with Locquin that 1785 marks a climax of textual history painting. After the progressive decline of the text in painting from 1700 through to the 1750s, the text begins a resurgence, through Greuze and through one side of Diderot, to emerge in triumph in 1785. That is by no means the whole significance of 1785, which is of course a stylistic revolution as well as a textual one. But David is as much a master of text as he is of paint, and his work manipulates the textuality of the image with much greater subtlety than, for example, LeBrun or Greuze. The work of discourse there operates, if I may use an awkward expression, by massive exploitation of the 'equals sign': this expression equals pity, that expression equals admiration, the broken pitcher equals loss of virginity, the dead bird equals childhood's end. When we 'read' LeBrun's *Darius* or Greuze's *L'Accordée* in the manner of Félibien or Diderot, we check off the signifieds against the signifiers in much the same way as we read words

in a foreign language by means of a lexicon. It is an obvious and indeed a mechanical process. But David asks for a different kind of reading, that is less like translation and much closer to interpretation: there is a greater distance between the image and our reading, and there are no easy one-to-one equivalences. When the lexicon is as close at hand as it is in LeBrun or in Greuze, the image risks depletion and exhaustion: too much of the image is translated into discourse too quickly, and for the image *per se* there is loss of vitality and interest: the depletion of Hogarth's *Industry and Idleness*, once it has discharged its textual content, is exemplary. David tries to prevent this kind of semantic strip-mining. His anatomy is not at all overexpressive – if he took anything from Winckelmann at the level of theory, it was the idea of the beauty of impassivity; heightened expressivity mars Drouais, Taillasson, and the *Davidiens*, but David himself avoids their vulnerability before the consuming glance of body- and face-reading. Hence the strategy of the great works of the 1780s: a simultaneous release of two opposing and 'distanced' texts which in effect cancel each other out, or so mutually paralyse each other that, as we realise that neither one can drain the image, we attend instead to its materiality, its figurality, its being-as-image.

If this description of the textual strategy in David's work before the Revolution is true, we are in a position to place it in relation to the earlier strategies of the 1760s and 1770s. Rococo, following in the direction of Watteau, had progressively eliminated the textual dimension of the image, to concentrate on the figural work of the plane of signifiers. The innovations of Peyron, Drouais, and the *Oath* is towards breaking that rococo hegemony of the signifying plane. By re-energising lighting, perspective, composition, and anatomy, their innovations transfer awareness to the imaginary or fenestral space 'behind' the plane. This is fully accomplished by 1785. But whereas rococo, with its stress on the autonomy of the painterly trace, had run little risk of appropriation by didactic programme, the new style, which renders the plane of signifiers invisible or transparent and renounces the autonomy of the trace, is highly vulnerable to discursive control, all the more so at a time when the policy of d'Angiviller was towards an expansion of that control. In the work of the *Davidiens*, the style degenerates into a theatrical exaggeration of expression – 'waxwork classicism'.[37] David protects himself from this danger by a systematic, 'paralysed' ambiguity which no didactic programme can put to easy or certain use, and by blocking discursive confiscation of the image, he keeps the figural alive in the new order he has helped to bring into being.

Conclusion: Style or sign?

THIS STUDY HAS tried, in a very elliptical and shorthand fashion, to trace the outlines of an alternative history of painting in eighteenth-century France. We are accustomed to thinking of the history of art as the history of successive visual styles, and the categories to which we assign an individual work correspond to the general visual 'look' we detect: a baroque style, Italianate but modified by the French tradition, in LeBrun; a transition towards rococo with Watteau, high rococo with Boucher and Fragonard; and the reaction against rococo excess – neo-classicism. In fact, I doubt whether many art historians whole-heartedly believe in or practise this kind of categorisation, but many who are not art historians do still think in this way, and to some extent it remains official doctrine. But can stylistics do justice to *French* painting? France differs from the rest of Europe in that its art is intimately connected with the state, through the Académie. In England, whatever hallowed place history painting may have officially had for Reynolds and for the founders of the Royal Academy, it has always seemed an importation, just as the Royal Academy has never in its history exercised the extraordinary monopolistic power of its French equivalent. The result of this is that in France the visual arts react not only towards and against specific visual styles, but towards and against the Académie and the high-discursive painting promoted by the Académie at different moments in its history. When we examine the painting of eighteenth-century France *as sign*, we discover a somewhat different progression to the one put forward by stylistics. In part, this alternative history is concealed from us by the fact that it is often in phase with the stylistic history: the change from the discursively saturated painting of LeBrun to the discursively drained painting of Watteau is accompanied by a change of visual style so striking that when we have described it stylistically our account seems complete. But an exclusive use of stylistics creates serious anomalies: artists whose work does not easily fit into the saga of successive visual styles become unclassifiable sports. Chardin is one such case; but if we turn to the evolution of painting as sign, the similarity between Chardin and his stylistically alien rococo contemporaries becomes much clearer: we can now see a common direction which stylistics could not see. 239

Greuze is another supposedly anomalous figure: neither rococo nor evidently neo-classical, yet not sufficiently great an artist to demand a modification of the saga of styles, he becomes category-less and marginal. But seen from the point of view of painting as sign, this artificial marginality is banished, and we can begin to see how central the work of Greuze is to the new demand for high narrativity and 'transparency' of the painterly sign. And so it is also with *The Oath of the Horatii*: the stylistic saga asks for a central neo-classical work, and the *Oath* seems to answer that requirement; but only at the cost of misrepresenting what in fact is new about the painting, and of claiming a propagandist intention for the *Oath* which distorts the significance of David's innovation at the level of text.

A good example of the insensitivity of stylistics is its reaction to works that have a similar status as sign, but quite different visual styles. Durameau's *Clemency of Bayard* might, if we give it a cursory glance, trick us into thinking that it belongs to the next century. Brenet's *Continence of Scipio* (illustration 94) is clearly 'neo-classical'. Stylistically, they go into different boxes. Yet at the level of narrative they are almost identical: a ruler refuses to take advantage of a young girl in his power, and instead gives her a dowry. For d'Angiviller their didactic status would have been equivalent. Ménageot's *Death of Leonardo* (illustration 96) has stylistically nothing to do with David's *Death of Socrates* or *Death of Seneca* – it is hard to think of three paintings more unlike at the level of stylistic provenance, but nonetheless they form a tightly knit grouping at the level of *topos*.[1]

Stylistics is equally insensitive to the changing nature of the role of style itself in French painting of the late eighteenth and early nineteenth centuries. The equalising of styles in a didactic policy such as that of d'Angiviller is reinforced by the equalisation that comes from increasing stylistic erudition. Brenet, whose *Continence of Scipio* seems wholly neo-classical, was able without difficulty to pass from the classical world to the high Middle Ages: his *Death of the Chevalier Bertrand du Guesclin* (illustration 97) clashes with his neo-classicism stylistically and suggests a double personality, but in fact at the level of erudition they are on the same plane – both are detailed archaeological reconstructions; their dissimilarity occurs rather as *topos* – one fits into the narrative figure of the exalted death (Socrates, Seneca, Leonardo), the other into the figure of magnanimity (Trajan, Alexander, Bayard). The enormous attention paid to historical reconstruction makes available to the painter working in the period called 'neo-classical' an unprecedented array of styles; the style of antiquity is only one in an increasingly expanding repertoire. The twin forces of

96 François Ménageot, *Death of Leonardo*

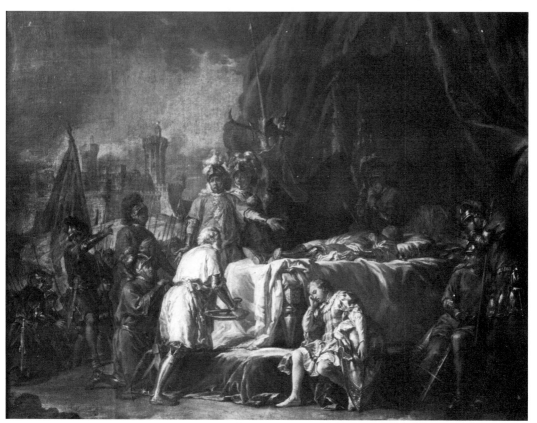

97 Nicolas-Guy Brenet, *Death of the Chevalier Bertrand du Guesclin*

erudition and rhetoric have effectively flattened and equalised all the styles, and this levelling out marks the beginnings of a new anxiety about the status of a central or natural style which is vital in our understanding both of David and of his successors.

This is something new. Perhaps I can illustrate the change by a literary analogy. Here are two translations of the moment in the *Aeneid* when Dido ascends the funeral pyre in Carthage:

> But Furious *Dido*, with dark thoughts involv'd,
> Shook at the mighty Mischief she resolv'd.
> With livid spots distinguish'd was her Face,
> Red were her rowling eyes, and discomposed her Pace:
> Ghastly she gaz'd, with Pain she drew her Breath,
> And Nature shiver'd at approaching Death.
> Then swiftly to the fatal place she pass'd;
> And mounts the Fun'ral Pile, with furious haste;
> Unsheaths the sword the *Trojan* left behind,
> (Not for so dire an Enterprise design'd) . . .[2]

> But Dido, trembling, wild at heart with her most dread
> intent,
> Rolling her blood-shot eyes about, her quivering cheeks
> besprent
> With burning flecks, and otherwhere dead white with
> death drawn nigh,
> Burst through the inner doorways there and clomb the
> bale on high,
> Fulfilled with utter madness now, and bared the Dardan
> blade,
> Gift given not for such work, for no such ending
> made. . . .[3]

The first translation is at ease with Vergil and eager to make him sound acceptable to the contemporary ear: it is Dryden, and he uses the new heroic couplet form which imposes on him some of the discipline of Vergil's hexameter. He certainly does not believe that he is Vergil's equal, but he is relaxed, he feels free to depart from the original when he needs to, and he can be playful if he chooses. He tries to imagine how he himself would have written the scene in his own idiom, and it has not occurred to him that he should think of imposing on himself an alien manner. Why should he? Vergil is the great point and symbol continuation, from Troy to Rome, from the pagan world to the Christian world, and Dryden feels himself the natural heir to this long cultural tradition. The second translation has lost that sense of continuity and heritage. Embarrassed by the fact that English is a mixture of Latin and Anglo-Saxon, it abandons the attempt to match Vergil in a natural idiom and goes entirely the other way. It has more historical erudition than Dryden, and more styles are available from which to make a selection: it decides to make Vergil sound archaic and

Nordic. But although it has more historical awareness in the sense that it can manipulate more of the styles that come to the translator from history, its attitude towards the past is that it is alien and irretrievable. The translator cannot simply imitate Vergil in the natural style of its own period: he does not believe his period *has* a 'natural style'; and instead, he offers a version of a historical style in all its alienness and archaism. That Vergilian continuity, the sense of being heir to a living tradition, has gone. And among the factors that have destroyed it is the awareness of a multiplicity of available styles, all accessible, and none natural or idiomatic.

Something of the same kind – a greater acquaintance with past style leading to an alienation from all style – is beginning to occur in the medieval and Renaissance revivals in the work of Durameau, Ménageot, and Brenet, in the pre-Revolutionary Salons. But it is there also where we would less expect it – within neo-classicism itself. Of course, neo-classicism had Rome, and the French had the Académie in Rome, and that is the great difference: there, one could feel the unbroken continuity as a fact of life. And while lesser artists may have experimented with revivalism, and may have been encouraged to do so both by the European force of erudition and the French force of didacticism, David never went in for that sort of thing. But is David at ease with *antiquity*? I have suggested that the most striking features in David's work of the 1780s are, roughly, lighting, anatomy, composition, perspective, and textual ambiguity. Yet none of these actually concerns, or was born from confrontation with, antiquity. We cannot say of David, as we must of Poussin, that the forms of antiquity have entered the bloodstream. David's attitude towards scholarship is revealing. On the one hand his work is full of error – *Belisarius* shows no thought of Byzantium, a Roman vault intrudes into Socrates' Athenian prison, the warriors at Thermopylae are imagined as naked. I mention these quibbles because this was just the sort of thing David was nervous about; and his paintings had to stand up to real pedantry – people like Quatremère de Quincy, and Séroux d'Agincourt. David seems to have thought himself vulnerable before such critics. 'Sketch for me', he writes to Wicar, 'a coiffure in the position I indicate. It seems to me that you will probably find it among the Bacchanales. One often sees Bacchantes with this sort of pose. However, no matter as long as you send me a dishevelled coiffure of a young girl, a period coiffure.'[4] In fact, David had already completed his sketch of the fainting girl in the *Brutus*, which he retained in the painting, and his Roman sketchbook contained a number of appropriate coiffures. But David is anxious about his historical accuracy. Before embarking on the *Leonidas*, he instituted a competition among his

students to obtain accurate depictions of the terrain of Thermopylae; Delécluze was overjoyed when his entry was accepted. We should remember that from 1795 onward, David's pupils were far more committed to a pure neo-classicism, based on Winckelmann, 'Etruscan' vases, and a new linear purity, than their master; the *penseurs* even went so far as to castigate David as 'Van Loo, Pompadour, rococo'. David tends to discharge his neo-classical duties by proxy: 'Quick, quick, turn the pages of your Plutarch' was his advice to Gros, of all people. This anxiety over accuracy should tell us that for David, neo-classicism is an uneasy style, one he feels that everyone is at home with except himself.

From 1790, David found release from these difficulties because the imagery of contemporary life had become more exciting than the imagery of the classical world. We can pinpoint the moment of transition – the 'Versailles sketchbook'.[5] David was present at the real Oath of the Jeu de Paume and seems to have perceived it literally as a moment out of antiquity: Barnave, Robespierre and Sièyes are Romans (illustration 98). But when it came to executing the scene, they revert

98 J.-L. David, sketches towards *The Oath of the Tennis Court*

to Frenchmen, as we see in the engraving of *The Oath of the Tennis Court* (illustration 88). The *Death of Marat* (illustration 99) comes directly from the contemporary world – David had visited Marat the day before his assassination and, during the arrangements he made for the display of Marat's corpse at the Cordeliers, he had the opportunity to acquire a mortician's familiarity with his subject. In the painting, he relies completely on his own resources: there is no time for anything else. He has to paint fast – and he ignores antiquity. The features which had made *The Oath of the Horatii* and the other great works of the 1780s so outstanding could now be concentrated on exclusively: lighting, anatomy – naturally a central interest; and composition, which is daring because David has chosen not to depart from the facts of the natural disposition of the body, and not to impose upon it a classical, sculptural arrangement, as he had done for Lepelletier de Saint-Fargeau. The images of *Marat* and the *Oath* commune with one another in the absence of antiquity, and we can almost say that once

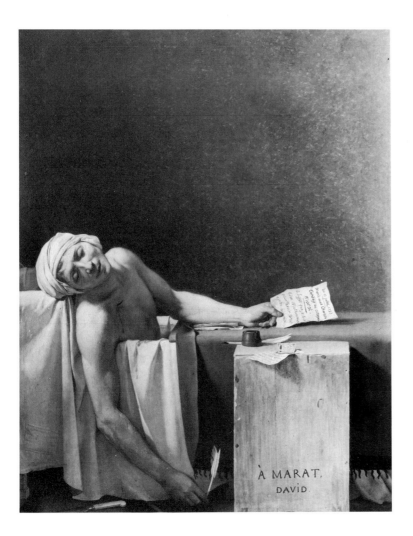

99 J.-L. David, *Death of Marat*

David could shake off the constrictions of neo-classicism, he could then, and perhaps only then, reveal his unique gifts in their purest form.

Let us jump a decade and see how David fares when forced to return to neo-classical doctrines. David was imprisoned after Thermidor and released only on condition that he abstain from political activity. Until the advent of Napoleon, he is living under the shadow of his Jacobin reputation, and to prove that during the régime of Robespierre he was simply an innocent artist dragooned into politics against his will (far from true), he had to show the world that he considered himself to be essentially a painter, and one whose natural idiom was antiquity and not contemporary history. His work of public recantation is the *Intervention of the Sabine Women* (illustration 100) which breaks with the textual ambiguity of the 1780s and states quite clearly that the women, with their emotionalism and their allegiance to the family over the state, were after all right. The textual apology is matched by a style David took pride in for its purity:

I want *grec pur*; I am nourishing my eyes with antique sculpture; I even mean to imitate some. The Greeks had no scruple about copying a composition, a movement or a type already familiar and current. They devoted all their care and art to bringing to perfection

100 J.-L. David,
Intervention of the Sabine Women

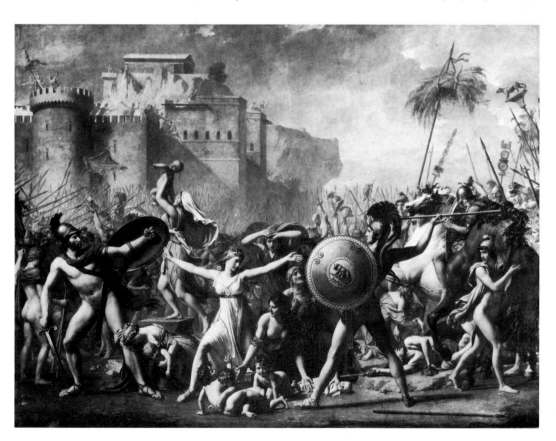

the idea they had before them ... Without the Greeks, *messieurs*, the Romans would have remained barbarians in art. I will return to the source.[6]

The result is, to my mind, dry and disappointing, because in returning to the neo-classical fold David becomes inhibited; in seeking the effect of statuary he loses the 1785 strength of lighting and anatomy; and in cultivating the new *de rigueur* bas-relief space without complicating it through perspective, he is just following form.

Let us compare two portraits of Napoleon: the one by David

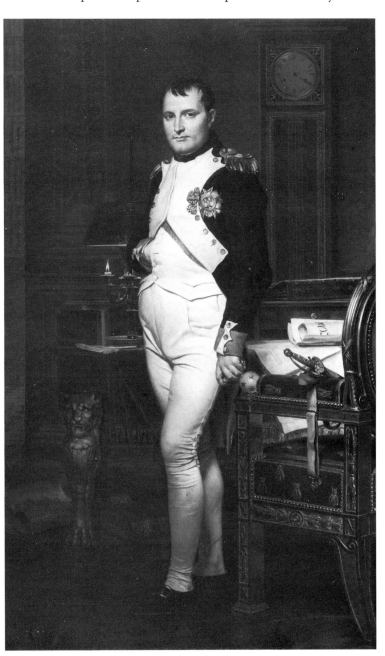

101 J.-L. David, *Portrait of the First Consul*

showing the First Consul working for the good of his people into the small hours of the morning (illustration 101); and the *Imperial Portrait* by Ingres (illustration 102). David's painting proves, as do all his portraits, that he always had access to a natural idiom. I agree with Kenneth Clark that no imprisonment, no threat of the guillotine even, would have distressed David so greatly as the modern view that he is chiefly memorable for his portraits – and I do not subscribe to that view. But I would maintain that it is only when David manages to incorporate into his history paintings the qualities available to him

102 J.-A.-D. Ingres,
Imperial Portrait of Napoleon

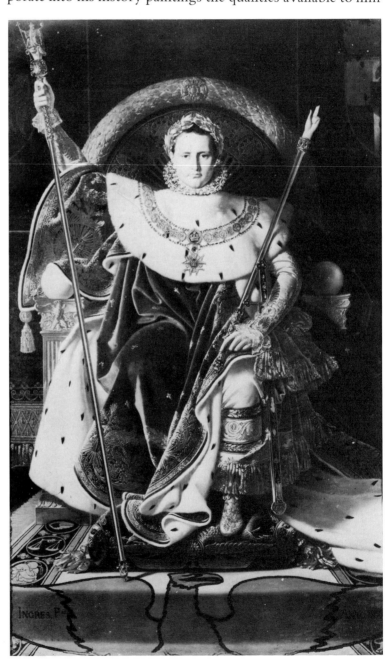

in portraiture that they come to life. David always had that to fall back on. Ingres was not so lucky. Far more styles were available to him than to David, who tended – it proves that he was not much interested in Winckelmann – to think of antiquity as stylistically uniform, and only very late came to realise that it included a variety of styles, or at least a Roman manner and a Greek. Ingres was in David's atelier during its most turbulent period, when Maurice Quai was converting even quite sober students to the belief that painting had discovered the wrong antiquity, that everything after Phidias was mannered, like all the art of the Italians, including Raphael. He found interest in visual experiences that meant nothing to David – cameos, vase painting, Roman painting, miniatures, ivories, encaustic, 'gothic'. The *Imperial Portrait* is dazzled by the multiplicity of available styles. Amongst its many quotations are Phidias, the cameo, Roman consular ivories, Ottonian miniatures; the bizarre costume of the enthronement, which conceals beneath the timeless opulence of its substances and cut the hastiness of a manufactured pedigree, itself raids many more provenances. At this stage, Ingres is giving no thought to the future or to the risk he is running by cutting himself off from the earthbound reality of portraiture that David's painting is rooted in; he has only just discovered the drug of style.

The *Imperial Portrait* is all about style and styles and takes it as the normal state of affairs that there is no one style which, unlike the others, is normative. Erudition, the idea of art as propaganda, and the opportunism of Empire have flattened them all. This is not the place to begin to describe how Ingres came to lose his sense of dazzlement before the array of styles; but one can see from the *Imperial Portrait* that alienation from style and through style is already quite advanced. There is an obvious symmetry between Napoleon and Ingres – as Napoleon claims to be the heir to Justinian, so Ingres alludes to the art of late antiquity; as Napoleon claims continuity with Charlemagne, Ingres raids his Ottonian or Carolingian sources; as he claims the charisma of Emperor, Ingres introduces an emotion of awe (and so far from thinking the work a *bibelot*, as Clark does, I for one find it rather frightening; crepuscular, lunar). The point is that the styles do not emanate from Ingres, the creator of the painting, but from Napoleon, the subject of the painting: choices amongst the styles have been pre-determined by the sitter, they originate with him and not with the supposed producer of the image. The only note of personality is that strange solo bid for power – the allusion to Raphael in the Virgo of the Zodiac; Raphael cannot come from anyone but Ingres, and to ensure the inclusion of that detail, the Zodiac has in fact been curiously re-arranged.[7] Ingres

allows the subject to dictate the style he is to use – a practice which persists through many of the portraits, and which will be the guiding principle of that most self-effacing work, the *Apotheosis of Homer* (illustration 20). Ingres here is still at ease with the absence of personal idiom: it is the order he grew up inside. David could never relax with the neo-classical style because it forced him to work in a manner alien to his personal interests – alien even in 1785. Alienation from style begins here, and is the great curse David transmits to Ingres, who at first does not recognise that it is a curse, and thinks it a pretext for virtuosity.

But can stylistics detect such a 'curse' – is it sensitive enough? If one looks at a work and then lists whatever other works have served to influence it, one does not necessarily take into account the attitude of the work itself to those discovered sources. Let us take this striking case: David borrowed from Greuze the disposition of Hector's body, in the first version of *Hector and Andromache*, which follows the pattern of Greuze's *La Dame de Charité*. This fact was not always recognised, and it is of interest because it shows how close to history painting David considered Greuze to be, and because it proves that David and Greuze have more in common than we might think if we see David primarily as the neo-classical master. Now consider Ingres's *Vow of Louis XIII* (illustration 103). The upper half quotes from Raphael's *Sistine Madonna*, and the lower from Louis's court painter, Philippe de Champaigne. Stylistics has done its work when it tells us that this is the case, and names the sources and the styles present in the painting, but a revolution has occurred between the two paintings, of David and of Ingres, precisely in the role of the source. David borrows naturally, almost – but not quite – unconsciously, from Greuze. The painting is continuous with its source, as Dryden's *Aeneid* is continuous with Vergil. By contrast Ingres in 1824 was at his wits' end trying to find a style that suited him. I suspect he no longer had any access to the kind of vernacular idiom David shows in his portrait of the First Consul; all he could do was to quote, and allude, and painstakingly to squeeze out of himself those elusive visual-erotic ideas buried in the depths of his being, which are finally all assembled together in *Le Bain Turc*. He felt himself severed from origin, with no natural style to his period or within himself; lacking in what the quotation from Philippe de Champaigne eminently had – the style appropriate to its era. That is why the quotation is there – from a nostalgic or post-lapsarian feeling that certain periods *once* had certain styles which were their natural self-expression, as Philippe de Champaigne is perfect *Louis treize*. For Ingres, Raphael was a personal religion, and when he quotes from the *Sistine Madonna* he is not like any

other artist drawing on his source. The *Sistine Madonna* is one of the few visual ideas, like those massed together in *Le Bain Turc*, which Ingres found obsessive: it was part of an inner pantheon. When Ingres paints from this or from his other tiny group of obsessional figures and poses, he is trying to reach the buried internal source, and the effort is exhausting; the subject must be done and redone without end. That is part of the significance of the quotation: the remoteness of the internal image, and the mysterious connection between Ingres's private imagination and the images in Raphael. And the quotation is significant also in that Ingres regards Raphael as a source in an almost reverential sense: in the *Apotheosis* he alone steps

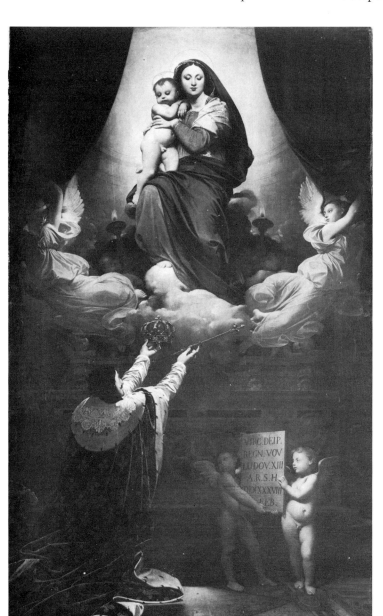

103 J.-A.-D. Ingres, *Vow of Louis XIII*

out of his place in history, from the ranks of moderns relegated to the inferior stage below Homer; Raphael is being conducted straight towards the central cultural source, Homer. The juxtaposition of the Raphael Madonna – uniting the sources of private imagination with the absolute cultural source of Raphael – against the figure of Louis from Philippe de Champaigne – the dream of a natural period style – places these 'problems of the source' at the centre, in a meditation on the origin of images that everywhere implies that for Ingres there *is* no available origin; the painting becomes a public confession of artistic pain. But the usual routine of stylistics reads off the image's sources as though they were on the same level as David's source for *Hector and Andromache*; it just lists.[8]

Stylistics cannot easily account for such shifting distance between an image and its origin. It cannot easily perceive that in David, as in Ingres, there is anxiety about the relation between the artist and the style he chooses to work in. One of David's central difficulties was that the prevailing neo-classical style, of which he was the supposed master, conflicted with his own artistic personality, and may even be said, as we look at the *Leonidas*, to have suffocated it. And for David's successors, after their leader's exile to Brussels, neo-classicism inspires *guilt* – the guilt of a lost and irretrievable orthodoxy whose demise has let loose an anarchy no one is strong enough to curtail. 'As for me', Gros stated at Girodet's funeral, 'not only do I lack the authority to direct our school, I accuse myself for having been one of the first to set the bad example I myself have followed, of not putting into the choice and execution of the subjects I have treated, that severity our master recommended, and which he never ceased to display in his own work.'[9] Gros was wrong – David is at his best when he has found ways around the severities and austerities which Gros believed he represented; and nothing is sadder than the spectacle of Gros attempting to reproduce in his own work, which can be brilliant only when he ceases to think of neo-classicism, an orthodoxy David himself found constricting. There is a real sense of personal tragedy in his academic histories; and the *Leonidas* seems to me tragic for similar reasons – a lament for the passing of a style which had never been fully alive.

The Anglo-Saxon world has never taken seriously the idea of history painting and has always, with the notable exception of Blake, tended to avoid the representation of texts through images; it is a much more figural school. While there may be a fair measure of philistinism in this, it has allowed our painting to be spared the plight of stylistic alienation which ruined Gros, and tormented Ingres. The Word is indifferent to the vehicle of its incarnations; it hides, like a god, behind the abundance of its attributes. All the styles will equally suit its

purpose. Erudition, and Empire, poured into France an unpre-
cedented array of styles, and had the influx occurred when the
Word was in abeyance, its artists might have successfully
absorbed the shock. But the Word was approaching its zenith,
in the authentically propagandist art of the Revolution and of
Napoleon. And once the Word was finally deposed, with the
double exile of David and of Napoleon, French painting found
itself strewn with a debris of styles which no longer made
coherent sense. Only Ingres, and with increasing difficulty,
could find solace among the ruins. Delacroix became
necessary.

Notes

I. DISCOURSE, FIGURE

[1] See B. Rackham, *The Ancient Glass of Canterbury Cathedral*, illustrations 28, 29 and pp. 73–80.

[2] Cf. Alcuin: 'imagines quas prior synodus nec etiam cernere promiserat, alter adorare compellit . . . Nos nec destruimus, nec adoramus', cited in E. de Bruyne, *Etudes d'esthétique médiévale*, volume I, p. 262.

[3] Cited *ibid.*, p. 272.

[4] Cf. St Gregory: 'Ayant travaillé avec des couleurs comme dans un livre parlant, l'artiste a clairement raconté la lutte du martyr, car la peinture muette parle sur le mur et fait beaucoup de bien', cited in de Bruyne, *Etudes d'esthétique* p. 264.

[5] The distinction between the signifier and the signified occurs originally in part one of Ferdinand de Saussure's *Course in general linguistics*, pp. 65–74; references here are to the edition of C. Bally and A. Sechehaye, translated by W. Baskin from the first edition, Zurich, Bakst Verlag, 1914.

[6] On the situations which permit 'direct' contemplation of the signifier, see R. Barthes, *Le plaisir du texte*, *passim*; and J. Kristeva, *Sémeiotikè*, esp. pp. 174–207.

[7] On the image as a place of relay for text, see the two essays by R. Barthes in *Image–music–text*, pp. 15–31, 32–51.

[8] The legends are as follows: for Moses striking the rock, HAVSTVS SPIC PATITVR. LAPIS IS LATVS HIC APERITVR: EST AQVA CARNAL CRVOR AVTEM SPIRITVUALI; for the Passover, LABE CARENS NATVS: ET AGNVS VT INMACVLATVS: PECCATVM FACT'. PECCATORVM PIE TACTVS; and for the Grapes of Exchol, BOTRVM RESPICERE NEGAT HIC. SITIT ISTE VIDERE: ISRAEL IGNORAT CHRISTVM: GENTILIS ADORAT. The inscription for the Offering of Isaac is lost.

[9] On the usefulness of question-and-answer in the closure of the sign, see R. Barthes's remarks on the 'Hermeneutic code' in *S/Z*, and especially sections IX, XXXI, XXXII, XXXVII, and LXXXV; and S. Heath, *The nouveau roman*, pp. 15–43, esp. pp. 33–4.

[10] See S. Eisenstein, *Film form*, pp. 45–83; and *Film essays*, pp. 92–107, 155–83.

[11] See John Berger, *Ways of seeing*, from which the Van Gogh example is taken; pp. 27–8; and M. Butor, *Les mots dans la peinture*.

[12] P. Francastel, *La figure et le lieu*, pp. 234–5.

[13] On the image as a place of resistance to meaning, see R. Barthes, *Image–music–text*, p. 32; and S. Heath's 'Narrative space'.

[14] For two very different, and equally interesting, discussions of the historical nature of the codes governing the 'transposition' of the real into the sign, see Sir Ernst Gombrich, *Art and illusion*; and C. Prendergast, 'Writing and negativity', esp. pp. 206–12.

[15] E. Husserl, *Werke*, volume III, p. 63.

[16] On the refounding of coded social practice in a 'natural' perception, see S. Heath, *The nouveau roman*, pp. 22–34; and G. Genette, 'Vraisemblance et motivation', in *Figures II*.

[17] P. Berger and T. Luckmann, *The social construction of reality*, p. 69.

[18] Within a project of naturalisation, behaviour and belief which contradict

ien 'hallucination'; cf. Berger
ice this knowledge is socially
dy of generally valid truths
nstitutional order appears as a

prigine du modèle, c'est son
iis critiques, p. 199.

of a general 'narrative gram-
the folktale; amongst Propp's
Mythologiques), and Barthes's

n of meaning, see Ferdinand de
, pp. 101–37); and J. Culler's
ire, pp. 18–52. The analysis of
es is, of course, central to the
ie literature here is enormous,
anthropologist are The elemen-
logy; and The savage mind; see
id Leach's critical introduction

he means for its expansion, and
Watt in The rise of the novel, pp.

es, pp. 133–9.
is categories available to semio-
rtant elaboration occurs in R.
; trans. A. Lavers and C. Smith,
concluding essay in Barthes's
, London, 1972, pp. 109–59.
ire's Course (part two), Baskin
translation, pp. 101–39; see also Barthes, Eléments, pp. 58–86. One of the
clearest descriptions of syntagm and paradigm occurs in P. Pettit, The
concept of structuralism, pp. 7–10, to which my own compressed account is
indebted.

[27] See 'Two aspects of language and two types of aphasic disturbances', in
Selected writings of Roman Jakobson, volume II, pp. 239–59.

[28] See A. C. Danto, Analytical philosophy of history (Cambridge, 1968), pp.
112–42.

[29] See I. Watt, Rise of the novel, pp. 32–7.

[30] See Barthes's article 'Le monde-objet', in Essais critiques, pp. 19–28.

[31] The model used in the present study divides the painterly sign between a
pole of domination by the signified ('discursivity') and a pole dominated
by the signifier ('figurality'). The works discussed in ch. 1 can be distri-
buted or tabulated as follows:

Glyph, sigil Discursivity ↑
Hieroglyph, ideogram
Canterbury window
Masaccio
Piero
Still-life
Vermeer
(Cubism)
Abstract expressionism
Painterly trace Figurality ↓

¹ On Académie and Maîtrise see Pevsner, *Academies of art*, pp. 82–101; J. Montagu's superb doctoral dissertation 'Charles LeBrun's "Conférence sur l'expression générale et particulière"', to which, for its many insights, every student of LeBrun is indebted; H. Jouin, *Charles LeBrun*, pp. 63–128; and B. Teyssèdre, *Roger de Piles*, pp. 15 ff.

² *Ibid.*, pp. 15–16.

³ *Ibid.*

⁴ See Anthony Blunt, *Nicolas Poussin*, pp. 208–18.

⁵ See A. Fontaine, 'Les premiers académiciens', in *Académiciens d'autrefois*, pp. 1–32.

⁶ A. Fontaine, *Académiciens*, pp. 17–18; and Teyssèdre, *Roger de Piles*, pp. 24–6.

⁷ See H. Jouin, *Charles LeBrun*, ch. 6.

⁸ See J. Thuillier's Preface to the Catalogue of the LeBrun exhibition at Versailles, 1963, pp. xvii–xxxii, esp. p. xix: 'Or, la vie de LeBrun est d'abord une carrière'.

⁹ A. Fontaine, *Académiciens*, p. 18.

¹⁰ On the foundation of lectures at the Académie, see A. de Montaiglon (ed.), *Procès-verbaux*, volume I, pp. 72–6. The decision to hold lectures was made long before Colbert became connected with the Académie, as early as 1653; but once the connection was formed the lectures became much more centrally placed: see Introduction to A. Fontaine, *Conférences inédites de l'Académie*.

¹¹ See A. Félibien, 'Conférences de l'Académie royale de peinture et de sculpture', in *Entretiens*, volume v, pp. 402 ff.

¹² The ascendancy of France over Italy, at least in French eyes, can be dated from Bernini's return to Rome: the non-realisation of his French projects indicates that foreign direction was no longer considered necessary.

¹³ On the importance of rhetoric in the formation of an earlier stage of European painting, see M. Baxandall, *Giotto and the orators*; on *dispositio* and its relation to the other branches of rhetoric, see F. Yates, *The art of memory*, pp. 1–104.

¹⁴ See Guillet de Saint-Georges, *Mémoires inédits* (Bibliothèque nationale), volume I, pp. 245 ff, and H. Testelin, 'Discours sur l'expression', in *Sentiments des plus habiles peintres* (Paris, 1696). There is a useful résumé of the Eliezer and Rebecca debates in H. Lemonnier, *L'art français au temps de Richelieu et Mazarin* (Paris, 1913), p. 352.

¹⁵ The role of warfare in Tolstoy and especially in Stendhal is more complex than it is in epic, since their work is in part concerned with denying the kind of hyper-intelligibility which the epic text insists on, and at once achieves, by concentrating on the events of fighting. Tolstoy's intention seems to be to establish a zone of intelligibility – the Napoleonic War – near his narrative but not within it; in the *Chartreuse de Parme* Stendhal places his hero at the heart of the battlefield, but so blocks the expected narrative clarity that the idea of a patently intelligible event itself recedes, opening the text to new forces of randomness and subjectivity. Both of these sophisticated narrative techniques depend on a subversion of the traditional collusion between war and legibility of event.

¹⁶ One place where the banned eroticism of the martial body surfaces, however, is in David: covertly, in the incongruous nudity of the warriors in the *Intervention of the Sabine Women*, and overtly in the *Leonidas*, where it can be rehabilitated as 'Spartan'; see also J. de Madrazo, *Death of Viriathus*, Museo de Arte Moderno, Madrid.

¹⁷ See J. Starobinski, *L'oeil vivant*, pp. 31–90.

¹⁸ See S. Doubrovski, *Corneille et la dialectique du héros*.

[19] See Tony Tanner's discussion of paranoia and narrative in *City of words* (London, 1971), pp. 153–80.

[20] Cf. Barthes on the Racinian 'peur des signes': 'Le héros est enfermé. Le confident l'entoure mais ne peut pas pénétrer en lui; leurs langages s'échangent sans cesse, ne coincident jamais . . . le héros vit dans un monde de signes, il se sait concerné par eux, mais ces signes ne sont pas sûrs . . . La *bouche* étant le lieu des faux signes, c'est vers le visage que le lecteur se porte sans cesse: la chair est comme l'espoir d'une signification objective: le *front*, qui est comme un visage lisse, dénudé, où s'imprime en clair la communication qu'il a reçu, et surtout les *yeux*, dernière instance de la vérité', *Sur Racine*, pp. 63–4. See also W. Benjamin on the psychology of the courtier in *The origin of German tragic drama*, pp. 95–8.

[21] References here to *Memoirs of the Duc de Saint-Simon*, selected by W. H. Lewis and translated by B. St John, p. 5.

[22] *Ibid.*, p. 124.

[23] See J. Starobinski, *L'oeil vivant*, pp. 31–90; and R. Barthes, *Sur Racine*, pp. 22–8, 63–8.

[24] Saint-Simon, *Memoirs*, p. 183.

[25] For a vivid illustration of this problem, see the potato frozen in mid-air in Millet's *The Furrow*.

[26] Paracelsus, *Werke*, volume XI, pp. 171–6, cited in I. Hacking, *The emergence of probability*, p. 41.

[27] G. B. della Porta, *Fisonomia naturale*, edition of Padua, 1622, pp. 35–6. On analogical probability, see M. Foucault, *Les mots et les choses*, pp. 32–60; and the section 'Physiognomie animale' in J. Baltrousaitis *Aberrations*, pp. 7–46.

[28] G. B. della Porta, *Fisonomia naturale*, pp. 1–35.

[29] *Ibid.*

[30] See J. Montagu, 'LeBrun animalier', *Art de France*, pp. 310–14.

[31] Descartes, *Traité sur les passions de l'âme*, Amsterdam, 1649.

[32] Cited in Montagu, 'Charles LeBrun's "Conférence"', volume I, p. 26. Montagu provides a detailed comparison between LeBrun and Descartes in volume I, pp. 334–51.

[33] *Ibid.*, pp. 32–3.

[34] *Ibid.*, p. 33.

[35] LeBrun reduces the face, in fact, to what we would now describe as differential semantics: see P. Guiraud, *Semiology*, pp. 45–65.

[36] H. Jouin, *Conférences de l'Académie*, p. 25.

[37] Descartes, *Traité*, article CXVI.

[38] Jouin, *Conférences de l'Académie*, p. 38.

[39] Descartes, *Traité*, article CCIV.

[40] See Jouin, *Charles LeBrun*, pp. 133–7.

[41] Félibien, *Les Reines de Perse aux pieds d'Alexandre, peinture du cabinet du Roy*, trans. Collonel Parsons, London, 1703, as *The Tent of Darius Explained* (henceforward *Parsons*), p. 11.

[42] *Parsons*, p. 15.

[43] *Ibid.*

[44] *Ibid.*, p. 17.

[45] *Ibid.*, p. 19.

[46] *Ibid.*

[47] *Ibid.*, p. 21.

[48] *Ibid.*, p. 23.

[1] It is likely that LeBrun based his interpretation on a specific theological tract, possibly l'abbé Gallois's *De raptu Sancti Pauli ad tertium coelum*. See A. Fontaine, *Les Doctrines d'Art en France*, pp. 80–3.

[2] From M. Cureau de la Chambre's *L'art de connaître les hommes et le caractère des passions*. See A. Fontaine, *Doctrines*, pp. 101–2.

[3] See Fontaine, *Doctrines*, pp. 98–9.

[4] L. Hourticq, *De Poussin à Watteau*, p. 84.

[5] See H. Jouin, *Charles LeBrun*, ch. 4.

[6] See Fontaine, *Doctrines*, pp. 98–156.

[7] On the Poussin/Rubens debate, see Fontaine, *Doctrines*, chs. 4 and 5; Teyssèdre, *Roger de Piles*, passim; and R. F. Verdi, *Poussin's critical fortunes*, doctoral dissertation at the University of London, 1976.

[8] In his *Balance des peintres*, R. de Piles awarded Raphael a score of 18 for expression, just above Rubens and Domenichino (17), and LeBrun (16).

[9] Poussin's score for colour was 6, below LeBrun (8).

[10] The chart is based on Teyssèdre, *Roger de Piles*, p. 84.

[11] Descartes, *Traité . . .*, part one, p. 70.

[12] Teyssèdre, *Roger de Piles*, p. 178.

[13] R. de Piles, *Dialogue sur le coloris* (Paris, 1673), p. 16.

[14] Cited in Hourticq, *De Poussin à Watteau*, p. 49.

[15] See E. Krantz, *L'esthétique de Descartes* (Paris, 1882); and Hourticq, *De Poussin à Watteau*, ch. 2.

[16] LeBrun's reliance on Descartes is demonstrated point by point in Montagu, *Charles LeBrun's 'Conference'*, pp. 335–51.

[17] See Descartes, *Traité*, articles XCIV to CXX.

[18] See Fontaine, *Doctrines*, pp. 1–40.

[19] See I. Hacking, *Why does language matter to philosophy?*, pp. 26–33.

[20] *Ibid.*, pp. 28–9.

[21] This comes about by definition: an idea is any object which can be contemplated by a thinking being without existential commitment to anything except that being.

[22] Blanchard delivered his defence of colour on 7 November 1671; see Teyssèdre, *Roger de Piles*, pp. 165–75.

[23] See Guillet de Saint-Georges, *Mémoires inédits*, volume I, p. 246.

[24] In Orlandi's *Abecedario Pittorico* (1719); reprinted in H. Adhémar, *Watteau: sa vie, son oeuvre*, p. 165.

[25] Antoine de la Roque, in the *Mercure de France* (August 1721).

[26] Jean de Jullienne, *Abrégé de la vie d'Antoine Watteau*.

[27] Edmé Gersaint, *Catalogue de la collection du feu M. Quentin de Lorangère*.

[28] Reprinted by Edmond and Jules de Goncourt in *L'Art au dix-huitième siècle* (Paris, 1856–74; trans. R. Ironside, London, 1958) (henceforward *Goncourts*), pp. 10–33.

[29] In *Oeuvres Diverses de M. l'abbé de la Marre* (Paris, 1763), pp. 26–34.

[30] Hédouin, *L'Artiste*, 16, 23 and 30 November 1845.

[31] On the rue de Doyenné cult of Watteau, see S. O. Simches, *Le Romanticisme et le goût esthétique du XVIIIᵉ siècle* (Paris, 1964); and A. Johnson's perceptive 'Watteau and his critics', pp. 26–41.

[32] Gautier, 'Watteau' (1838). See also 'Arlequin et Colombine', *Les Stalactites*, XXVI, by Théodore de Banville (1846).

[33] *Goncourts*, pp. 5–7.

[34] C. Mauclair, *Watteau*.

[35] R. Huyghe, 'L'univers de Watteau', in H. Adhémar, *Watteau*.

[36] S. Sitwell, *Antoine Watteau*.

[37] See Lord Clark, *Civilisation*, p. 336.

[38] No one, surprisingly, ever 'hears' Rameau.

[39] In G. W. Barker, *Antoine Watteau*, pp. 143, 157.

[40] *Ibid.*, pp. 138, 157.

[41] *Ibid.*, pp. 138, 141, 157.

[42] *Ibid.*, pp. 200–2.

[43] By M. Levey, *Rococo to Revolution*, p. 72.

[44] See chapter head in C. Phillips, *Antoine Watteau*, p. 68: 'He has been a sick man all his life. He was always a seeker after something in the world that is there in no satisfying manner, or not at all' (Pater).

[45] Cited in Barker, *Watteau*, p. 85.

[46] *Goncourts*, pp. 8–9.

[47] *Ibid.*, p. 27.

[48] Mauclair, *Watteau*, pp. 3–13.

[49] *Goncourts*, pp. 1–2; and A. Brookner, *Watteau*, p. 7. Brookner and A. Johnson are alone among Watteau critics in drawing attention to the excesses and dangers of the myth.

[50] Lord Clark, *Civilisation*, p. 232: 'Gilles ... is a sort of idealised self-portrait.'

[51] Levey, *Rococo to Revolution*, pp. 76–8.

[52] *Ibid.*, p. 62.

[53] *Ibid.*, p. 56.

[54] *Goncourts*, p. 8.

[55] Levey, *Rococo to Revolution*, p. 57.

[56] *Ibid.*, p. 70.

[57] *Ibid.*, p. 76.

[58] *Goncourts*, p. 6.

[59] Levey, *Rococo to Revolution*, p. 78.

[60] *Goncourts*, p. 309.

[61] See J. Casey's discussion of the problematic musical signified in *The language of criticism*, pp. 61–71.

[62] Suzanne Langer, *Feeling and form* (London, 1959), p. 28.

[63] See Barthes, 'The death of the author', in *Image–music–text*, pp. 142–8.

[64] Levey, *Rococo to Revolution*, p. 55.

[65] The existence of *La Toilette intime* (private collection, France) makes one wonder how many such images Watteau produced. See the bottom left-hand corner of the Dresden *Réunion Champêtre*.

[66] See W. Benjamin, 'Allegory and *Trauerspiel*', in *The origin of German tragic drama*.

[67] L. C. Knights, *How many children had Lady Macbeth?* (Cambridge, 1933).

[68] *Goncourts*, p. 7. (See p. 82 above.)

[69] See D. Davie, *Articulate Energy* (London, 1955).

[70] See Y. Boerlin-Brodbeck, *Antoine Watteau und das Theater*, pp. 122–37.

[71] See A. Brookner, *Watteau*, p. 8.

[72] Remond de Sainte Albine, *Le Comédien* (Paris, 1747), p. 185.

[73] J. L. de Cahusac, in the *Encyclopédie* article *Geste*.

[74] See in particular Quintilian's *Institutiones oratoriae*, book XI, ch. 3, articles 65–149.

[75] See D. Barnett, 'Eighteenth-century acting', p. 25.

[76] See Quintilian, *Institutiones oratoriae*, book XI, ch. 3, articles 88–91.

[77] Brookner, *Watteau*, p. 7.

[78] *Goncourts*, pp. 24, 26.

[79] G. Austin, *Chironomia; or a treatise on rhetorical delivery* (London, 1806), p. 185.

[80] K. A. Boettiger, *Entwickelung des Ifflandischen Spiels in Vierzehn Darstellung auf dem Weimarischen Hoftheater* (Leipzig, 1796), p. 227.

[81] Watteau's difficulties with the compositional management of groups emerges clearly in the Wallace Collection's *Les Champs Elysées*, where the uncertainty of ground-plan, uneven massing, and reliance on filling

intervening spaces with a crude grass-notation recall the rudimentary solutions of naive painting.

[82] See K. T. Parker, *The drawings of Antoine Watteau*, p. 11.

[83] See Hourticq, *De Poussin à Watteau*, pp. 60–6.

[84] See J. Thuillier, 'Temps et tableau'.

[85] *Ibid.*

[86] See M. Levey's article, 'The real theme of Watteau's *Embarkation for Cythera*'.

[87] With the notable exception of O. T. Banks, *Watteau and the North* (New York, 1977).

4. TRANSFORMATIONS IN ROCOCO SPACE

[1] See 'Two aspects of language and two types of aphasic disturbances', in *Selected Writings of Roman Jakobson*, volume II, pp. 239–59.

[2] P. Francastel, *Etudes de sociologie de l'art*, pp. 136–7.

[3] M. Fried, in *Three American painters*, cited in M. Kapos, 'The languages of realism', p. 79.

[4] C. Greenberg, in *Modernist Painting*, cited in Kapos, 'The languages'.

[5] Cf. L. Nochlin, *Realism*, p. 23: 'The demonstration of the artness of art – or even the inherent conflict between the representation of contemporary reality and the reality of the formal means of art themselves ... could now be achieved straightforwardly: indeed, the demonstration that art is art and nothing more, an independent system of signs having no signified ... becomes the business of art.'

[6] S. Heath, 'Narrative space', p. 77.

[7] *Ibid.*, pp. 75–84

[8] Cf. M. Pleynet, Interview with G. Leblanc, *Cinéthique* 3 (1969): 'a camera productive of a perspective code directly constructed on the model of the scientific perspective of the Quattrocento'.

[9] Some critics have expressed the view that LeBrun's contempt for flesh-tones is part of a generally sadistic attitude towards the body. See, for example, the Preface to the Versailles exhibition catalogue, 1963. If LeBrun's loyalty to the utterance of inner state is by means of a material medium that is of no intrinsic interest to him, this may also account for the anti-cartesian personalisation of animals, evident not only in the Physiognomic Studies, but in his work generally: see J. Montagu, 'LeBrun animalier'.

[10] Lee L. Bersani, 'The hazards of literary fusion', in *Novel*, VIII, 1 (Fall, 1974), 16–28.

[11] See *ibid.*, p. 16; and Barthes, *Sur Racine*, pp. 22–6.

[12] *The literary works of Leonardo da Vinci*, ed. J. P. Richter, volume I (London, 1939), p. 150. Cf. Alberti: 'Painters should only seek to present the form of things seen on this pane as if it were of transparent glass. Thus the visual pyramid could pass through it, placed at a definite distance with a definite position of centre in space and a definite place in respect to the observer', cited in R. J. Spencer, *On painting* (New Haven and London, 1956), p. 51. On 'Quattrocento' space see also J. White, *The birth and rebirth of pictural space* (London, 1957), pp. 27–9.

[13] On the role of posture in 'erotic discourse', see Barthes, *Sade, Fourier, Loyola*, trans. R. Miller (London, 1976), pp. 26–37.

[14] See L. Mulvey, 'Visual pleasure and narrative cinema', pp. 8–13.

[15] The phrase is taken from D. Wakefield's study *Fragonard*, p. 9.

[16] The painting corresponds almost exactly to Freud's account of the mechanism of fetishism in the paper 'Fetishism', *Standard Edition*, XXI, 152–7; see also Freud's 'Three essays on sexuality', *SE*, VII, 153–5.

[17] Roger de Piles, 'Un traité de peinture parfait', in *Abrégé*, pp. 69–70. Cf. J. Starobinski's observation that the eighteenth-century observer's pleasure in a sketch 'lay in completing mentally, in a complicity of the imagination, the work that the artist had abandoned'; *The Invention of Liberty*, pp. 119–20.

[18] Bouhours, *La Manière de bien penser* (1687), Paris, 1771, pp. 417–18. See E. Rothstein's valuable article '"Ideal presence" and the "non finito" in eighteenth century aesthetics'.

[19] Cited in Rothstein, 'Ideal Presence', p. 321.

[20] Du Bos, *Réflexions critiques sur la poësie et sur la peinture* (1719) (2 vols., Paris, 1755), volume I, pp. 267–8.

[21] J. M. Lambert, in *L'Etude de Homère et de Virgile au Collège parisien de la Marche en 1757*, ed. E. Jovy (Vitry-le-François, 1911), p. 32.

[22] J. Spence, *An essay on Pope's Odyssey* (London, 1726), p. 66.

[23] See E. Rothstein, '"Ideal presence" and the "non finito"'.

[24] Mendelssohn, 'Réflexions sur les sources et les rapports des beaux-arts et des belles-lettres', *Variétés littéraires* (Paris, 1768–9), pp. 156–7.

[25] *Tom Jones*, XVI, v.

[26] See appendix to the Birrell translation of Diderot's *La Religieuse*, pp. 195–7.

[27] L. Garcin, *Traité du mélo-drame, ou réflexions sur la musique dramatique* (Paris, 1772), pp. 119–20.

[28] M. Levey, *Rococo to Revolution*, p. 117; and D. Wakefield, *Fragonard*, p. 13.

[29] *Goncourts*, pp. 301–2.

[30] The problem of intention is enormous, and so is its literature. Some indispensable texts are E. D. Hirsch, 'In defense of the author', in D. Newton-de Molina's collection *On literary intention* (Edinburgh, 1976), pp. 87–103; R. Barthes, *Critique et vérité* (Paris, 1966); Frank Kermode's *The classic* (London, 1975), and his article, 'The use of codes', in *Approaches to poetics*, ed. S. Chapman (Columbia University Press, 1973).

[31] See Barthes, *S/Z*, pp. 9–10; Miller translation, pp. 3–4.

[32] See in particular, M. A. Laugier, *Jugement d'un amateur sur l'exposition des tableaux, Lettre à M. le marquis de V.* (Paris, 1753), pp. 42–3; and Garrigues de Froment, *Sentimens d'un amateur sur l'exposition des tableaux du Louvre et la critique qui en a été faite* (Paris, 1753).

[33] See M. Fried's excellent article 'Absorption: a master theme in eighteenth century French painting and criticism'.

[34] Fried, 'Absorption', p. 145.

[35] See *Goncourts*, pp. 118–19.

[36] *Goncourts*, p. 115.

[37] See M. Praz, *Studies in seventeenth century imagery* (Studies of the Warburg Institute); and D. de Chapeaurouge, 'Chardins Kinderbilder und die Emblematik'.

[38] Sebastian de Covarrubias Orozco, *Emblemas Morales* (Madrid, 1610); cited in de Chapeaurouge, 'Chardins Kinderbilder' p. 51. See also canto IV of Marino's *Adone*:

> Palla a terra sospinta al ciel s'inalza,
> E sferzato – alèo piu fate sbalza.

[39] In the emblematic tradition, Chardin's rubric

> Sans souci, sans chagrin, tranquille dans mes désirs,
> Une raquette, et un volant forment tous mes plaisirs

would have signified an advanced state of depravity; see, for example, B. Aneau's discussion of ball-games and sin in *Picture poesis*, cited in A. Henkel and A. Schöne, *Emblemata*, pp. 1124–5; and de Chapeaurouge, 'Chardins Kinderbilder', p. 53.

[40] See W. Benjamin, *The Origin of German tragic drama*, trans. J. Osborne.

[41] See L. B. Martz, *The poetry of meditation* (New Haven, 1954).

[42] See Brookner's discussion of Greuze's *Un Ecolier qui étudie sa leçon*, in *Greuze*, p. 98.

5. GREUZE AND THE PURSUIT OF HAPPINESS

[1] See Brookner, *Greuze,* pp. 72–3.

[2] Cf. L. Nochlin, *Realism*, p. 23: 'the demonstration that art is art and nothing more, *an independent system of signs having no signified* . . . becomes the business of art' (my italics).

[3] Diderot, *Salons,* ed. J. Seznec and J. Adhémar (henceforward *Salons*); volume I, p. 141.

[4] See the introduction to J. H. McDowell's translation of *La Nouvelle Héloïse,* 1968.

[5] Between 1761 and 1800 *La Nouvelle Héloïse* passed through seventy-two editions in French.

[6] See Brookner, *Greuze,* pp. 30–6; and A. Guedj, 'Les drames de Diderot'.

[7] See Laclos, *Les Liaisons Dangereuses,* Letter 22 (1782). Valmont explicitly parodies *La Nouvelle Héloïse* in Letter 110.

[8] *Goncourts,* p. 205.

[9] One of the reasons contemporary English versions of the theme of charity strike us now as callous in their attitude towards poverty is that the confrontation between donor and recipient is stark: Greuzian charity insists on the theme of age as well as riches, and the asociality of the former softens the impact and visibility of the division by wealth.

[10] See Tony Tanner's remarkable analysis of bourgeois happiness, and its fiction, in 'Julie and "La Maison Paternelle"'.

[11] *Ibid.*: 'la fille est une jolie bouquetière'.

[12] Contemporary reception and description of Greuze's early work is some-times cast in terms dictated solely by the categories of age and family role: e.g., *Description des tableaux exposés avec des remarques par une société d'amateurs* (1763), 'The principle personage is a venerable old man of 80 . . . his daughter-in-law, a woman of about 23 . . . his wife who looks about 60 . . . a boy of 18 adjusts a coverlet over the old man's legs . . . another of his grandsons, aged 15, brings him a drink . . . a child of 3 has brought a bird to show him . . . a girl of 14 or 15 supports his head.'

[13] On the question of Greuze's artistic Protestantism, see E. Munhall, 'Greuze and the protestant spirit'. The painting's full title is: *Un mariage, et l'instant où le père de l'accordée délivre la dot à son gendre.*

[14] Interest in the hymenal moment recurs in the *Jeune fille qui pleurt la mort de son oiseau* (Louvre), *La vertu chancellante* (Alte Pinakothek Munich), *Le miroir cassé* (Wallace Collection), and *Les oeufs cassés* (Metropolitan).

[15] See P. A. Tanner's article 'Julie and "La Maison Paternelle": Another Look at Rousseau's *La Nouvelle Héloïse*'; and Tanner's brilliant *Adultery in the novel,* pp. 113–78 and 382.

[16] *Ibid.,* p. 24.

[17] Fascination with that which crosses or evades normal categories is a phenomenon well charted in anthropology: see the discussion of 'abomi-nation' in Leach's *Genesis as Myth,* and M. Douglas's *Purity and Danger.* The elisions or anomalous fusions most favoured by Greuze tend to focus on the transgression of familial categories: father–daughter in *Lot and his Daughters, The Widow and her Curate,* and the *Hermit (Le Donneur des Chapelets);* mother–wife in *La Mère Bien-aimée* and in *L'Innocence, entraînée par les amours;* daughter–mistress in the many variants of the Greuze girl.

[18] *Salons*, volume II, p. 155.

[19] This comment suggests that there may be some irony in Diderot's idea of Greuze's 'preaching population'.

[20] A. Brookner, *Greuze*, p. 111.

[21] In *Sentiments sur plusieurs des tableaux exposés cette année 1755 dans le Grand Salon du Louvre* (anon., Bibliothèque Nationale).

[22] In *Observations d'une société d'amateurs sur les tableaux exposés au Salon cette année 1761* (anon., Bibliothèque Nationale).

[23] In *Lettres sur le salon de 1763*. The habit of linking Greuze's paintings into continuous narrative was widespread: 'Certain people without much education have understood this mournful scene as some domestic quarrel in the life of his paralytic', in *Sentiments sur les tableaux exposés au Salon, 1769*; and Diderot on *L'Enfant gâté*, 'It is his little laundrymaid of four years ago who has got married and whose story he now proposes to tell us' (*Salon* of 1765).

[24] There are grounds for believing that the first stage of the anti-rococo reaction based itself on discontent with the lack of expression in current artistic practice. See, for example, Estève's criticism of *The Setting of the Sun* (Wallace Collection): 'l'expression de ces figures n'a pas paru convenable. Abandonnées à leur nonchalance, elles ne prennent aucun intérêt à l'arrivée d'Apollon. Ne devroient-elles pas tout au moins imiter leur Souveraine, qui daigne honorer le Dieu du jour d'un regard de complaisance?' (*Lettre à un ami*); and La Font de Saint-Yenne's similar complaint about Boucher's painting in *Sentimens sur quelques ouvrages*.

[25] Baillet de Saint-Julien, *Lettre à un partisan du bon goût*. By the 1770s the demand for legibility had become standard: 'If the poet should be a painter in execution, the painter should be a poet in invention ... the first duty of any intelligent man who composes for the public is to leave no doubt surrounding his subject. A painter should not even need a title for his work. The work should imply the title straight away'; Laugier, *Manière de bien juger les ouvrages de peinture* (Paris, 1771).

[26] 'I make so bold as to say that this great man is far superior to the famous LeBrun'; see G. Lundberg, 'Le graveur Pierre Floding à Paris, 1755–1764', *Archives de l'Art Français*, LXVII (1931–2).

[27] *Salons*, volume II, p. 144.

[28] Greuze's legibility has not always met with Diderot's enthusiasm. See C. Normand: 'Les gestes ont cela pour eux qu'ils complètent la parole et souvent même qu'ils la remplacent ... (Greuze) force les jeux de phisionomie de façon à ce que personne ne puisse arguer de son intelligence pour esquiver la leçon ... La Decalogue en tableau ...', *J.-B. Greuze*, pp. 28–30, 38, 46. This expands Bachaumont's reaction of displeasure in *Sur les peintures, sculptures, et gravures de Messieurs de l'Académie Royal exposés au Salon du Louvre le 25 août 1769* (Paris, 1769): 'M. Greuze's first mistake is to have chosen to paint a speech and not an action.'

[29] *Lettre de M. Raphaël à M. Jérôme* (Paris, 1769).

[30] *Ibid.*

[31] See also J. Seznec, 'Diderot et l'Affaire Greuze', *Gazette des Beaux-Arts* (May 1966).

[32] Cf. A. Brookner: 'His curious, almost Victorian conscience made him yearn for a kind of patriarchal simplicity and obedience: sexuality is permitted only in young girls at puberty and must be instantly reprimanded and repressed into the symbol of a broken egg or a spoilt dish once these girls grow into sexual awareness ... While continuing to scold, chastise, and humiliate in his moral homilies, he cannot refrain from exploring, hinting, exposing, in his studies and genre pieces'; *Greuze*, p. 90.

[33] Full text quoted in Brookner, *Greuze*, pp. 156–61.

[34] Diderot, Eloge de Richardson, in *Oeuvres esthétiques*, pp. 30–1.

6. DIDEROT AND THE WORD

[1] Cf. Diderot: 'On ne peint plus en Flandre. S'il y a des peintres en Italie et en Allemagne, ils sont moins réunis; ils ont moins d'émulation et moins d'encouragement ... La France est la seule contrée où cet art se soutienne, et même avec quelque éclat': *Salons*, volume I, p. 20.

[2] See A. Brookner, *The genius of the future*, pp. 7–29.

[3] See L. Spitzer, *Linguistics and literary history*, p. 136.

[4] *Ibid.*

[5] *Ibid.*, p. 135.

[6] See T. M. Kavanagh's deft attack on the Auerbach/Spitzer position in the opening section of *The vacant mirror*.

[7] If Auerbach and Spitzer were right, no text or painting could ever have the power to disturb the *status quo;* they would afford only the limited pleasure of confirming cultural identity, and could never disrupt or transcend cultural context.

[8] From the *Encyclopédie*, volume VIII, p. 889.

[9] *Denis Diderot's The Encyclopedia*, editor and translator, S. J. Gendzier, pp. 95–7.

[10] Spitzer, *Linguistics and literary history* p. 135.

[11] See Barthes, *The pleasure of the text*, pp. 66–7 and Quintilian, *Institutiones oratoriae*, book XXIX, ch. 2, articles 77–8.

[12] Diderot, *Oeuvres romanesques*, pp. 347–8.

[13] *The Nun*, trans. M. Sinclair, pp. 142–3.

[14] See Introduction to F. Birrell's translation, *Memoirs of a Nun*, pp. 7–10.

[15] 'And now for a circumstance scarcely less singular. While this mystification went to the head of our friend in Normandy (the Marquis de Croismare), the imagination of M. Diderot was similarly excited. He was persuaded that the Marquis would never admit into his house a young person without knowing her, and so began to write out in detail the story of our nun.

One day when he was entirely absorbed in his work, one of our friends, d'Alainville, went to call on him and found him plunged in grief, with his face bathed in tears.

"What on earth is the matter?" said M. d'Alainville; "what a state you are in!"

"What is the matter?" answered Diderot; "I am miserable about a story I am writing ..."'; from Grimm, *Correspondance littéraire*, 1770, trans. Birrell, *Memoirs of a Nun*, pp. 196–7.

[16] Rousseau, *Julie ou la Nouvelle Héloïse*, Editions Garnier (Paris, 1960), p. 451: 'A table, à la promenade, tête à tête, ou devant tout le monde, on tient toujours le même langage.'

[17] *Oeuvres romanesques*, pp. 406–7.

[18] *Rameau's Nephew*, trans. J. Barzun and R. H. Bowen, pp. 17–18.

[19] Hegel, *The phenomenology of mind*, Baillie translation, p. 450.

[20] See Barthes, *Sade, Fourier, Loyola*, trans. R. Miller, pp. 122–71.

[21] M. J. Morgan, *Molyneux's question*, pp. 25–58.

[22] *Oeuvres complètes* (22 vols.) ed. J. Assézat and M. Tourneux (henceforward *A.-T.*), volume I, p. 319.

[23] *A.-T.*, volume I, pp. 319 and ff; 'One experiences, in the first instants of vision, only a multitude of confused sensations which untangle themselves only with time and by habitual reflection on what passes in us.'

[24] The two-tier model is from D. Funt, *Diderot and the esthetics of the Enlightenment*, pp. 104–7.

[25] *A.-T.*, volume IX, p. 366 ff.

[26] *A.-T.*, volume I, p. 369. Cf. *A.-T.*, volume II, p. 325: 'The state of the soul, in an indivisible instant, was represented by a multitude of terms that the precision of language required, and which distributed a total impression into parts; and because these terms were pronounced successively and were apprehended only in the measure that they were pronounced, people were inclined to believe that the impressions of the soul that they represented had the same succession. But this is not at all the case.'

[27] For a highly stimulating discussion of Hegel's response to *Le neveu*, see L. Trilling, *Sincerity and authenticity*, pp. 26–52.

7. DIDEROT AND THE IMAGE

[1] See Doolittle's excellent 'Hieroglyph and Emblem in Diderot's "Lettre sur les sourds et muets"'.

[2] *A.-T.*, volume I, p. 369.

[3] *A.-T.*, volume I, p. 376.

[4] Diderot's conviction that thought is distinct from linguistic expression might produce, as one inference, the viability of translation: since all verbal expression is the difficult translation of thought, no one language, not even the native language of the speaker, enjoys the privilege of transparent communication of thought. But the same conviction also, in the *Eloge de Terénce*, yields the opposite view: some languages are *so* alien to thought-processes that those processes can never be expressed without mutilation and loss. Only when thought concretises into image, held by the mind outside language, is translation possible under such circumstances: the image is lucid where discourse is opaque: 'S'il y en a qui comptent pour rien ces images qui dépendent si souvent d'une expression, d'une onomatopée qui n'a pas son equivalent dans leur langue; s'ils méprisent ce choix de mots énérgiques dont l'âme reçoit autant de secousses qu'il plaît au poète ou à l'orateur de lui en donner; c'est que la nature leur a donné des sens obtus, une imagination sèche et une âme de glace'; *Oeuvres esthétiques*, p. 66.

[5] *A.-T.*, volume III, p. 190.

[6] *Salons*, volume III, p. 190.

[7] *Salons*, volume III, p. 155.

[8] Letter to Sophie Volland of 30 September 1760; in *Lettres et réponses de Diderot à Sophie Volland*, ed. M. Darmon Meyer. See also the tableaux in the letters to Sophie Volland of 5 and 17 September and 20 October 1760.

[9] Letter to Sophie Volland of 17 September 1761.

[10] *Salons*, volume I, pp. 215–16.

[11] *Salons*, volume I, p. 66.

[12] *Salons*, volume I, p. 114.

[13] *Salons*, volume I, pp. 114–16; see also the remarks on Lagrenée's *Judgment of Paris*, volume I, p. 66.

[14] *Salons*, volume I, pp. 232–3.

[15] The hieroglyph can be described as a sign distorted at two points:

$$\left.\frac{Sr^{I}}{Sd^{I}}\right\} \quad Sign^{I} \rightarrow \left.\frac{Sr\ II}{Sd\ II}\right\} \quad Sign\ II \rightarrow \left\{\frac{-}{\cdot\ Sd^{I}}\right.$$

$$(A) \qquad\qquad (B)$$

where (A) corresponds to the move from real to imaginary paintings, and (B) to the moment when the text yields the desired visualisation.

[16] *Salons*, volume I, pp. 63–4.

[17] *Salons*, volume II, pp. 82–4.

[18] *Salons*, volume II, pp. 84–6.

[19] *Salons*, volume III, p. 157.

[20] See J. Thuillier, 'Temps et tableau'.

[21] See Félibien, *Entretiens*, volume V, pp. 402 ff.

[22] *Salons*, volume I, p. 228.

[23] Vernet's work at the Salon of 1767 is described in terms of a walking-tour: 'Mon compagnon de promenades connaissait supérieurement la topographie du pays ... c'etait le *cicerone* de la contrée ... J'allais, la tête baissée, selon mon usage, lorsque je me sens arrêté brusquement, et présenté au site que voici.' There are seven 'sites' or stations (*Salons*, volume III, pp. 129–62), by the sixth of which Diderot is apologising for forgetting that the landscape is only painted; 'j'ai oublié que je vous avais fait un conte ... puis tout à coup je me suis retrouvé de la campagne au Sallon' (pp. 158–9). The hallucinatory excursion into Vernet country is at once followed by accounts of nightmares resembling the 1765 dream of Plato's cave.

[24] *Salons*, volume III, pp. 74–9.

[25] *Salons*, volume I, pp. 112–13: 'Cet homme a tout, excepté la vérité.'

[26] See ch. 5, n. 24.

[27] *Salons*, volume II, p. 75.

[28] *Salons*, volume I, p. 222.

[29] The advantage of the inventory for the 'hieroglyphic' Diderot is that it bypasses altogether description of the material work of the paint: see the accounts of eight paintings by Chardin in the *Salon* of 1765 (*Salons*, volume II, pp. 112–14).

[30] *Salons*, volume II, p. 111.

[31] *Salons*, volume II, p. 121. Diderot defines 'Magie naturelle' in the *Encylopédie* as 'L'étude un peu approfondie de la nature'.

[32] *Salons*, volume I, pp. 66–7: 'La largeur de faire est indépendante de l'étendue de la toile et de la grandeur des objets.'

[33] *Salons*, volume I, p. 125: 'Il y a longtemps que ce peintre ne finit plus rien; il ne se donne plus la peine de faire des pieds et de mains. Il travaille comme un homme du monde qui a du talent, de la facilité, et qui se contente d'esquisser sa pensée en quatre coups de pinceau.'

[34] See Seznec's Preface to volume IV of the *Salons*, which established clearly Diderot's growing reliance on secondary material; and M. T. Cartwright, *Diderot critique d'art*, pp. 218–28.

[35] The *Salons* of 1767 ('Je vous ai prevenu sur ma stérilité') and 1769 ('J'ai vidé mon sac') both open with apology.

[36] See N. MacGregor's 'Diderot and the *Salon* of 1769', which contains many valuable insights into the 'technical hardening' of the later Diderot, arguing that the change is largely due to Diderot's late 1760s embrace of materialism.

[37] *Salons*, volume II, pp. 189–98.

[38] *Salons*, volume IV, pp. 203–4.

[39] *Salons*, volume IV, p. 389.

[40] *Salons*, volume IV, p. 89.

[41] See T. M. Kavanagh's Derridean reading of '*Jacques le fataliste*', *The Vacant Mirror*.

[42] 'Les Deux Amis de Bourbonne', *Oeuvres*, ed. A. Billy (Pléiade, Paris, 1957), pp. 756–7.

[43] *Le Rêve de d'Alembert*, *Oeuvres philosophiques*, ed. Roger (Paris, 1965), p. 157.

[44] *Oeuvres esthétiques*, p. 354.

[45] See Brookner, *Greuze*, pp. 66–71, 109–10.

[46] *Salons*, volume IV, p. 106.

[47] *Le Rêve de d'Alembert*, pp. 310–12.

[48] See D. Funt, *Diderot and the esthetics of the Enlightenment*, pp. 75–136.

[49] See *Thomas Reid's Lectures on the Fine Arts*, transcribed P. Kiny (The Hague, 1973), esp. pp. 47ff: and Bryson, 'Hazlitt on painting', pp. 42–4.

[50] See D. Funt, *Diderot and the esthetics of the Enlightenment*, pp. 131–6.

[51] *Encyclopédie*, volume VIII, p. 50. The pun may come from the double sense, in French as in English, of musical (formal) and visual (mimetic) *harmonie*.

[52] *Salons*, volume IV, p. 83.

[53] *Salons*, volume IV, p. 82.

[54] *Salons*, volume IV, p. 88.

8. 1785

[1] A rather more radical version of the historian's position is stated by H. Mitchell in 'Art and the French Revolution: an exhibition at the Musée Carnavalet'.

[2] See Brookner, *Greuze*, p. 110.

[3] See K. Holma, *David: son évolution et son style*, p. 40.

[4] See D. Irwin, 'Gavin Hamilton: archaeologist, painter, and dealer'; and R. Rosenblum, 'Gavin Hamilton's *Brutus* and its aftermath'.

[5] See E. K. Waterhouse, 'The British contribution to the neo-classical style in painting', p. 62.

[6] J. Locquin, *La peinture d'histoire en France de 1747 à 1785*.

[7] L. Hautecoeur, *Rome et la Renaissance de l'antiquité à la fin du XVIII^e siècle*.

[8] J. A. Leith, *The idea of art as propaganda in France 1750–1799*.

[9] See E. Wind, 'The revolution of history painting'.

[10] On the Comte d'Angiviller, see F. H. Dowley, 'D'Angiviller's *Grands Hommes* and the Significant Moment', *Art Bulletin*, XXXIX (1957), 259–77; J. S. de Sacy, *Le Comte d'Angiviller*; and E. Done's fine M.A. report, 'Le Comte d'Angiviller and *Les Grands Hommes de la France*'.

[11] See *Winckelmann, writings on art*, sel. and trans. D. Irwin.

[12] See F. Biebel's article on the work of Fragonard and of Vien for Mme du Barry's Pavilion at Louveciennes, *Gazette des Beaux-Arts* (October 1960), and G. Wildenstein, *Fragonard*, p. 268.

[13] The remark comes from a Salon review of 1763, cited in Rosenblum, *Transformations*, p. 5.

[14] See Brookner, 'J.-L. David – a sentimental classicist', pp. 184–90.

[15] See Brookner, *Greuze*.

[16] See Brookner, 'J.-L. David – a sentimental classicist', p. 187.

[17] E. Delécluze, *Louis David* (henceforward *Delécluze*), pp. 113–14.

[18] J. H. W. Tischbein, *Aus meinem Leben* (Braunschweig, 1861), volume II, p. 56.

[19] *Delécluze*, pp. 20–1.

[20] See, for example, F. H. Hazlehurst, 'The artistic evolution of David's *Oath*'; R. Rosenblum, 'A source for David's *Horatii*'; E. Wind, 'The sources of David's *Horaces*'; and the excellent article by T. Crow, 'The *Oath of the Horatii* in 1785: painting and pre-Revolutionary radicalism in France'.

[21] Grimm, *Correspondance*, volume XV, p. 536: 'Plusieurs personnes ont observé qu'il existait dans ce tableau (Brutus) deux scènes separées, le plus grand défaut qu'on puisse reprocher à un ouvrage de ce genre, et nous conviendrons qu'avant d'avoir vu l'ensemble du sujet, avant d'avoir pu saisir toute la pensée de l'artiste, l'oeil est en quelque sort blessé de ce partage singulier de lumière et d'ombre qui divise, pour ainsi dire, le toile en deux parties tout à fait différentes.'

[22] See Lord Clark, *The romantic rebellion* (London, 1973), p. 234.

[23] See R. L. Herbert, *Brutus*, p. 40.

[24] *Ibid.*, p. 39.

[25] See R. Rosenblum, *The international style of 1800: a study in linear abstraction*.

[26] For the best discussion to date of spatiality in Ingres, see R. Rosenblum, *Jean-Auguste-Dominique Ingres*, 1967.

[27] See *Horace*, act IV: 'Rome, unique objet . . .'

[28] See Brookner, 'Jacques-Louis David: a personal interpretation', pp. 159–60.

[29] *La Vie de Henry Brulard*, ch. 31.

[30] See M. Florisoone, *Catalogue de l'exposition David* (Paris, 1948), p. 49.

[31] See R. L. Herbert, *Brutus*, pp. 49–121.

[32] See D. L. Dowd, *Pageant-master of the Republic: Jacques-Louis David and the French Revolution*.

[33] See R. L. Herbert, *Brutus*, pp. 31–2.

[34] Clough/Dryden edition of Plutarch's *Life of Brutus*, quoted in R. L. Herbert, *Brutus*, p. 17.

[35] See L. Trilling, *Sincerity and authenticity*, ch. 4.

[36] The effect of 'breaking in two' is already established in the fable. Two sets of brothers, of identical number and similar patronym, destroy each other. There has been exchange of women, which counters the enmity, but the exchange has been precisely symmetrical; and the exchange itself is annulled by the murder of Camilla. David takes the mirror or chiasma structure of the fable and reworks it in terms of male and female: what we know of the three-versus-three conflict between Rome and Alba becomes, in the painting, the three (warriors) versus three (non-warriors) across the genders.

[37] The later and more ghastly manifestations of 'waxwork' classicism are already present as emergent tendencies in Drouais's *Marius à Minturne*, and Taillasson's *Vergil declaiming the Aeneid* (National Gallery, London). David's relation to waxworks is the subject of H. Hinman's 'Jacques-Louis David and Mme. Tussaud', as well as a macabre anecdote in *Delécluze*, pp. 343–5.

CONCLUSION. STYLE OR SIGN?

[1] See R. Rosenblum, *Transformations*, pp. 50–106, where Rosenblum discusses the *topoi* of the Virtuous Widow and of the Exemplary Death. The stylistic versatility of Brenet is by no means exceptional in this period: cf. the work of F.-A. Vincent. Vincent, having already completed *Président Molé*, joins the Peyron–Drouais–*Oath* cluster with *Job* (Musée Thomas-Henry, Toulouse): the painting combines a perspective plunge across flagstones and cornices, with planimetric walls and processional grouping; besides this double spatiality, the work divides at the middle by means of the *Curius Dentatus* device of eye-movement, and supplies a false resolution of the resultant break across two rhyming hand-gestures in a manner that is close to the *Cymon and Militiades*; moreover, its interest in the slackness of ageing male muscle looks Ribera-like (closer to *Saint-Roch* than to *Seneca*), and the lighting is heading towards David's elimination of middle tones. Vincent's *Sabines* of 1781 (Musée des Beaux-Arts, Angers) is also cognate with the 1785 group: although at first the painting makes sense rather as inspiration for David's *Intervention*, in fact David's later version will eliminate the strong '1780s' features – compositional disunity and agitation, anatomical precision (down to reflections on the sweat of the warriors' muscles), mixture of relief space (two full and parallel profiles) with perspective (foreshortening of the two fallen males, a distant fortress clearly announcing the vanishing point). But Vincent looked on neo-classicism as only one among many available styles: see also his

contemporary history painting *The Oath of Galaizière* (Versailles), his
Henry IV, and *William Tell* (Toulouse).

[2] From Dryden's translation of *The Aeneid*, book iv, lines 927f, ed. R.
Fitzgerald (Macmillan, 1964), pp. 142–3.

[3] William Morris, *The Aeneids of Vergil* (London, 1876), p. 113.

[4] Letter to Wicar, 14 June 1789; in Jules David, *Le peintre Louis David*, p. 622.

[5] See V. Lee, 'Jacques-Louis David: the Versailles sketchbook'.

[6] *Delécluze*, p. 62.

[7] It is hard to make coherent sense of the zodiac in the *Imperial Portrait*. The
fixed points that Ingres supplies are Virgo (6), Libra (7), Scorpio (8) and
Pisces (12). But if we imagine the part of the series 9 through 11 (Sagit-
tarius through Aquarius) as hidden beneath the throne, there is asym-
metry: Virgo (6) corresponds to Pisces (12), Libra (7) would correspond to
a hidden Aquarius (11), Scorpio (8) to a hidden Capricorn (10), but
Sagittarius (9) would have no partner. If the sign at the lower right of the
painting is Cancer (4), then the sign at the lower left is Leo (5): but what
happens to 1 through 3 (Aries through Gemini)? Astrologically-minded
friends point out that Ingres was a Virgo and Napoleon a Leo: it seems to
them that if any sign were to be stressed in the *Imperial Portrait*, it should be
Leo, not Virgo; this 'ousting' of the Imperial lion by the Ingres–Raphael
Virgo, if it exists, would correspond to the painting's overall suggestion of
an Ingresian Imperialism rivalling the Napoleonic Imperialism, and enjoy-
ing similar privileges of raiding and 'ensemblisation'. Although astrologi-
cal thinking was doubtless not so widespread in the early nineteenth
century as it used to be in the 1960s and 1970s there would have been more
awareness of the zodiac in the Revolutionary period than before: Fabre
d'Eglantine's Revolutionary months began at the 'cusp' not the kalend;
and David was sufficiently persuaded of the recognisability of the zodiacal
signs to include them in a Revolutionary medal issued before Thermidor.
Although Ingres's re-ordering of the zodiac probably passed largely
unnoticed, such marginal effect, like the allusion to the Raphael *Madonna
of the Chair*, and to the disparate source-styles of the portrait, are very
much part of the work's 'atmosphere' (i.e. half- or quarter-stated visual
information). The 'scrambling' of the zodiac contributes to the general
temporal disorientation of the image: viewed one way, the disorientation
is Ingres's perversity; viewed another, it is part of a global statement that
Empire transcends normal temporality.

[8] See, for example, the account of the *Vow* in the Catalogue to the Ingres
exhibition at the Petit Palais, 1967–8; pp. 190–2.

[9] *Delécluze*, p. 294.

Societies affiliated to CINOA

AUSTRIA

Bundesgremium des Handels mit Juwelen, Gold und Silberwaren, Uhren, Bildern, Antiquitäten und Kunstgegenständen

BELGIUM

Chambre des Antiquaires de Belgique

DENMARK

Dansk Kunst and Antikvitetshandler Union

EAST GERMANY

Bundesverband des Deutschen Kunst- und Antiquitätenhandels e.v.

FRANCE

Syndicat National des Antiquaires, Négociants en Objets d'Art, Tableaux anciens et modernes

Chambre Syndicale de l'Estampe, de dessin et du tableau

GREAT BRITAIN

The British Antique Dealers' Association

The Society of London Art Dealers

IRELAND

The Irish Antique Dealers' Association

ITALY

Associazione Antiquari d'Italia

Federazione Italiana Mercanti d'Arte

THE NETHERLANDS

Vereeniging van Handelaren in Oude Kunst in Nederland

NEW ZEALAND

The New Zealand Antique Dealers' Association

SOUTH AFRICA

South African Antique Dealers' Association

SWEDEN

Sveriges Kunst- och Antikhandlerforening

Syndicat Suisse des Antiquaires et Commerçants d'Art
(Verband Schweizerischer Antiquare und Kunsthändler)

UNITED STATES OF AMERICA

The Art and Antique Dealers' League of America

The National Antique and Art Dealers' Association of America

Select bibliography

Adhémar, H., *Watteau: sa vie, son oeuvre*, Paris, 1950.

Baltrousaitis, J., *Aberrations*, Paris, 1957.

Barker, G. W., *Antoine Watteau*, London, 1939.

Barnett, D., 'Eighteenth-century acting', in *Hippolyte et Aricie*, Covent Garden, 1978.

Barrell, J., *The dark side of the landscape: the rural poor in English painting 1730–1840*, Cambridge University Press, 1980.

Barthes, R., *Sur Racine*, Paris, 1963.

 Essais critiques, Paris, 1966.

 S/Z, Paris, 1970; trans. R. Miller, London, 1975.

 Le plaisir du texte, Paris, 1975; trans. R. Miller, *The pleasure of the text*, London, 1976.

 Image–music–text, essays selected and trans. by S. Heath, London, 1977.

Baxandall, M., *Giotto and the orators*, Oxford, 1971.

Benjamin, W., *The origin of German tragic drama*, trans. J. Osborne, London, 1077.

Berger, J., *Ways of seeing*, London, 1972.

Berger, P. and Luckmann, T., *The social construction of reality*, London, 1972.

Biebel, F., 'The pavilion at Louveciennes', *Gazette des Beaux-Arts* (October 1960), 207–26.

Blunt, Sir Anthony, *Nicolas Poussin*, London and New York, 1967.

Boerlin-Brodbeck, Y., *Antoine Watteau und das Theater*, Basle, 1973.

Booth, W., *Rhetoric of fiction*, Chicago, 1961.

Brookner, A., *Watteau*, London, 1967.

 'J.-L. David – a sentimental classicist', *Stil und Überlieferung in der Kunst des Abendlandes*, Berlin, 1967, I, 184–90.

 The genius of the future: studies in French art criticism, London, 1971.

 Greuze: the rise and fall of an eighteenth-century phenomenon, London, 1972.

 'Jacques-Louis David: a personal interpretation', *Proceedings of the British Academy*, LX (1974), 155–71.

Bruyne, E. de, *Etudes d'esthétique médiévale*, Bruges, 3 vols., 1945.

Bryson, N., 'Hazlitt on painting', *Journal of Aesthetics and Art Criticism*, XXXVII, 4 (1978), 37–45.

Butor, M., *Les mots dans la peinture*, Geneva, 1969.

Cantinelli, R., *Jacques-Louis David*, Paris, 1930.

Cartwright, M. T., *Diderot critique d'art et le problème de l'expression, Diderot Studies*, XIII, Geneva, 1969.

Casey, J., *The language of criticism*, London, 1966.

Chapearouge, D. de, 'Chardins Kinderbilder und die Emblematik', *Actes du XXIIᵉ Congrès international d'histoire de l'art* (1969), Budapest, 1972, 51–6.

Lord Clark, *Civilisation*, BBC and John Murray, 1969.

Crow, T., 'The *Oath of the Horatii* in 1785: painting and pre-Revolutionary radicalism in France', *Art History*, 1, 4, 424–71.

Culler, J., *Saussure*, Glasgow, 1976.

David, J., *Le peintre Louis David, 1784–1825: souvenir et documents inédits*, Paris, 1880.

Delécluze, *Louis David: son école et son temps: souvenirs,* Paris, 1855.

Descartes, René, *Traité sur les passions de l'âme*, Amsterdam, 1649.

Diderot, D., *Oeuvres complètes*, ed. J. Assézat and M. Tourneux, Editions Garnier, 22 vols., Paris, 1875–7.

Salons, ed. J. Seznec and J. Adhémar, 4 vols., Oxford, 1957–67.

Oeuvres esthétiques, ed. P. Vernière, Editions Garnier, Paris, 1968.

Oeuvres romanesques, Editions Garnier, Paris, 1962.

Lettres et réponses de Diderot à Sophie Volland, ed. M. Darmon Meyer, Paris, 1967.

Rameau's nephew, trans. J. Barzun and R. H. Bowen, Doubleday and Company, New York, 1956.

Memoirs of a Nun, trans. of *La Religieuse* by F. Birrell, London, 1959.

The Nun, trans. of *La Religieuse* by M. Sinclair, New English Library, 1966.

Diderot, D. and D'Alembert, Jean le Rondd, *Encyclopédie*, 'Neufchastel' (Geneva), 1751–65. (Neufchastel was a false place-name.)

Done, E., 'Le Comte d'Angiviller et les grands hommes de la France', M.A. report, University of London, 1976.

Doolittle, J., 'Hieroglyph and emblem in Diderot's "Lettre sur les sourds et muets"', *Diderot Studies*, II (1952), 148–67.

Doubrovski, S., *Corneille et la dialectique du héros*, Paris, 1963.

Douglas, M., *Purity and danger: an analysis of concepts of pollution and taboo*, London, 1966.

Dowd, D. L., *Pageant-master of the Republic: Jacques-Louis David and the French Revolution. University of Nebraska Studies*, Lincoln, Nebraska, 1948.

Eisenstein, S., *Film forum: essays in film theory*, ed. and trans. J. Leyda, New York, 1949.

Film essays, ed. and trans. J. Leyda, London, 1968.

Félibien, A., *Les Reines de Perse aux pieds d'Alexandre, peinture du cabinet du Roy,* Paris, 1663; trans. as *The Tent of Darius Explained; or the Queens of Persia at the Feet of Alexander*, by Collonel Parsons, London, 1703.

Entretiens sur les vies et sur les ouvrages des plus excellens peintres anciens et modernes, 5 vols., Trevoux, 1725.

Fontaine, A., *Conférences inédites de l'Académie royale de peinture et de sculpture*, Paris, 1903.

Les Doctrines d'Art en France, Paris, 1909.

Académiciens d'autrefois, Paris, 1914.

Foucault, M., *Les mots et les choses*, Paris, 1966.

Francastel, P., *La figure et le lieu*, Paris, 1967.

Etudes de sociologie de l'art, Paris, 1970.

Fried, M., 'Absorption: a master theme in eighteenth century French painting and criticism', *Eighteenth Century Studies*, IX, 2 (Winter 1975/6), 139–77.

Funt, D., *Diderot and the esthetics of the Enlightenment*, *Diderot Studies*, XI, Geneva, 1968.

Gendzier, S. J. (ed. and trans.), *Denis Diderot's The Encyclopedia*, New York, 1967.

Genette, G., *Figures II*, Paris, 1969.

Gombrich, Sir Ernst, *Art and illusion: a study in the psychology of pictorial representation*, London, 1968.

Goncourt, E. and J. de, *L'Art au dix-huitième siècle*, Paris, 1856–75; trans. R. Ironside as *French eighteenth-century painters*, London, 1958.

Grimm, F. M., Baron von, *Correspondance littéraire, philosophique et critique adressée à un souverain d'Allemagne*, 16 vols., Paris, 1877–82.

Guedj, A., 'Les drames de Diderot', *Diderot Studies*, XIII (1971), 15–94.

Guiraud, P., *Semiology*, London, 1975.

Hacking, I., *The emergence of probability*, Cambridge, 1975.
Why does language matter to philosophy? Cambridge, 1975.

Hautecoeur, L., *Rome et la Renaissance de l'antiquité à la fin du XVIIIe siècle*, Paris, 1912.
Louis David, Paris, 1954.

Hazlehurst, F. H., 'The artistic evolution of David's Oath', *Art Bulletin*, XIII (March 1960), 59–63.

Heath, S., *The nouveau roman: a study in the practice of writing*, London, 1972.
'Narrative Space', *Screen*, XVII, 3 (Autumn 1976), 68–112.

Hegel, *The phenomenology of mind*, trans. J. B. Baillie, Harper Torchbook Edition, New York, 1967.

Henkel, A. and Schöne, A., *Emblemata*, Stuttgart, 1967.

Herbert, R. L., *Brutus*, London, 1972.

Hinman, H., 'Jacques-Louis David and Mme Tussaud', *Gazette des Beaux-Arts*, LXVI (December 1965), 331–8.

Holma, K., *David: son évolution et son style*, Paris, 1940.

Hourticq, L., *De Poussin à Watteau*, Paris, 1921.

Husserl, E., *Gesammelte Werke*, ed. W. Biemal, 22 vols., The Hague, 1963–79.

Irwin, D., 'Gavin Hamilton: archaeologist, painter, and dealer', *Art Bulletin*, XLIV (1962), 98 ff.
Winckelmann, writings in art, London, 1972.

Jakobson, R., *Selected Writings of R.J.*, 5 vols., The Hague, 1972.

Johnson, A., 'Watteau and his critics', M.A. report, University of London, 1974–5.

Jouin, H., *Conférences de l'Académie royale de peinture et de sculpture*, Paris, 1883.
Charles LeBrun et les arts sous Louis XIV, Paris, 1889.

Kapos, M., 'The languages of realism', *Screen*, XIII, 1 (Spring 1972), 79–86.

Kavanagh, T. M., *The vacant mirror: a study of mimesis through Diderot's 'Jacques le fataliste'*, *Studies on Voltaire and the Eighteenth Century*, CIV, 1973.

Kristeva, J., *Séméiotikè: recherches pour une sémanalyse*, Paris, 1969.

Leach, Sir Edmund, *Genesis as myth*, London, 1969.
Lévi-Strauss, London, 1970.

LeBrun, Charles, *Conference of Monsieur LeBrun ...*, trans. of the *Conférence sur l'expression ...* by J. Smith, London, 1701.

Lee, V., 'Jacques-Louis David: the Versailles sketchbook', *Burlington Magazine*, CXI, 197–208 and 360–9.

Leith, J. A., *The idea of art as propaganda in France, 1750–1799*, Toronto, 1965.

Levey, M., *Rococo to Revolution*, London, 1966.
 'The real theme of Watteau's *Embarkation for Cythera*', *Burlington Magazine*, CIII, 180–9.

Lévi-Strauss, C., *Les structures élémentaires de la parenté*, Paris, 1949; trans. J. H. Bell, J. R. von Sturmer and R. Needham, London, 1969.
 Anthropologie structurale, 2 vols., Paris, 1958 and 1973.
 La pensée sauvage, Paris, 1962; English translation (anonymous), London, 1966.
 Mythologiques, 4 vols., Paris, 1964–71.

Locquin, J., *La peinture d'histoire en France de 1747 à 1785*, Paris, 1912.

Lundberg, G., 'Le graveur Pierre Floding à Paris, 1755–64', *Archives de l'art Français*, LXVII (1931–2).

Lyotard, J.-F., *Discours, Figure*, Editions Klincksieck, Paris, 1974.

MacGregor, N., 'Diderot and the *Salon* of 1769', M.A. report at the University of London, 1976.

Mauclair, C., *Watteau*, Paris, 1920.

Mitchell, H., 'Art and the French Revolution: an exhibition at the Musée Carnavalet', *History Workshop*, no. 5 (Spring 1978), 123–45.

Montagu, J., 'Charles LeBrun's "Conférence sur l'expression générale et particulière"', doctoral dissertation at the University of London, 1959.
 'LeBrun animalier', *Art de France*, IV (1964), 310–14.

Montaiglon, A. de (ed.), *Procès-verbaux de l'Académie royale de peinture et de sculpture, 1648–1792*, 10 vols., Paris, 1875–92.

Morgan, M. J., *Molyneux's question*, Cambridge, 1977.

Mulvey, L., 'Visual Pleasure and Narrative Cinema', *Screen*, XVI (Autumn 1975), 6–18.

Munhall, E., 'Greuze and the protestant spirit', *Art Quarterly*, XXVII (1964), 3–22.

Nochlin, I., *Realism*, Pelican, 1971.

Normand, C., *J.-B. Greuze*, Paris, n.d.

Panofsky, E., *Renaissance and renascences*, Uppsala, 1960.

Parker, K. T., *The drawings of Antoine Watteau*, London, 1931.

Pettit, P., *The concept of structuralism: a critical analysis*, Gill and Macmillan, 1975.

Pevsner, Sir Niklaus, *Academies of art, past and present*, Cambridge, 1940.

Phillips, C., *Antoine Watteau*, London, 1895.

Piles, Roger de, *Abrégé de la vie des peintres*, 2nd edition, Paris, 1715.

Porta, Giovanni Baptista della (dalla), *De Humana Physiognomia*, Hanover, 1593.
 Fisionomia naturale, Padua, 1622.

Praz, M., *Studies in seventeenth-century imagery*, *Studies of the Warburg Institute* III (1939–47).

Prendergast, C., 'Writing and negativity', *Novel*, VIII, 3 (Spring, 1975), 186–213.

Propp, V., *Morphology of the folktale*, ed. S. Pirkova-Jakobson, Bloomington, Indiana, 1958.

Rackham, B., *The ancient glass of Canterbury Cathedral*, London, 1959.

Rosenblum, R., *The international style of 1800: a study in linear abstraction*, doctoral dissertation at New York University, 1956.

'Gavin Hamilton's *Brutus* and its aftermath', *Burlington Magazine*, CIII (1961), 8–16.

Jean-Auguste-Dominique Ingres, London, 1967.

Transformations in late eighteenth-century art, Princeton, 1969.

'A source for David's *Horatii*', *Burlington Magazine*, CXII (May 1970), 169–73.

Rothstein, E., '"Ideal presence" and the "non finito" in eighteenth century aesthetics', *Eighteenth-Century Studies*, IX, 3 (Spring 1976), 307–32.

Saint-Simon, Duc de, *Memoirs of the Duc de Saint-Simon*, selected by W. H. Lewis and trans. B. St John, London, 1964.

Saussure, F. de, *Course in general linguistics*, ed. C. Bally and A. Sechenaye, trans. W. Paskin, New York, 1966.

Seznec, J., 'Diderot et l'Affaire Greuze', *Gazette des Beaux-Arts* (May 1966), 339–56.

Silvestre de Sacy, J., *Le Comte d'Angiviller, dernier Directeur Général des Batiments du Roi*, Paris, 1953.

Sitwell, S., *Antoine Watteau*, London, 1925.

Spitzer, L., *Linguistics and literary history: essays in stylistics*, Princeton, 1948.

Starobinski, J., *L'oeil vivant*, Paris, 1961.

The invention of liberty, trans. B. C. Swift, Geneva, 1964.

Tanner, P. A., 'Julie and "La Maison Paternelle"; another look at Rousseau's *La Nouvelle Héloïse*', *Daedalus*, CV, 1 (Winter 1976), 23–46.

Adultery in the novel: contract and transgression, The Johns Hopkins University Press, Baltimore and London, 1979.

Teyssèdre, B., *Roger de Piles et les débats sur le coloris au siècle de Louis XIV*, Paris, 1957.

Thuillier, J., *Catalogue*, LeBrun exhibition, Versailles, 1963, XVII–XXXII.

'Temps et tableau: la théorie des "péripaties" dans la peinture française du XVIIIe siècle', *Stil und Überlieferung in der Kunst des Abendlandes*, Berlin, 1967, III, 191 ff.

Trilling, L., *Sincerity and authenticity*, London, 1972.

Verdi, R. F., *Poussin's critical fortunes*, doctoral dissertation at the University of London, 1976.

Wakefield, D., *Fragonard*, London, 1976.

Waterhouse, E. K., 'The British contribution to the neo-classical style in painting', *Proceedings of the British Academy*, XL (1954), 57–74.

Watt, I., *The rise of the novel*, London, 1976.

Wildenstein, G., *Fragonard*, Phaidon, 1960.

Wind, E., 'The revolution of history painting', *Journal of the Warburg and Courtauld Institutes*, II (1938–9), 20f.

'The sources of David's *Horaces*', *Journal of the Warburg and Courtauld Institutes*, IV (1940–1), 124–38.

Yates, F., *The art of memory*, London, 1966.

Index